Willem de Kooning
Drawings · Paintings · Sculpture

Whitney Museum of American Art, New York
December 15, 1983 – February 26, 1984

Akademie der Künste, Berlin
March 11 – April 29, 1984

Musée National d'Art Moderne,
Centre Georges Pompidou, Paris
June 26 – September 24, 1984

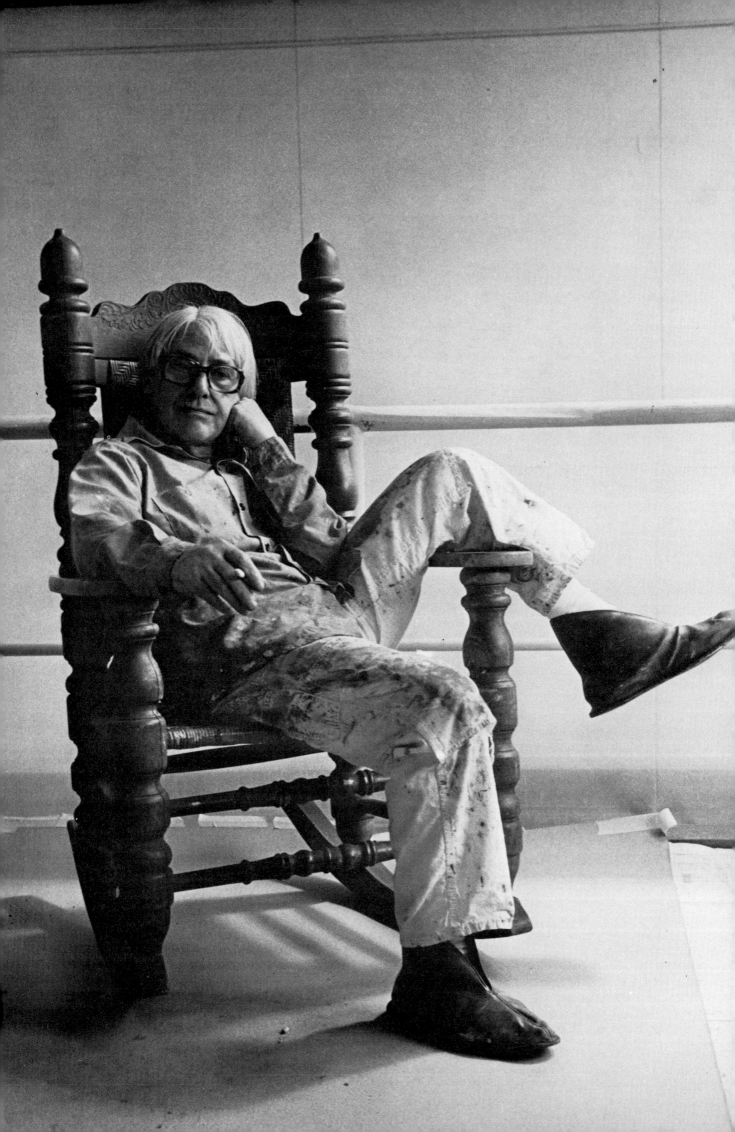

Willem de Kooning

Drawings · Paintings · Sculpture

New York · Berlin · Paris

Paul Cummings, New York
Jörn Merkert, Berlin
and Claire Stoullig, Paris

Whitney Museum of American Art, New York
in association with
Prestel-Verlag, Munich
and W. W. Norton & Company, New York · London

Frontispiece: Willem de Kooning in his East Hampton studio, March 1975

Front cover: Women IV, 1952-53 (Cat. 193)
Back cover : Two Women Torsos, 1952 (Cat. 54)

Willem de Kooning: Drawings, Paintings, Sculpture was published on the occasion of
two exhibitions at the Whitney Museum of American Art, New York: "The Drawings
of Willem de Kooning", December 7, 1983-February 19, 1984, supported by grants
from Warner Communications Inc. and the National Endowment for the Arts; and
"Willem de Kooning Retrospective Exhibition", December 15, 1983-February 26,
1984, supported by grants from Philip Morris Incorporated and the National
Endowment for the Arts.
The de Kooning exhibitions were organized jointly by the Whitney Museum of
American Art, New York, the Akademie der Künste, Berlin and the Musée National
d'Art Moderne, Paris.
The publication was organized at the Whitney Museum by Doris Palca, Head, Publi-
cations and Sales; Sheila Schwartz, Editor; James Leggio, Associate Editor; and
Amy Curtis, Secretary.

This book contains 308 pages with 321 illustrations of which 143 are reproduced in color.
Prestel-Verlag wishes to thank Xavier Fourcade, New York, for his generous cooperation.

The essay of Jörn Merkert was translated by John W. Gabriel, Berlin.

ISBN 0-87427-045-6 (Whitney Museum of American Art; softcover edition)
ISBN 0-393-01840-7 (W. W. Norton & Company; hardcover edition)

Type set by Fertigsatz GmbH, Munich
Offset lithography by Brend'Amour, Simhardt GmbH & Co., Munich
Printed by Karl Wenschow GmbH, Munich
Bound by R. Oldenbourg, Graphische Betriebe GmbH, Munich
Printed in Germany

Contents

Sponsors

Philip Morris Incorporated is pleased to sponsor the "Willem de Kooning Retrospective Exhibition" of paintings and sculpture by a giant of twentieth-century art.

With extraordinary vigor and creative exuberance, Willem de Kooning just keeps on expanding our visual language. He has reshaped our view of the world and, nearing eighty, he apparently is not yet done. It seems this national treasure of ours remains endlessly open and ready for whatever new ideas, new possibilities, arise to confront him: "I think whatever you have can do wonders if you accept it." He insists, time and again, "I have my own eyes." Rejecting all dogma and clichés that censor our vision, he remarks "I am always looking. And I see an awful lot sometimes."

This power of contemporary art to thrust us all forward has inspired Philip Morris and has received our support for twenty years and more in the United States and abroad. We are eager, as an economic enterprise and a responsible social organization, to add to the enjoyment of people in the lands in which we live and work.

George Weissman
Chairman of the Board and
Chief Executive Officer
Philip Morris Incorporated

Willem de Kooning's mastery of painting and sculpture is, of course, well known. Until now, however, the extraordinary body of work represented by his drawings has not received comparable attention.

The exhibition "The Drawings of Willem de Kooning" and this catalogue, which survey nearly sixty years of his career from student days to his most recent works, provide a unique opportunity to study and evaluate de Kooning's draftsmanship and its relationship to the development of his paintings.

We extend our sincere thanks to Mr. de Kooning and congratulate the Whitney Museum of American Art and Paul Cummings for their initiative in organizing this exhibition. It is our hope that this exhibition will stimulate and delight those who view it at the Whitney Museum in New York and, thereafter, in West Berlin and Paris.

Warner Communications Inc. is proud to present the first in-depth survey of the drawings of Willem de Kooning.

Steven J. Ross
Chairman of the Board and
Chief Executive Officer
Warner Communications Inc.

Foreword

It is an extremely gratifying experience to be able to devote the facilities and resources of three international institutions to the work of an artist who within his lifetime has changed the nature of painting and our understanding of art. More than any other American artist of the twentieth century, Willem de Kooning has added to the vocabulary of painting, altered the perception of what painting represents, and provided us with the stimulus to respond to art in new ways.

No style of art in our time has had a more pervasive influence than Abstract Expressionism. As a leader in pursuing this extraordinarily innovative approach, de Kooning focused attention on American art to an unprecedented degree. For the first time, the United States became a leader in the visual arts. Artists looked to American culture for their inspiration. As American art achieved international preeminence, many artists assimilated the vocabulary and mannerisms of Abstract Expressionism, but no one could use the language as well as de Kooning. Eventually the dignity he brought to American art generated reactions from others who went on to create new modes of expression in response to the challenge of his overwhelming vitality.

In a recent film, de Kooning could be seen actually working on a painting in front of the camera. The most amazing aspect of this film was the incredible authority which he brought to what seemed to be a spontaneous activity. His sure-handed gestures and his relationship with the brush and paint created the sense that one was witnessing a personal encounter only he could conduct. It was awesome to watch such a private experience become public.

This exhibition and associated publication include besides the most important paintings and examples of his sculptural work the first retrospective view of de Kooning's drawings, an aspect of his work which reveals in part the working methods that produce such energy in his paintings. The drawings stand on an equal footing with his paintings: an understanding of de Kooning's art depends to a great extent on appreciation of gesture, and nothing translates that better than line. We are very pleased that so many of the drawings and paintings could be assembled to expand our comprehension of de Kooning's achievement.

We are extremely grateful to all the museums and private collectors who have allowed us to share their works through loans to this exhibition, and to the sponsors – Philip Morris Incorporated, Warner Communications Inc., and the National Endowment for the Arts – for their vision in supporting this project. We are delighted that the accomplishments of this extraordinary European-born artist, who changed American cultural history after immigrating to this country, will be presented in Europe.

Tom Armstrong
Director
Whitney Museum of American Art, New York

Acknowledgments

An elementary public recitation of appreciation for the contributions in time, labor, thought, or goodwill of the many individuals who have directly or indirectly assisted the organization of this exhibition is not a sufficient reward for the value of their aid and concern. Those whose goodwill and support allowed the development of this exhibition are: first and foremost, the artist himself, Willem de Kooning, his longtime friend, Lee Eastman, and Xavier Fourcade, his dealer; the staff of Xavier Fourcade, Inc., especially Jill Weinberg and Margaret Parker, who provided efficient and always charming assistance in solving innumerable problems; Elaine de Kooning, a friend of many years, who has always provoked the mind with stimulating conversation and cogent insight into the accomplishments of her husband and much else in art and life; Tom Ferrare, who assisted in the artist's studio and helped to make many useful arrangements. My interns at the Whitney Museum deserve commendation for their labors and inventive research methods, especially Barbara Thexton, who worked on the initial research, and Anne Hartog and Sue Klein, who completed the task during the summer of 1983. Sue Marlieb, my secretary, coordinated the complicated schedules for everyone, and always coped with the ever-shifting nuances of the participants. Sue Felleman, her successor, for a brief time worked toward the completion of the exhibition. I am indebted to the staff of the Whitney Museum for their continuing support, and especially to Anita Duquette for her extraordinary skills in arranging for photography under the pressure of time and often in distant places. The kindness of Cortney Sale Ross and her staff at Cort Productions gave me access to her own interviews with the artist and the materials she assembled for her film *de Kooning on de Kooning*. The whole undertaking was made easier by Jörn Merkert of the Akademie der Künste, Berlin, with his friendly understanding of the complexities of the exhibition.

Paul Cummings
Adjunct Curator, Drawings
Whitney Museum of American Art

Paul Cummings

The Drawings of Willem de Kooning

I had a gift. When I was a child I used to draw. . . .

*I was really influenced by Gorky because I liked
his painting better than anybody's.*

de Kooning

Willem de Kooning is one of the consummately inventive draftsmen of the twentieth century. He was born on April 24, 1904, in Rotterdam, to Cornelia Nobel and Leendert de Kooning, a successful distributor of wines, beers, and soft drinks. His parents divorced when he was five years old, and the court assigned him to his father, but his mother fought the decision and simply took him home with her. Later she won legal custody through a successful appeal of the original decision. His father married again and now with a new family had little time to see his son. Many children draw and so did the young Willem. This talent for drawing led to an apprenticeship at the age of twelve to the firm of the commercial artists and decorators Jan and Jaap Giddings. The exceptional aptitude shown by the young apprentice provoked Jaap Giddings to take him to the Rotterdam Academy of Fine Arts and Techniques and enroll him for the full course of evening classes. [1]

In the early days of this century the Rotterdam Academy offered an education which blended a guild craft tradition into the seventeenth-century concept of Fine Art as a pure intellectual endeavor. The youthful student was trained in the disciplines and technical skills, which included perspective, proportion, cast drawing, wood graining, and marbelizing. These were filled out by lectures on art, theory, and history, from Egypt to the Renaissance. Drawing from the male figure preceded instruction in drawing the female figure. For eight years de Kooning studied, learning many of the crafts which would later provide him with a livelihood. He accomplished the demanding rhythms of lettering. The final test one year was to make a masterful sign. His interest in crisp lettering would always be noted and de Kooning is known to have remarked on the golden letters which once graced the sides of beer trucks. On his first visit to Paris, in January 1968, he commented on the fine quality of French sign lettering. It was an expression of the trained craftsman's eye, and empathetic wrist.

Few drawings remain from de Kooning's student years, or indeed from the years through 1945. Much of his early work failed to meet his later critical evaluations and was destroyed. [2] While a student he was introduced to modern art, but *Dish with Jugs* (c. 1921; Cat. 2) demonstrates the high degree of traditional skills which he achieved during his academic studies. He remembers the professor who admonished his students, gathered around a still-life object in the amphitheater, by saying: "Draw without ideas! Draw what you see, not what you think!" [3] This advice remained a keystone in de Kooning's methodology. Years later he said, "I think it is the most

bourgeois idea to think one can make a style beforehand." [4] *Dish with Jugs* substantiates his memory of being the best student in the class. It is a masterful demonstration of the technical skill required to understand and employ foreshortening, modeling, and the rendering of light and shadow. Through the ability to develop a variety of contrasting textures and by differentiating the various elements which comprise this rather standard art-student's problem, he succeeds in rendering dishes believable in the mind's eye. Black-and-white drawing is employed to identify the form-making process. Light, playing on the outer and upper rims of the bowl, flows into space and clarifies the lower dark tones. De Kooning recalls that the drawing was to be finished with a series of minute conté crayon dots and points to give its surface a textureless trompe-l'œil illusion. This method of finish was a revealed guild "secret." [5] The purpose was to exclude the artist's personality and individual handwriting and, by adhering to the rules, to succeed.

In 1920 he left the Giddings' studio to work under Bernard Romein, the art director of a large department store. He continued night classes at the academy, but during the day became acquainted with the modern art of Holland, Germany, and Paris. Romein was acquainted with the art of the de Stijl group. De Kooning discovered the art of Mondrian, whom he and fellow students appreciated. Because of Mondrian they felt they were able to abandon symmetry in such endeavors as sign-making. [6] In 1924 de Kooning traveled with some friends to Belgium. There he supported himself with odd jobs such as sign and portrait painting, illustrating, and making window displays. He returned to Holland in 1925 and the following year set out for America.

De Kooning had read Walt Whitman, knew about cowboys and Indians, and had studied the designs of Frank Lloyd Wright. Photographs of long-legged American girls fascinated him. He also thought he could make some money. "I was crazy about American illustrators, they were so terrific. I thought it would be nice if I could be one of those illustrators. But I had no talent for it." [7] Leo Cohan, a friend, arranged for de Kooning to earn his passage to America by working as a wiper in the engine room of the English freighter S.S. *Shelley*, bound for Newport News, Virginia. He arrived on August 15, 1926, but left the ship with insufficient papers, though he was soon able to sign on a coaler going to Boston and subsequently left that ship in Hoboken, New Jersey, with acceptable documents. Cohan arranged for de Kooning to stay in Hoboken at a Dutch seamen's boardinghouse. The only English word he knew was

"yes." For some time he worked as a house painter. In 1927 he moved to a studio on West Forty-fourth Street in Manhattan and again supported himself by commercial art jobs – sign-making and designing the backgrounds of windows in the A. S. Beck shoe stores.

On weekends de Kooning would find a little time for drawing or painting. He began to visit the museums and the few art galleries in New York City. Earning a living required most of his time and energy, and little work remains from this period. He met John Graham in April 1929 at the opening of an exhibition of the latter's paintings at the Dudensing Gallery.[8] "I was lucky when I came to this nation to meet the three smartest guys on the scene: Gorky, Stuart Davis, and Graham. They knew I had my own eyes alright, but I wasn't always looking in the right direction."[9] Who were these early and vital influences?

Of these three friends, Graham was the eldest. Born Ivan Dabrowsky in Kiev in 1881, he had arrived in New York in 1920. A frequent traveler to Paris, he was acquainted with Picasso, Eluard, Breton, and others, and was a major source of information on the latest art to be seen in the French capital. He was also a connoisseur of primitive art, and assembled the Frank Crowninshield collection of African masks and objects. The bases for many of these objects were made by David Smith. Graham's book, *System and Dialectics of Art*, published in 1937, is a compendium of art theory and cultural history, laced with political, social, and mystical information, and interpretation. It is one of the few books of the period to circulate among and remain in the studios of the artists who emerged during the 1940s. It offers a rare insight into the thinking and intellectual atmosphere of the period. Graham had an eye for talent. He singled out several young artists for mention in his book, including Stuart Davis, Jan Matulka, David Smith, Willem de Kooning, and Milton Avery, stating that they were as good and sometimes better than the leading artists of the same generation in Europe. His book was among the first to integrate American artists of the post-Stieglitz group into international art history. Another of Graham's contributions was the organization of an exhibition contrasting the work of the youthful Americans with the mature work of Picasso, Braque, and Matisse. Presented by McMillen, Inc., a decorating firm, the exhibition took place in 1942, and became the first gallery appearance of de Kooning, as well as Jackson Pollock, who as a consequence of it met Lee Krasner. Graham continued as a catalyst and proselytizer for modernism until about 1943, when he renounced Picasso, Marx, Jung, and Freud, replacing them in his pantheon of heroes with Uccello, Raphael, Poussin, and Leonardo.[10] Mystical, cabalistic, black-magic signs and symbols appear in his drawings and paintings. Another manifestation of an increasing antiquarianism was the designation of IOANNUS as his new signature. At the time of his death in London in 1961, the once vital exponent of modern thought who had later rejected Picasso with the invective "the world's best caricaturist... cynical... not divine..."[11] had completed his transition from "modernist to Magus."[12] Graham also withdrew his support of the Americans, whom he had championed, by stating in a letter to David Smith and his wife, Dorothy Dehner, that "making abstractions is like making refrigerators."[13]

Stuart Davis, a decade older than de Kooning, was born in Philadelphia on December 7, 1894, a son of Edward Wyatt Davis, the art director of the *Philadelphia Press*, and the sculptor Helen S. Davis. He grew up among the journalists and illustrators of the newspaper, studied briefly with Robert Henri, and participated in the Armory Show of 1913, which confirmed his commitment to vanguard art. From late May 1928 to August 1929 he was in Paris. Davis was also a social activist and writer. The thoughtful drawings through which he prepared the compositions for his paintings were, he stated, influenced by the jerky rhythms of jazz. His high-key, solid colors, set in flat space, stood in dramatic contrast to much of the soft, tonalist painting of the time which was influenced by Renoir, George Grosz, and Jules Pascin. While Davis never ventured into complete abstraction, his activities as artist and writer provided an intelligent, validating reassurance of the values of modernism for many younger artists. His presence and thought were admired, though his style seems not to have affected any major talents.

About 1930-31, de Kooning was introduced to Arshile Gorky in the studio of Mischa Resnikoff.[14] The young artists, only ten days apart in age, were to remain close friends until Gorky's suicide in 1948. The tall Armenian, who had a respected, though modest and romantic, reputation among the vanguard artists, taught at the Grand Central School of Art from 1926 to 1931. He had meticulously worked his way through modern art from Cézanne onward and in the early 1930s was exploring the recent paintings of Picasso. Neither Gorky, de Kooning, nor Davis displayed much interest or concern with the subject matter of social realism, or the regional painting styles then in public ascendancy. Gorky and de Kooning frequented the museums and galleries together. Their responses to what they saw differed. Gorky would examine a painting by later painting his version of it, while de Kooning would exercise his imagination, using selected elements of the pictures, combined with objects or situations seen in the street, and would synthesize them into pictures which often bore little relationship to their sources. In de Kooning's work, therefore, the usual scholarly device of comparing one picture with one by a predecessor is less fruitful than the careful exploration of the artist's thinking as evidenced in the development of his drawings and paintings. The world about him always was a major resource, but whatever the ostensible subject matter, he has always been concerned with light, water, and flesh.

By the end of his first decade in New York, de Kooning was moving within a circle of sophisticated individuals who, like himself, were on the brink of emerging as the major forces in shaping a new art. These included Gorky, Clement Greenberg, Edwin Denby, David Smith, and Fairfield Porter. They were filled with admiration for de Kooning's accomplishments and the promise of his talent and provided a friendly, though demanding audience.

In these years, his small paintings reveal a diversity of fragmentary influences from Le Nain, Ingres, Miró, Picasso, Graham, Mondrian, Léger, and Lurcat to Mexican mural art, de Chirico perspective, and more.[15] Two themes slowly emerged. One was an interest in abstraction, the other an examination of man in a series of often isolated figures, male or female, set in a murky, anonymous space – the so-called "no-environment" of the city.[16]

In 1935 de Kooning joined the Federal Art Project, a division of the Works Progress Administration, a government organization established to aid fine artists during the Depression years by providing them with work and a monthly stipend. The artists produced murals for public buildings or worked in their studios

at painting or printmaking. During this year de Kooning participated in several mural projects, none of which reached fruition. At one time he was assigned, as an assistant, Harold Rosenberg, who later, as a critic, emerged as an ardent champion of de Kooning's art.

De Kooning's first museum appearance was in a 1936 exhibition at the Museum of Modern Art which surveyed the efforts of the Art Project. His study for a mural in the Williamsburg Federal Housing Project in Brooklyn went unnoticed and was subsequently destroyed.[17] Congress passed a law against having aliens on the Art Project (de Kooning did not become an American citizen until 1962), so he left after one year.[18] Some years later he told Irving Sandler in an interview: "even the year I was on gave me such a terrific feeling that I gave up painting on the side and took a different attitude. After the project I decided to paint and to do odd jobs on the side. The situation was the same, but I had a different attitude."[19] Before the Federal Art Project he had considered himself a "modern person" in the "real world," using his highly developed skills as a professional house painter, carpenter, designer, or portraitist. Now, in his mid-thirties, he found in the project a catalyst by which he transformed himself into a full-time artist, and it is from this moment that we can date the true beginning of his career. In a recollection of the 1930s, Edwin Denby, poet and premier dance critic, wrote: "I met Willem de Kooning on the fire escape, because a black kitten lost in the rain cried at my fire door. And after the rain it turned out to be his kitten. He was painting on a dark, eight-foot picture that had sweeps of black across it and a big look. That was early in '36."[20] Denby's are among the most plausible descriptions of the vanguard artists' life in the New York of the Depression. The "big look" he observed suggests a new and dramatic picture-making activity in progress. Denby and the photographer Rudolph Burckhardt were to become the first significant patrons of de Kooning. They were soon joined by the painter Fairfield Porter, who also acquired important de Kooning paintings.[21]

Though de Kooning's decision to become a full-time painter expressed a change of attitude, he nevertheless continued to explore various paths in arriving at his own forms and methodologies. His intellectual response to the poetic formulations of his friend Gorky can be observed in his untitled study for the Williamsburg Federal Housing Project mural (c.1935; Cat.28) in the Whitney Museum of American Art. This drawing can now be dated to the brief period before 1937, when he dropped the "de" from his name. He thought it would be "catchier."[22] The rigid composition, with its planes and broken bars of color, relates to Léger. This small page also relates to the ideas explored by Gorky in his mural *Administration Building, Newark Airport* (1935-36), a study for which is now in the collection of the Museum of Modern Art, New York. De Kooning's inclusion of the circle, oval, and the head-and-shoulders-like configuration reveals an interest in Arp and biomorphism. The isolated shapes are set into geometric structural configurations, thereby introducing a recurring theme. Rectangles are used as windows, doors, mirrors, pictures, and other rigid architectural elements; these forms would continue to be used in the background of his drawings and paintings as space modulators for decades. The refined shapes are held in a balanced tension. The rich, luminescent pastel tones of these lush, clear, bright colors would remain a part of his palette. De Kooning's light-filled colors differ diametrically from the muddy tones employed by the majority of Depression-period artists. The

pastels changed the color values used by Mondrian or Léger in their highly structured pictures.

In 1937 de Kooning gained a private commission to design one section of a three-part mural for the Hall of Pharmacy at the New York World's Fair. The design (illustration, p.270) was painted by professional mural painters. The images he chose suggest a scientific modernism, though dominated by man's presence. The composition blends biomorphic and surreal interests. Little of the anecdotal social motivations seen in other murals of the time appears in de Kooning's work. There are hints of what he learned from Léger in the structural collage of flat forms spread across the rather free-form shapes. We can already note the implications of ambiguity and suggestion rather than a specific "realist" statement.

It is a significant comment on the culture of the moment that the artists of de Kooning's generation neither followed nor displayed any great interest in the established figures in American art. Save for Stuart Davis and Burgoyne Diller, who had little public reputation outside their immediate circle of friends, the sources for the new art were still sought in Europe and in the individual's psyche. It is rare to find, in either their conversations or their works, references to the then critically acclaimed work of artists such as Franklin C. Watkins, Thomas Hart Benton, Alexander Brook, or Rockwell Kent. This attitude also extended itself to the work of the Stieglitz group: Dove, Hartley, Marin, and O'Keeffe. The modestly scaled paintings of Dove and O'Keeffe did not capture the imagination of these artists or of following generations. We do not find the inventive figures of de Kooning's generation dealing with the social or political issues offered by such men as the Soyer brothers, William Gropper, or Ben Shahn. Rather, they contended with a more complex and powerful tradition. They looked, for example, to the larger and more substantial problems stated by Cézanne, Picasso, Kandinsky, Miró, Léger, Matisse, and Mondrian. It was the high aspiration of their imaginations that was to bring post-World War II American art firmly into the international scene for the first time.

In the last years of the 1930s de Kooning produced a series of small abstractions. These compositions, often made on paper, are executed with bright, clear color in ink, gouache, and pencil. They suggest objects set in an interior, a still-life atmosphere of cool light. He also drew studies of the male figure, often sketching himself in a mirror or from photos taken by Ellen Auerbach.[23] These drawings reveal that de Kooning's ambition was to develop a way of drawing the figure which differed from his contemporaries' approach. His interest in the Le Nain brothers, sparked by Gorky, is revealed in *Self-Portrait with Imaginary Brother* (c.1938; Cat.9) and the seated-men sketches. Gorky, too, searched along the same road, as can be seen in his *Self-Portrait* (c.1936; Fig.1), made about the same time as the de Kooning drawings. De Kooning's brittle, short lines evoke a choppy, nervous effect and suggest a restraint upon his as yet unrevealed lyrical skills. The delicate line remains charged with conviction and knowledge, establishing a believable image on the page. He would often challenge his trained talent – the quality differs from the secure line and tonal control displayed in his youthful academic studies.

Control is assiduously maintained in the drawing *Reclining Nude (Juliet Browner)* (c.1938; Cat.5). The carefully posed reclining figure, drawn in pencil, with its elegantly elongated torso, suggests a sustaining interest in blending the biomorphic into an abstract impulse. Behind the model is a round table of

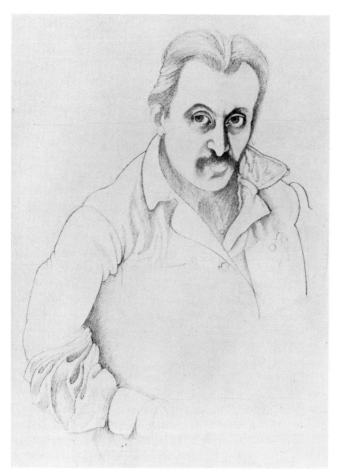

Fig. 1. Arshile Gorky, *Self-Portrait*, c. 1936. Pencil on paper, 9x6″. Collection of Ethel Schwabacher

the kind de Kooning might have designed in those days. Upon this cylindrical shape is an object presented as a dark, vertical plane which emphasizes the shallow space of the picture plane. The body's shapes are delicately clarified. In generalizing these shapes, de Kooning reduced sexual connotation. A craftsman's obsession is denoted by the carefully modulated tones of the textures. The darker demarcation lines imply the initial generation of generalized shapes leading to increased abstraction. The fractured face remains incomplete, yet the fracturing draws our attention to it. It is not a difficult leap of the imagination to see these forms as the source for the seated-female figure drawings of the early 1940s and thence into the attenuated floating shapes in paintings such as *Pink Angels* (1945; Cat. 156). These intimate shapes retain their emotional charge because memory merges them into the viewer's own transformed reminiscences.

De Kooning's sequential method of painting, of resolving the image by painting and repainting on the same canvas, soon established his reputation among the underground painters, or "loft rats" as they were called in the 1930s, of talented brilliance, fecund invention, if not genius, but also as one who never completed a picture. His attitude is reflected in Hess' observation that de Kooning "dislikes conclusions almost as much as he hates systems."[24] The "incompleteness" was not only the result of an economic situation – of lacking funds for new materials – but also revealed de Kooning's method of thinking, which is the process of metamorphosis. This is evidenced to a greater degree in the paintings than in the drawings

because there are several fallow periods in the production of drawings. Even when drawings exist, the purpose of discovery and development which they serve is more fully explored in the paintings.

While de Kooning may look at art, and frequently claims he is an "eclectic" and a "very influenced" artist, much of this influence is also generated from the real world around him. This willingness to contend with chance, to gain either failure or success, instills an energy in his art which appears with increasing insistency through 1940 and continues to the present. This stance allows for the viable interplay between figural and abstract imagery. It augments the tension of thought.

For many years he searched for something to paint, as well as the way to paint it. In the late 1930s, in order to have a model to work from, he made a mannequin perhaps suggested by those he had worked with in store windows. "I took my trousers, my work clothes. I made a mixture out of glue and water, dipped the pants in and dried in front of the heater, and then of course I had to get out of them. I took them off – the pants looked pathetic. I was so moved, I saw myself standing there. I felt so sorry for myself. Then I found a pair of shoes – from an excavation – they were covered with concrete, and put them under it. It looked so tragic that I was overcome with self-pity. Then I put on a jacket, and gloves. I made a little plaster head. I made drawings from it and had it for years in my studio. I finally threw it away. There's a point when you say enough is enough."[25]

Though he employed this constructed figure, de Kooning was suspicious of the seductive nature of cloth, its mounting curvaceous shapes and variable textures, even when held firm with glue. He told Harold Rosenberg: "As a matter of fact, I object to that whole Renaissance drapery business. It looks like an upholstery store to me. It would drive me crazy. Do you understand what I mean? Well, when you look at all those paintings, the amount of drapery they used, it covers too many sins. You know in many ways those guys were over-rated too. If it wasn't for all the drapery being used as a form for covering up...whenever they came to a difficult part they put another piece of cloth over it. Marvelous. They were interior decorators."[26] Yet fabric continued to play a major role. Few of de Kooning's women are nude; most have some costume, ranging from the formal or semi-formal attire of the seated portraits of the 1940s to the blouses and skirts of the seated women or, much later, the bikinis of the beach scenes.

De Kooning's increasing response to modernist thought emerges in his process of self-discovery. This can be observed by comparing two drawings of standing male figures. *Two Standing Men* (c. 1939-42; Cat. 14), quasi-humanized dummies standing in a store window, are depicted in a sure, hard outline demarking new formal shapes and leading toward a higher mode of abstract expression. *Self-Portrait with Imaginary Brother,* (c. 1938; Cat. 9) still contains distant historical references in its recourse to traditional, soft tonalism. De Kooning has called *Self-Portrait with Imaginary Brother* a double self-portrait.[27] A comment on two stages of man, it exposes the subtle transformation from adolescent to adult; from student to professional; from craftsman to artist. The casual street clothes are delineated in a careful, but looser line than the line of Ingres or Le Nain, augmented by a tonal rendering of the shadows. The fabric, the refinements of face, are tinged by a sense of Dutch realism while set in undescribed space. The hands are treated as a bunch of accumulated fragmentary ovals.

The store window suggests the stage, and some degree of theatricality is apparent in the way the outlined figures are presented. There are facial references which hint at self-portraiture. The line describes self-contained shapes which fit together like a puzzle. The setting is modestly suggested, not stated directly. The lingering specificity indicates a persisting realism, though the fragmentation of the face and the paneling of the costume suggest an increasing sense of abstraction. It is also the first sign of his long, flowing line, which will achieve great finesse in the later drawings and paintings.

Keen observations of daily life are evident in the drawing of de Kooning. His images are a transformed visual diary of significant or captivating moments in his history. The careful observations of the world are countered by a restless spirit which responds to the intimate adventure of art-making as displayed in his shifts between figuration and abstraction. The recurring reference to the figure, its destruction and reconstruction, admits a tendency to repress the underlying natural violence of creation which always energizes his art.

His imagination at this moment in the 1930s transformed perceived reality into increasingly abstract statements. De Kooning was never completely to renounce the figure or landscape, his undisputed sources of generative imagery. He began to abandon the crisp, brittle lines reminiscent of Ingres, and to employ softer shapes, curved and rounded, stated in delicate tonal contrasts. These developments were fortified with increasing intellectual differentiations reinforced by his emotional experience. The rite of transformation imbues the form with the impact of sign. De Kooning's innate ability to elicit new insights and conjoin diverse sources soon produced a statement of original power and beauty.

Portrait of Elaine (c. 1940-41; Cat. 11), produced before de Kooning's marriage, is a culminating obeisance to the art of the distant past. Henceforth, he would project a contemporary vision. It is the last manifestation of his skillful natural talent, trained to deal with a transcription of perceived reality. We see a seated young woman in a casual, relaxed pose, slightly bent forward as if she were about to move toward the viewer. This gesture of movement out of the picture plane increases the pictorial tension. The figure is placed in an isolated space, unidentified by background architecture or specifics of costume. What, in fact, she wears is an old shirt of the artist's. The result of de Kooning's intent observation is felt in a palpable physicality, dramatically rendered by his intense focus on the head, hair, and eyes, which establishes a presence unequaled by any other American portrait of the moment. The lightly rendered fabric does not intrude upon our apprehension of the artist's statement about the person. De Kooning's emphasis on large eyes has sometimes been ascribed to the physical traits of his friends Gorky or Denby, yet we can recognize the emergence of this interest in a now lost painting, *Death of a Man* (c. 1932), which is documented in a photograph. *Portrait of Elaine* is an extraordinary drawing, probably the only portrait of classic quality executed in mid-twentieth-century America. The drawing completes de Kooning's response to Le Nain, Ingres, and other historical figures. It also represents the final exercise of the restrained line. He said that to continue its use would drive him crazy. Restraint was about to be shattered.

The Federal Art Project closed down in the spring of 1943. Artists' organizations now dissolved or were reduced in membership. The war years took many artists into military service. This, in many instances, profoundly affected their careers.

Political activity among vanguard artists was never their strong point. Many of the politically active were illustrators or near-illustrators. The complete collapse of political interest and influence among the modernists came in the late 1930s, when even the left-leaning artists rejected radical social ambitions. The Moscow trials of 1936-38, the cynical repression of all non-Stalinists, and the Nazi-Soviet Non-Aggression Pact of 1940 produced the final division between art and politics.[28] It was under these circumstances that de Kooning began formulating what would slowly become his working methods and from which would emerge his distinctive style. With neither social support nor an art market to consider, he, like many other modernists, devoted himself to purely aesthetic problems. The experience of art and daily living was at complete risk.

In the drawings of the early 1940s, de Kooning rapidly liberated himself from the control demonstrated in *Portrait of Elaine*. His line loosened, moving with increased velocity about the image. He began segmenting parts of the body (though not isolating them) and turning them into flat-patterned images. The flattening of these biomorphic or curvilinear constructions emphasized the surface plane of the page. Shortly, these shapes separated from direct figural representation but retained synergetic echoes of their sources. During the 1940s, from *Portrait of Elaine* to the black-and-white abstractions shown in his first one-man exhibition in 1948, we see the forceful emergence of an intrinsic ability to perfect his metamorphosing skills and his distinctive, incisive handwriting. Line became the key element in the evolution of his style, a style which resulted from an act of will. Will resolved the intellectual conflict between classical restraint and expressions of violence. This allowed him to remain himself, yet be open to any influence to which he responded. His art became packed with imagery, fragmented, distorted, whole, or invented, stated in an enriched vocabulary of line. Unlike his friend Jackson Pollock, whose thrown and poured lines offered succeeding artists little opportunity for emulation, de Kooning's line, structure, and invention have proved to be beneficial resources for artists of figurative, abstract, or even academic inclination.

In the early 1940s, two studies of seated female figures (Cats. 16, 17) demonstrate the loosening line as it changes into a quick, thrusting, searching line. In these drawings, line retains its function of figural depiction, but the energy of the bunched lines suggests a nervous desire seeking something else. The lines augur a sense of growing irritation. By synthesizing his sources in Le Nain, Ingres, Cézanne, and in Soutine's expressionism, and pushing them through his northern temperament, de Kooning bypassed the effects of Cubism. He now moved toward the discovery of a new way of picture-making. The abstractions of the late 1930s, with their flat patterning, reflect Gorky and Léger, but filtered through de Kooning's youthful interest in Mondrian. These geometric substructures recede into the background, but continue to appear in his work for decades as framing devices. The medium deep space of the portrait paintings becomes increasingly shallow in these drawings of women, where it is now infused with a shimmering light akin to that of Cézanne's late watercolors. Space is subtle and evanescent but is revealed in contemplation. De Kooning has always been highly inventive in his spatial manipulations and has persisted in the exploration of light throughout his career.

De Kooning has often been discussed as a late Cubist artist, but that designation might be applied willy-nilly to many artists, a process which would obscure the recognition of their indi-

vidual contributions. De Kooning has denied ever painting a Cubist painting, though he reiterates that he has been influenced by everything and is an eclectic. To examine this situation we will apply Alfred H. Barr's description: "Cubism depends fundamentally not upon the character of the shapes – straight edged or curved – but upon the combination of other factors such as the flattening of volumes and spaces, the overlapping, interpenetrating and transparency of planes, simultaneity of points of view, disintegration and recombination, and, generally, independence of nature in color, form, space, and textures – without, however, abandoning all reference to nature."[29]

Fragments of this description could be applied to de Kooning, as well as others, but in the end it does not lead us to either a definition or a clarification of our experience of his work. The individual yet united shapes are important as form-building elements, whether related to the examination of the figure or nature, or in his manipulation of such shapes into abstraction. By reducing external references and employing these developed shapes, he moves into the higher realms of self-referential abstraction. Overlapping, interpenetration, and transparency were surreal devices as well. De Kooning also eschews the Cubist simultaneity of points of view, and the central, focused geometric structure of most Cubist works. What is important is his visionary transformation of the figure or the landscape in ways which are as fecund as the Cubists'. The function of line or drawing, ignored in Barr's thoughts on Cubism, is the primary graphic element for de Kooning. For de Kooning, line compresses light.

Drawings such as *Still Life* (c. 1945; Cat. 32) contain an assemblage of referential shards of furniture, architectural settings, interiors, and street scenes in an admixture with warm, curved body shapes: an imaginative sweep of flesh color twists through his curious "no-environment." De Kooning was still developing his biomorphic shapes when, in the spring of 1946, he was asked to design a backdrop for a dance recital by Marie Marchowsky.[30] Studies for this and the backdrop itself have survived. This theatrical setting and *Excavation* (1950; Cat. 180) remain the largest paintings executed by de Kooning. They also serve to synthesize his interests at the moment, usually signaling a new form of expression. After these works, de Kooning's women emerged. The backdrop contains four figures, based on angels and the Roman frescoes from Boscoreale in the Metropolitan Museum of Art. These shapes were hinted at in the drawings and paintings of seated women, produced during the previous four or five years. The fluid line moves about the forms, separating them from the structural background, integrating their internal shapes. The four major shapes announce his exploration of shallow space, the inventive use of color, a loosening of the drawing line, and, with their emphasis on frontality, the use of the canvas itself as an arena of action. These ideas are fully exploited in greater abstraction in paintings such as *Light in August* (c. 1946) or, later, in *Black Friday* (1948; Cat. 167), *Dark Pond* (1948; Cat. 166), and *Night Square* (c. 1949). They recall the forms which initially emerged in the late 1930s, in pictures such as *Pink Landscape* (c. 1938; Cat. 137) or *Elegy* (1938; Cat. 141). The compositions have increased in complexity, the color has changed, and the line moves in affirmation of powerfully felt emotions. The images are densely packed with an accumulation of visual stimuli.

Few drawings were produced in the years 1947 to 1949.[31] In 1950, Philip Pavia, the sculptor and a longtime friend of de Kooning's, heard that the U.S. Customs Office was selling a surplus government stock of watercolor and chart paper. Some of this he bought and offered to his friends. De Kooning chose the chart stock, which was printed on one side with a grid.[32] The paper was used in several drawings of that year. These loose line drawings were made after the black-and-white series of paintings, produced from 1946 to 1949.[33] De Kooning worked with a liner brush, used by sign painters, theatrical painters, and others, which he might have known from his student days. Its extra-long, flexible bristles are capable of bearing a heavy charge of paint, which can lay down flowing lines of continuous tonal weight. Overcharged, the brush can drop the paint in loose, thin runnels, as in two untitled drawings of c. 1949-50 (Cats. 25, 36). De Kooning would then frequently scrape the line with a pallete or putty knife. Scraping would change the unctuous nature of the drawn line into a thin, splayed surface. The planes broke the speed and direction of the original line. These foliate shapes appear to move in opposition to the thrust of the initial line. This gesture increases the sense of motion or speed, hence action is implied. The knife's action transformed the autographic quality of the hand-drawn lines. The oddly shaped planes that result change the open, but unified, lace work of the linear construction by their abrupt and seemingly arbitrary shapes. Since he could not know exactly how far the line could be pulled by the knife, the element of chance was increased. Individual shapes were treated like acrobats, moved, twisted, lifted into space, and thrown into novel distortions and juxtapositions. These gestures of action were promoted by a surreal freedom, but the images produced were not stated in the academic vocabulary of traditional European Surrealism.

From the late 1930s, de Kooning considered his images from various points of view on the canvas or the page. In the mid-1940s he began to paint from all sides of the canvas.[34] Shapes now move into, out of, or across the picture plane in increasing variety. It is rewarding, if not incumbent, to study his work from all points of view. By changing his method of attack, a shift of emphasis results. The mind reacts, establishing new, unforeseen relationships, and traditional picture-making methods are questioned by the novel possibilities which are revealed. The method decreases reliance on exterior information by moving toward greater abstraction and a contained development of the picture, which becomes internally referential. This development is exploited in the black-and-white drawings of the late 1940s, in which de Kooning shifts the elements in response to the demands of pictorial necessity. The motif is but a resource from which to select elements to be employed in the picture-making process. The exercise of picture-making does not reduce the highly charged content. Though any transformation might argue for the assumption of a symbolic statement, the pictures are now abstract communicative devices. In this way, the artist reveals his sensibility. No longer is the picture a restatement of preexisting ideas of form. No longer is de Kooning held to the impulse of courting a realistic homage to the external world. The fragments remain fecund, suggestive, and open. It is in this activity that the high degree of his artistic accomplishment resides. By the mid-1950s de Kooning had set the pace for the art of the next fifty years, in much the same way that the Cubists had initiated inventive solutions, or posed new problems, for painting in the century's early decades. The vitality of his art is sustained by the exercise of will, acting in the insecure arena of invention, of finding and recognizing the unknown, of persisting to work prompted by

the instability of the unknown. The essential pictorial structures developed by de Kooning clearly originate in the drawings. He employs a sweeping line, shimmering illumination, varying spatial concepts and often ordinary motifs, seen in the street, which become the stuff of his magical synthesis. His speed of application with brush, pencil, pastel, charcoal, or pen turns about his varied shapes with a warm, sensual caress. The flowing, biomorphic impulse is augmented by his admiration for the discoveries of Gorky, which continue to inform his art. The act of drawing offers periodic insights that accumulate into a handwriting which has promulgated one of the great styles of the twentieth century.

In the first days of June 1950, de Kooning pinned two sheets of paper about seven feet high to the studio wall and began drawing (illustration, p.272). These two standing female figures became the first marks leading toward the painting *Woman I* (1950-52; Cat. 190). In the development of this painting and its successors, dozens of drawings would be made and destroyed. The cartoon itself was destroyed in the process of transferring it to canvas.[35] In the ensuing two years de Kooning would explore an extraordinary range of emotions and ideas to evolve the abundant vocabulary of shapes and images derived from his contemplation of the figure. His largest painting, *Excavation,* the summation of several years work, was also completed the same month. It was now time for something new.

These new drawings were not confined to the replication of perceived reality, as in *Portrait of Elaine* (Cat. 11) of a decade earlier. Because de Kooning chose not to draw a specific representation, what emerged was the artist's sensate and conceptual response to the figure. Conveyed by the drawn line, this response now formed a vocabulary of images charged by personal revelation. The artist's marks have become a sign of possession. De Kooning is gifted with an extraordinary natural talent for linear and formal invention. The apparent shift in his role as the leading abstractionist to a delineator of the figure aroused considerable controversy. Was this backsliding? Had he lost his inventive drive? Actually, he had always worked in both modes of expression. As with so many other artists, his critics and admirers demanded consistency. His consistency is the state of change.

What prompted de Kooning to emphasize this particular subject matter? The figure, a long and consistent concern in his painting, was often painted concurrently with abstractions. To revitalize his spirit and in preparation for ventures into unknown territory, he would return to something he knew. The security of that vantage point would prove a springboard into the insights of invention. His imagination responded to the complex nature of the figure with all its provocative responses and associations. The figure is man's most intimate structure for the display of pictorial invention. In contemplating the figure, de Kooning would join that ancient historical continuum of great artists whose passion was man's observation of man. It was his way of restructuring the appreciation of the art in museums and challenging past masters. It is not unusual for de Kooning to begin a painting by drawing a figure or two on the canvas, though the final image might not reflect its origins. Thus the figure is an initiator, yet it is something more. "I think all of my people are really performers, actors. All these women and men that I paint. They are not real people. They are all playing a part in my painting. They are paintings."[36] Was action painting then theater?

De Kooning's women are voluptuous. They stand erect on firm, delicate legs, with prominent bosoms and curvaceous hips, full fleshed. Bursting with fleshy life they offer an agitated nature variously proclaiming the coquette, the movie doll, or the four-color pin-up, if not the mother-earth goddess. They might be read as personifications of persevering fertility and blatant concupiscence; strident symbols of the ancient vivifying forces of woman. Yet, somehow, for all this dynamism or suggestion, they are isolated, standing aloof from each other and the viewer. This implies that they could be read as icons. Just as the pin-up is a powdered and made-up dream reality, so is the powerfully evocative and mythic woman de Kooning presents. Or, the emergence of this female figure could be explained, as Harold Rosenberg suggests: "In fact, the thing that de Kooning did, that was very interesting, was to discover that for a painter like himself, who had been painting for already 20 or more years, the figure would emerge spontaneously out of the act of painting. Obviously, you have certain habits, and if you really let yourself go, you would not produce a mess, you'd produce a figure. The figure would be a new kind of figure, and this was very consciously practiced by de Kooning."[37] He had indeed invented a new figure. His explosive, reconstructed woman, possessed of voluptuous humor, is not only an earth mother, or an avenging dream, but a modern scavenging consumer. Standing bold, frontal, inviting, suggestive, yet inaccessible, her image continues to torment as she is perused.

Early in this series of women drawings, de Kooning introduced pastel to augment the pencil and charcoal, thereby changing the spatial and tonal aspects of the page. The pastel is often ground deeply into the paper's texture, resulting in delicate luminous tints rather than its usual grainy or velvety textures. His line in these few years underwent its greatest changes. This is recognized in the increasing velocity of application, the varying graphic weights achieved by the reiteration of the gesture in building a reinforced line, and his innovative use of the eraser as a stylus of light. This tool becomes a coequal aid to the darker mark-making pencil or charcoal. Through use of the eraser he manipulates the line by changing the immediacy of its original autographic statement. The once dark marks are often reduced to a delicate tone, thereby opening the spatial aspects of the design. The lines, which fall unhesitatingly from the charcoal stick, unify the surface and affirm the sensation of freshness. The once cautious line of the first women drawings, in which de Kooning renewed his acquaintance with the figure, is quickly superseded. With the introduction of pastel, the lines soon accumulate upon each other, often no longer describing a specific figure but abstracted fragments over which they colorfully cloud. Inherent in the development of these nearly autonomous shapes is the rising sense of a latent abstraction. As he had done in the black-and-white pictures of the late 1940s, he would combine shapes redolent of the figure by pushing the biomorphic impulse to new limits. His formulation of circles, ovals, cones, parabolas, or wedge shapes constitutes an abstract vocabulary and, when compounded, offers a form with figural appearance. What captures the viewer's attention is the thrilling observation of the imagination functioning in the enchantment of discovery.

Initially, de Kooning would follow the head's natural curves, the thrust of the nose, or the arc of an eyebrow. He would, by lengthening or otherwise changing them, emphasize the curves' graphic qualities rather than their function in describing human features. A woman possibly wears a hat, which is transformed

into a head, which becomes a star in *Woman* (c. 1951; Cat. 37). A skirt formed in a net of lacework echoes a shape he drew in the late 1930s or in the 1945 *Still Life* (Cat. 32). Visual echoes rebound throughout his work. In time, with some historical distance, many of his abstractions will be decoded and read as easily as once obscure Cubism is now read.

The pastels of the early 1950s are usually studies depicting two standing women. In these pages de Kooning formulates variation upon variation in an interplay of forms in light and line. These dense, compact compositions are filled with shards of still-life elements or hints at a fragmented landscape. In others there are pentimenti indicating compositional changes. The stacked conical forms of the legs, over which are placed the ovoids of the hips, support the circular reference to the mid-torso, topped by an expansive bust and crowned by a vigorously transformed head on which is sometimes a face. The reiterated line is displayed as a seeking, reinforcing gesture. It describes shapes which not only suggest the figure, but distract from the contemplation of the figure by their inherently abstract nature. Sections of some torsos are solid, others luminously transparent, while others offer a void, and still others display a greater interest in automatic mark-making than in the depiction of specific imagery. Nevertheless, the female figure remains the focus of lengthening conjectures. The background forms occasionally suggest the 1950 painting *Excavation* (Cat. 180). These hint at a degree of closure, of a world circumscribed. Since the women were not drawn from the model, it is a test of his imagination to construe known values into a new graphic language. This act relates to abstract form-making, for as Hess quotes him, "even abstract shapes must have a likeness,"[38] an inference that there is some perceived universal perfection toward which he moves.

De Kooning's touch invites intellectual and emotional intimacy with his working methods. But then, as Cennini states, "the mind delights in drawing." The emotions may well drive the application of line, but the results are considered by the intelligence and changed if they do not achieve his requirements. Our response to the figure or to abstraction is qualified by the personality of the lines, the structure and the spatial suggestions. The women series provided de Kooning with an opportunity to increase the variety of his calligraphic line. Often, in this series, a brittle line is countered by the softness of the curvaceous shape described or is set apart from it by crosshatching. Hatching counters the direction of the containing line. Textures offer differing and frequently discontinuous spatial considerations within the figure itself. Hence, a plane we normally experience in life as recessive, in the drawing may bulk outward, therefore questioning our perceptions of reality. What is our understanding of the visual history which informs these shapes? The contrast is striking between the late 1940s black-and-white drawings (Cats. 25, 36) with their cursive lines clinging to the surface in a shallow space, and those of a year or two later (Cats. 37, 38) in the fullness of his consideration of the female figure. The reintroduction of deepening space, the evolution of his "no-environment" into a setting which suggests the substance of his previous painting, rather than city or landscape references – these are signs of an increasing hermeticism. The coherent shapes which compound these figures project images which stand static, with their hollowed eyes, sardonic expressions, alienated even in companionship.

Most all of the women drawings are filled with lines which seem to suggest fleeting images caught briefly by the artist's eye during the process of making the drawing. Are they imagined or dream images? Captured on the page, they suggest an automatic motor response to unknown stimuli. These furtive lines emphasize the drawing process. The image is tested, and the figure is set into the composition, by the activity of these lines. De Kooning is an artist who rides his imagination, pushing it to increase his experience.

Examples of these semi-automatic lines can be seen in the single standing figure *Woman* (1951; Cat. 38), which is wrapped in a superstructure of lines. Though they often touch parts of the figure, the lines continue into space, then form a transparent network which contains the figure. Echoes of simplified architectural elements, such as the house or window, and the no-environment atmosphere persist in these drawings. Light is trapped in the deftly controlled formulations. Fragments of the torso are closely studied with emphasis on the volumes. De Kooning carefully records the thrusting line of the shoulder or the hip.

Shapes are formed by light from within or are inferred by its reflection. Light penetrates the figure, marshaling its various segments to create homogeneity. The artist's sense of plasticity is demonstrated in the destruction and reconstruction of the figure. Often the central portion of the torso is jammed into the lower portion, producing a seated or a squatting configuration. The assertive nature of the individual sections is forthrightly stated in color. The color is expressionistic because de Kooning rarely relies upon the suggestions of natural coloring. His crucial use of color tells us less about observing nature than about his musings on these created figures. The imagination plays over the torso, revealing its fascinations, charms, frustrations, and rewards. Invention is a primary constituent of his great draftsmanship. While the figure may be pulled and twisted in space, it retains its natural central structure, for it is not de Kooning's aim to destroy the figure totally.

Among the most complex of mid-twentieth-century drawings, these figures are charged with a keen emotional drive, intellectual taste, and visual dynamics. Increasingly expressionistic, the figures stand before or become enmeshed in background architectonics, which resemble his 1950 painting *Excavation*. By placing his figures in an environment which suggests art rather than nature, de Kooning stresses the nature of their role as characters in a continuing drama. As such, they are treated somewhat differently from the background, which is loosely drawn, in contrast to the tightly drawn figures. The delicate tone of the color, for all the seeming violence in the application of line or in its rhythmic grasping of the figural elements, is romantic. The figure seated on a chair stresses bulky monumentality of scale even in these modestly sized pages. The flat segmentation emphasizes the surface of the canvas while echoing fragments of drawings dating from the late 1930s.

Concurrent with the pastels was a series of pencil or charcoal drawings employing scrappy, wiry, brittle lines. As the 1950s progressed, color was replaced by an increasing use of pencil, ink, and charcoal. Erasure, a skillfully engaging technical device, hides the once carefully stated shapes in clouds of gray or drives bands of light, which cut through the dark striations of pencil or charcoal. The impersonal materials accommodate his natural rhythms, resulting in a painterly, plastic surface.

The compositions of the pastel women drawings become less complex after 1953. The drawing now begins to reveal a process whereby individual shapes become increasingly visible. Though the figure remains a central motif, it is now often isolated on

the page without reference to a background. The background becomes an ambiance, sketchily indicated.

In the masterful expression *Woman* (1953; Cat.59), a voluptuousness remains as the same frontal, exposed nude is investigated. But in this new presentation there is a heightening of isolation. Concurrently, de Kooning produces double figure drawings that are often bisected by central vertical lines, which compartmentalize the figures. The demeanor suggested is one of mutual disinterest, giving the warmly colored pictures a certain aloofness. If this is so, what then of their interpretation as pin-ups and other cultural glories? But is not the erotic often an isolated experience? What the figures suggest is conflict. They carry an abiding anguish resulting in the finality of tragic expression. The artist himself seems to suggest that the mythic interpretations which his images have kindled are based on invalid assumptions and that the images are not necessarily a revelation of an inner necessity. "My paintings . . . are supposed to make me a matricide or a woman hater or a masochist and all sorts of other names. Maybe I am a little bit like other men, but I certainly wouldn't show it off in my paintings. I don't believe in Venus at all. I am not interested in Greek mythology."[39] De Kooning's denial nevertheless fails to consider that his images have ancient and wide cultural generalizations into which they might well be classified. His statement is a reiteration of his generation's proclamation that naming is a limitation.

The summation of the figural investigations of the 1950s was stated in a series of abstract pastels dating c.1956-58. The forms and interests in these pages acted as the source for another series of paintings which became known as the urban landscapes. These delicately toned, complex structures move off the edge of the page, as if forecasting the paintings that were to follow. For the moment, the female figure had run its course as specific subject matter, but it was to continue to project shapes that would be woven into the forthcoming landscape configurations. The fleshy, inspired shapes, by merging with those of nature, conjure up visions of an urban apocalypse. The pastel *Figure in Interior* (1955; Cat.65) hints at this, though there is a loosely perceptible geometric substructure over which the speedily running lines move. Shapes which echo human forms are blended into those of an atmospheric country landscape. This page was followed by several pastels in which the shapes become decidedly geometric and edged. These drawings no longer catch light within a textured surface, as Giacometti does in his pitted crevices, but have become light-filled planes demarcated by dark lines. Light is de Kooning's transmutable building clay. After these pastels, there was a year or two during which few drawings were made. His next series would begin in the country.

About 1958, de Kooning began a series of brush-and-ink still-life drawings of shirts lying loosely in a just-opened laundry package (Cats.68, 69). These contain implications which were to fully emerge during a trip to Rome in late 1959 and early 1960. The free, crisply drawn lines cover the page with large shapes suggested by the folded shirts in their wrapping paper. There is a graphic similarity in these pages to a few isolated ink drawings dating from 1954. The moving line, while it may suggest to the Occidental viewer "calligraphy" with an Oriental connotation, differs from its Eastern source, since it springs neither from the written language nor from the stylized system of marks developed for drawing. The stable, blocky, geometric forms are in forceful contrast to the curvilinear forms, whose

brio evokes the quick thrust of the brushes. The correctness of the line's path is always assured, even though the velocity is increasing. The lines here offer the occasion to enjoy the dynamics of the drawn gesture for its own sake.

From December 1959 through January 1960, de Kooning resided in Rome, where he used a studio provided by a friend, the painter Afro. De Kooning worked with black enamel to which he had added powdered pumice stone, thereby introducing a gritty texture to the paint's usually even, velvety surface. He placed the pages on the floor and then drew with long, sweeping lines. Many were then torn in half or into strips to be reassembled later.[40] Again, he employed this mechanical device, often trumpeted by the Surrealists, to introduce chance. The drawings became literal abstract constructions, differing from the mental construct of the figure drawings. The reconstitution of a destroyed image into something new is an aspect of de Kooning's process of renewal. The sundered drawings collaged together make new forms, continuing serrated edges, truncated images, chopped space, and lyrical gestures stymied in their motion. The technique of these pages is akin to the technique of stop action in film editing, and stresses the ever fecund nature of drawing. De Kooning emphasizes the individuality of the brushstroke, or the torn edge, while affirming a high sense of abstraction. The powerful expression of the original sheet is not contravened by its destruction, but is integrated into another newly invented expression. These pages were the preliminary steps to his most abstract paintings, which emerged during the years 1961 to 1963, and are concerned with the major graphic elements that constitute the Abstract Expressionist vocabulary. Their non-referential, graphic manipulation is an early step in the process Rosenberg later described: "Painting became its own subject."[41] To have one design countered by contiguous fragments asserting a diverse point of view is an aspect of disorientation in these sheets. This disorientation introduces a dynamic unlike that found in other forms of abstract art. The gestures in concert retain, for the most part, their individuality, yet combine to kindle diverse psychological suggestions. The dynamic of broken visual tensions is an unorthodox resolution to composition. Invention, iconography, and technical methods were major aspirations of the artists of the Abstract Expressionist generation.

There is a long tradition in both the Orient and the West for the inventive use of cut and torn papers. There are suggestions that the technique had been used from the twelfth century in Japan, frequently in conjunction with calligraphy. A similar tradition in the West dates from the seventeenth century.[42] In contemporary times the use of paper as an additive to picture construction arose at the end of the nineteenth century in Northern Europe. It became a principal technique for the Cubists, when Braque began to use it around 1909 or 1911. De Kooning's painted papers were torn and reconstructed differently from those of the twentieth-century Europeans, who carefully cut and pasted their elements into the composition, occasionally drawing or painting over them for visual unification. De Kooning's torn edges, ripped from their original form, are in dramatic contrast to those delicate operations. The references in these abstract collages are obscure and suggest a concept which explores the gesture and the impersonal nature of the materials of picture-making.

The structure of many of these pages from the time in Rome (Cats.67, 73) recalls the geometric substructure of the late 1930s drawings. The torn edges and planes, freed from rigorous

intellectual formulations, move into an arena of deep expressionism, emotional release, with an energetic, if not frantic, drive toward completion. Freed also from Constructivist implications, the gesture emerges as an entity, proclaiming its singular identity. Informed by the artist's own history of image-making, the graphic gestures open and become the freest forms de Kooning produced up to that time.

Images made by brushing ink on absorbent paper reflect de Kooning's continued reference to water, the ocean, and the beach. How like moving water his images are. How often light seemingly bounces from their surface or emerges from some interior depth. In later years charcoal is used as a mutable, almost fluid, tonal substance. Its blackish-gray clouds fill the pages with complex compositions. The dark lines are firmly made to define recessive areas or state the compositional elements. Light is contained and defined, animating the sensual nature of his compositions. In retrospect, his sense of light is a reminder of the "real" sources and "real" nature which engender the dominant spirit of his work, no matter how abstract it apparently becomes. A viscous nature animates these surfaces, as well as those in the later paintings. The terminal strokes of the smudged lines suggest sea foam or turbulent, surging waters. They evoke the intimate experience of the artist at work by disclosing his methods.

For several years de Kooning worked in a New York studio at 831 Broadway. In the summer of 1961, he bought a small house from his brother-in-law, Peter Fried, in the Springs, East Hampton, Long Island.[43] The next winter he began making plans for a large studio on some land he had acquired not far from the house. It was the beginning of his withdrawal from New York and the art world. By the summer of 1963, his move from Manhattan to the newly constructed studio was completed.

Moving from the city to the country and settling into the new studio took time away from his work. There were few drawings produced in the years 1960 through 1963.[44] This hiatus provided a period of gestation in which the older images could be incorporated into the paintings. The drawings began to emerge again in quantity after 1963, when the figure returned to his consideration. A 1963 sheet, depicting a standing figural image, was quickly fabricated of lines that remind one of the floating lines of Daumier or the light-pitted surfaces of Giacometti's sculpture. This drawing (Cat. 82) also forecasts the surfaces which would dress his sculpture half a dozen years later. The nonspecific identity of the figure and the lines floating in space again imply a deep concern with abstraction.

The standing male figure returns again to his consideration. Two drawings of c. 1964 (Cats. 81, 83) depict bushy haired, bearded figures wearing what appear to be knickers and jackets. These denizens of memory harken back to the figures of the 1930s and 1940s, but are now expressed in a new construction of flowing lines which had developed in the recent abstractions. They stand in a space deduced from the torn collages, centered on the page with no reference other than to themselves. They stress the artist's interest in the qualities of the brushstroke that delineates them with such vigor. De Kooning's concept of space is that its presence outside the figure is not qualitatively different from that within the shapes composing the form. Hence the figure stands in a self-referential space in a non-specific scale. Our mind's eye fills in and adds to the image to authenticate our apprehension of the configuration as a standing male figure.

By 1964 the effects of the shimmering light on the waters about East Hampton began to appear in his paintings and drawings. This can be observed in the luminosity of the paintings, and the quivering line which pervades them, as well as in the drawings. In a series of paintings on doors, c. 1964, which he had once considered showing as a polyptych, he explores the motif of a standing woman. At about the same time, he produced a series of drawings of a female figure nestled in the bottom of a small rowboat. This idea was explored in several small pages and in two monumental drawings (Cats. 84, 85). These major sheets depict the figure in a boat which appears to be moored to a piling. By tilting the boat upward, eschewing the perspective one might generally consider such a view to employ, he instills a sense of confined space. Shattered perspective forces this writhing figure, encapsulated by the firmly stated gunwales, into the viewer's space. The eddying water, echoed in the light-dappled figure, introduces a kinetic sensation. The splayed open legs, the grimacing mask, the plump figure, augmented by the water's rhythm, increase the sexual suggestion of these figures. The boat serves to define and focus, to enclose and echo the physical suggestions and containment. It is an image which had lingered in his mind of something seen on a beach in the Hamptons, or it might refer to youthful experiences in Holland. "When you go rowing with a girl, she looks good there."[45] The large-size pages suggest that they could be cartoons for paintings, and they are seen strewn on the studio floor in the 1964 photographs taken by Dan Budnick (illustration, p. 277).

The large standing figure (1964; Cat. 86) in the Hirshhorn Museum and Sculpture Garden collection is aflutter in shimmering light, continuing de Kooning's investigations of transient animation and the ability of light to dissolve the very forms it stresses. In the monumental drawing *Woman* (1965; Cat. 87) – a partially dressed figure – the individual fragments of the torso are fitted together like a puzzle. This drawing also demonstrates de Kooning's split view of the figure, for we observe the upper half of the torso from below and the legs from above. The figure's presentation ensures that it will overwhelm the spectator through disorientation. Though this is a physically large drawing, the manipulation of perspective unsettles the viewer by establishing the sensation of being pulled in two opposite directions from the center, making it difficult for the drawing to be contained within a single glance.

Monochrome drawings exist in many periods of de Kooning's work. Yet from about 1960 onward, he restricts his materials to pencil, ink, and charcoal with a brief investigation of oil in a few pages made about 1975. The physical properties and the necessary technical controls for pastel annoyed him, and so it was abandoned. Occasionally pencil would be used, but charcoal became the preferred material because it offered a wide range of tonal and textural possibilities. Charcoal is easy to remove from the page, and any soft gray tint which remained was incorporated into the next stages of the drawing. The colors of gray in de Kooning's drawings are varied and often iridescent. Erasers could push the charcoal about the page or he would use a finger, applying pressure, smoothing the surface by filling the paper's texture. His mastery of charcoal allowed him to concentrate on the act of drawing, on the compositions, and to capture those fleeting images which populate his pictures.

In these late monochrome pages, de Kooning questions the use of the material to redefine what constitutes a "fine" or "classic" drawing. High invention, energy, and graphic skills

combine in his fertile mind's transformation of things seen. He incorporates his experience at the moment of creation in these pages, which become a diary of his creative life – a diary of act and feeling. This felt experience is communicated through the twisted, distorted figures charged with the harsh energy of their rendering, revealing to the viewer the tragic nature of the artist's statement.

In 1966 de Kooning wrote a brief statement for a booklet which reproduced two dozen of his eight-by-ten-inch charcoal drawings. He had "made them with closed eyes.... Also, the pad used was always held horizontally. The drawings often started by the feet ... but more often by the center of the body, in the middle of the page...."[46] These small sheets were often made in the evening, sometimes while watching television. His refined skills now became a problem which he wished to challenge by the imposition of external restrictions. Hence the closed eyes. Just as previously in the cut or torn drawings he would challenge success and thus, by courting disaster, discover a fresh statement. The result of this courtship was the production of unforeseeable compositions. His anti-classical drawing method became a source of classic images.

The charcoal drawings of the mid- and late 1960s continue to examine the visible world seen transformed. *Screaming Girls* (c. 1967-68; Cat. 102), figures viewed on a television show, proclaim physical and emotional passions. Crowned by tousled hair, weakened with passion, they communicate with automatic gestures of concupiscence. In other drawings the figures blend into the landscape. Gone are the references to the "no-environment" of the city, with its gritty, gray, lusterless, cold isolation. The backgrounds have been replaced by lush nature, trees, shrubs, beach, sky, and the reflecting light of the waters off Long Island. His characters, now released from the geometric life of the city, emerge as hedonistic figures engaged in the sensual entertainments of the summer, outdoor cooking, beach

life, adult games. These are "modern cuties," ebullient and plump, rejoicing in their physicality. The drawing dramatizes the artist's enjoyment of their figures.

Toward the end of the 1960s the number of figures in the compositions increases, forming what he once described as "tableaux." The compositions suggest humorous or dramatic exchanges between the characters portrayed. While some setting is often evoked, the environment remains non-specific. The figures often blend into the shrubs, or the trees.

In the summer of 1969, de Kooning was invited to the Festival of Two Worlds in Spoleto, Italy, at which he and the poet Ezra Pound were honored. As on previous travels, he found a space in which to work, in this instance, a backstage room in one of the theaters. He made a series of drawings using pen and ink, producing images set forth in a complex of hooked lines, hatches, squiggles, splatters, and loops. A small group of these were variations based on a reproduction of Pieter Bruegel's *Blind Leading the Blind* (Fig. 2).[47] Following the original configuration, de Kooning's line describes its major forms (Cat. 110). The hulking figures wend their way to disaster as they move across his pages, changed into abstract shapes pushing to the right, as in the Bruegel. One major change occurred when de Kooning turned the page ninety degrees, transforming the configuration into a vertical composition. This act removes the specific references to the original and energizes the composition by bulking a fluttering weight at its top. In altering the historical reference, he establishes a new psychological effect, increasing the sense of abstraction and reducing the humanistic interpretation of the original. The ovals and the spiney lines take on individual significance as formulators of an abstract composition. De Kooning frequently refers to being susceptible to a vast array of outside influences, but he always retains his own sense of self. "I might be influenced by Rubens, but I certainly would not paint like him."[48]

Fig. 2. Pieter Bruegel the Elder, *The Blind Leading the Blind*, 1568. Tempera on canvas, 34 x 60". Museo Nazionale di Capodimonte, Naples

In contrast to these spare line drawings are those of about a year later which depict walking men. For a brief moment in 1970, this character appeared in his drawings, walking toward the right, wearing a panama or borsolino hat, which is sometimes drawn floating slightly above his head. Here the figure is caught in a welter of lines that designate as well as camouflage. Reminiscent of the standing mannequin men of the late 1930s, these characters have a sense of city business about them as they rumble along the sidewalk. They are not the carefully tailored window dummy humanized, but are rumpled, energetic go-getters. Curiously, in these drawings, there again appears the set of central vertical lines which separate the two men. This is either a convention to set forth two similar drawings on one page or an expression of division, isolation, and compartmentalization. The early abstractions hint at these motivations, and they reoccur with some frequency.

With the exception of a few of the late 1930s to 1940s pages and of some of the women drawings of the early 1950s, de Kooning does not produce presentation drawings, that is, refined, completed pages made for their own sake. Most of his drawings occur in the process of evolving a vocabulary of images and strokes to be used in the paintings. The painterliness inherent in his manner of using charcoal can be observed in the way he pushes tones and the emphatic, dark, defining lines. Occasionally he will consult older drawings, thus establishing an interplay between these and contemporary pages. Since he rarely dates a drawing, this creates a problem for anyone trying to make a strict chronological sequence. It is much as he would want it. He seems willing to let the work stand as it is and he shows little interest in discussing the past.

The 1974 pastel *Untitled (Figures in Landscape)* (Cat. 75), now in the collection of the Australian National Gallery, is a drawing of exceptional attack and completion. There seem to be multiple figures, which are compressed into their country setting in such a way as to become identified with nature itself. The free sweeps of color are manipulated with great assurance and are reminiscent of the handling in the late paintings of Gorky. In bold contrast to this richly colored sheet is a 1979

charcoal drawing entitled *Woman* (Cat. 130), a large walking figure constructed of fluttering filaments or Lazarus-like bandages. Approaching life size, this disjointed figure, with its partially obliterated face and its aching demeanor, portrays a dramatic and sorrowful countenance. By being set in a nondescript space, its isolation is augmented.

An increasing compositional complexity appears in drawings toward the end of the 1970s. Though the sheets are often modest in size – de Kooning frequently uses typewriter paper – the number of characters in the tableaux increases, and their interaction blends to obscure individuality. While this may suggest a growing interest in abstraction, the need to manipulate the human figure remains a dominant feature of these pages. Here and in the pages of the early 1980s, de Kooning again questions the traditional definitions of what constitutes a "fine" or "classic" drawing. A prolific inventor of form, charged with a driving energy, he perennially changes his mark-marking methods, yet all his drawings bear the impress of his personality. Darkness seems to enclose these writhing figures set into a spume of dusty charcoal that no longer pushes light to the surface nor reveals an interior light. It forms clouds to cover the moments of terror which blend into that long crepuscular time in every life. Among these small pages are some of the most splendid and difficult of his drawings. In contrast to the light-filled paintings, his use of modest materials – bits of charcoal and small sheets of paper – is like Shakespeare's use of everyday words, and they have proved to be the best demonstration in his synthesis of decades of exploration. A myriad of lines in the turmoil of discovery, the drawings' shattered figures are wrought of one man's revelation of life as a tragic experience. The tragic irony in such intimate revelations is rarely encountered in American art. For all the accomplishment of de Kooning's art, there remains art's illusion, difficult to define, but always expressive of a dynamic vitality. In his famous interview with Harold Rosenberg, he says: "That's what fascinates me – to make something that you will never be sure of, and no one else will. You will never know, and no one else will ever know. . . . That's the way art is."[49]

Notes

1 Willem de Kooning, interview with Harold Rosenberg, 1971 (unpublished transcript); excerpts published in *Art News*, 71 (September 1972), pp. 54-59, and Thomas B. Hess, *Willem de Kooning,* exhibition catalogue (New York: The Museum of Modern Art for the Arts Council of Great Britain, 1968), p. 12.

2 Elaine de Kooning, telephone conversation with the author, January 6, 1983.

3 Thomas B. Hess, *Willem de Kooning Drawings* (Greenwich, Conn.: New York Graphic Society, A Paul Bianchini Book, 1972), p. 18.

4 De Kooning, interview with Rosenberg.

5 Hess, *Willem de Kooning,* p. 14.

6 Sally E. Yard. "Willem de Kooning: The First Twenty-six Years in New York, 1927-1952" (Ph. D. dissertation, Princeton University, 1980), n. 49, p. 202.

7 Willem de Kooning, filmed interview with Cortney Sale, November 1980; quoted from a transcript of the film *de Kooning on de Kooning,* 1980.

8 Yard, "Willem de Kooning," p. 5.

9 De Kooning, interview with Rosenberg.

10 Everett Ellin, *John D. Graham, 1881-1961,* exhibition catalogue (New York: André Emmerich Gallery, 1966), unpaginated.

11 Ibid.

12 Hayden Herrera, "Le Feu Ardent: John Graham's Journal," *Archives of American Art Journal,* 14, no. 2 (1974), p. 6.

13 Ibid., p. 8.

14 Yard, "Willem de Kooning," p. 5.

15 Hess, *Willem de Kooning,* p. 20.

16 Hess, *Willem de Kooning Drawings,* p. 17.

17 Hess, *Willem de Kooning,* p. 18.

18 Irving Sandler, *The Triumph of American Painting: A History of Abstract Expressionism* (New York: Praeger Publishers, 1970), p. 7.

19 Quoted in Hess, *Willem de Kooning,* p. 17.

20 Edwin Denby, "Willem de Kooning," in *Dancers, Buildings and People in the Streets* (New York: Horizon Press, 1965), p. 232.

21 John Ashbery and Kenworth Moffett, *Fairfield Porter (1907-1975): Realist Painter in an Age of Abstraction,* exhibition catalogue (Boston: Museum of Fine Arts, 1982), p. 95.

22 Yard, "Willem de Kooning," n. 65, p. 204.

23 Hess, *Willem de Kooning Drawings,* p. 22.

24 Hess, *Willem de Kooning,* p. 25.

25 Yard, "Willem de Kooning," p. 50.

26 De Kooning, interview with Rosenberg.

27 Hess, *Willem de Kooning Drawings,* p. 24.

28 Sandler, *The Triumph of American Painting,* p. 11.

29 Alfred H. Barr, Jr., *Picasso: Fifty Years of His Art,* exhibition catalogue (New York: The Museum of Modern Art, 1946), p. 132.

30 Hess, *Willem de Kooning,* p. 49.

31 Hess, *Willem de Kooning Drawings,* p. 33.

32 Ibid., p. 35.

33 Ibid., p. 34.

34 Yard, "Willem de Kooning," p. 149.

35 Hess, *Willem de Kooning Drawings,* p. 42.

36 De Kooning, interview with Rosenberg.

37 Harold Rosenberg, conversation with the author, February 7, 1971; transcript on file at the Archives of American Art, Smithsonian Institution, Washington, D.C.

38 Hess, *Willem de Kooning,* p. 47.

39 De Kooning, interview with Rosenberg.

40 Hess, *Willem de Kooning Drawings,* p. 49.

41 Rosenberg, conversation with the author.

42 Herta Wescher, *Collage,* trans. Robert E. Wolf (New York: Harry N. Abrams, 1968), p. 7.

43 Hess, *Willem de Kooning,* p. 122.

44 Hess, *Willem de Kooning Drawings,* p. 33.

45 Willem de Kooning, conversation with the author, fall 1982.

46 Hess, *Willem de Kooning Drawings,* p. 53.

47 Ibid., p. 55.

48 De Kooning, interview with Rosenberg.

49 Ibid.

Drawings

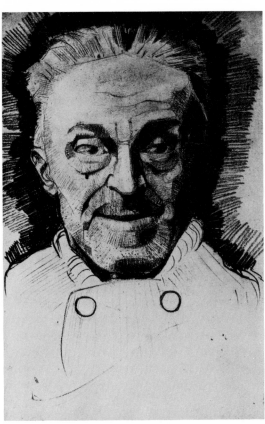

1
Male Portrait Head, c. 1922
Pencil on paper
5¹³⁄₁₆ x 9³⁄₁₆"
Collection of H. Mariën

2
Dish with Jugs, c. 1921
Conté crayon on paper
19¾ x 25⅜"
The Metropolitain Museum
of Art, New York

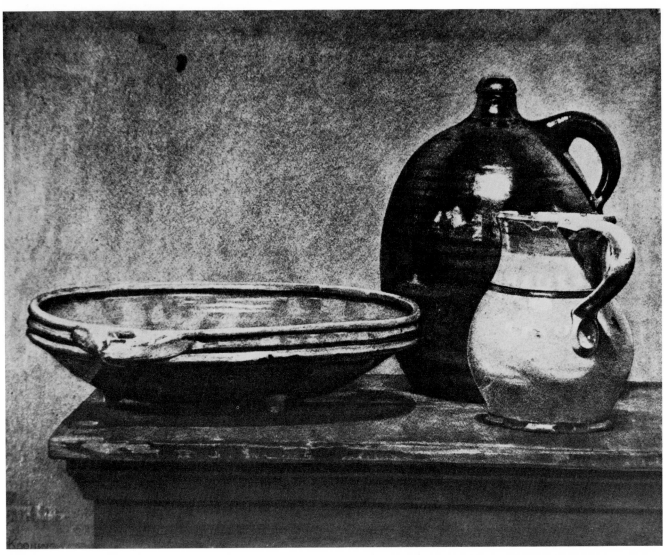

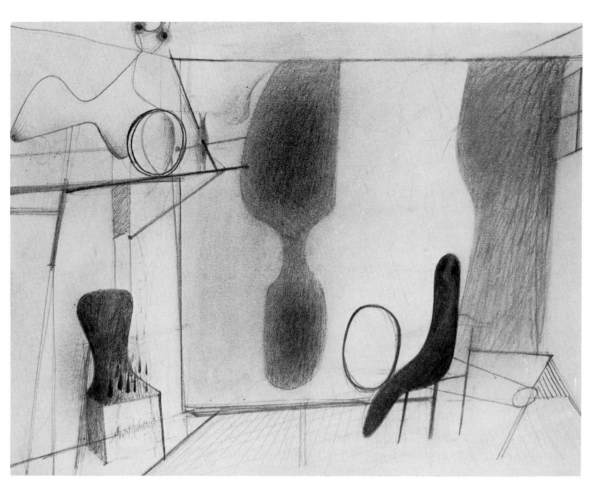

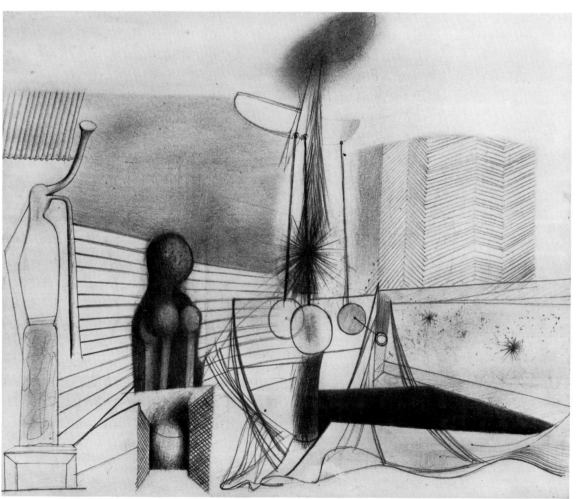

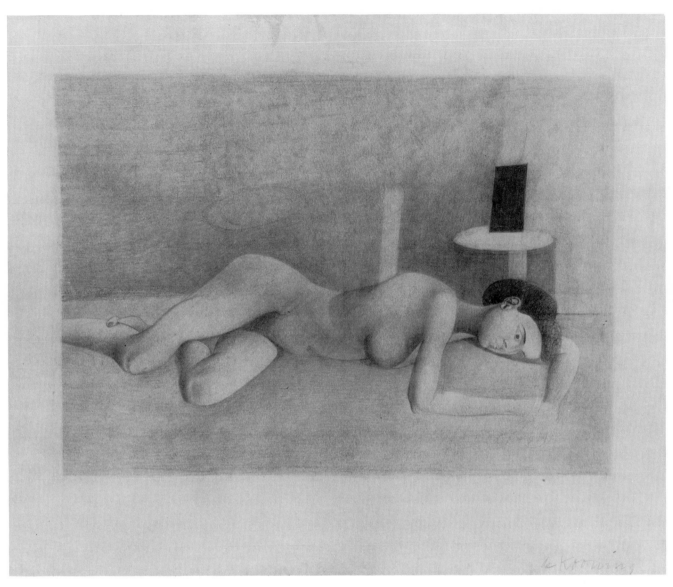

5
*Reclining Nude (Juliet Browner), c. 1938
Pencil on paper
10¼ x 12¾"
Collection of Mr. and Mrs. Steven J. Ross

3
Study for Father, Mother, Brother, and Sister
or Study for Father, Mother, Sister and Brother,
c. 1937-39
Pencil on paper
6½ x 18¾"
Collection of Eve Propp

4
Untitled, c. 1937-39
Pencil on paper
9½ x 11½"
Private collection, courtesy Allan Stone Gallery, New York

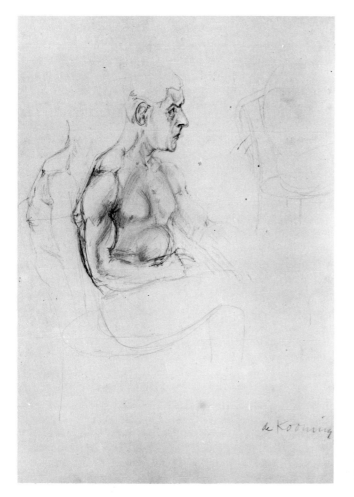

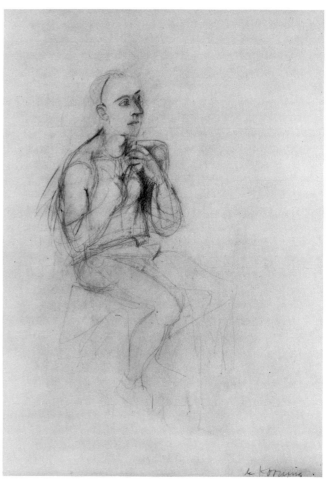

7
*Seated Man, c. 1938
Pencil on paper
13½ x 10½"
Collection of Mr. and Mrs. Steven J. Ross

6
Study for Seated Man (Self-Portrait), c. 1938-39
Pencil on paper
14¼ x 11½"
Private collection

8
*Study for Seated Man (Self-Portrait), c. 1940
Pencil on paper
14⅛ x 11"
Collection of Mr. and Mrs. Steven J. Ross

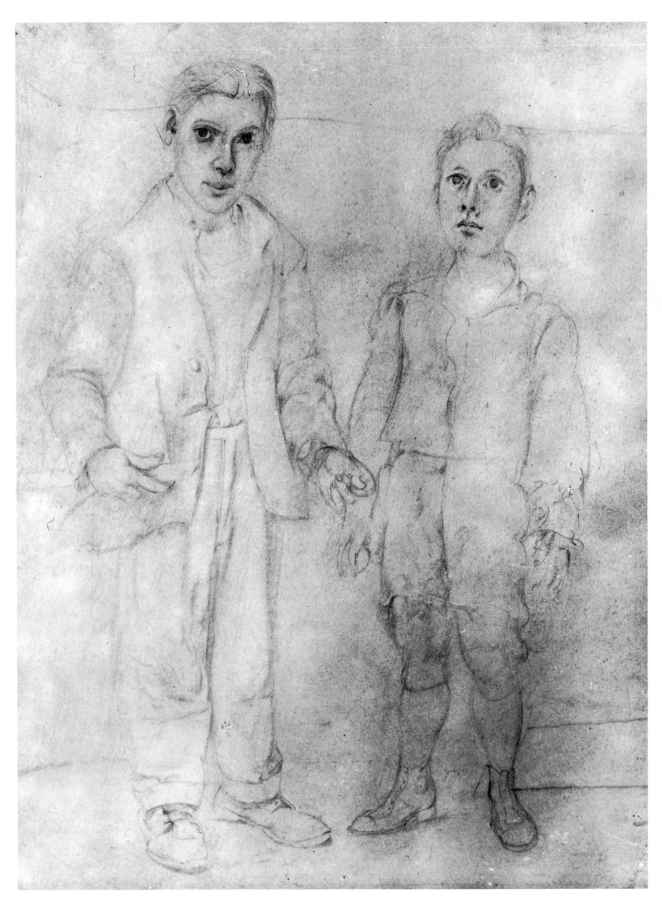

9
Self-Portrait with Imaginary Brother, c. 1938
Pencil on paper
13⅛ x 10¼"
Private collection

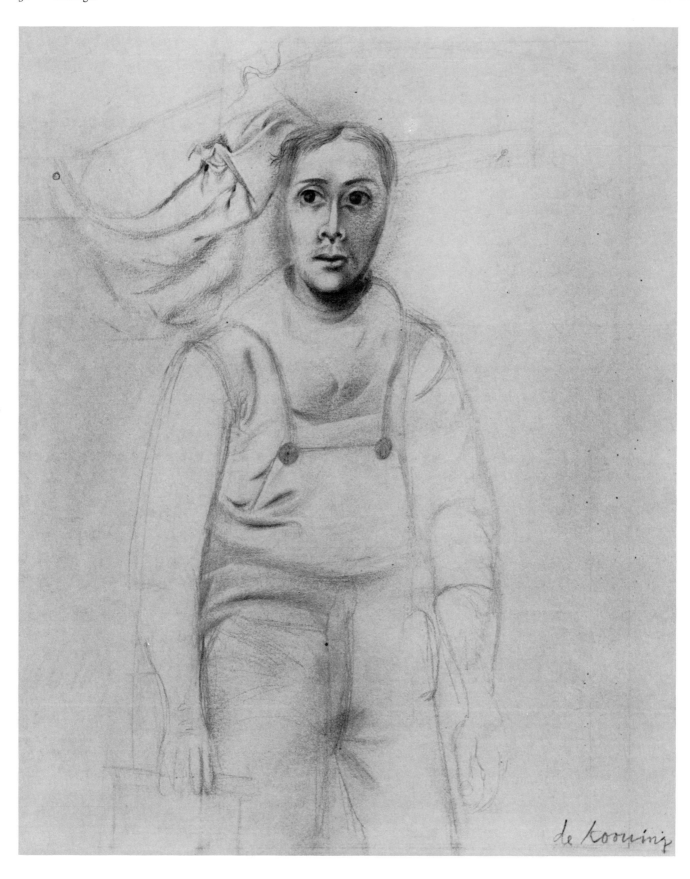

10

Working Man, c. 1938

Pencil on paper
11 x 9″
Collection of Max Margulis

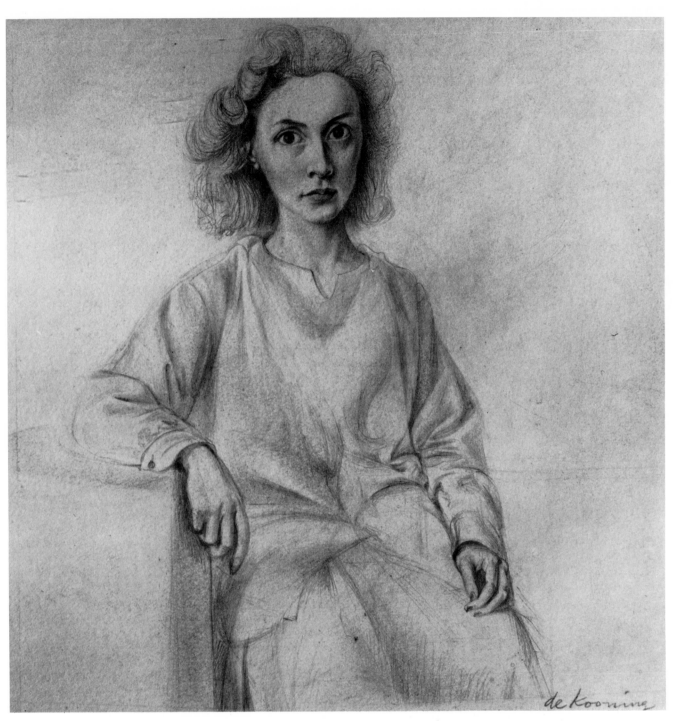

11
Portrait of Elaine, c. 1940-41
Pencil on paper
12¼ x 11⅞"
Private collection, courtesy Allan Stone Gallery, New York

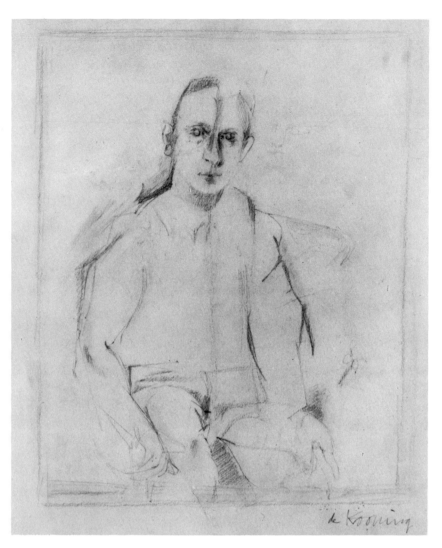

12
Seated Man, c. 1940
Pencil on paper
13⅛ X 11″
Xavier Fourcade, Inc., New York

14 ▷
Two Standing Men, c. 1939-42
Pencil on paper
13³⁄₁₆ X 16¼″
Warner Communications, Inc.,
New York

15
Manikins, c. 1939-42
Pencil on paper
13⅛ X 16⅞″
Xavier Fourcade, Inc.,
New York

13
*Three Studies of Men,
c. 1938
Pencil on paper
7⅝ X 9¹¹⁄₁₆″
Collection of Mr. and
Mrs. Steven J. Ross

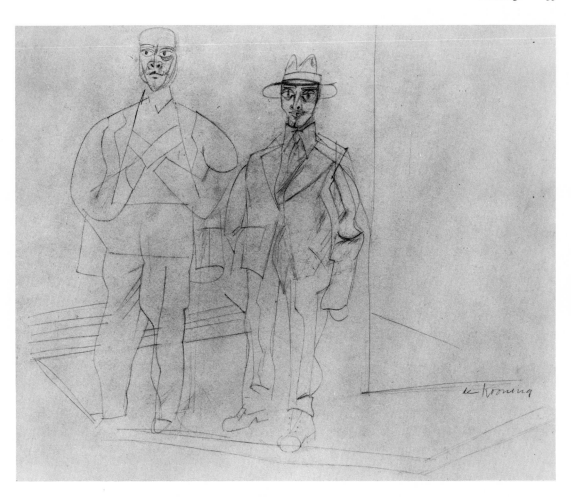

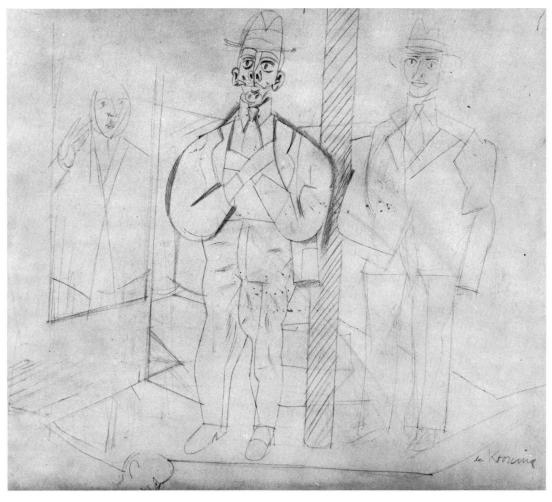

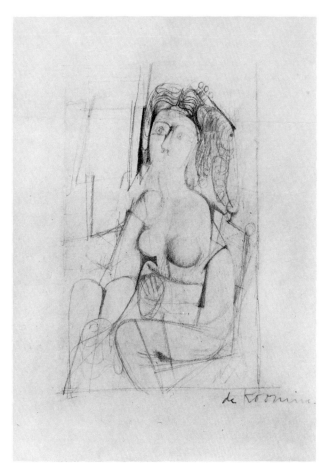

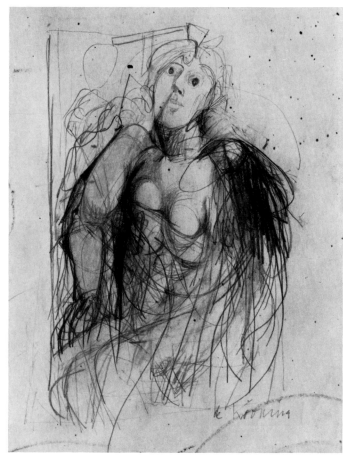

16
Seated Woman, 1943
Pencil on paper
8¾ x 6¼"
Collection of Mr. and Mrs. Donald A. Petrie

17
Study of Woman, 1942
Pencil on paper
7½ x 4⅞"
Private collection, courtesy Allan Stone Gallery, New York

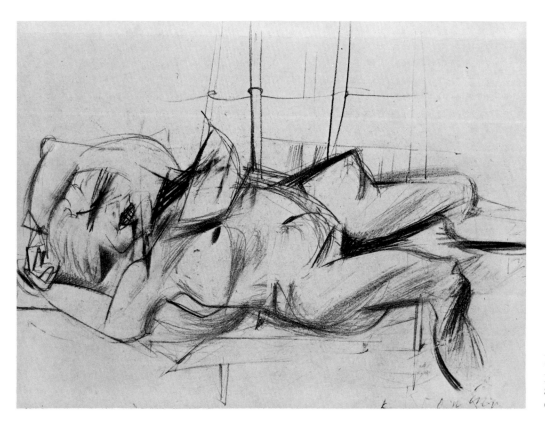

18
Reclining Woman, 1951
Pencil on paper
8⅞ x 11¾"
Collection of Wilder Green

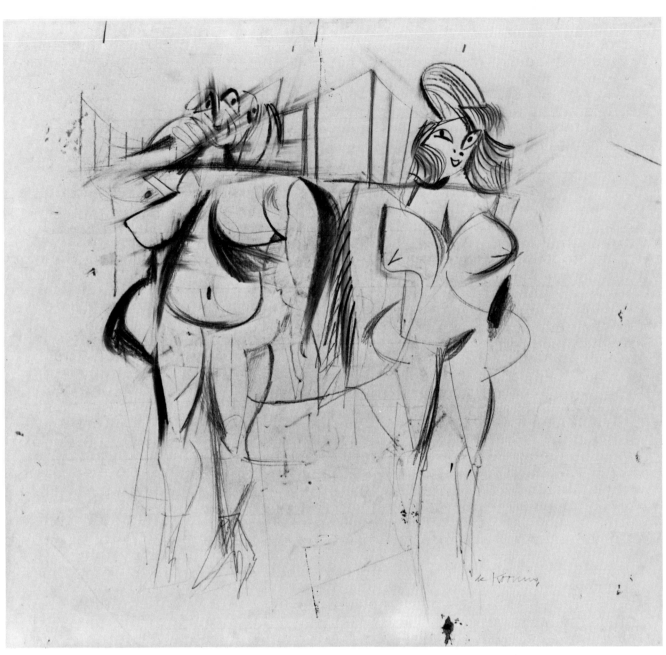

19
*Two Women, c. 1949-53

Pencil on paper
17¾x9½"
Collection of Mr. and Mrs. Steven J. Ross

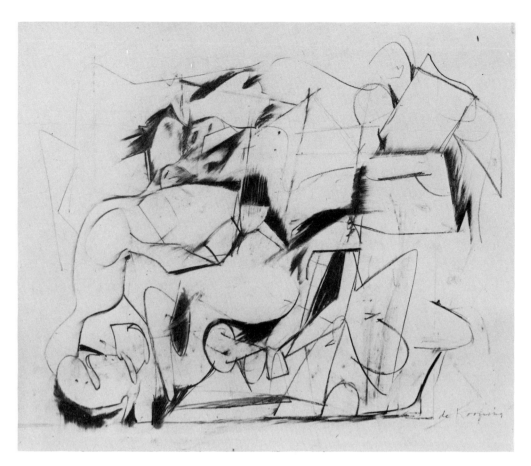

20

Untitled, c. 1945
Pencil on paper
18×23″
Collection of Mr. and
Mrs. Lee V. Eastman

21

Landscape, Abstract, 1949
Oil on paper mounted on board
19×25½″
Whitney Museum of American Art,
New York; Gift of Mr. and
Mrs. Alan H. Temple 68.96

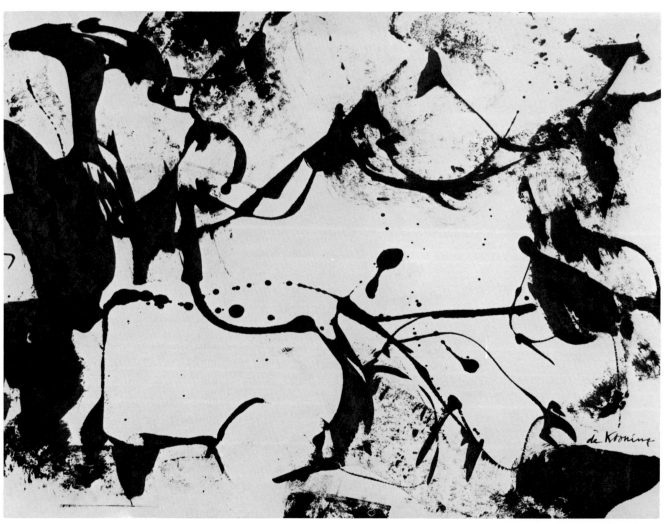

22
Untitled, 1949
Ink on paper
22 x 30″
National Gallery of Art, Washington, D.C.;
Gift of the Woodward Foundation, 1976

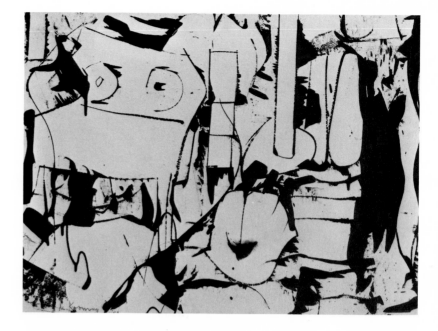

23
Black and White Abstraction, 1950
Sapolin enamel on graph paper
21½ x 29½″
Collection of Harold and May Rosenberg

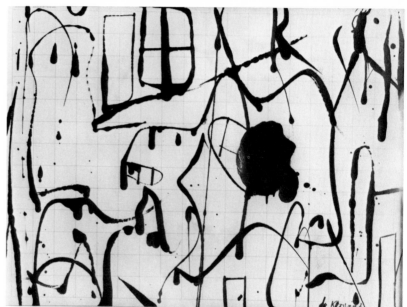

24
*Untitled, 1950
Sapolin enamel on paper
17½ x 23″
Collection of Mr. and Mrs. Paul Kantor

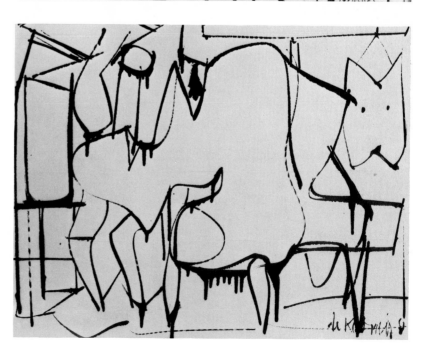

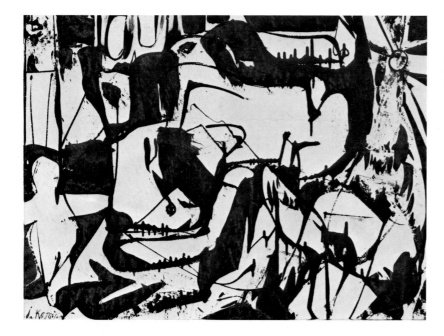

25
Untitled, c. 1949-50
Sapolin enamel on paper
21 X 29″
Collection of Mr. and Mrs. Ralph I. Goldenberg

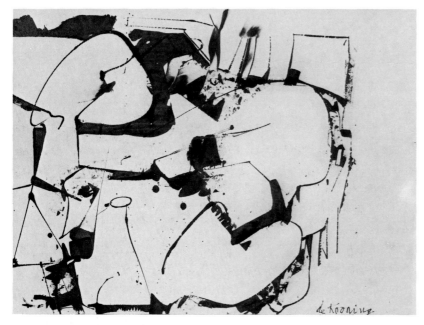

26
Untitled, 1950
Oil on paper
22 X 30″
Collection of Eve Propp

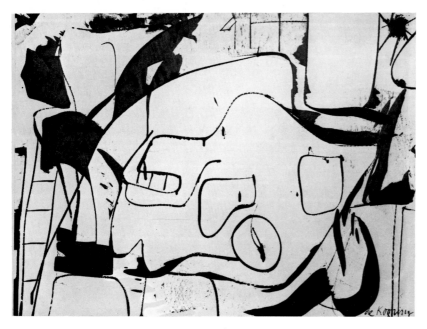

27
Black and White Abstraction, c. 1950-51
Sapolin enamel on paper
21¼ X 30¼″
Private collection, courtesy Allan Stone Gallery,
New York

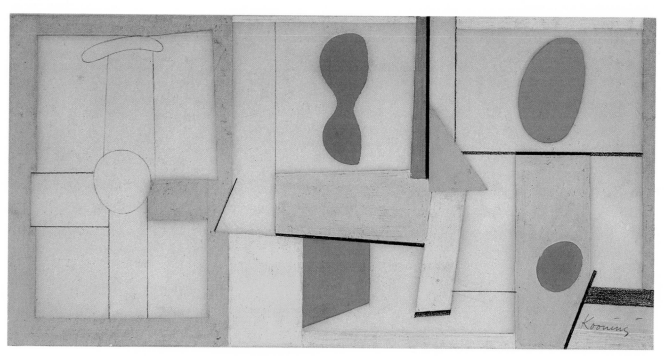

28
Untitled, c. 1935
Gouache and pencil on paper
6¾ x 13¾"
Whitney Museum of American Art, New York;
Gift of Frances and Sydney Lewis 77.34

29 ▽
*Untitled (Matchbook), c. 1942
Oil and pencil on paper
5½ x 7½"
Private collection

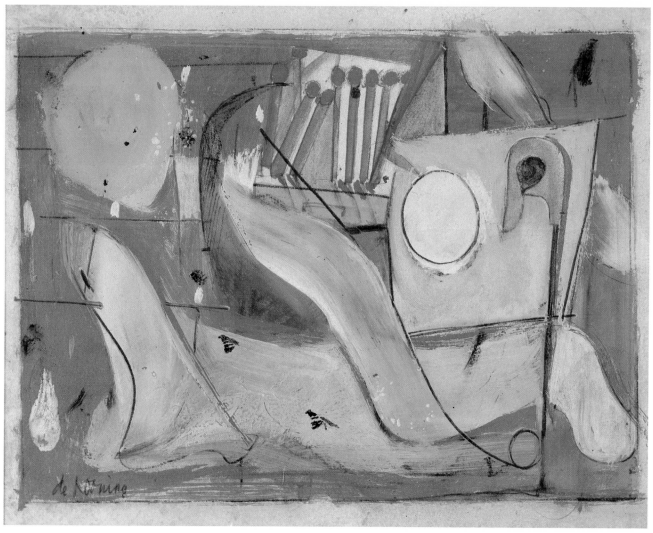

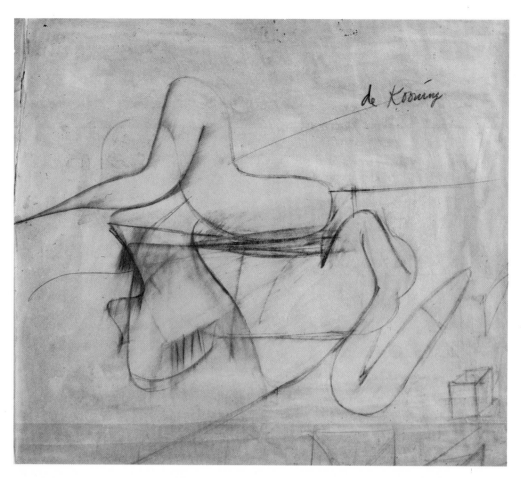

30
Abstraction *or* Study for
Marsh Series *or* Study for
Pink Angels, 1945
Pastel and pencil on paper
12 x 13⅞"
Private collection, courtesy
Allan Stone Gallery, New York

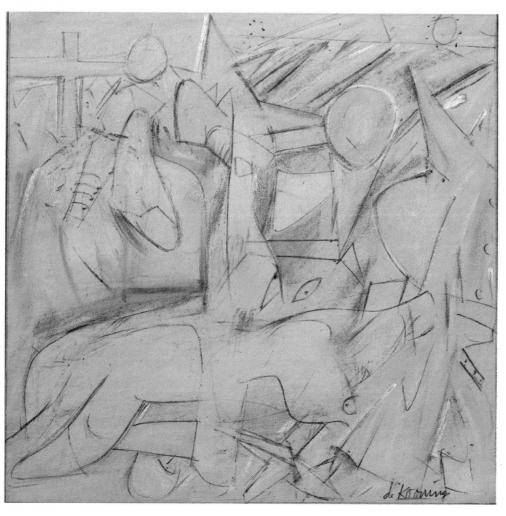

31
*Study for Backdrop, 1945
Pastel and pencil on paper
9¾ x 10"
Collection of Mr. and
Mrs. Donald Blinken

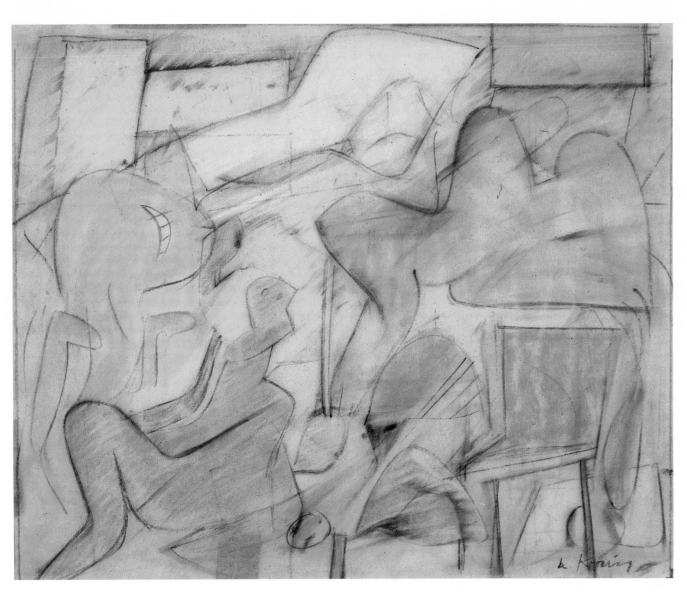

32
Still Life, c. 1945
Pastel and charcoal on paper
13⅜ x 16¼"
Estate of Betty Parsons

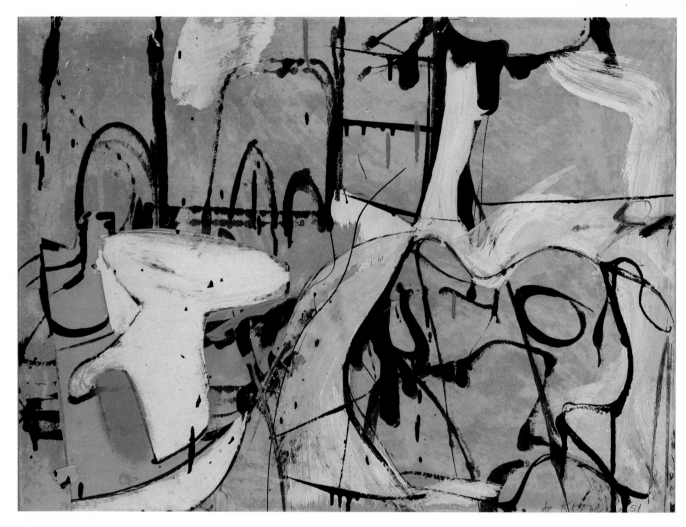

33
Untitled, 1951

Oil and collage on paper
22 x 30"
Collection of Vincent Melzac

34
Untitled (Black and White Abstraction),
c. 1950
Ink on paper
21½ x 29½″
Collection of Mr. and Mrs. Lee V. Eastman

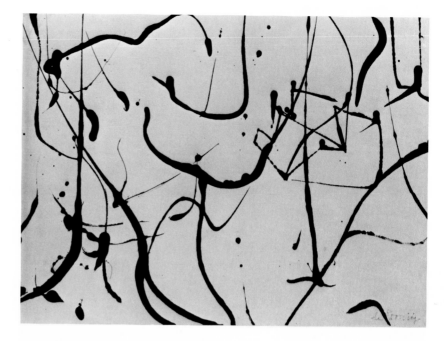

35
Itinerant Chapel, 1951
Sapolin enamel on paper mounted on board
22 x 30″
Private collection, courtesy Allan Stone Gallery,
New York

36
*Untitled, c. 1950
Ink on paper
21⅞ x 29⅞″
Museum of Art, Rhode Island School of Design,
Providence ; Museum Works of Art

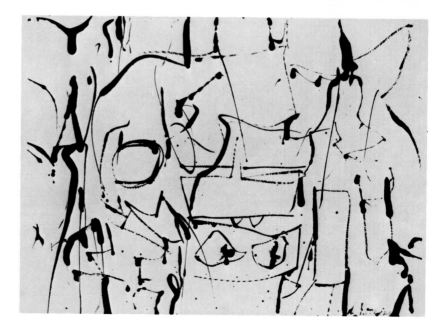

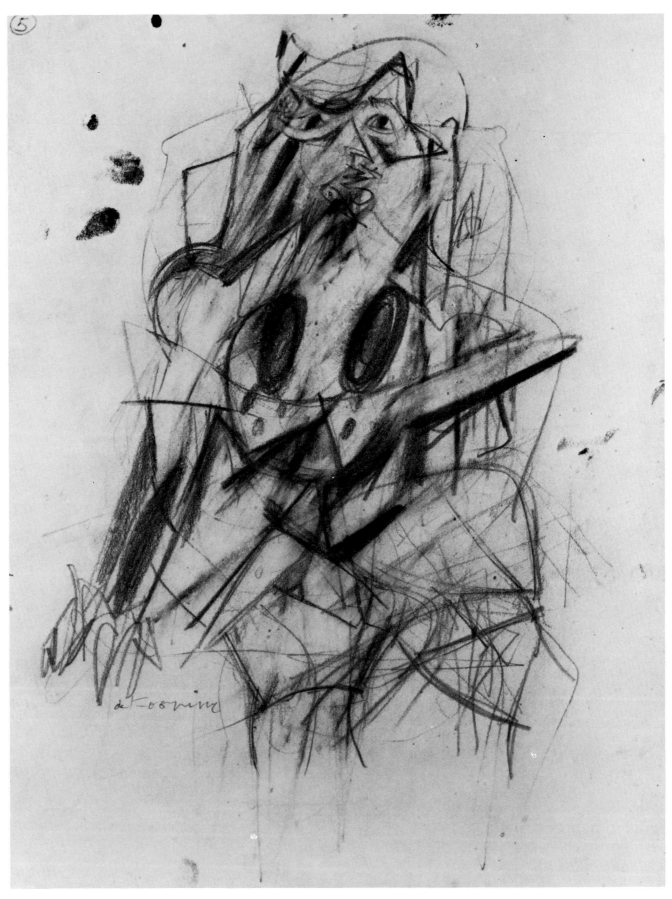

37
*Woman, c. 1951
Pencil on paper
12½ x 9½"
Collection of Mr. and Mrs. Steven J. Ross

38 ▷
Woman, 1951
Charcoal and pastel on paper
21½ x 16"
Collection of Paul and Ruth Tishman

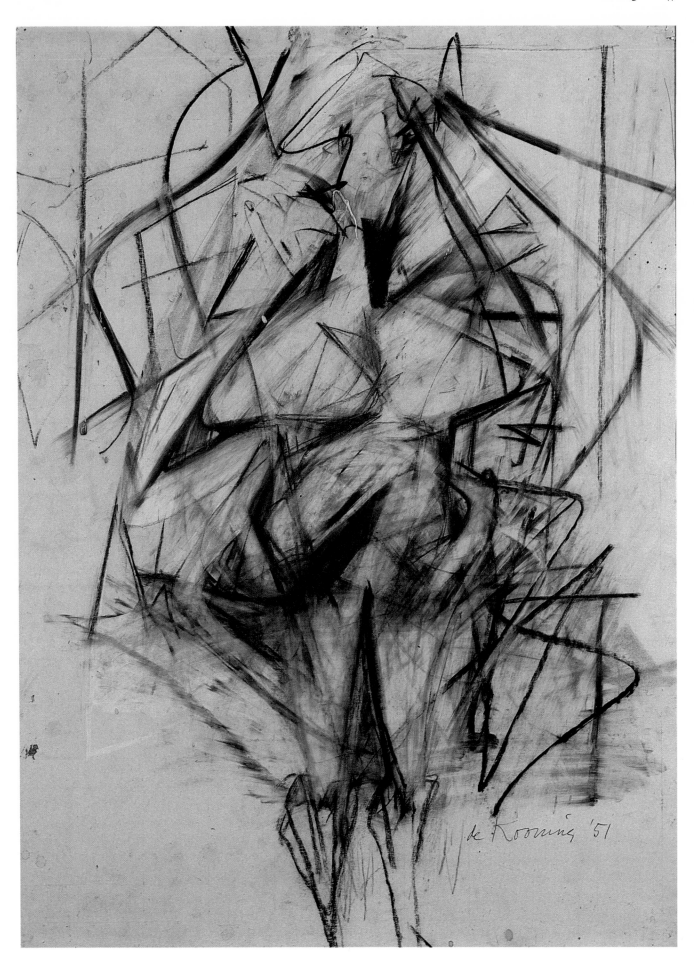

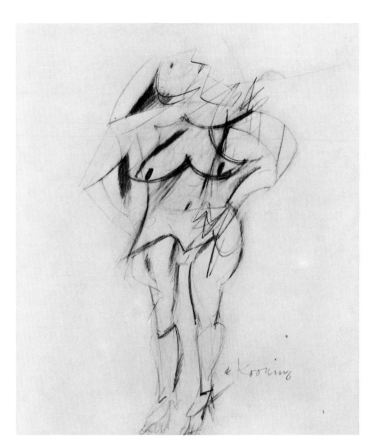

39
Woman, 1951
Pencil on paper
11⅛ x 7⅛"
Xavier Fourcade, Inc., New York

40
Woman, c. 1951-52
Pencil on paper
12½ x 9½"
Private collection

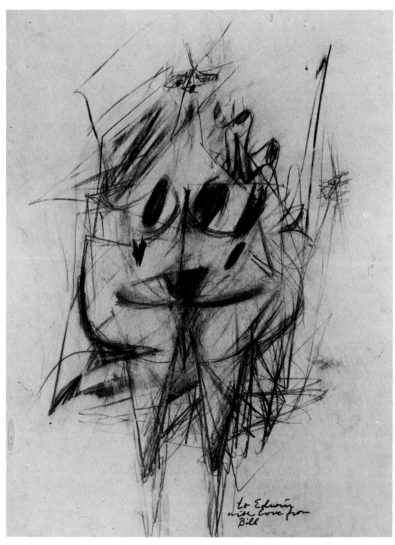

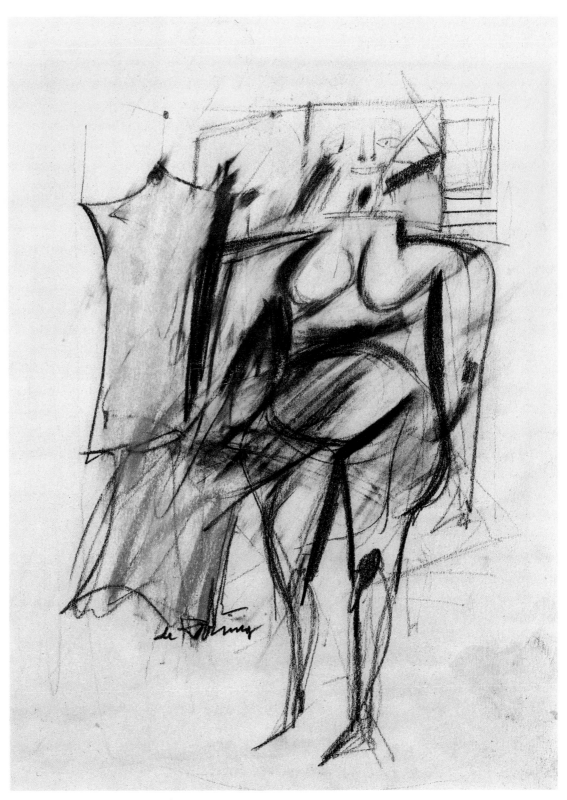

41
Woman, c. 1951
Pastel and pencil on paper
12½ x 9¼"
Private collection, courtesy Allan Stone Gallery, New York

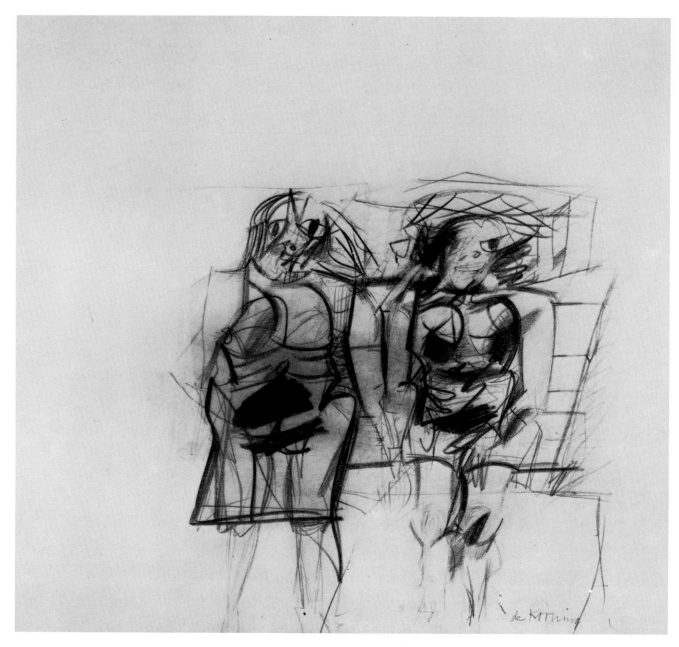

42
*Two Women, c. 1951-52

Pencil on paper
14⅜ x 16⅛"
Collection of Mr. and Mrs. Steven J. Ross

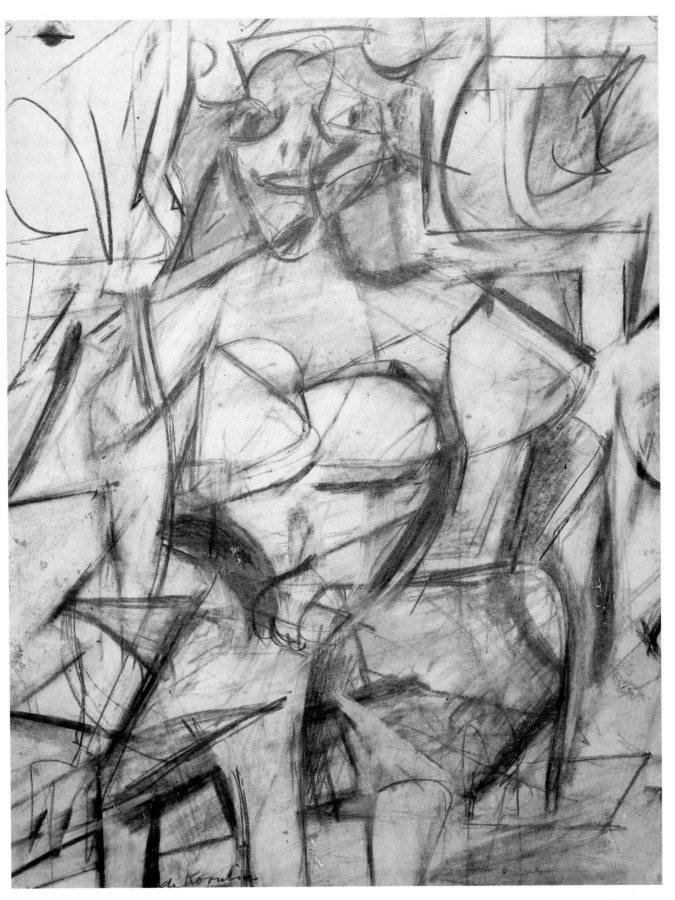

43
*Woman, c. 1951-52

Pastel and crayon on paper
13¼ x 10¼"
Private collection

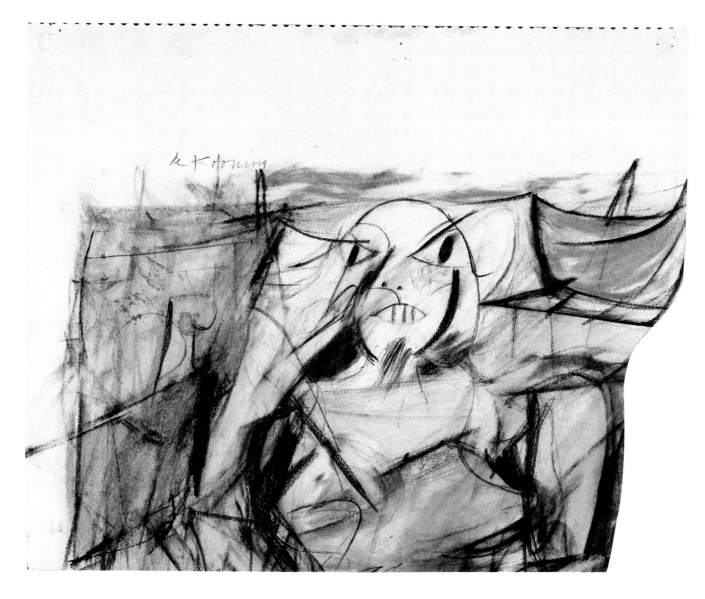

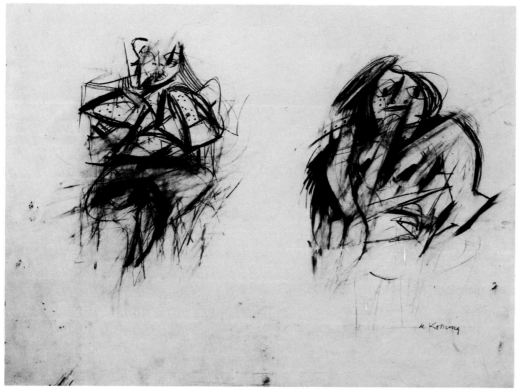

44 △
Study for Woman I,
1952

Pastel and crayon on paper
8⅞ x x 11⅛″
National Gallery of Art,
Washington, D.C.; Andrew
W. Mellon Fund, 1978

45
*Women, c. 1951-53

Pencil on paper
17¾ x 23¾″
Collection of Mr. and
Mrs. Steven J. Ross

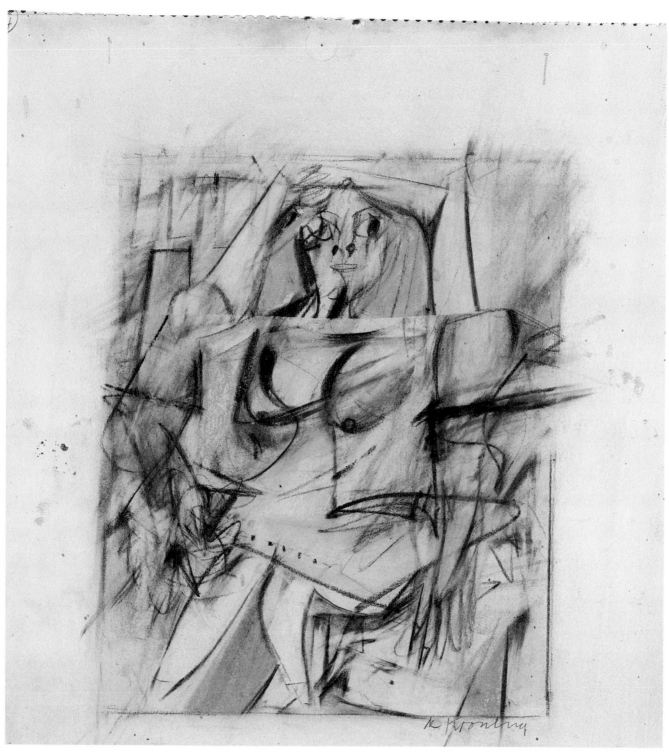

46

Seated Woman (Study for Woman I), 1952

Pastel and pencil on paper
12⅛ x 11½″
National Gallery of Canada, Ottawa

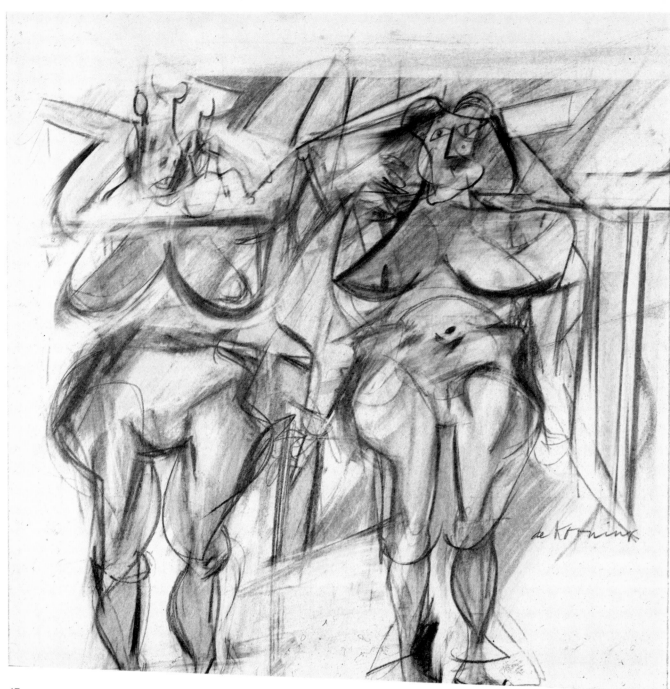

47
Two Women, 1952

Pencil on paper
12¾ x 12¾"
Collection of Richard and Mary L. Gray

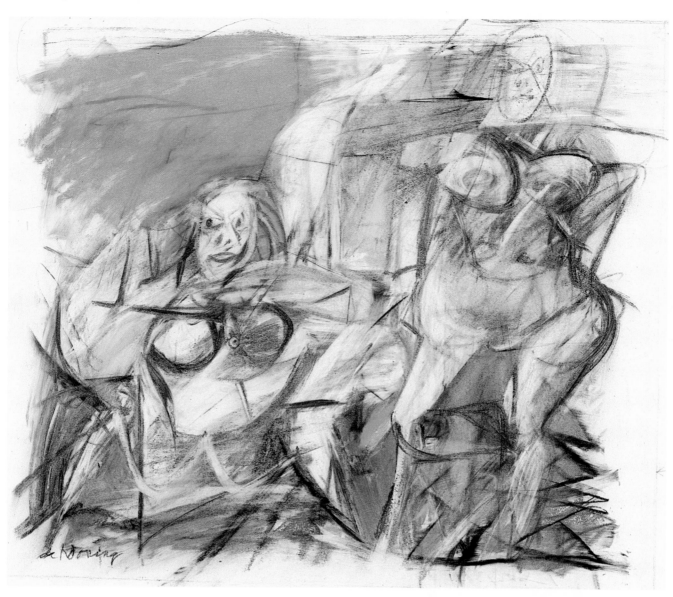

48
*Two Women, 1952

Pastel on paper
18 x 21"
Private collection

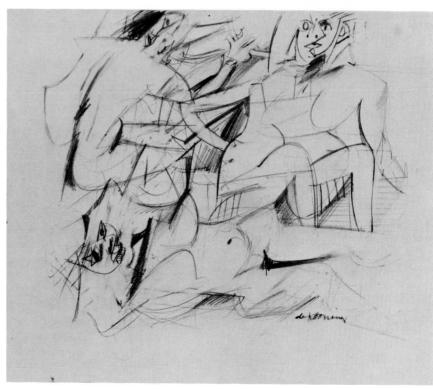

49
Three Women, 1952

Pencil on paper
14 x 16¾"
The Brett Mitchell Collection, Inc., Cleveland

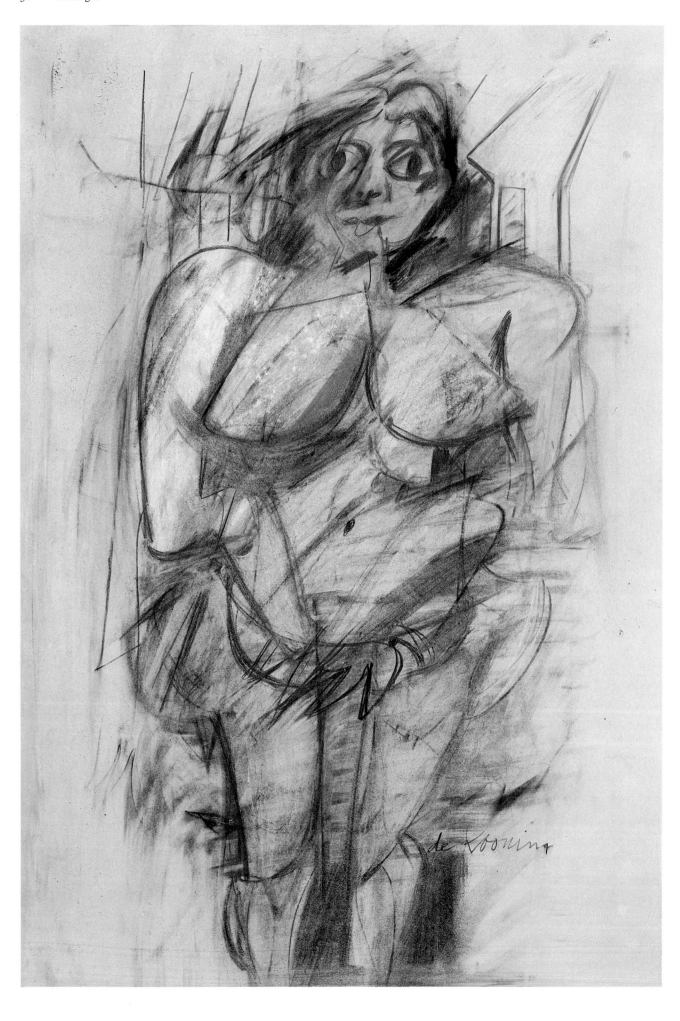

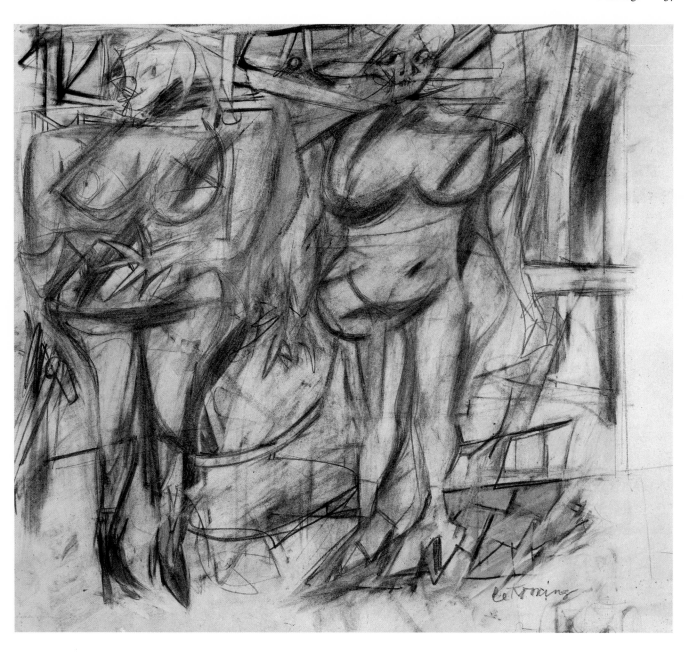

51
Two Women, 1952
Pastel on paper
15½ x 17½"
Private collection

50
*Woman, 1952
Pastel and pencil on paper
21 x 14"
Private collection

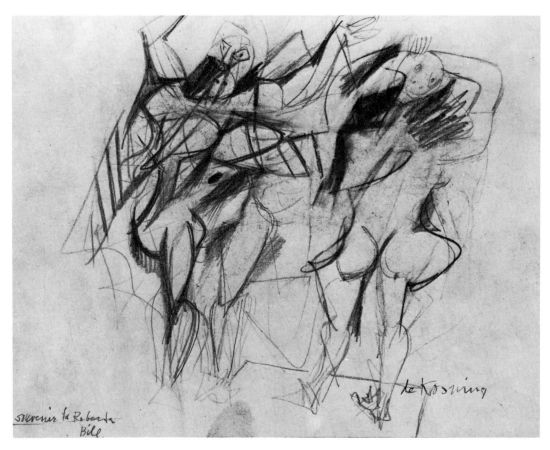

52
Untitled (Two Figures), 1952
Pencil on paper
8½ x 11″
Collection of Mr. and Mrs. Lee V. Eastmann

53
Five Women, c. 1952
Pencil on paper
17⅜ x 28⅞″
Private collection

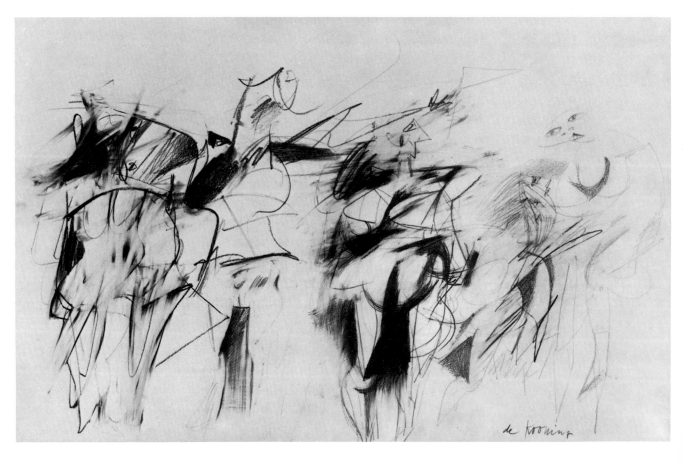

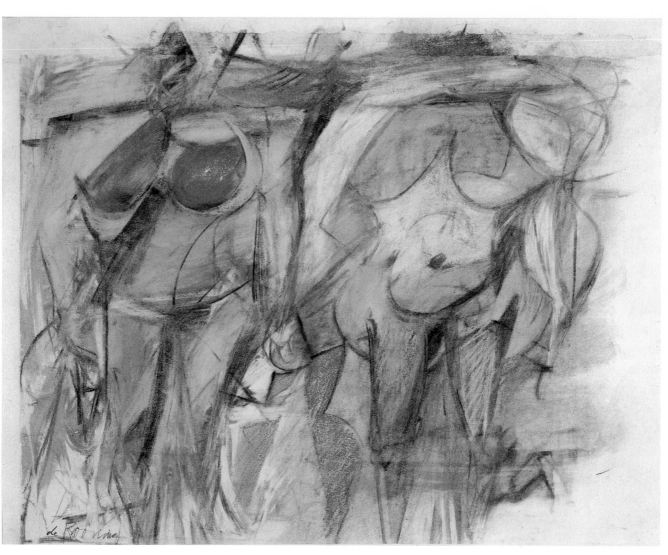

54
Two Women Torsos, 1952
Pastel on paper
18⅛ x 24"
The Art Institute of Chicago ; The John H. Wrenn Collection

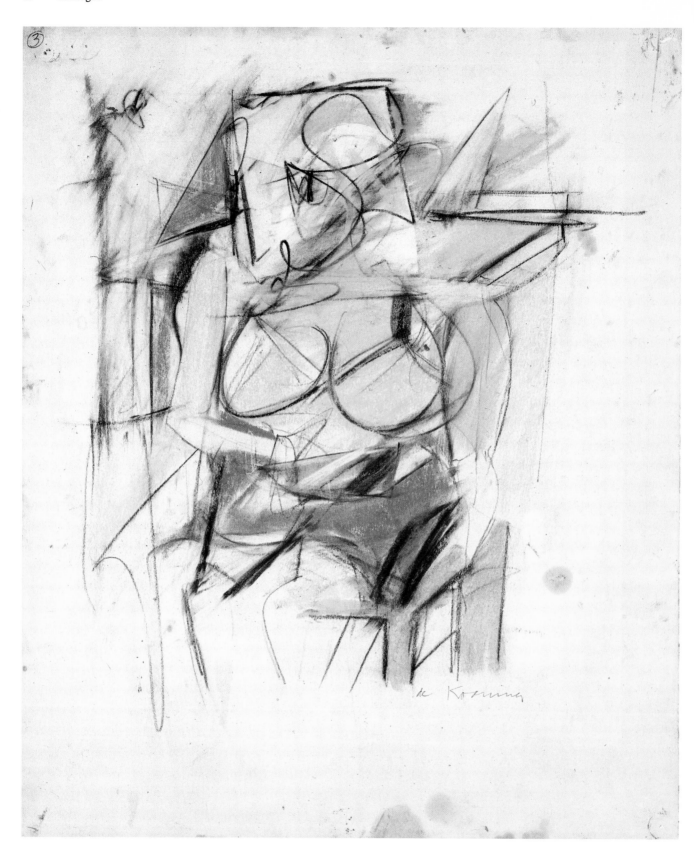

55
Woman, c. 1952

Pastel, pencil, and charcoal on paper
16½ x 13½"
Los Angeles County Museum of Art;
Purchased with Funds Provided by the
Estate of David E. Bright, Paul
Rosenberg & Co., and Lita A. Hazen

56
Woman, 1952

Pastel on paper
11⅜ x 7¾"
Collection of Mr. and Mrs. Sherman H. Starr

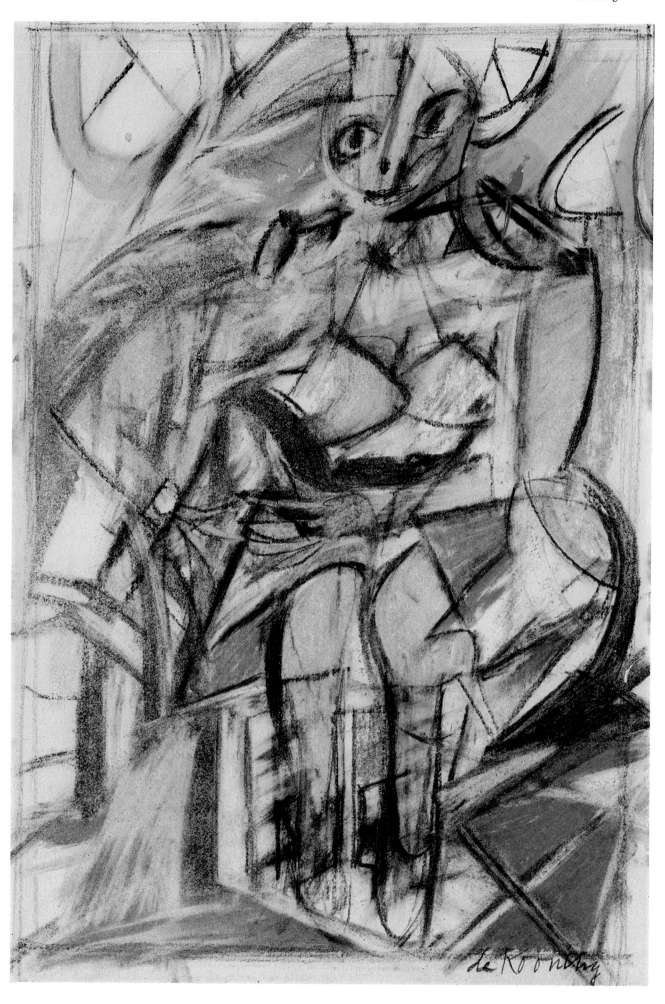

57
Seated Woman, c. 1953-54
Pencil on paper
20 x 22″
Collection of Stella Waitzkin

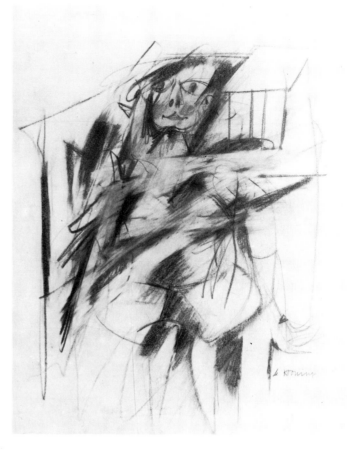

59 ▷
*Woman, 1953
Charcoal on paper
36 x 23½″
Collection of Mr. and
Mrs. S. I. Newhouse, Jr.

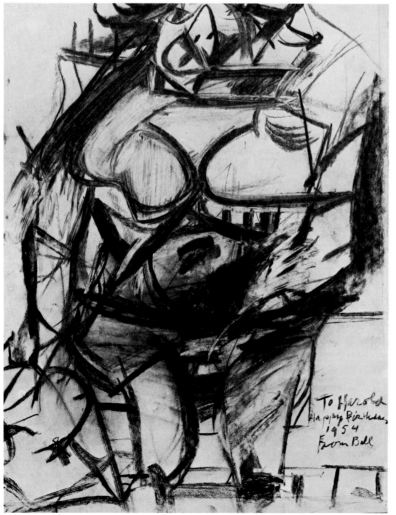

58
Monumental Woman, 1953
Charcoal on paper
28½ x 22½″
Collection of Harold and May Rosenberg

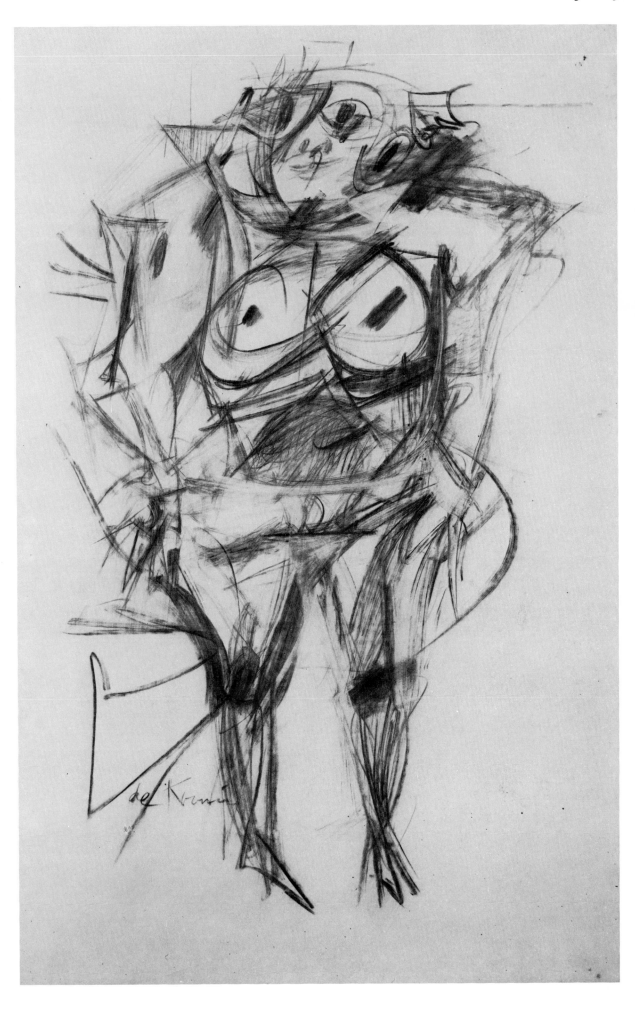

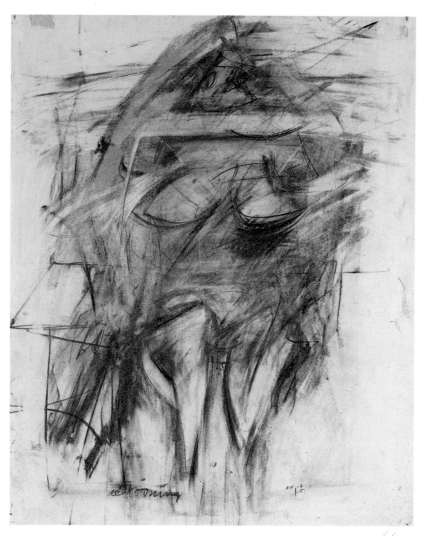

62 ▷

Woman, c. 1952
Crayon and charcoal on paper,
two assembled drawings
29½ x 19¾"
Musée National d'Art Moderne,
Centre National d'Art et de
Culture Georges Pompidou, Paris

60

Woman, c. 1952-53
Pastel and pencil on paper
16¾ x 14"
Collection of Eve Propp

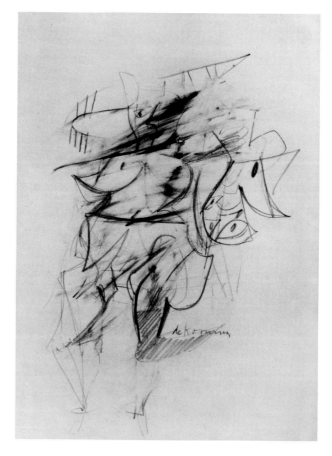

61

Untitled, 1953
Pencil on paper
14 x 10½"
Estée Lauder Cosmetics Collection, New York

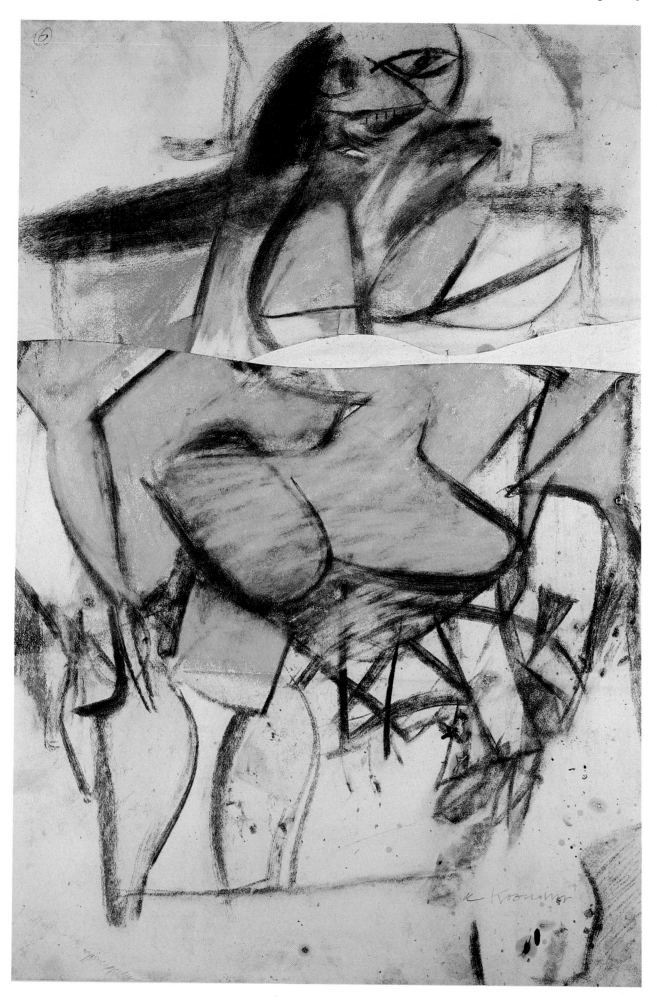

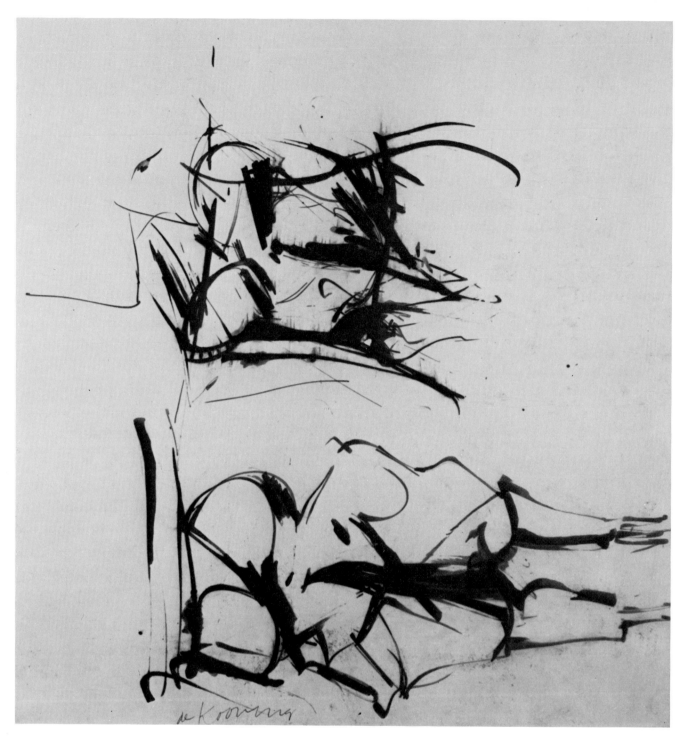

63
Untitled, 1954
Ink on paper
18⅜ x 17½"
Collection of Glenn Janss

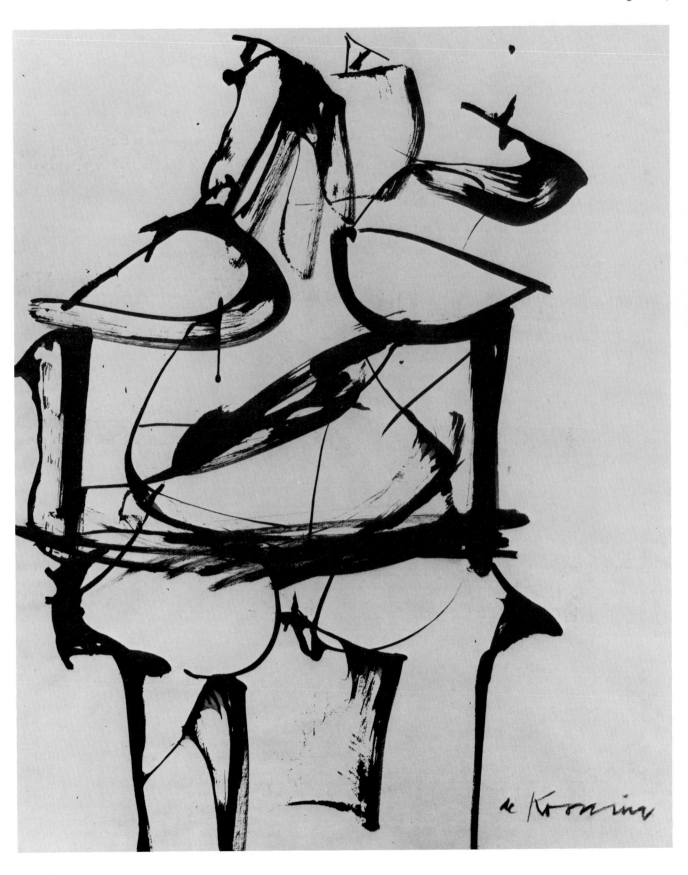

64
Woman, c. 1959
Ink on paper
23 x 18¾"
Private collection

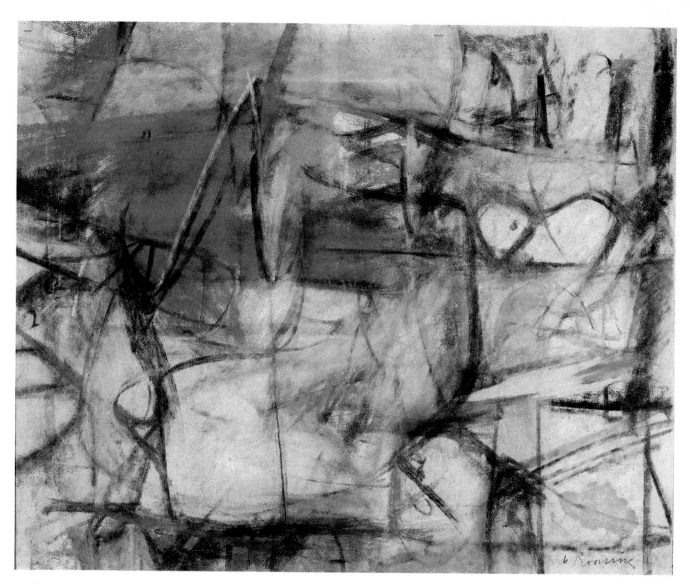

65
*Figure in Interior, 1955
Pastel on paper
26½ x 33¼"
Private collection

66
Untitled, c. 1956-58
Pastel on paper
22½ x 30¾"
Xavier Fourcade, Inc., New York

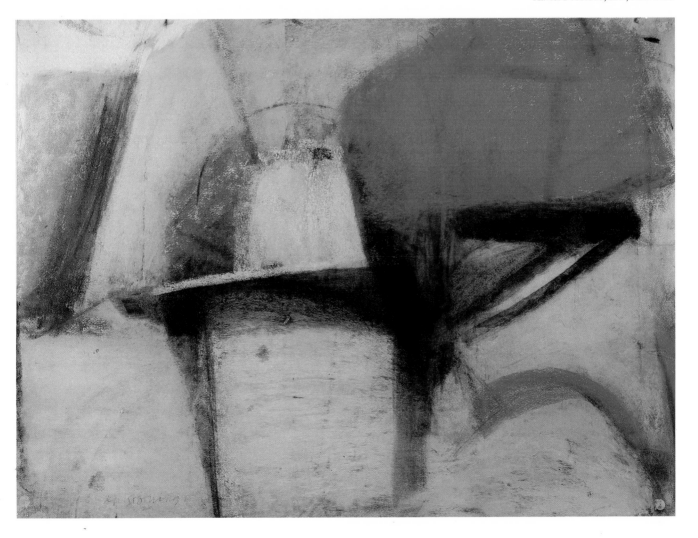

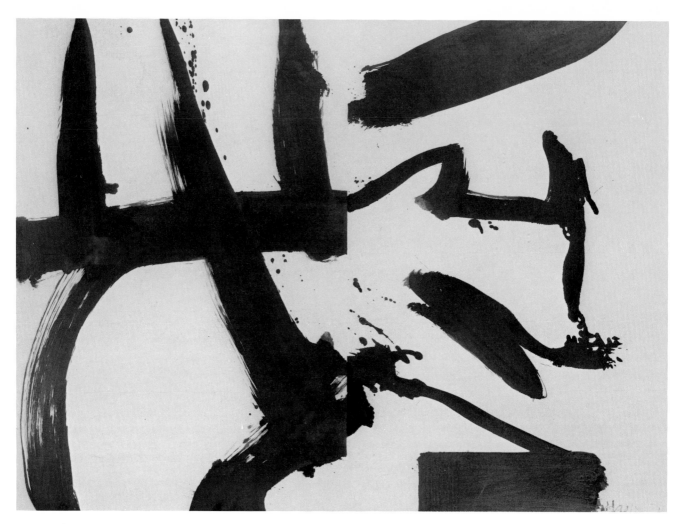

67

Black and White (Rome) Q, 1959

Oil on paper
40 × 55¾″
Xavier Fourcade, Inc., New York

68
Folded Shirt on Laundry Paper, 1958

Ink on paper
16⅞ x 13⅞"
Xavier Fourcade, Inc., New York

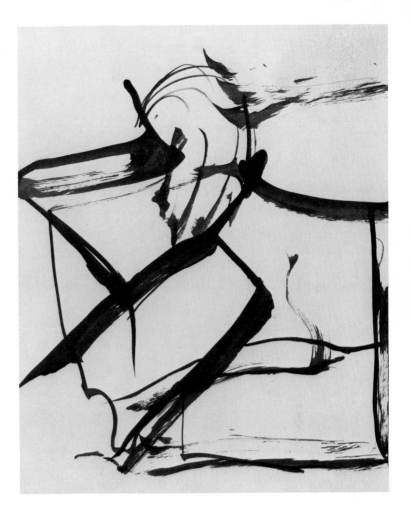

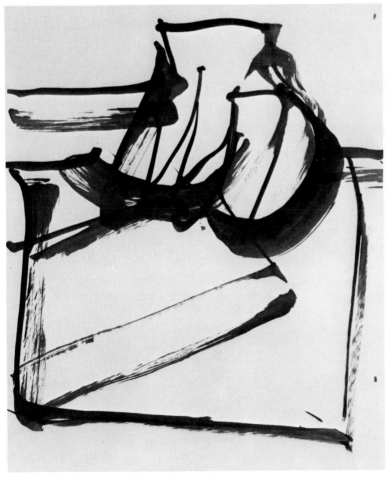

69
Folded Shirt on Laundry Paper, 1958

Ink on paper
16⅞ x 13⅞"
Xavier Fourcade, Inc., New York

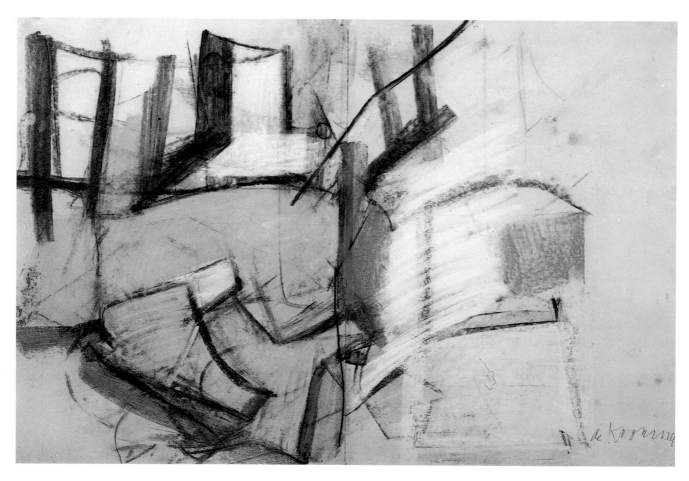

70
Untitled, c. 1956-58
Pastel on paper
22⅛ X 33¾"
Warner Communications, Inc., New York

71
*Untitled, c. 1956-58
Pastel on paper
30½ X 22½"
Collection of Susan Morse Hilles

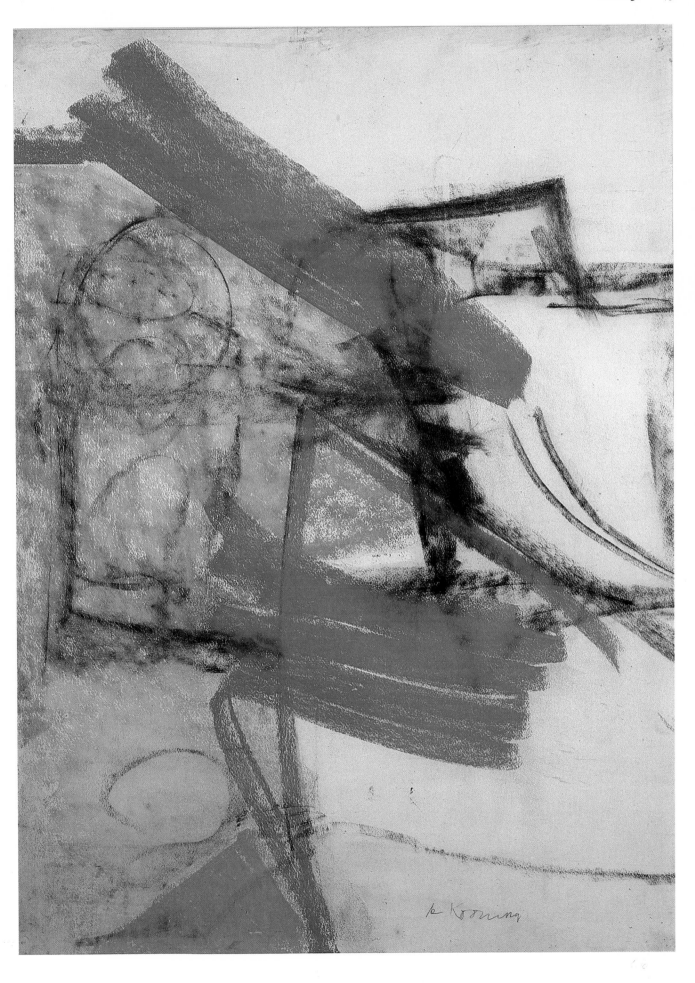

72
Black and White (Rome) F, 1959
Oil on paper
28x40″
Collection of Mr. and Mrs. Randolph P. Compton

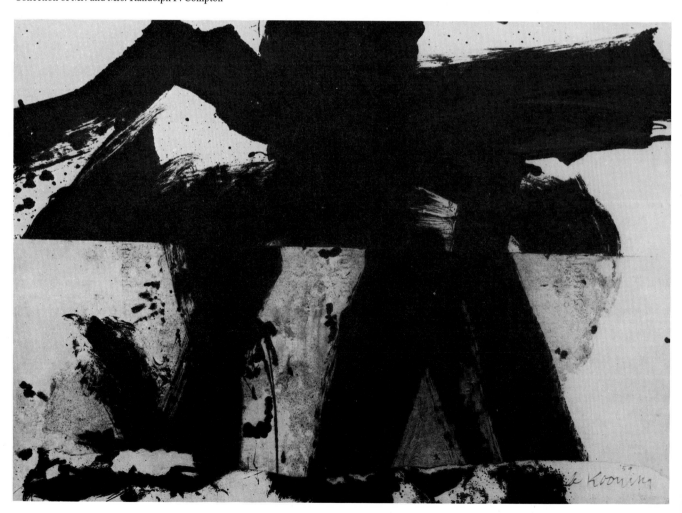

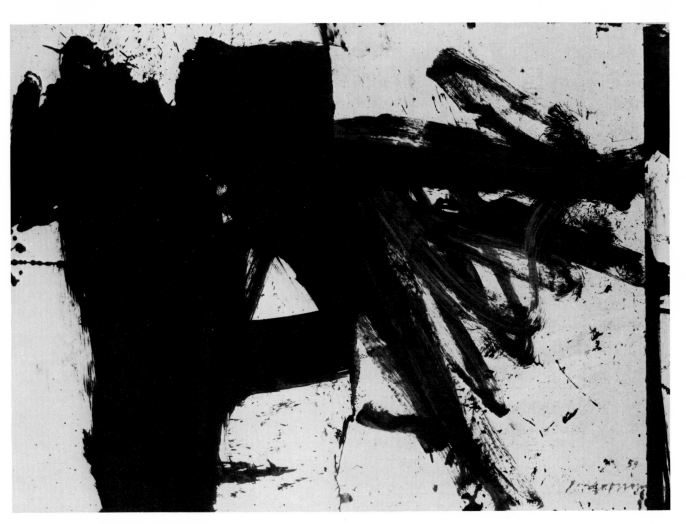

73
Black and White (Rome) T, 1959
Oil on paper
28 x 40"
Xavier Fourcade, Inc., New York

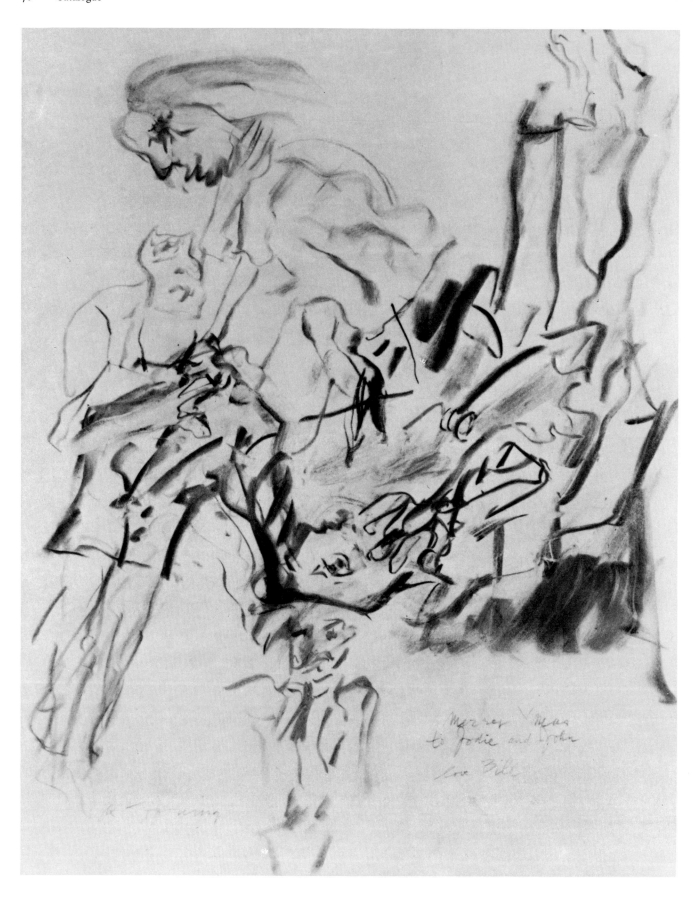

74
Untitled, 1973
Charcoal on paper
24 x 19″
Collection of Mr. and Mrs. John L. Eastman

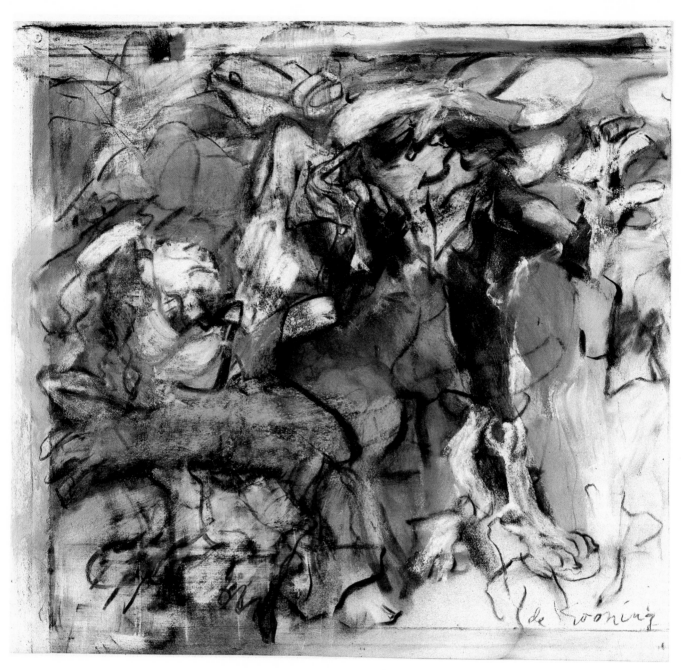

75
Untitled (Figures in Landscape), 1974
Charcoal and pastel on paper
29¾ x 30½"
Australian National Gallery, Canberra

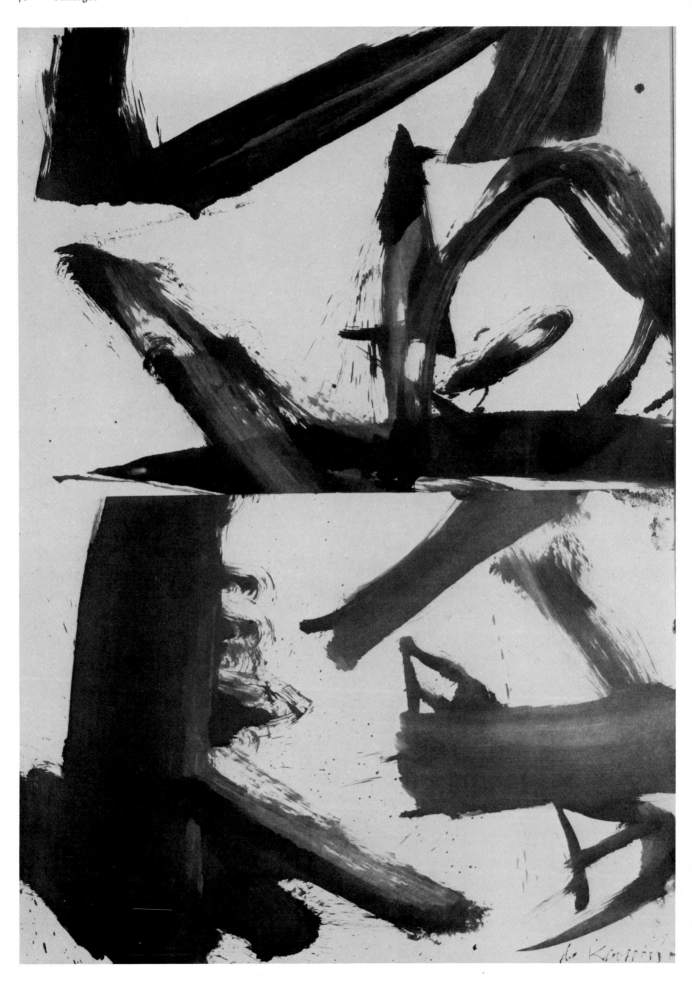

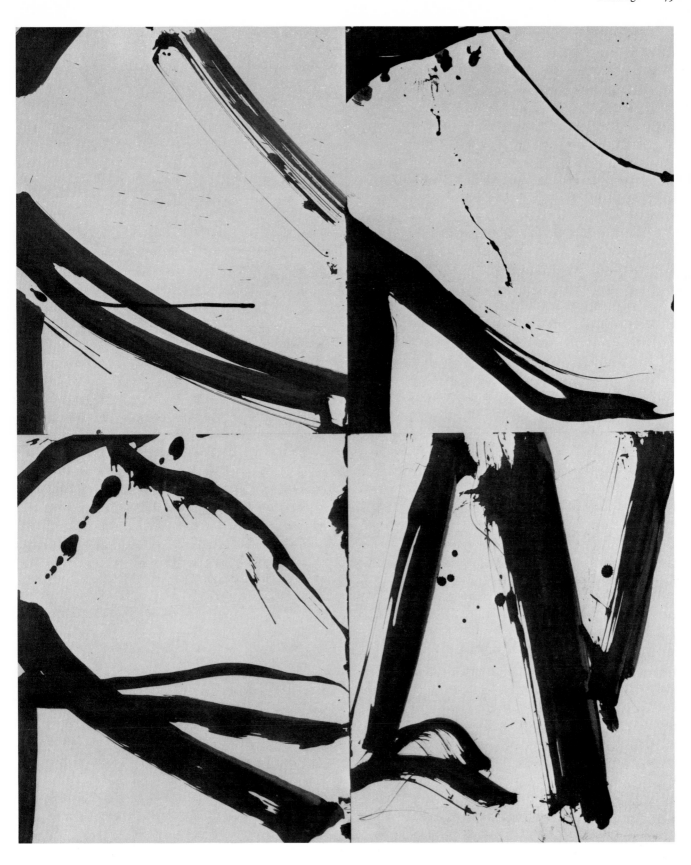

76
Black and White (Rome), c. 1959-60

Oil on paper, two assembled drawings
55¾×40″
Xavier Fourcade, Inc., New York

77 △
Black and White (San Francisco), 1960

Ink on paper, four assembled drawings
33¾×27½″
Warner Communications, Inc., New York

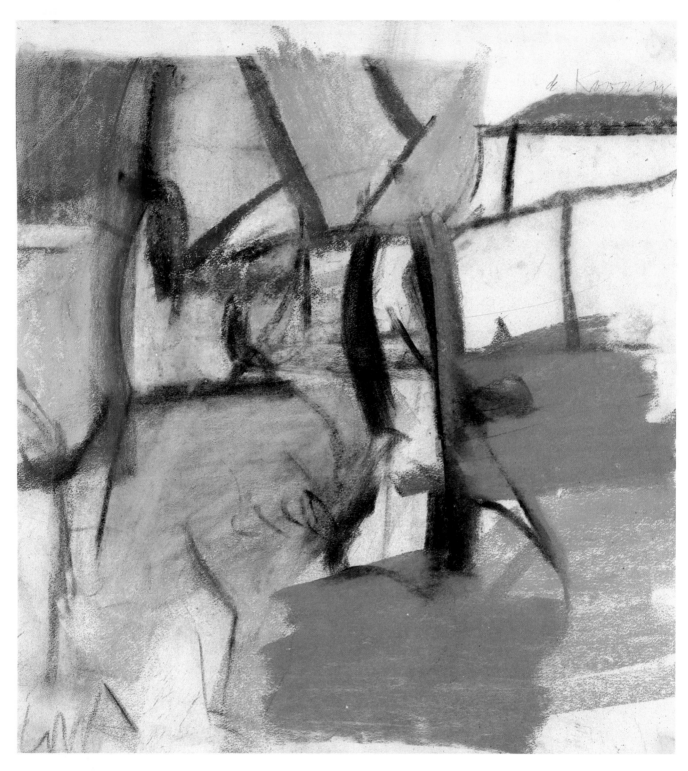

78
Untitled, c. 1956-58

Pastel on paper
22½ × 21″
Mnuchin Foundation, New York

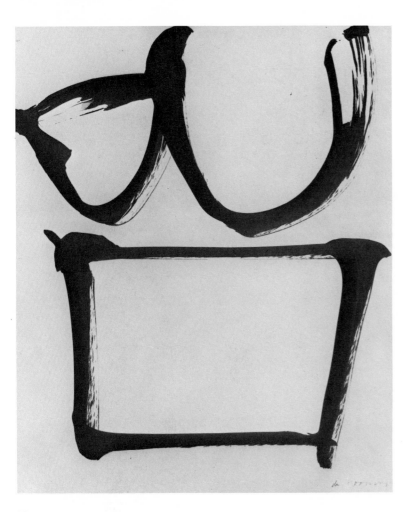

79
Untitled, c. 1958

Ink on paper
17 x 14"
Xavier Fourcade, Inc., New York

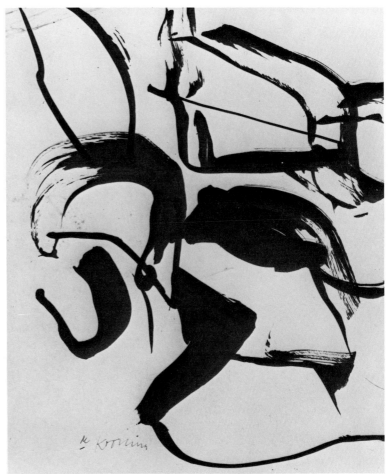

80
Untitled, c. 1958

Ink on paper
17 x 14"
Xavier Fourcade, Inc., New York

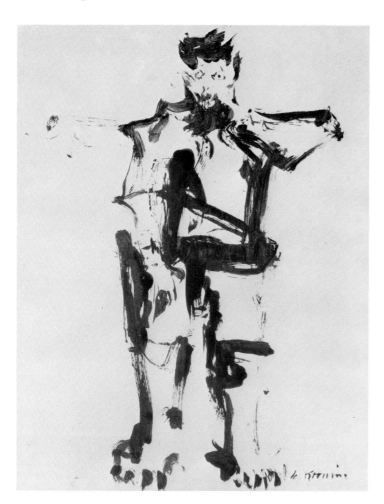

81
Figure *or* Untitled (Man), 1964
Ink on paper
23¾ x 18¹³⁄₁₆"
Hirshhorn Museum and Sculpture Garden,
Smithsonian Institution, Washington, D.C.

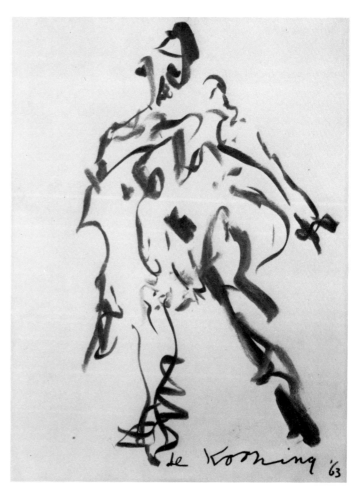

82
Woman, 1963
Charcoal on paper
11⅜ x 8⅜"
Collection of Mr. and Mrs. Lee V. Eastman

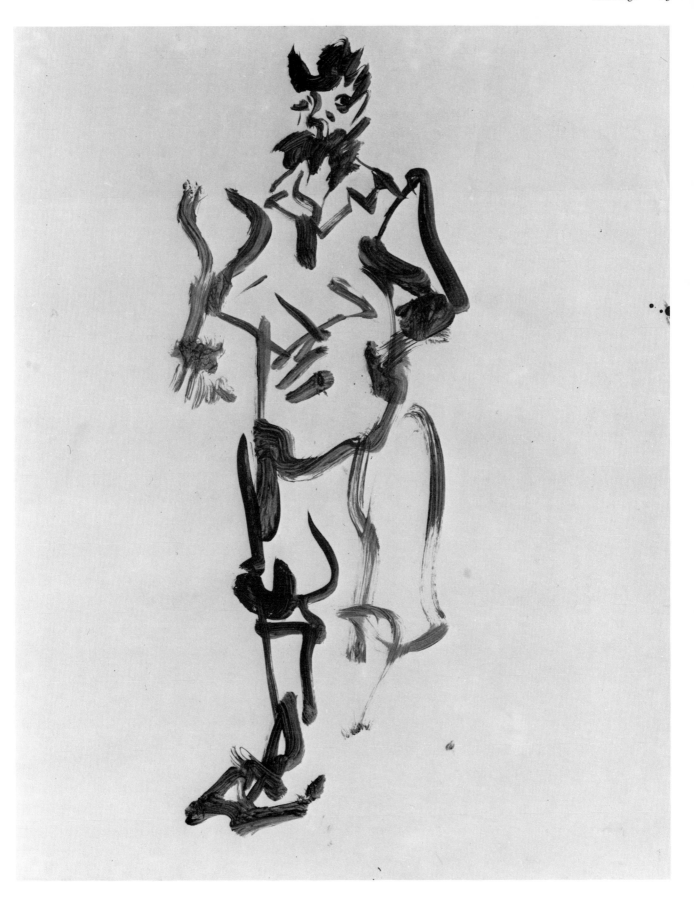

83
Man, 1964
Ink on paper
23¾ x 18¾"
Collection of Elaine de Kooning

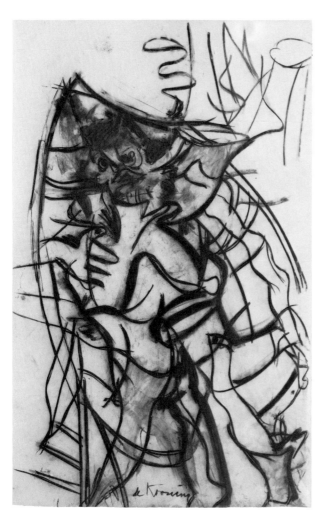

84
Woman in Rowboat, c. 1964-65

Charcoal on vellum
56×35½″
Vanderwoude Tananbaum Gallery, New York

85
Study for Woman in Rowboat, 1964

Charcoal on vellum
58×35½″
Collection of James and Katherine Goodman

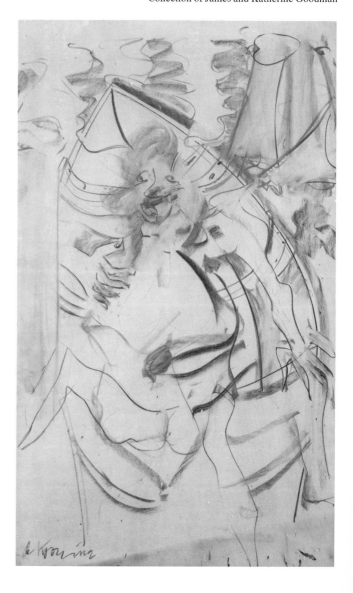

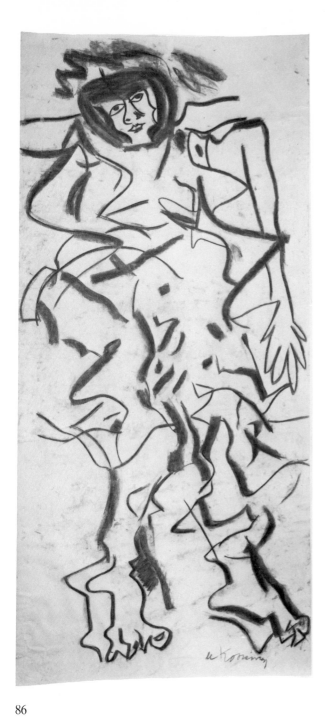

87
Woman, 1965
Charcoal on vellum
85½ x 45½"
Collection of Kimiko and John Powers

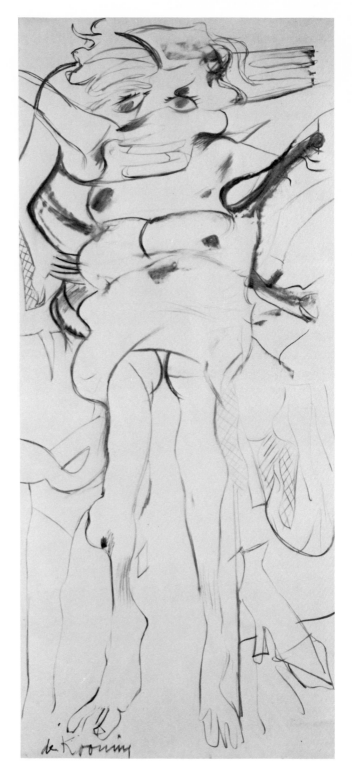

86
Woman, 1964
Charcoal on waxed paper
79¾ x 36"
Hirshhorn Museum and Sculpture Garden,
Smithsonian Institution, Washington, D.C.

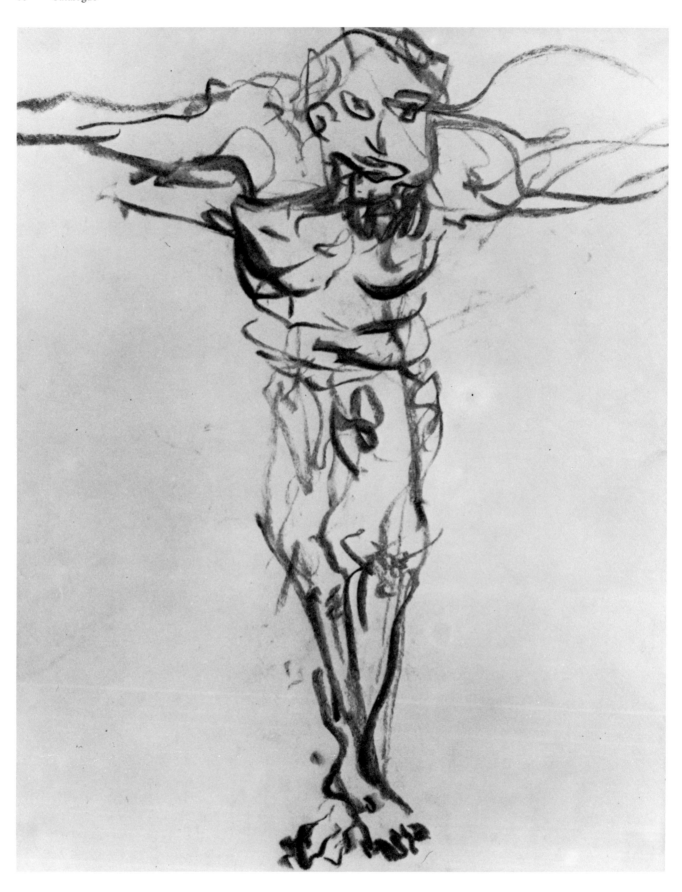

88
Untitled, 1966
Charcoal on paper
8 x 10"
Xavier Fourcade, Inc., New York

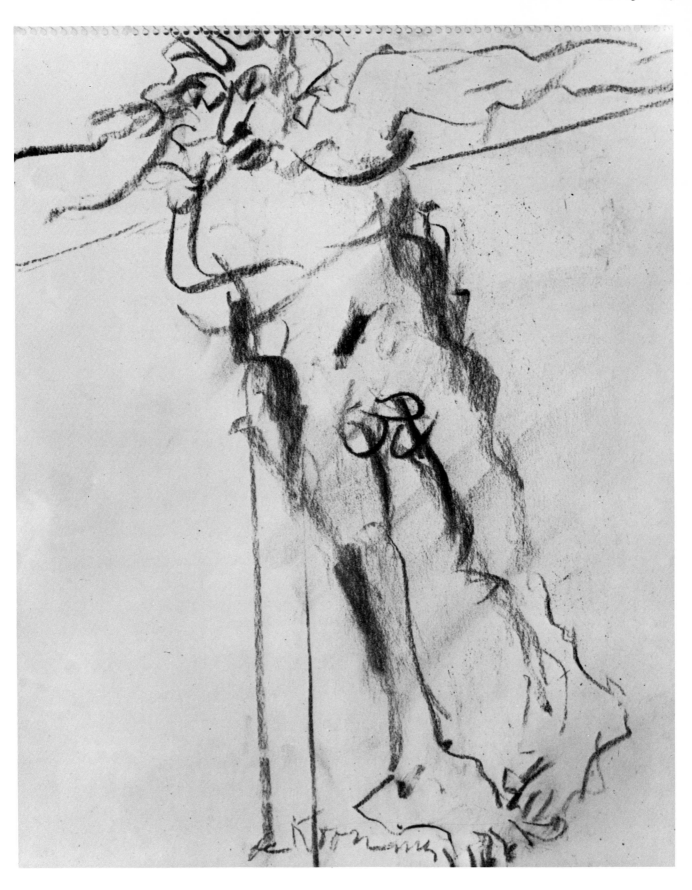

89
Untitled (Crucifixion), 1966
Charcoal on paper
17 x 14"
Xavier Fourcade, Inc., New York

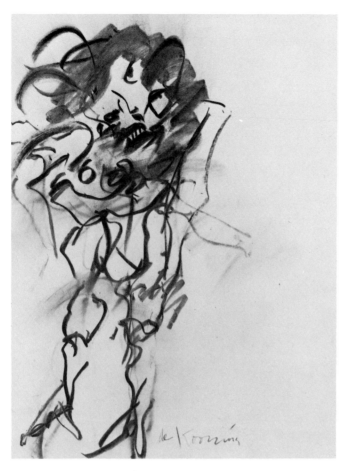

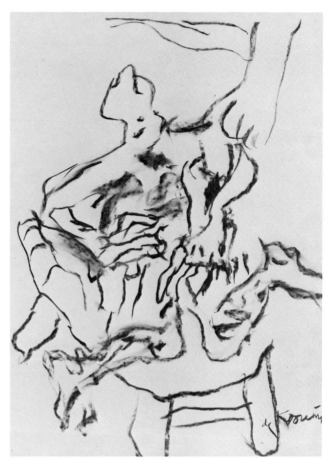

90
Woman, 1966
Charcoal on paper
24 x 18⅝″
Andrew Crispo Gallery, Inc., New York

91
*Seated Figure, c. 1966
Charcoal on paper
41 x 29¼″
Private collection

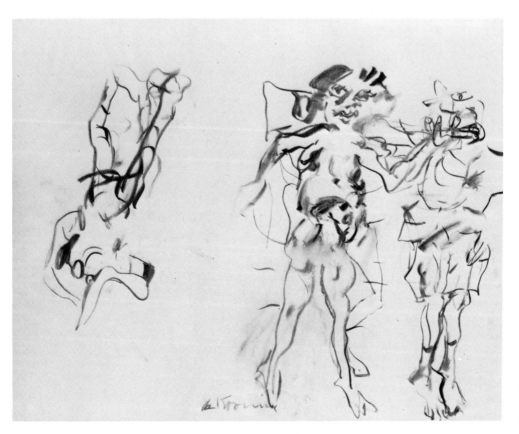

92
Untitled, 1967
Charcoal on paper
18⅝ x 23¾″
Collection of Susan Brockman

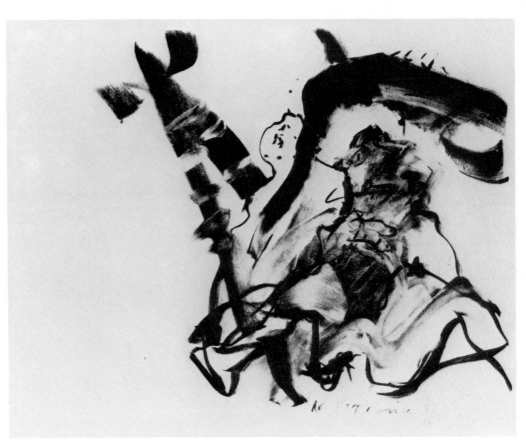

93
Untitled (Figures in Landscape), c. 1966-67

Charcoal on paper
18¾ x 24″
Private collection

94 ▽
Untitled (Figures in Landscape), 1967

Charcoal on paper
18⅝ x 23¾″
Collection of Susan Brockman

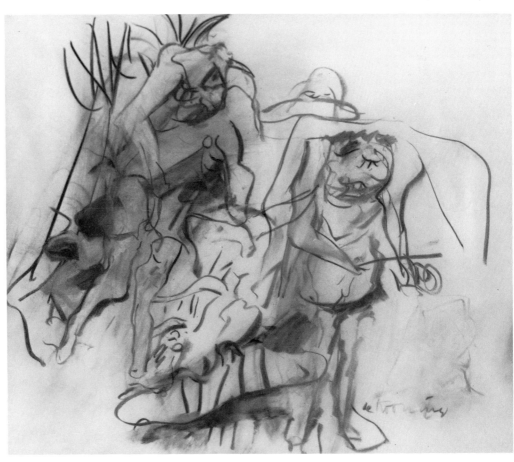

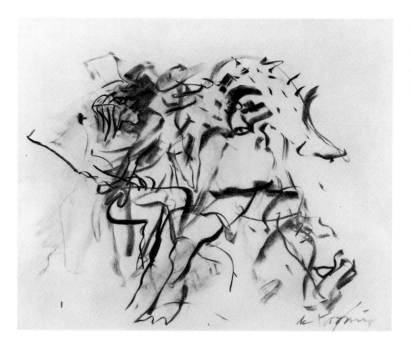

95
Untitled (Woman), c. 1967
Charcoal on tracing paper
24 x 18¾″
Private collection

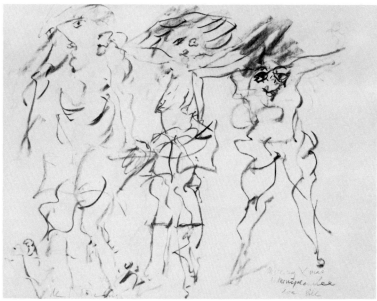

96
Untitled, 1968
Charcoal on paper
17½ x 23″
Collection of Mr. and Mrs. Lee V. Eastman

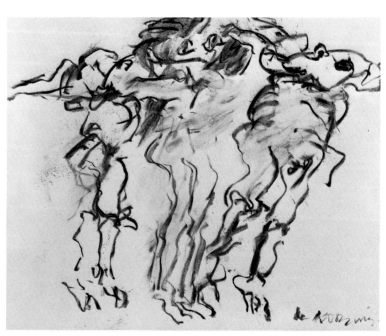

97
Three Figures, 1968
Charcoal on paper
19 x 24″
Collection of Linda Loving and Richard Aaronson

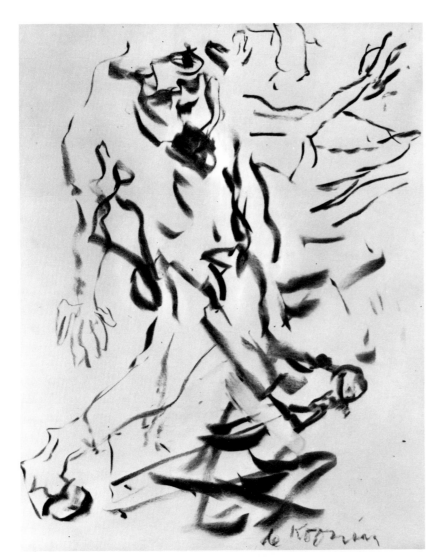

98
Untitled, 1968
Charcoal on paper
24 x 19"
Xavier Fourcade, Inc., New York

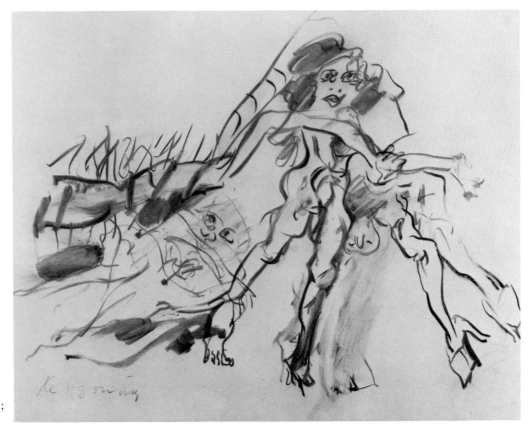

99
Untitled, 1968
Charcoal on paper
18¾ x 24"
Walker Art Center, Minneapolis;
Art Center Acquisition Fund

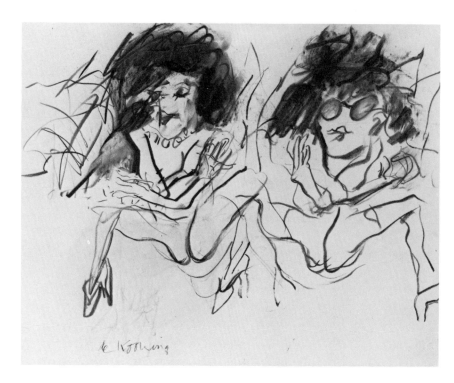

100
Untitled, 1968
Charcoal on paper
19 x 24"
Stedelijk Museum, Amsterdam

101
Untitled, 1969
Charcoal on paper
24 x 18¾"
Collection of Mr. and Mrs. Richard Selle

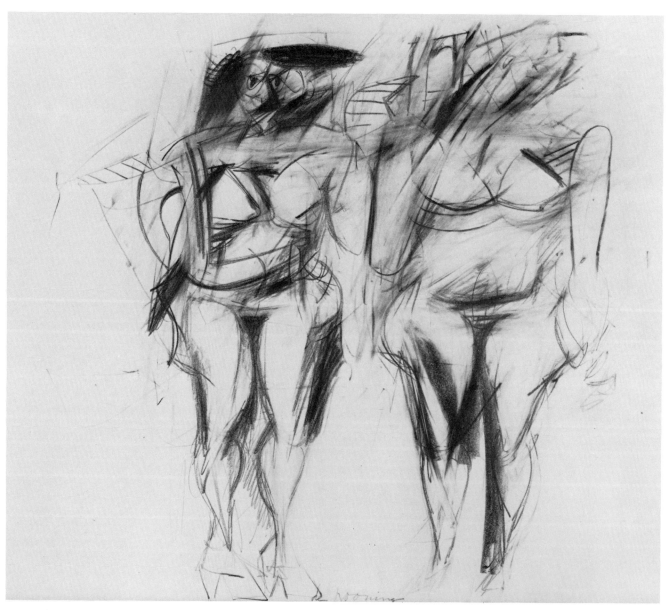

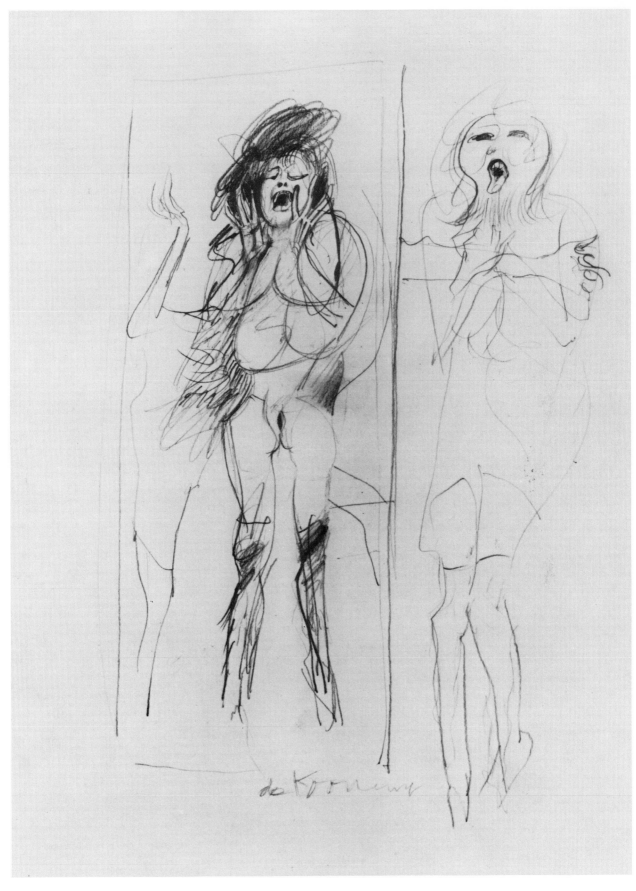

102

Screaming Girls *or* Untitled, c. 1967-68

Pencil on paper
18 x 12″
Private collection

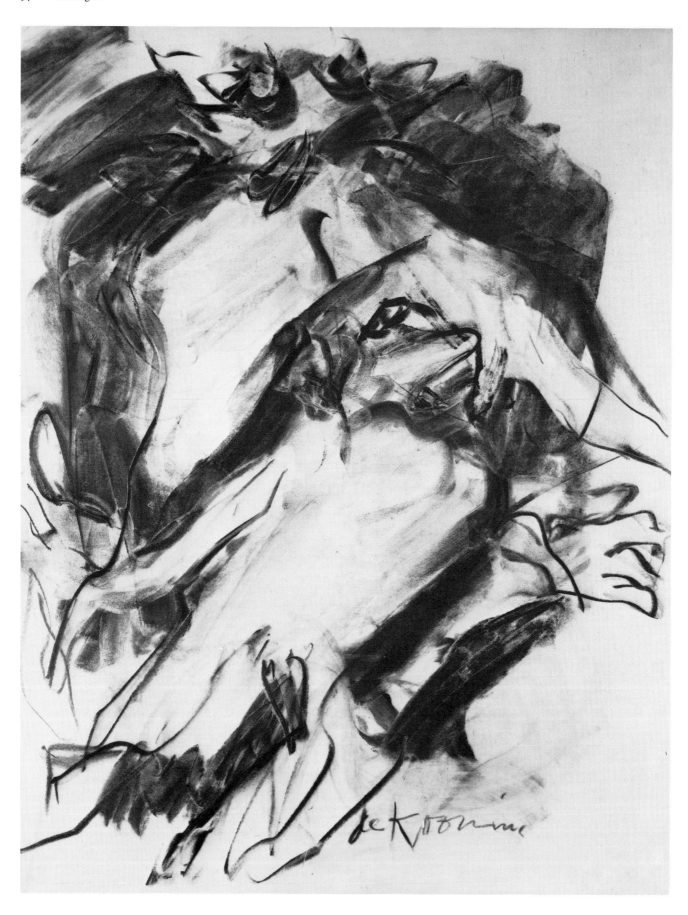

103

Untitled (Woman and Child), c. 1968

Charcoal on tracing paper
18¾ x 24″
Collection of Mr. and Mrs. Stanley O. Beren

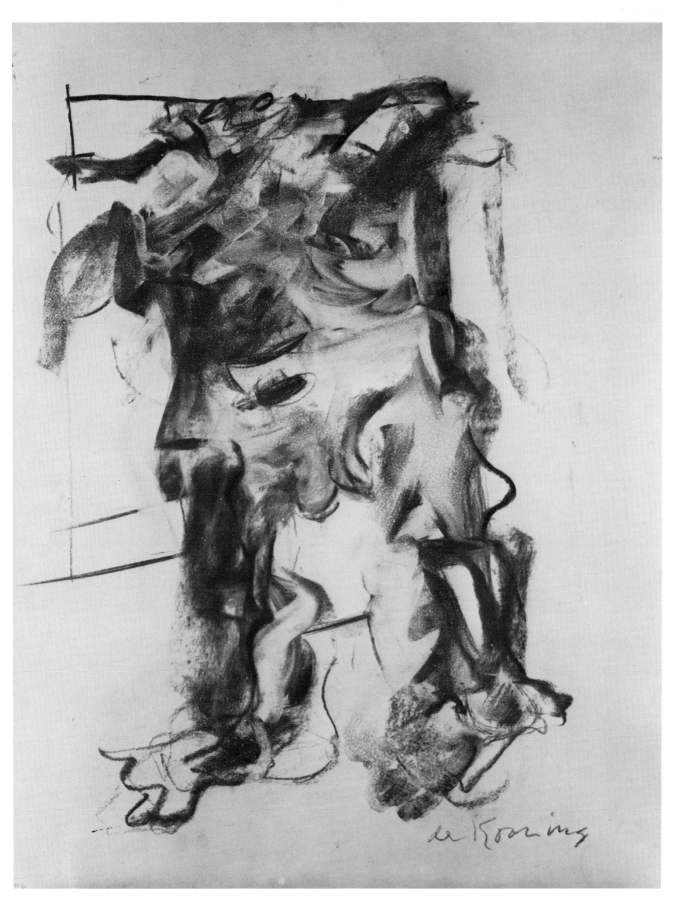

104
*Walking Figure, c. 1968
Charcoal on paper
23¾ x 18¾"
Private collection

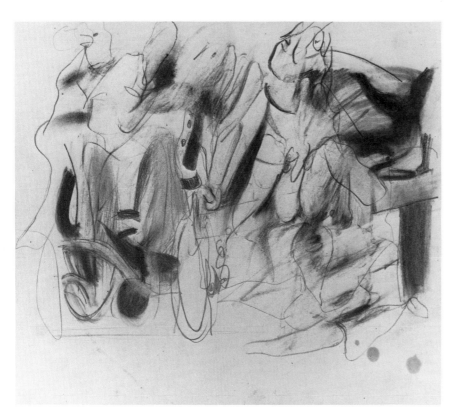

105
Figures with Bicycle, c. 1969
Pencil on paper
11½ x 13¼"
Xavier Fourcade, Inc., New York

106
*Untitled, 1969
Charcoal on paper
18¾ x 24"
Private collection

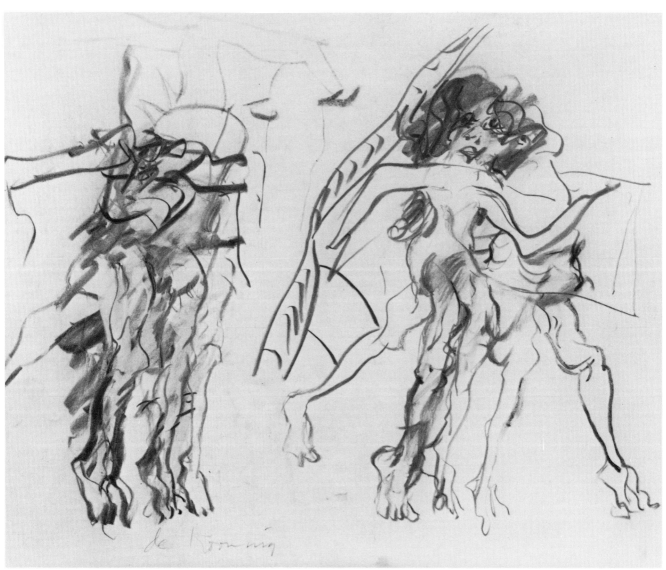

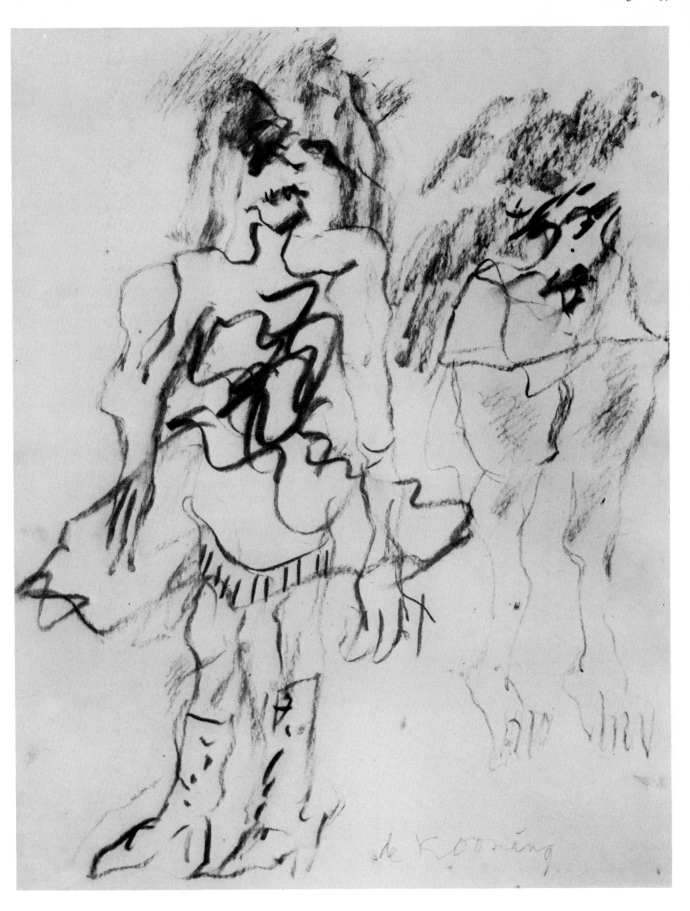

107
Untitled (Two Figures), 1971
Charcoal on paper
14⅛ x 11¼"
Collection of Emilie S. Kilgore

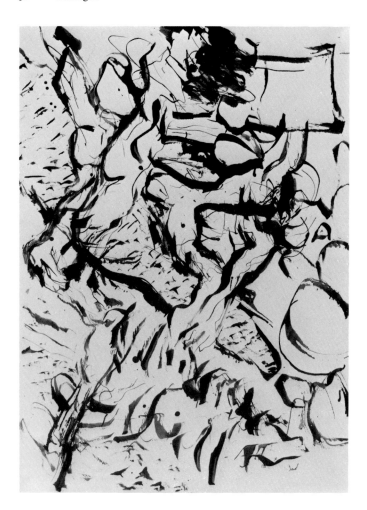

108

Untitled (Spoleto), c. 1969-70

Ink on paper
26 x 18⅞"
Xavier Fourcade, Inc., New York

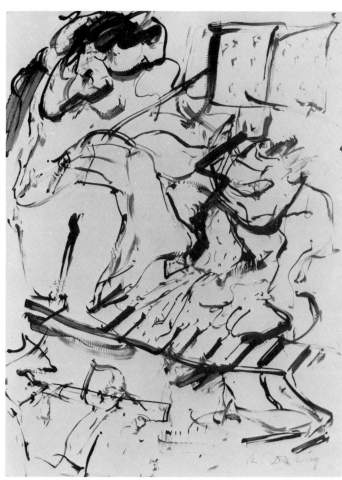

109

Untitled (Spoleto), c. 1969-70

Ink on paper
26 x 18⅞"
Xavier Fourcade, Inc., New York

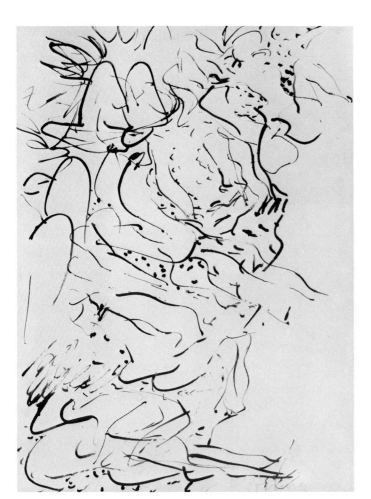

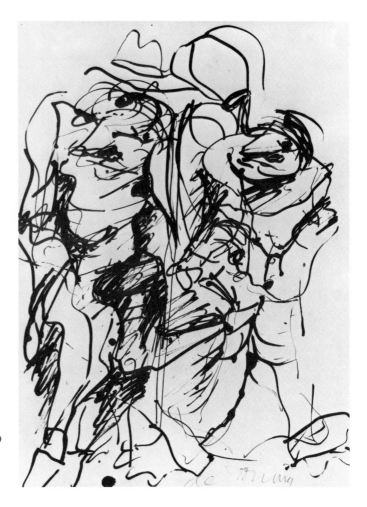

110
Untitled (Spoleto after Bruegel), c. 1969-70
Ink on paper
26 x 18⅞"
Xavier Fourcade, Inc., New York

111
Untitled (Spoleto), 1970
Ink on paper
26 x 18⅞"
Private collection

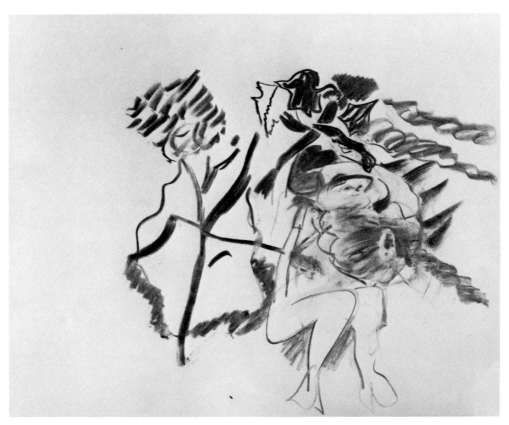

112
Untitled, c. 1975
Charcoal on paper
19½ x 24¾"
Xavier Fourcade, Inc., New York

113
Untitled, c. 1975
Charcoal on paper
19 x 24½"
Xavier Fourcade, Inc., New York

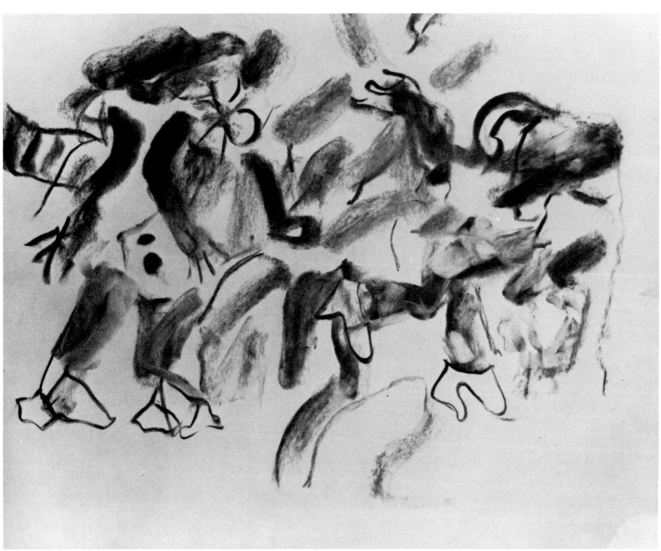

114
*Untitled, c. 1975-80
Pencil on paper
14 x 11"
Collection of Mrs. Berthe Kolin

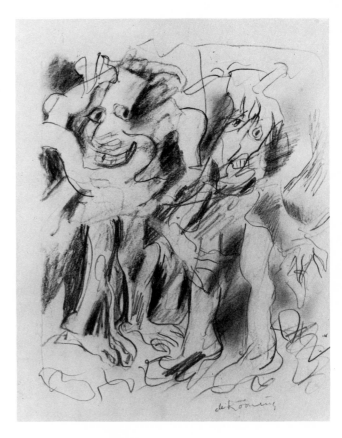

115
Untitled, c. 1975
Charcoal on paper
19⅛ x 24¼"
Xavier Fourcade, Inc., New York

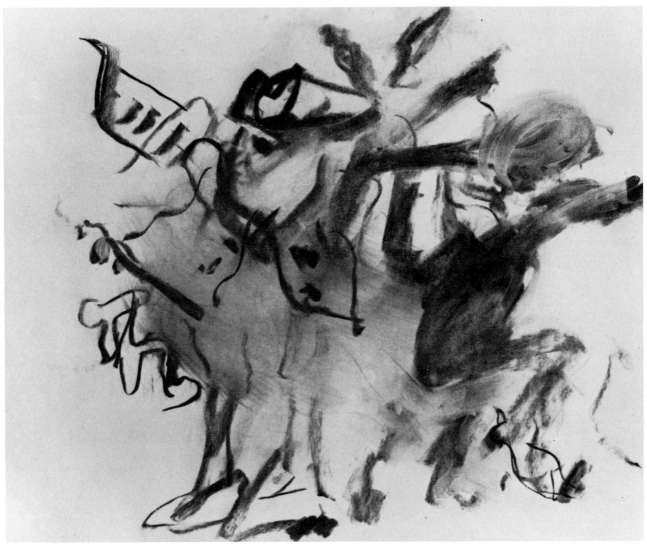

116
Untitled, c. 1975-80
Ink on paper
23¾ x 18¾"
Xavier Fourcade, Inc., New York

118 ▷
Untitled, c. 1975-80
Charcoal on paper
11 x 8½"
Xavier Fourcade, Inc., New York

117
Untitled, c. 1975
Oil on paper
18 x 24"
Xavier Fourcade, Inc., New York

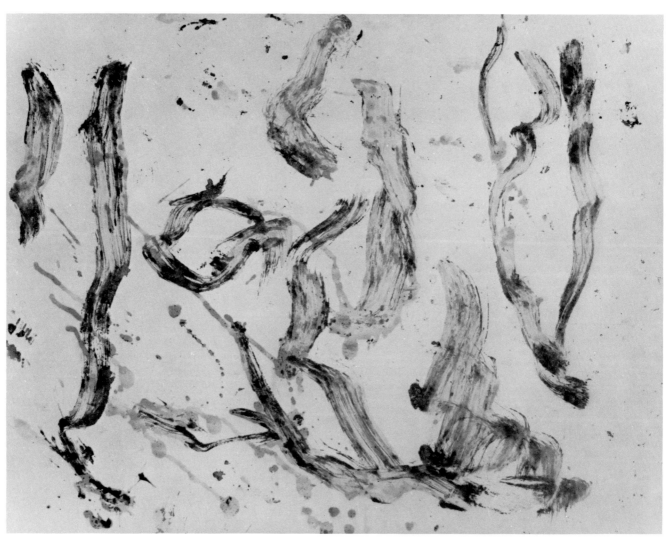

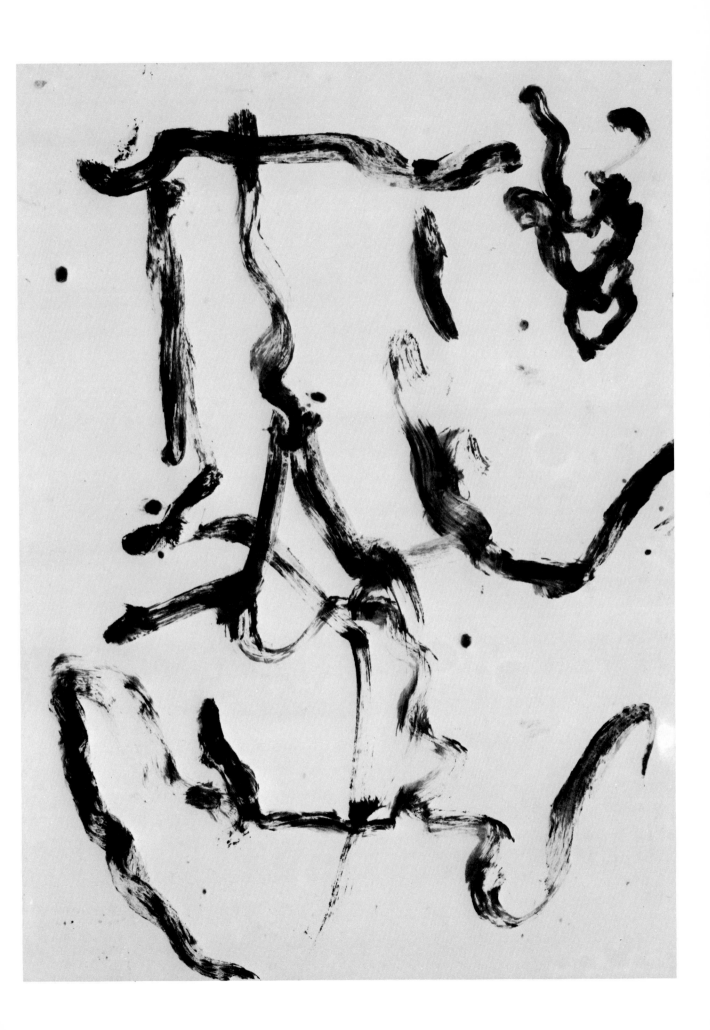

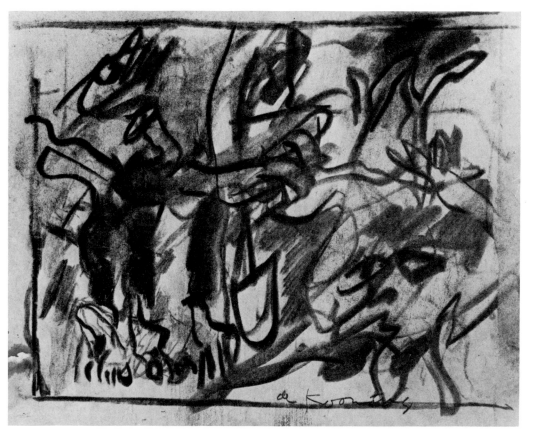

121 ▷
Untitled, c. 1975-80
Charcoal on paper
8 x 10″
Xavier Fourcade, Inc.,
New York

119
Untitled, c. 1975-80
Charcoal on paper
8½ x 11″
Xavier Fourcade, Inc., New York

120
Untitled, c. 1975-80
Charcoal on paper
8½ x 11″
Xavier Fourcade, Inc., New York

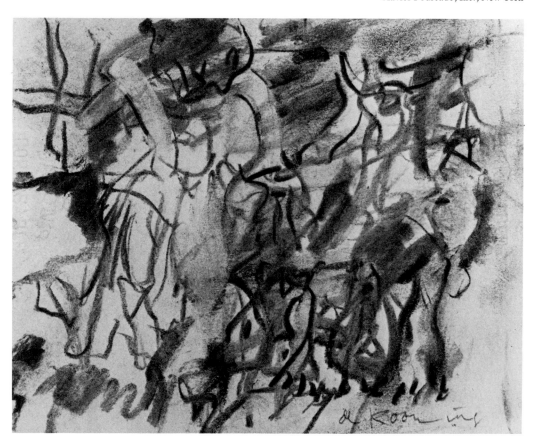

122 ▷
Untitled, c. 1975-80
Charcoal on paper
8½ x 11″
Xavier Fourcade, Inc.,
New York

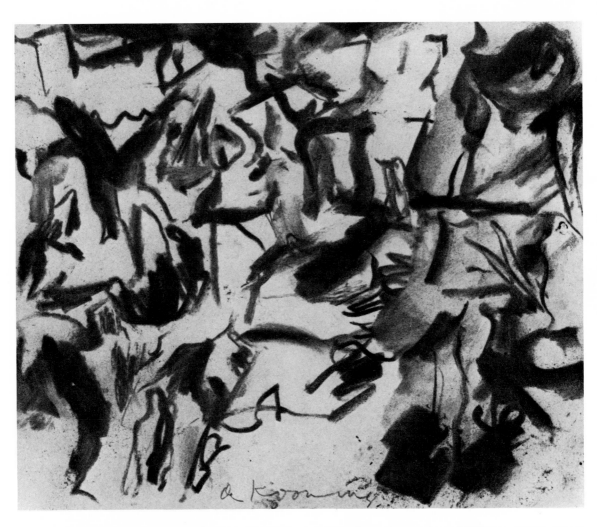

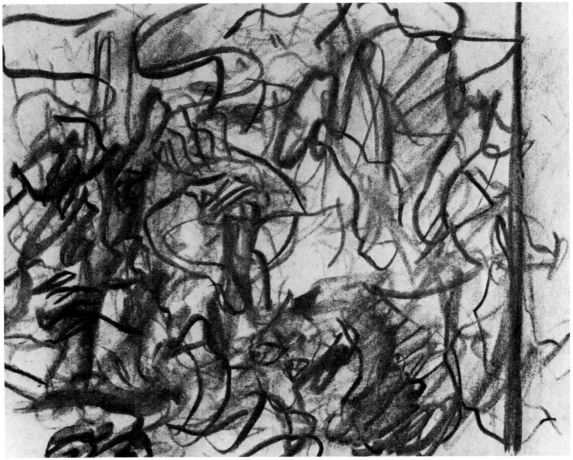

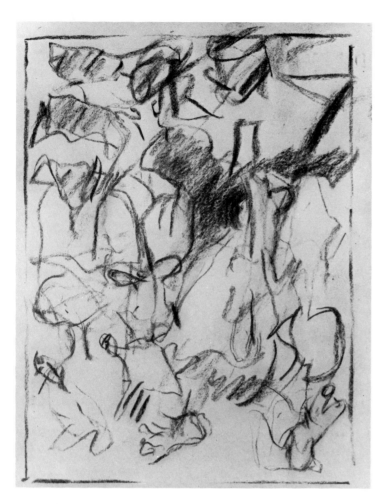

123
Untitled, c. 1975-80
Charcoal on paper
11 x 8½"
Xavier Fourcade, Inc., New York

124
Untitled, c. 1975-80
Charcoal on paper
11 x 8½"
Xavier Fourcade, Inc., New York

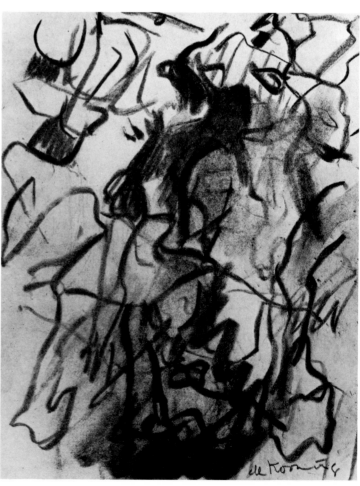

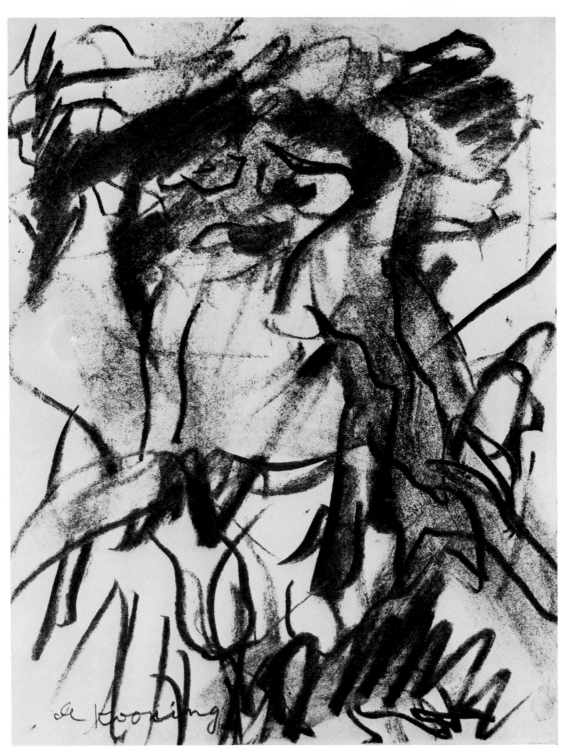

125
Untitled, c. 1980
Charcoal on paper
11 x 8½"
Xavier Fourcade, Inc., New York

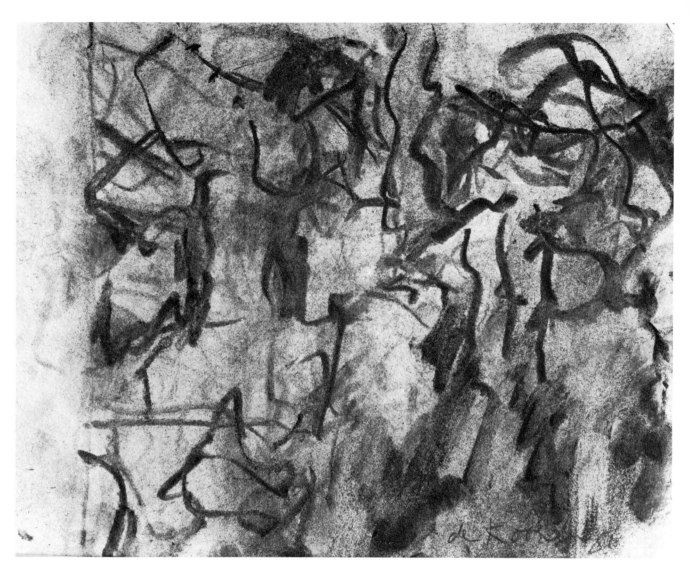

126
Untitled, c. 1975-80

Charcoal on paper
8½ x 11"
Xavier Fourcade, Inc., New York

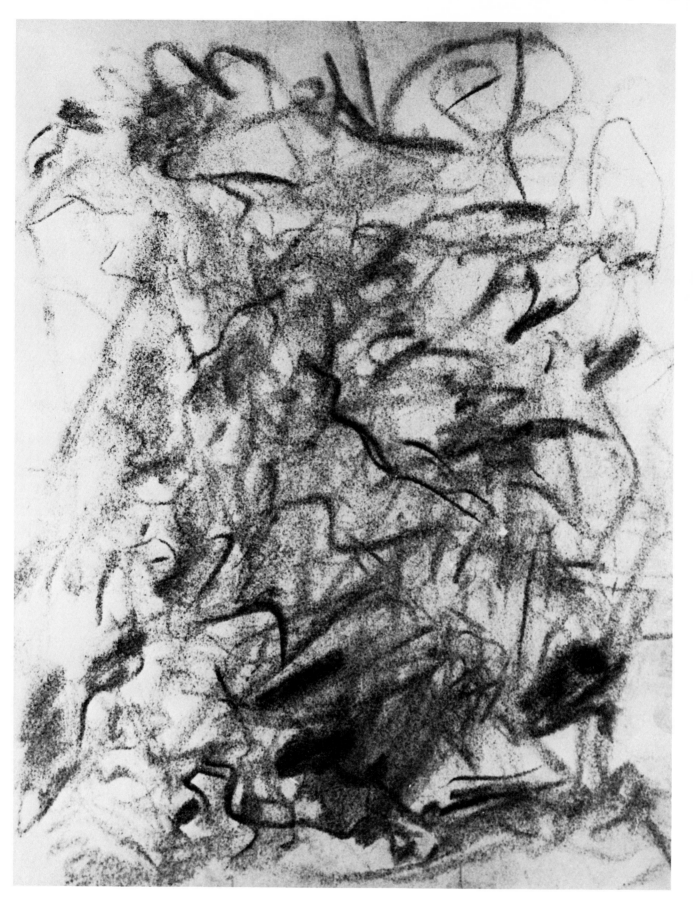

127
Untitled, c. 1980
Charcoal on paper
11 x 8½″
Xavier Fourcade, Inc., New York

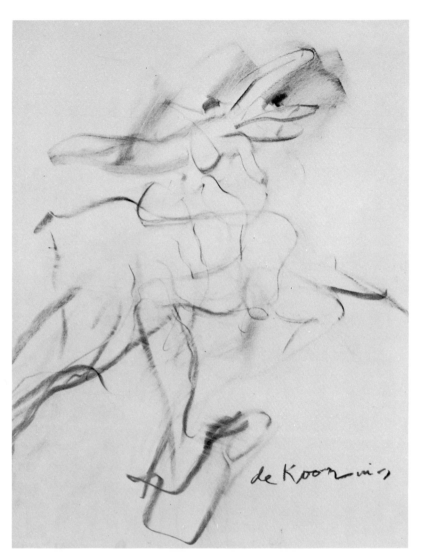

128
Untitled (*Susan Smith Blackburn Prize Drawing*), 1978
Charcoal on paper
24 x 18¾″
Collection of Emilie S. Kilgore

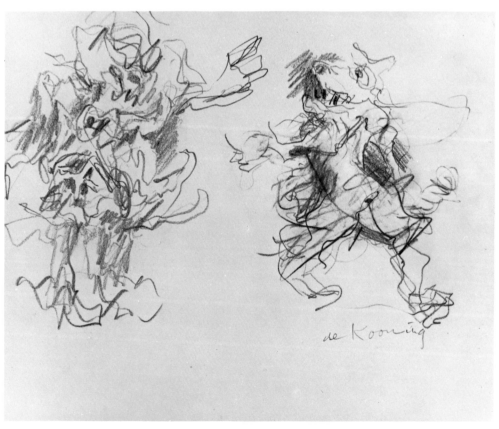

129
Untitled, c. 1975-80
Pencil on paper
11 x 14″
Xavier Fourcade, Inc., New York

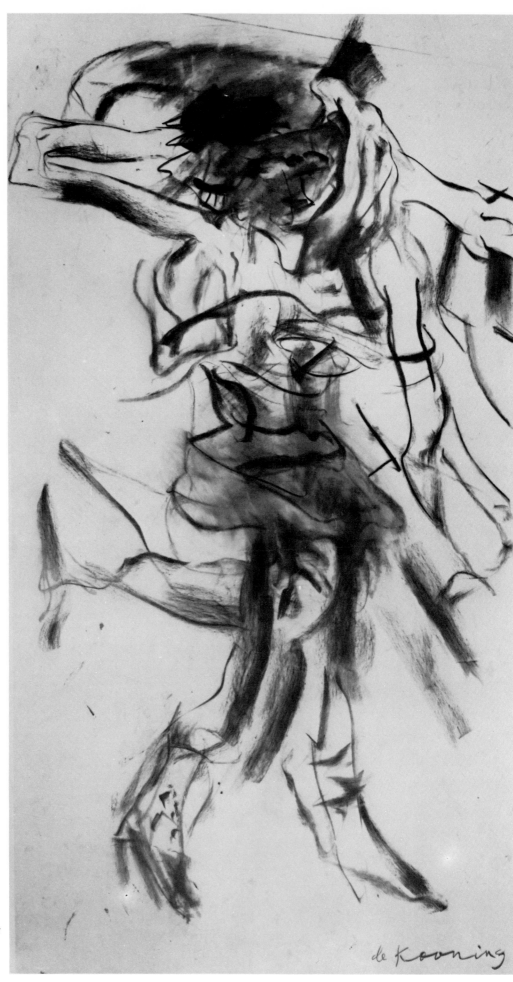

130
*Woman, 1979
Charcoal and traces of oil on paper
75¾×40″
Collection of Mr. and
Mrs. Fayez Sarofim

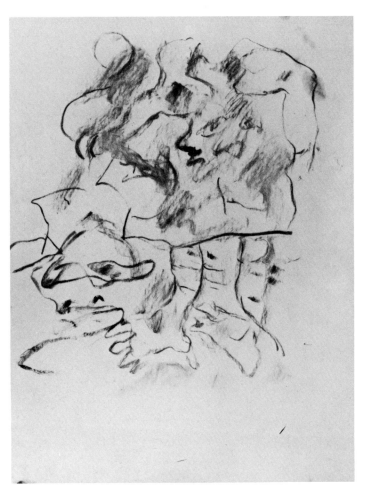

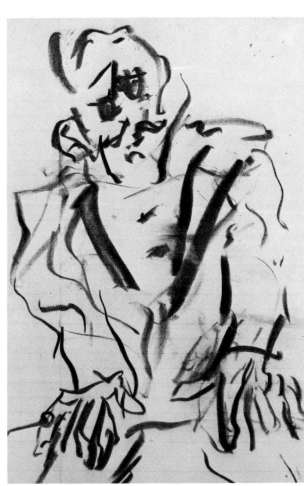

131
Untitled, c. 1980

Charcoal on paper
14¾ x 11¼"
Xavier Fourcade, Inc., New York

132
Untitled, c. 1980

Charcoal on paper
12½ x 8¼"
Xavier Fourcade, Inc., New York

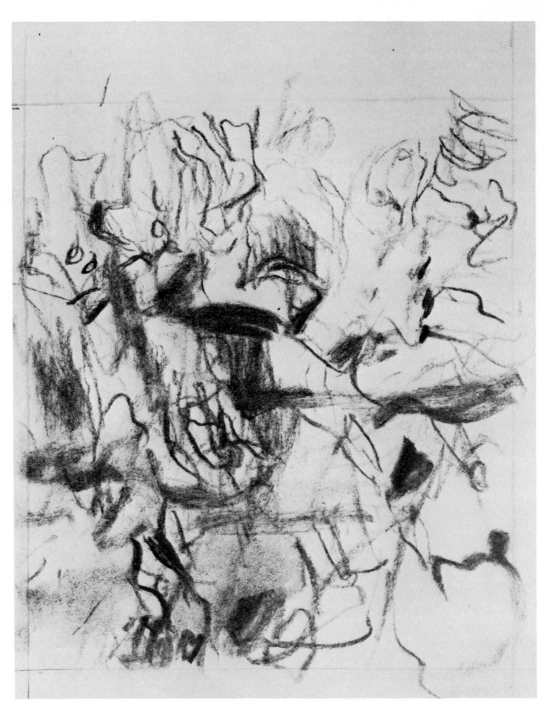

133
Untitled, c. 1980
Charcoal on paper
11 x 8½"
Xavier Fourcade, Inc., New York

Jörn Merkert

Stylelessness as Principle:
The Painting of Willem de Kooning

Flesh was the reason
why oil painting was invented.

de Kooning

Honoring Willem de Kooning with a fifty-year retrospective amounts to confronting a myth – more so in Europe than in America. He is the greatest living American painter, a man whose work has influenced generations of artists the world over. And now that a new violence in painting has been catapulted into the vanguard, de Kooning's achievement seems more brilliantly contemporary than ever.

That the last de Kooning retrospective seen in Europe took place about fifteen years ago[1]; that de Kooning's œuvre is almost unknown on the Continent; and that in France and Germany only two small shows of his work, in private galleries, have ever been mounted, is not accidental and requires explanation. These facts stand in sharp contrast to the international reputation which de Kooning has enjoyed for decades. The strange thing about this reputation, however, is that except for a very short period – from the late 1940s to the latter half of the 1950s – his work has stood as far as possible outside the various "ruling" vanguards, those streams of art that dominated the market and thus public opinion. This was due only in part to the rapidity with which fashions changed – leaving (in)credibility out of account for the moment; de Kooning himself was largely responsible for maintaining this gap.

Precisely because his work still cannot be subsumed under any style and he has invariably resisted even cautious attempts to classify it, de Kooning has advanced to the rank of an authority, exerting a tremendous influence on the most diverse contemporary developments. He has been represented, as an outsider, in almost every major thematic or group exhibition of recent years. His system was, and is, not to fit into any system. In a highly provocative way he thus has avoided maneuvering himself into any kind of anti-art position of permanent negation. His manner of refusal has been to hold, persistently and unswervingly, to a line of pictorial inventions which place him firmly in the tradition of great painting yet which will not brook stylistic classification.

Throughout his life de Kooning has been convinced that a painter runs a terrific risk when he attempts to find an inimitable style. Style is a claim to general validity, and this, sooner or later, is bound to stifle individual creativity. The formal repertoire of a style can easily turn into a cage for some smug and noncommittal world view. That is why de Kooning has always declined to adopt and use other artists' stylistic inventions, even to spur his own inventiveness when beginning a canvas. Nevertheless, his concern with style has been deep, whether with the labyrinths of twentieth-century art, the mas-

terful painting of an Ingres or El Greco or of the Italian Renaissance, or with the ideas of his contemporaries.

Rather than leading him to adopt others' procedures, his investigations into the art of all ages have helped him to trace underlying concepts, which he then redefines and transforms to suit his own purposes. This transformation has often been so thorough as to turn the idea in question inside out. When combined in the process of painting with some other, completely unrelated approach, something like a chemical change takes place, giving rise to a new, third quantity, a third form. The resulting image cannot be classified in terms of any style because this "third quantity" is never pure or unalloyed but shot through with impurities – inconsistencies, breaks, ambiguities. And it is precisely these unknowns which, in their multiple polarities, give rise to the force field out of which de Kooning's painting has developed to this day. Open-ended, unfinished imagery and the process of making which it reveals are the consequences of an approach that characterizes all of his work – and makes access to it so difficult for anyone who has been trained to spot traditional, recognized styles.

And yet during the late 1940s the artistic loner de Kooning played perhaps *the* decisive role in a development which put American art, for the first time, in the forefront internationally. By the time artists, critics and a gradually growing audience had found a stylistic label for this development – Abstract Expressionism – de Kooning had protested against this co-option of his work by producing imagery that was dialectically opposed to the new mainstream.

At the 1950 Venice Biennale he still could be acclaimed as one of the leading representatives of the new American painting. His black-and-white canvases (Cats. 164-167, 169, 170), already shown two years previously in New York at the Egan Gallery, were the focus of a critical appraisal which proclaimed the new American art to be the most advanced in the Western world. And his masterpiece, *Excavation* (Cat. 180), finished in spring 1950 just in time for the Biennale, the sum of fifteen years of work, won the Art Institute of Chicago's Logan Medal the next year. De Kooning was publicly recognized, with all honors, as the master of contemporary American painting. Yet in 1950 he had already begun a series of canvases which, when they were exhibited three years later, shocked the American art scene and even brought accusations of betrayal. In his Women paintings de Kooning had dared to apply the pictorial means which had led to such convincing, "style-shaping" abstractions, to a tabooed subject, – the human figure – and, what is more, to

expand and redefine those means in the process. This achievement, so typical of de Kooning, caused a scandal, the vociferousness of which the present-day observer may find hard to grasp; we shall come back to it later.

This turnabout, as it appeared to the broad public and to many critics, was, however, no "fashionable" counter-position. De Kooning had no need of tricky tactics to increase his visibility on the New York and international scenes. Nor was this the first sharp break in his artistic development; rather, it was one of many he had already made, and would continue to make, on a variety of levels. These breaks reflected a fundamental attitude toward life and art, an attitude that it is not too much to call ethical.

When de Kooning considers painting a "way of living," he not only sees external reality in a new light but his inner world experiences a metamorphosis. The means he uses to express himself will undergo continual change as well; and he will be free to take advantage of every possibility that presents itself. The distinctions between "abstract" and "realistic," between "objective" and "non-objective" art lose their validity. The only thing that counts is the act of painting itself; his senses keyed up, the artist fashions in the image an objective mirror of his subjective experience. An approach of this kind encourages working in series, which allows de Kooning to repeat and develop and gradually bring into focus his sensory and imaginative insights. It also means that no pictorial solution, once found, can claim to be conclusive. For every successful formulation there are countless other, as yet unrealized possibilities generated by the abundance of imagery in the external world. In this sense, the unfinished look of de Kooning's canvases, a result of his subjective approach, reflects not only in formal but in *substantial* terms the questionableness of any closed, hermetic image, of a visualization of some once-and-for-all objective truth.

In this flowing, open, seemingly fragmentary process of image-making we may also find an explanation for why his series, even in retrospect, refuse to fall into precisely bounded, neatly successive groups. The observer is forced to realize that in painting after painting the most contradictory solutions and formal configurations merge, interpenetrate like waves, and, above all, *depend* upon one another. One arises from the other; and the second flows back into the first before it breaks, lending it force and changing its configuration. Extreme and freely improvised abstraction may confront, sometimes in the same image, equally free and aggressive but joyfully unrestrained figuration; the pictorial means, procedures, and formal inventions grow similar to the point of identity, become interchangeable, yet are charged with ever different meaning. De Kooning's fundamental tenet in all this is to recognize no rules. On principle he mistrusts every pictorial solution as soon as it is found. That is why he continually and consciously brings into his working procedures elements of uncertainty on every level, in order to curb his own fluency – in order to invoke the spirit of risk, to wrestle with unknowns, and to release their image-creating power.

Here we have both the motive and the goal of de Kooning's art: to avoid becoming entangled in solutions that proclaim some clear truth beyond the pictorial order achieved. "The only certainty today," he said, "is that one must be self-conscious. The idea of order can only come from above. Order to me is to be ordered about and that is limitation."[2] Limits not only have to be avoided, they must be overcome, be declared invalid. Holding this stance, and holding to it tenaciously, has in itself been enough to make de Kooning a solitary artist; the loneliness that goes with it is an inherent condition of his art. Nor is this contradicted by the fact that during the latter half of the 1950s his was one of the most significant contributions to American Action Painting, a contribution affirmed by worldwide acclaim. De Kooning has never been impressed by collective applause and has surprised and frequently even angered or horrified his admirers and friends with his new work – he refuses to be pinned down.

Paul Klee, in his famous speech "On Modern Art," given at Jena in 1924, complained that "No people support us." This is still a widespread longing among artists – to bridge the gap between art and society. But de Kooning had no such aspiration; he never entertained it. Being in agreement with the many would only have limited and curtailed his artistic potentialities.

Despite years of poverty, he experienced existential despair only when confronting the image. He met financial need by taking odd jobs. Nor could success and public acceptance penetrate the loneliness of his experience, which only a dialogue with the image was able to dispell.

Because de Kooning takes comprehensive freedom on all levels of image-making as his right, it may seem contradictory that he radically limits his subject matter to figures and landscapes. These themes, however, overlap and intertwine just as thoroughly as the means he has developed to treat them; since in a de Kooning painting nothing is unambiguous, the human body may metamorphose into an abstract landscape, or an evanescent experience of nature may be given concrete, physical presence. Sometimes an interpenetration takes place and, in an exasperating ambiguous dissolution, man and nature become *one* in the play of form.

Going more deeply into the questions, problems, and themes already broached is bound to lead to the realization that all of them have continually cropped up, in changing guises, throughout the fifty-year development of de Kooning's art. The "logical" basis on which this complex œuvre was built, the observer begins to perceive, is nothing less than a unification of opposites.

A chronological arrangement of the paintings can be a helpful instrument, particularly in the interest of a comprehensive view. It helps us see that the always changing, always repeated subjects and treatments are part of a many-chambered imaginative edifice, a system of thought which Thomas Hess, in his catalogue to the 1968-69 retrospective, attempted for the first time to organize in thematic, pictorial and chronological terms.[3]

Search for a Lost Identity: The Human Image I

The human figure has been one of de Kooning's prime concerns throughout five decades of work. The figure may sometimes disappear abruptly and unexpectedly, but it crops up again with equal suddenness a short time later, as if it had never been absent. Often, de Kooning's involvement with the human image has run parallel to work on what appear to be purely abstract pictorial problems. His depictions have been almost exclusively of women, and he has never painted male and female figures together. Women appear in his images singly, sometimes in pairs, and more rarely in groups, but they are

never involved in a common activity; they stand next to one another, isolated, like versions of one image slightly refracted by shifts in formal emphasis. Only once has de Kooning taken the male portrait as a subject, in his 1935-40 series of Men (Cats. 136, 138-140, 144, 146, 148), and even these were soon joined by a series of Women done at roughly the same period, in which he began to treat the figure in a very different manner, both in terms of color and form.

When de Kooning began his series of Men he had just decided to make art his primary occupation. Up to then he had been earning his living at odd jobs and painting during his spare time. In 1935, the W.P.A. Federal Art Project had brought him a few commissions, only one of which was realized, but which gave him modest financial independence and enabled him, for the first time since he had come to the United States, to devote himself wholly to his art.[4] When, a year or so later, he was struck off the Project's lists because he was not an American citizen, he resumed his odd jobs; but the experience had changed him from a workingman who painted on the side to a painter who worked on the side to stay alive. Though this did not alter his situation materially, it was psychologically an extremely important decision.[5]

The paintings de Kooning did at the time show male figures, standing or seated before flat backgrounds which contain only rare and uncertain references to the space that surrounds them. Their torsos are usually bare, or sparsely garbed, in working clothes that seem a few sizes too large, threadbare trousers and baggy suits hanging loosely from their bodies. The folds have been given sculptural emphasis here and there by delicate glazes applied layer on layer. As if cut out of some different material, these figures are silhouetted against undefined background planes which are sometimes relieved by vaguely geometric shapes – shapes that may suggest such objects as mirrors, windows, tables or tablecloths, a newspaper lying crumpled on the floor, jugs, lamps, chairs, or fireplaces. Yet these unassuming things have been described so allusively, defined so sparingly and reduced to such basic forms, rendered in a "cutout" manner, that they too become purely "abstract" elements in the planar organization of the image. Thus the figures, modeled to evoke depth, exist in a purely autonomous pictorial "space" that seems related to the faceted and inter-locking planes of Cubism. Harold Rosenberg pointed out that de Kooning here combined the eloquent graphic contours of Ingres' figures with the abstractly constructed pictorial space of Cubism, thus bringing together two styles, divorced from their historical contexts.[6]

This approach to image-making and style is very much akin to collage. It determines not only the structure of the image as a whole but the depiction of both space and the objects within it. The figures, too, have been enlisted in the service of abstraction, for instance, when de Kooning uses both the descriptive and the formal possibilities offered by draped trouser folds to construct a leg in terms of a seemingly non-objective formal organization (e.g., Cat. 139). The unclothed parts of the body also have been transformed into planar, abstracted forms which nonetheless remain organically vital and descriptive.

This ambiguity between objective description and abstract structure has been kept purposefully unresolved, and only rarely do the extremes fully coincide. In the painting just referred to, for example, there is a bottle shape incised on the background, a linear contour; if it were not for the fact that it partly overlaps an undefined ochre-colored "wall" and a red rectangle

which, in context, reads as a table seen from above, this shape would not be intelligible as a bottle containing a little red wine.

Another characteristic of these paintings is the indefiniteness of the figures' surroundings, lending an aura of uncertainty to the space in which they exist. And because the figures are frequently cut off by the canvas edge, and are only partially contoured and modeled, they too seem to be assembled out of separate, disparate elements. This is in keeping with the collage-like construction of the image as a whole. The spatial uncertainty of these images, formulated in precise pictorial terms, is shared by the figures, which suggests an interpretation of their content: by constructing a vague, fragile-looking space around them, de Kooning reflects the insecurity of the human beings he portrays.

Another aspect of de Kooning's work substantiates the view that he indeed describes the uncertainty and fragility of the human situation. It is a further example of his use of the collage principle, both "realistically" and as a point of departure for abstract formal inventions that operate as autonomous elements in the pictorial structure. I refer to *Glazier* (c. 1940; Cat. 143), with its decanter on a table before a tilted mirror. Only a section of this object is reflected in the mirror, an abstract, curved form without meaning in itself, but which, having its basis in the real object, indeed "stands for" something (Fig. 1). And though the background which is in the mirror has been integrated into the pictorial organism as an *abstract* rectangular color field, on the level of *content* it simultaneously signifies that portion of the space outside the painting which has been integrated into its intrinsic space – perhaps the very space which we, the spectators, occupy.

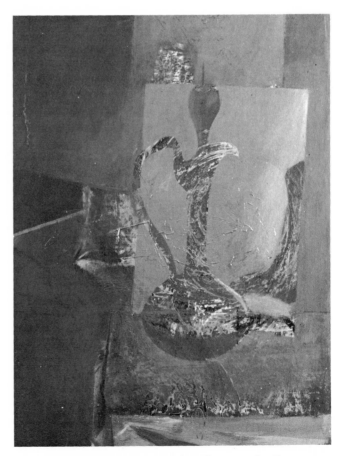

Fig. 1. Willem de Kooning, *Glazier* (detail), c. 1940. See Cat. 143.

This insubstantiality and ambiguity of both pictorial forms and the content they transmit suggest a view of the human situation which finds immediate corroboration in the social realities of the day – these paintings were done during the Great Depression. Unlike the huge frescoes in official buildings which the W.P.A. sponsored, de Kooning's paintings do not give us idealized, heroic workers confronting the adversities of the age with fight in their eyes and hope in their hearts. His Men paintings show individuals, isolated, crushed by loneliness and the nagging feeling of inner vacancy and uselessness. The expressive pictorial means de Kooning uses are, again, a fragmented and self-contradictory formal structure, as well as a range of subdued, all-pervading color that almost seems to console in its melancholy and lyrical minor key. Yet the spectator learns little about these men as individuals; their images are not portraits, nor can they be read by inference as self-portraits. It is precisely this anonymity that makes them forceful and generally valid analogies for the way each person, in his own inner world, existentially experiences the outside world and its compulsions.

With the series of Women, begun as early as 1938 (Cats. 145, 149, 151, 153, 155), a more relaxed and planar articulation of the overall surface, together with a bright, sometimes joyous and often riotous color range with violent contrasts, became the predominant expressive mode. The pictorial problem treated in the Men series shifted in focus and the solutions sharpened – the seated women were given in extreme close-up, filling almost the entire picture plane, with little regard for the laws of proportion. The immediacy of these figures alone propels them out to the foremost plane; they seem to obstruct the space they occupy. Built up of expansive shapes, often contoured in broad rapid flourishes, these are figures composed of parts that seem to live independent lives, creating crazy shifts in pictorial anatomy. Yet these organically vital "collages," dynamic as they may be, still possess a solid framework, a scaffolding that extends to the rest of the image – combinations of large, bright-colored rectangles usually framed in contrasting outline. The objective associations these forms evoke are only vague and arbitrary – a picture on the wall, perhaps, or a window frame, a chair back, door, or table – and they seem interchangeable.

Harsh form contrasts bring about a flickering disquiet without actually suggesting a third dimension. It is precisely these transitionless confrontations which work against the autonomous, space-evoking force of the colors, with the result that all the elements of the image seem locked, under enormous tension, in a *single* plane. Nor is this effect lessened by the violent movement of the brushwork, thanks to the interaction of color. In other words, it is not only the contrasting and interlocking of organic and geometric graphic structures which push the figurative subject toward abstraction; the transitionless, harsh impingement of form on form in endless combinations likewise contributes to the impression of strict planarity. But above all, it is the paint itself which raises this classic, realist theme to the level of abstraction: the paint handling and colors have been divorced totally from the need to designate real things. A woman's hair can be as pink as sections of the wall or the collar of her dress; the rectangular shape next to her can be green, but so can the shadow on her arm, or her enormous breasts, which with a few rapid curved strokes have been made to billow out of the amorphous orange surface that represents her dress. This very orange may glow again in the flat background plane adjacent to her.

Treating the image as an autonomous object and constructing it according to the laws of planarity leads to an identity of the subject – woman – with the surrounding space. The result is to de-identify space, to render the objective associations of abstract forms unclear and multi-leveled. The green rectangle is really nothing but a rectangle and hence pictorially contingent; yet it also designates some object. With the meaning oscillating in this manner, it is no longer possible to say whether the figure is seated in an interior or outdoors. Since the space in the pictures is not defined, or is defined very ambiguously, the Women images, too – though in a different way from the Men series – reveal a concern with the human situation in crisis.

The individual insecurity to which this crisis gives rise is visualized in both cycles by an ambiguity of pictorial means, and the crisis is answered – not solved – by a retreat into self, into personal isolation. Yet in the pictorial relation between human being and environment in these images, we sense the possibility that someday each individual may be able to determine and shape his own environment. Here, a utopian aspect of de Kooning's art filters through, an attitude which may well reflect his fundamental statement that "the only certainty today is that one must be self-conscious." This view finds its pictorial counterpart in the fact that the fragmented external world and the image of man, disjointed into ever more abstract forms, can be *reintegrated* by the process of painted collage. Pictorial means thus reflect not only the specific attitude of the individual toward the world but can be understood as well as a reflection of a society's condition.

In contrast to the Men series, the expressive mode in the Women is one of love, lust, joy of life, and sensual desire. That in 1938 de Kooning met the painter Elaine Fried, whom he was to marry in 1943, certainly has significance here, though of course it offers only one key to the meaning of the series. Another might be the artist's memories of the narrow streets of Amsterdam and the red lanterns outside the brothels where gaudily made-up girls sat in garish interiors, bare-breasted behind windows, or stood in open doors, or half out in the street, hooking for love. It would not be surprising if de Kooning had combined and superimposed not only forms and styles but diverse levels of content as well – eros and lust, beauty, longing, banal sex, and their sublimations in a *single* image. If so, the complexity and contradictions of his images in formal terms are reflected as well in content.

Painting as a Way of Living

Different as their modes of expression are, the two early cycles of figurative paintings have one key trait in common: a transformation of figure, objects, and pictorial space into the *single* formal language of distortion, disjunction and, finally, reintegration. The space in which the figures exist remains indeterminate because the image offers no information about it – or only ambiguous, random, or contradictory information. This indefinite quality of the external world, its insecurity, we have called a reflection of the insecurity within – a crisis of identity in which we can recognize both a crisis of the individual and of society.

The non-perspectival vision in de Kooning's collage-like images, however, is not merely a vision that has lost sight of the whole; beyond that, it creates a positive bond to the outside world by reassembling the fragments of reality and thus rede-

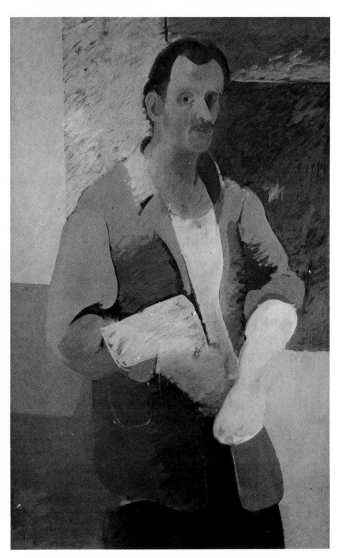

Fig. 2. Arshile Gorky, *Self-Portrait*. c. 1937. Private collection.

The External World as Inner World: Abstraction I

This insight and the experience de Kooning gained through his early figurative canvases logically led him to greater and greater abstraction; or, more precisely, led him back to abstraction. He had worked in a non-objective manner before, though even in the few surviving early abstractions (Cats. 134, 135, 137, 141, 142, 147, 154) an ambiguity is evident, his typical oscillation between autonomous abstract form and objective figuration. These works were painted before and contemporaneously with the early figures of Men, during the period when de Kooning shared a studio with his friend Arshile Gorky.

Gorky's *Self-Portrait* (c. 1937; Fig. 2) bears a more than superficial resemblance to de Kooning's Men, though it goes farther in an attempt to interweave figure and ground; and his *Organization* (c. 1936; Fig. 3) is almost identical in terms of formal articulation, for example, to de Kooning's *Untitled* of 1937 (Cat. 134). Yet while the objective references in Gorky's canvases remain almost indecipherable, associations crop up in de Kooning's, shadowy but there – suggestions of a shallow stage, for instance, populated by surreal-abstract, silhouette-like figurines; or eyes, breasts, or even trouser buttons called to mind by spots of color on larger fields. These are mere impressions, however, and they immediately fade, leaving configurations which sullenly resist the interpreting mind. Very probably, these images were inspired less by Gorky than by Picasso, perhaps by his *The Studio* of 1927-28 (Fig. 4), in the Museum of Modern Art, New York, since 1935, a collection de Kooning and his friends visited as regularly as they did the Metropolitan Museum.[8]

Yet while Picasso attached his subjects – abstracted but at least to today's eyes intelligible even to details – to a linear framework, this element appears only marginally in de Kooning's work. More in evidence are organically rounded fields juxtaposed in tense but unrelated and hence fragmented opposition to geometric elements. As with Picasso, however, everything is kept strictly to a *single* plane. But de Kooning's color fields appear not only "more abstract"; they seem to be set out randomly, as if they had been taken from another artist's for-

fining it. This redefinition is possible only to an eye and mind which see the miraculous and astonishing even in the most banal appearances; which create unexpected connections between incoherent things; and which even on a subconscious, emotional level feel the realms of imagination, experience, and work to be inseparably interrelated.

This is a complex way of appropriating reality, and it contains endless possibilities for variation. Its visual expression is the unfinished, open-ended look of de Kooning's images, which also explains why he produces them in series. What is full of contradictions, after all, is reality itself; absolutely clear situations in life are rare, and as often as not they turn out to conceal some unexpected pitfall.

What an artist must develop to meet this complexity is a formal language equally complex and comprehensive, a language that contains everything and with which everything can be described. It must be intrinsically contradictory and ambiguous so as not to falsify the way we experience reality. Behind this kind of approach to the external world lies the notion that painting is not only a way to describe reality but that the act of painting itself can be an opportunity to define one's own position within it – the notion that art can be an instrument of self-realization: "Painting is a way of living today, a style of living so to speak. That is where the form of it lies."[7]

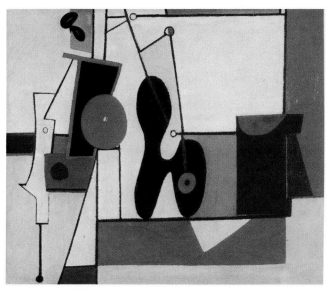

FIG. 3. Arshile Gorky, *Organization*, c. 1936. National Gallery of Art, Washington, D. C.

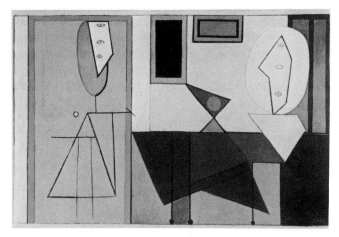

Fig. 4. Pablo Picasso, *The Studio,* 1927-28. The Museum of Modern
Art, New York; Gift of Walter P. Chrysler, Jr.

mal repertoire rather than being developed from objective
models.

Pink Landscape of c.1938 (Cat. 137), on the other hand,
consists only of broad, juxtaposed fields of anonymous, gently
rounded shapes which, despite the referential title, initially
seem hermetic, nothing more than independent parts of an
autonomous image. And yet here, too, a pure meditation in
color and form suggests fleeting interpretations – the easy,
upcurving, honey-yellow shapes rest like the hulls of boats
softly rocking on the water; the color fields suspended above
them recall sails; and the circle, finally, becomes a pale moon.

It is useful to consider a painting by another artist in which
similar references arise from an unhampered play of purely
non-objective form – Paul Klee's *The Ships' Departure* of 1927
(Fig. 5) – though no direct connections are suggested. It is not
mere speculation to attach realistic significance to de Kooning's
early abstractions; Harold Rosenberg once described another
work, *Untitled* of c. 1934 (Fig. 6), as ". . . made up of shapes
suggesting portholes and decks, with sea and sky in the back-
ground, and in the right foreground a masked head looking
inward to land."[9] Rosenberg sees this painting as reflecting de
Kooning's memories of his arrival in the United States after a
long ocean crossing eight years before.

Fig. 5. Paul Klee, *The Ships' Departure,* 1927. Staatliche Museen
Preußischer Kulturbesitz, Nationalgalerie, Berlin.

In the abstractions, executed contemporaneously with the
early Women, de Kooning employed a comparably garish
palette full of harsh contrasts. The previously clear ordering of
the elements gave way to a vital interlocking and superimposi-
tion of agitated curving forms which look as if they had been
taken from certain passages in the Women paintings (cf. Cats.
145, 147, 149, 150, 151, 153-156).

This coincidence reveals the extent to which de Kooning
began to charge his formal repertoire with psychological signifi-
cance, a tendency already apparent in his earlier work, but now
pushed farther: he developed a pictorial syntax that enabled
him to transform the picture plane into a stage on which to play
out the drama of his inner life without concealment and, sig-
nificantly, without losing touch with the sense-experienced
external world. In so doing he moved into the realm of psychic
improvisation as explored by the Surrealists. The pictorial pro-
cedure here was *écriture automatique* – rapid, spontaneous,
uncensored transcription as a key to unlock the mythic world of
unconscious imagery.

This technique by itself, however, could not satisfy de Koon-
ing, because he knew that images formed in the subconscious
mind always reflect some conscious experience. So rather than
externalizing his inner life, he attempted to keep the painted
image open, as a field of confrontation between external reality
and the workings of his subconscious. On the one hand, then,
by adopting Surrealist methods he attempted to go beyond
traditional categories such as figurative composition with its
order and intelligibility; on the other hand, he wished to retain
what was best in classical approaches to painting.

One example of the complex interlocking of pictorial formu-
lations this effort produced is *Pink Angels* (Cat. 156). The title
of this painting alone is rife with tradition, romanticism, dou-
ble-edged irony, and erotic suggestion. The image consists of a
tangle of biomorphic shapes which dramatically overlap, touch
fleetingly, then pull back defensively only to interpenetrate
again in rapid, almost violent movement. These shapes, though
they may evoke arms, legs, and hips, are not actually depictions
of these things. In the Women such shapes had already
acquired an independent life, describing the subject only in
fragmentary conjunction. In *Pink Angels* the forms, though
arising from an encounter with the subject, are deployed as
autonomous abstract elements. In this context, it is interesting
that the negative shapes between the collage-like parts have
also begun to take on positive form. Nevertheless, the plasticity
of this image is not so much the result of the overlapping and
interlocking of its elements as of expressive movement brought
about by rapidity of execution. Every degree of relation is
there, from gentle touch to mutual embrace to energy-laden
deforming collision.

Though arrived at with the aid of psychic improvisation, *Pink
Angels,* unlike Surrealist images, does not depend solely on
uncontrolled and hence chaotic and random expressive means.
During the spontaneous process of image-making, de Kooning
continually goes back to the store of original forms he has filtered
out of the object in an attempt to find its essential form. His
abstract definitions retain the image of the thing seen while
simultaneously cutting free of it; rather than signifying an object
in the world they record emotions felt in front of it. It is *because*
they have been developed out of objective descriptions that they
are charged with significance, sensation, expression and "sense."
And they retain these pregnant expressive qualities even in cases
where they have been divorced from every "real" context.

Fig. 6. Willem de Kooning, *Untitled*, c. 1934. Collection of John Becker.

In the paintings of men and women from the later 1930s, de Kooning had employed shallow Cubist space not only as a pictorial method but as an emotion-transmitting vehicle for significance. Now he began to mold the automatism of the Surrealists into a pictorial language strictly adapted to his own expressive needs while at the same time, by producing abstract form "purified" by exchange with the object, transcending mere willful subjectiveness.

Finally, there is a third twentieth-century aesthetic concept introduced into de Kooning's work at this point, and it is really an astonishing conjunction – the isolation of banal objects from their functional contexts. Marcel Duchamp, in such readymades as his *Bottle Rack* of 1914 (Fig. 7) had transformed mundane prefabricated products into magical things by removing them from their identifying environments. Bereft of their everyday meaning, they became "abstract" sculptures, a transformation that opened them to completely different expressive possibilities and thus significances. Similarly, de Kooning turned the forms he distilled out of his subject matter into "abstract" forms. By releasing them from accustomed contexts, he released new, unexpected, quite different meanings. They thus became polyvalent vehicles which drew their new significances from the new pictorial contexts in which they occurred.

As we have seen, de Kooning worked out his pictorial means by transforming existing stylistic methods without limiting himself to the modes of expression usually associated with them. He brought his procedures to a degree of formal inventiveness which was absolutely unique – it allowed him to construct and compose images while simultaneously, and paradoxically, keeping them completely open to spontaneous ideas and gestures. It was precisely his mastery of means that enabled him to use them with absolute freedom. They became an indeterminate, permeable "system" within which even the unfinished, even rejection and destruction could unfold as creative energy. De Kooning was thus able to conjure up the mythical in the human unconscious and to reveal the magic behind banal appearances, making both aspects coalesce into unity.

At the close of the 1940s de Kooning brought incredible creative effort to solving these complex and multifarious pictorial problems. Not that he painted *more* than usual; he painted more different *types* of images than ever before, working simultaneously on many different cycles. At the "abstract" end, there were his Color Abstractions of 1945-50 (Cats. 157-162, 171-173, 176, 178, 179), Black and White Abstractions of 1945-49 (Cats. 164, 166, 167) and the White with Black Abstractions of 1947-49 (Cats. 161, 169, 170, 175).

Fig. 7. Marcel Duchamp, *Bottle Rack,* 1914. Original lost.

The stylelessness which he had made his creative principle could now be investigated in all of its labyrinthine possibilities. First with the Color Abstractions, he introduced a creative provocation. As he was soon to do in the other series, he set himself a task which, typically, hovered between abstraction and symbolism – he began to use letters, words, and eventually even calligraphy. He traced rapid large letters in charcoal on the canvas, now a word, then two, and sometimes even a meaningless combination of letters which might take on some other, unconscious significance. This procedure enabled him to fill the picture plane spontaneously and arbitrarily, without a thought to ordered structure or limitation by right/left or up/down. The distorted letters, isolated from their function as symbols of communication, stimulated his search for new, liberated form. Pure provocation for the forming and transforming brush, these graphic symbols called forth an abundance of associations of content as well as of form, chains of meaning which then by further attacks of the brush could be interrupted or redefined or diverted into entirely different channels. A scribbled "W" might suddenly evoke a woman's body, an "O" a head or rib cage; or it might simply become a purely "abstract" oval or again revert to its original significance as a letter of the alphabet (Cats. 161, 167, 169, 173, 175, 179).

De Kooning's working process, more than ever before, now began to involve continual and repeated superimposition of the most diverse shapes and brush gestures, which generated ever further, hitherto unknown configurations. Drawing – or writing

– functioned as a corrective, underscoring or even sometimes negating the work of the brush, situating the constellations of form more precisely in their shallow space or cancelling their appearance of depth altogether. Movements which had just run in parallel paths might abruptly change direction and clash; the viewer's eye is compelled to leap from closed, form-describing contour to open gesture, from pulsating calm to scorching speed that suddenly comes to a dead stop. Without warning a deep fissure may open up and then, suddenly seen in a different formal relation, become a convexity, shooting out to the foremost plane. In an absolutely incomparable way de Kooning succeeded in utilizing for these images that amalgam of Cubist and Surrealist principles described above – the spontaneous mood transcription of automatism and the cool construction of interlocking planes of Cubist space.

De Kooning radicalized these procedures in two directions. First, he expanded his images beyond traditional European conventions in painting to encompass an unbounded, "all-over" pictorial space. And being, in de Kooning's sense, polyvalent "abstract" images, they marked his success in overcoming the classic conflict in painting between figure and ground. The Cubists had solved this problem by representing objects emblematically and, by treating the background in a similar manner, anchoring them in it or giving them the appearance of crystallizing out of the ground. Since de Kooning synthesized objects – and their mental associations – in autonomous, abstract forms without tying these forms strictly to their objective referents, figure and object are always present in his images, even in the abstractions that contain no clearly identifiable representation. This achievement allowed him to use the picture surface as a stage for free mental improvisation which, in the flux of transcription, is without beginning or end. Here, too, we confront the unfinished or unrealized character of the image in another guise. The entire surface is covered with graphic and painterly events.

Still, these images do not give the impression of being random sections of some larger field, because the plasticity of the pictorial space is extreme in its presence and density. The phenomenon observed in *Pink Angels,* where intervals between forms, negative shapes, became positive, has been taken so far in these new canvases that negative shapes no longer occur. Though one form develops out of the next, none has been incised into the ground or anchored there; advancing and receding, superimposed or interpenetrated, each form may come dominantly forward only to be pushed back by another to some deeper plane. All-over patterning becomes the prime characteristic of the image, leaving traditional approaches to painting far behind.

This phenomenon may become clearer if we compare the de Kooning abstractions with a painting by Hans Hartung, his *T-1936-2* (Fig. 8). Hartung began to develop his own, purely abstract, gestural repertoire out of objective motifs very early on, and by 1932 at the latest this had become his sole vehicle of expression. Movements captured on canvas became pictorial signs, which, however, were stated with such strict formal control that every gratuitous association with real objects was avoided. These carefully composed gestural traces of an individual's hand thus became supra-individual signs that stood for universal moods and emotions. Superimposed color fields and graphic marks evocative of gentle motion merged into a meditative, pulsing space which, like de Kooning's space, combined shallow Cubist structure with dynamic, spontaneous ges-

ture, transforming both in the process. Nevertheless, Hartung retained the traditional European conception of the image – that of a painting as a self-contained order – despite the fact that he found new solutions for the figure-ground problem that raised non-objective pictorial configurations to the level of iconic images reflecting inner spiritual states. De Kooning, with his all-over canvases, broke out of this tradition and expanded the possibilities of painting.[10]

The second way in which de Kooning radicalized the process of image-finding was by renouncing color. In both the series of Black with White and White with Black Abstractions the feeling of space, interwoven and conflict-ridden, was no longer produced by means of the plastic qualities of color. Here, de Kooning brought the all-over problem to a head by limiting himself to the basic contrast of non-colors. By thus reducing his means, he also made more complex the problem of creating depth in planarity. It is important to recall in this connection that these paintings were executed during the same period, and alternately with, the Color Abstractions. The way he employed black and white also increased the ambiguity of the image: rather than staging confrontations of equally weighted forms, in the one group he inscribed white lines on a black surface and, in the other, black on white. These lines, however, did not describe closed sections of surface. They generally remained unconnected, in flux, impinging on one another or crossing or standing out against the ground like curving incisions. Their extremely diverse character – sometimes sharp, narrow and

Fig. 8. Hans Hartung, *T 1936-2,* 1936. Musée Nationale d'Art Moderne, Centre Georges Pompidou, Paris.

sinuous, sometimes broader, almost planar shapes on black, raveling at the edges, painterly, letting the background shine through – transforms the elements of the image, apparently precisely positioned on the surface, into their exact opposites. More comprehensively than ever before, these paintings evince the ambiguity of abstract form, de Kooning's translation of representational elements into non-objective ones which articulate only the sensory reality of the image, and the form and content-generating properties of simple letters and words.

Metamorphosis: The Human Image II

In the Women, series II of 1947-49 (Cats. 168, 174, 177, 183) de Kooning continued to work on the form/content task he had set himself in the abstractions of the same years, adding to their complexity by introducing the figure. The experience he had gained in his black/white and color abstractions entered these new images seemingly without interruption.

A superb example is *Woman* of 1949-50 (Cat. 183). The formal vocabulary de Kooning had worked out is freely employed here in spontaneous rapid handling. Every random detail of the painting evinces its purely abstract, multi-leveled, interlocking, overlapping, and interpenetrating structures. As if by accident, certain of these non-objective elements group into a configuration which can be read as a figure with raised arms. Contradiction and ambiguity remain nonetheless. The zigzag line made up of angles and curves that denotes eye, nose, and mouth does so only because its position in the image suggests this interpretation. In other passages, similar formal conjunctions occur which can be read in different ways or which evoke nothing real at all. It remains unclear whether the woman is sitting or standing; and has she actually raised her right arm, or angled it behind her head? Can the similar beige-colored shape, partly contoured by two black lines, which touches her left breast really be construed as the other arm? If so, it would merge – lacking forearm and hand – directly into the objectively undefined "background." Thus it stays just as abstract as the other forms associated with it. The figure, rather than crystallizing out of the ground as an emblem, which happens in Cubist paintings, is part of the densely packed picture plane, ambivalent as only de Kooning's new pictorial means can make it, and without even the slightest suggestion of differentiation between solidly situated internal planes. The figure is built up of abstract elements which, without exception, have been divorced from a figurative, objective context. Like the violently agitated brushwork, the structure of the pictorial space is in a state of continual oscillation, sometimes augmenting the activity of the colors, sometimes working against it. De Kooning has created in this image a purely autonomous, shallow space-in-motion already familiar to us from the abstractions.

His "collage" procedure is still much in evidence here, translated into the terms of pure painting. The image is packed to bursting with fragmentary, incoherent formal elements, scattered gestural color flecks, truncated brushstrokes, and unexpected reversals of direction, all of which intermingle and often metamorphose into some third, completely new quality. Here we have one more example, if on a different level, of the "unfinished" character of de Kooning's imagery. Obviously, the abundance of shapes and strokes obscures not only portions of other passages, leaving the balance visible, but covers other

elements which have completely disappeared in the process of painting. The very fact that we are faced here with many images in one makes its abstract fragmentation all-pervasive and at the same time lends the figurative presence of the overall image great force.

Its expressive means, too, are marked by multiple contradictions. The image teems with fragmented dramatic gestures held together in a solid, cross-shaped axial scheme. They may evoke the despairing cries of an oppressed existence just as much as quiet, open-eyed pleading; some will hear hysterical laughter where others see only unconstrained *joie de vivre*. None of these evocations predominates; all moods suggested can be experienced simultaneously; they intermingle, conflict, one giving way abruptly to the next. However, rather than being a function of the subject matter, these sudden, erratic changes are bound up, directly and exclusively, with the pictorial means themselves. This may explain why even de Kooning's purely abstract paintings – though they are never only that – are charged with feeling and expression in a way that strikes us as immediately as does his figurative work. Their abundance of moods is a function of the infinite variety of formal inventions that transmit ever changing meanings and emotions. And this variety in turn is a function of the all-over patterning of the image – witness to a need to comprehend all of existence.

Success: Abstraction II

In the spring of 1950, after months of work, de Kooning completed what is still one of the largest paintings in his œuvre, *Excavation* (six by eight feet; Cat. 180). It was a summation of all the methods, experiments, and themes of fifteen years. With this painting and his black/white abstraction series, de Kooning, together with Jackson Pollock and Arshile Gorky, represented the celebrated new American painting at the 1950 Venice Biennale. If it had never been shown there, *Excavation* would surely be a very different painting today. De Kooning had great difficulty finishing it and made repeated changes. If the painting had not had to leave his studio for the Biennale, he would probably have altered it even further.

This prodigious painting confronts the viewer with a hermetic, closed image, forms densely interwoven in an impenetrable tangle. The predominant grayish-yellow, sandy tone is violently agitated by an all-pervading network – interdigitated, irregular, seemingly voracious and plantlike – which splits off complex strata from the underlying ground. Rifts and fractures open, revealing lodes of brilliant color throughout the image. The biomorphic structure, burgeoning and yet finely articulated, proliferates across the entire surface with undiminished intensity. Though the image gives the impression of having been barricaded against intrusion, the viewer paradoxically feels that he is somehow surrounded by it, closed in – a proximity in which things faintly recognizable begin to blur, as if expanding and contracting in slight but inexorable movement. Myriad evocations and allusions seem to rise to the surface in a rush, only to sink back the next moment into the purely abstract articulation of the image. An oval with a spot in it may seem for an instant to be an eye, broad curves may evoke breasts; a leg or body may materialize here, a door or window there – but they are really only rectangles. Completely non-objective, the image is nonetheless filled to the edges with "figuration."

A section of the surface may open out, revealing great depths, then instantly close; the colors flash like beacons. These oscillating and tension-filled sequences have much of the quality of real appearances. As the eye roams, a part of the image will emerge from indistinctness into identity, a fragmentary find that may suggest a whole, which in turn is swallowed up in a still larger whole that no eye can comprehend. Not only is this process comparable to the eponymous act of excavation; it is a phenomenon that parallels the dreamlike associations of a resting mind. The image might best be compared to an indeterminate field of memories, stretching into the future as well, memories that follow one another in rapid succession and change continually – a field of action and meditation in one. Memory and projections into the future, movement and stasis, recognition and forgetting, growth and decay, nature, history, and their sublimations in myth are all present, synthesized in a single image which is many images in one; a never-ending narrative of abstract formal developments to which endless others might still be added – just as life continually adds to and superimposes new experiences on our memories of the past.

Scandal: The Human Image III

During the first days of June 1950, de Kooning began a new cycle of paintings, his third series of Women; it was to occupy him for five years to come. The first painting in the series took him almost eighteen months to complete, though he also worked on others during this period. This image was radically different in type from *Excavation*. When the first Women were shown at the Sidney Janis Gallery in 1953 (Cats. 190, 191, 193-195) – de Kooning's third one-man exhibition – it must have appeared to a well-wishing public that de Kooning had abandoned the achievement which three years before had brought American painting international recognition. With Abstract Expressionism becoming dominant the world over, de Kooning turned back to a superseded phase of painting – figurative painting – an incomprehensible and inexcusable step backward. No one but de Kooning's close friends knew that he had always been involved with the subject of the seated female figure, and that he had long applied the results of his experiments in abstraction to the human image.

What was more scandalous than anything else, however, was the *way* he had treated the female subject. Not only was it impossible to identify with these grotesque, demoniacally distorted figures, but they were an affront, a slap in the face, a blasphemous transgression of a taboo. American society had quite a different notion of its women – whether as mothers or wives or puritanically sublimated sex objects.

Thomas Hess described the inception of the first canvas in the series (Cat. 190) shortly before it was exhibited at the Janis Gallery.[11] If it was absurd to paint a picture of a woman, de Kooning thought, it was equally absurd not to.[12] He was tormented with doubt concerning the subject, his own abilities, and the possibility of painting in the radical mode of *Excavation*. During the act of painting, even a knee, a hand, an eye or mouth are mere colors and shapes for the artist; by now, de Kooning had created an adequate and complex repertoire by systematically building up a vocabulary of forms in which abstraction and representation coincided. He had prepared himself well for the Women series. If we recall his *Woman of*

1949-50 (Cat. 183), it becomes clear that much of what he was now saying had been worked out in that picture. Moreover, he applied in this new series a principle already formulated in the first bright-hued Women of the early 1940s: by using the very same means in contradictory ways, contradictory messages could be interlocked within a single image.

The mythical and the banal; the mythical in banality and banality in the mythical – that was his true subject. The all-American girl of the cigarette ads and the monstrous dark goddess; primitive idol and superficial chattering cutie; the Venus of Western art, the truckers' pin-up girl, the loving whore and child-eating mother, eros and death, life and animal sexuality, dreamlike vision and everyday street life, the real and the magic, fear and longing.

The first painting cost de Kooning a year and a half of struggle. Simultaneously he produced innumerable drawings, smaller paintings, sketches and "unfinished" works on the same theme. The six stages of *Woman I* photographed by Rudolph Burckhardt (cf. Cats. 184-189) are only a small part of countless unrecorded stages. As Thomas Hess says, de Kooning over and over again rejected versions of the image that seem hardly less compelling than the one that finally survived.[13] They all served him as points of departure for several complete revisions of the image, though decisive developments of pictorial means are not perceivable in the treatment of this complex subject. At any rate, here, as in *Excavation*, many paintings contributed to the creation of one.

It is important to recognize how precisely described many of the objects still were in the documented early stages of the painting – window, chair, lamp, view of a tower beyond the window. These objects were submerged in the abstract strokes of the third version of *Woman I*, though they still can be made out. But only for an instant, until they disappear again, as if transformed back into pure painting. "Content is a glimpse of something," said de Kooning, "an encounter like a flash. It's very tiny – very tiny, content . . . it could change all the time; she could almost get upside down, or not be there, or come back, she could be any size. Because this content could take care of almost anything that could happen."[14] It is remarkable how de Kooning equates perception of the real world with perception of a painting in progress, and with the translation of things into gestures. Not only does the image of the woman shift continually, in whole or in part; things wander through the pictorial space, disappear altogether, then partially re-materialize but in different modes. This in itself illustrates, once again, the endless number of possibilities contained in de Kooning's image-making practice, and also the terrible doubts he experienced, which explains why his paintings can never be considered finished.

In the last version of *Woman I* – and in the Women pictures that followed – the means used to describe figure, objects, and space have become interchangeable and extremely contradictory. The figure stands in a completely transformed, autonomous abstract space, merging with it and sharing all its formal inconsistencies. We had seen this type of formal and contentual depiction of a figure within shallow space in *Woman* of 1949-50, an undefined space for which de Kooning coined the term "no-environment." We no longer can tell whether the woman is seated in an enclosed interior – the studio – or standing on a street. And the agitated, dramatically expressive "psychic improvisation" might also suggest that the woman's inner mood is reflected in the artist's handling of color and form.

In his brilliant analyses of de Kooning's work, Thomas Hess placed this no-environment, so to speak, by decoding it as one aspect of the way city people experience their surroundings. I believe that this apt term and Hess' interpretation of it can also be applied, in retrospect, to the Men pictures of 1935-40. The idea of no-environment is based on the experience that solid objects appear to dissolve when seen very close up – and not only then. The illusion, for example, that a thumb, when you look closely at it, may resemble a thigh, de Kooning called "intimate anatomy," uniting near and far in a graphic phrase, and suggesting that in a painted image as well perception continually oscillates. Hess has pointed out that such visual paradoxes can also occur at great distances, a phenomenon of life in the city.[15] By utilizing this simultaneity of disparate perceptions in his Women paintings, de Kooning divested the human image of all the references by which we normally determine where the figure actually stands.

This perspective on de Kooning's work again illustrates how intensely he attempted to describe similar experiences by diverse pictorial means – recall the feeling of proximity given by the huge *Excavation*, proximity in which everything dissolved, then revealed a glimpse of some fragment that stood for the whole, only to sink back into the maelstrom.

Technique: The Collage Principle

Up to this point we have described de Kooning's procedures largely on the basis of the final image. With the Women, however, it is especially helpful to go more deeply into the question of technique, for the techniques used in these series throw light on other aspects of de Kooning's oeuvre.

We have seen that the problem de Kooning set himself was to bring together diverse points of view – "intimate proportion" and "no-environment." To do this, relationships had to be established between unrelated things, a process that had already appeared, in various guises, in his earlier work. In conjunction with this process we observed another, one which is not only formal, but involved thought and vision as well – collage. Even though in many paintings the elements seem not so much pasted as painted together, as de Kooning developed his all-over approach, collage became a decisive method that stimulated the most varied solutions and directly intervened in the painting process. Collage increasingly became the adequate means to test and provoke the gaps, breaks, contradictions, stylistic clashes, and accidents which de Kooning was looking for.

In the Women images, collage was employed in its most radical form. De Kooning loved to experiment over and over again with passages that offered various solutions – and what passages in his painting did not? He would make sketches, tape or even tack them to the canvas, paint over them and remove them again, suddenly revealing the spot he had rejected and obscured – an element that now stood out in sharp contrast to its new surroundings. This led, for instance, to those sudden gaps in long brushstrokes or color fields, which stopped at the masked passage and resumed just as abruptly beyond it.

De Kooning the draftsman often intervened in the painter's work, drawing with charcoal in the wet paint or outlining with it, all to accentuate or tie together individual elements across the surface. And not only were formal problems treated in a

running commentary of drawings that accompanied the paintings, but often enough a drawing – not necessarily a sketch – was pasted directly onto the image, where it was either left as it was or painted over to the point of unrecognizability. Sometimes he would tear out sections of a drawing and paste them on the canvas like quotations of other representational possibilities. One key motive of this comprehensive use of collage was to exploit the creative potentialities of destruction.

This creative destruction becomes evident in yet another technique. Even in his most recent work de Kooning, after evaluating a day's revisions of an image, will sometimes scrape all or part of the paint off to reveal earlier passages. The new layer reads faintly, like the glimmer of a faded drawing. In this way, graphic and painterly networks are uncovered, unwittingly "collaged" combinations that arose in the process of painting and repainting and that might stimulate new ideas or be left standing as unexpected discoveries – as forms dug out from the depths of the image. Indeed, this method immediately brings archeological excavation to mind.

De Kooning can then further explore this interpenetration of diverse, superimposed forms by tracing parts of them on tracing paper and pasting these over another area of the painting; or, long after having rejected the traced version, by integrating it into the image after it had been completely reworked. Hence, collage can be said to take place in time as well as in space.

For a long period in his career de Kooning was in the habit of pressing newspaper onto the wet canvas in order to delay the drying process, allowing him to work into the wet paint again and again – and not only with the brush. Often a chemical change would cause the newsprint and photographs to transfer to the oil paint, and he let these countertypes stand as quotations from a banal reality that contrasted to the different "reality" of his paintings. This process, which he began to use early on, seems to anticipate the subjects and methods of Pop Art. De Kooning himself, however, never attached much importance to it since it arose by accident, and though he sometimes used the method ironically, he never used it purposefully to communicate some message.

In connection with the collage principle, it has become obvious, with hindsight, that the dissolution of objective form we have repeatedly noted – which produces autonomous, abstract, non-referential forms that nonetheless remain saturated with content and meaning – that this dissolution had its inception in pictorial techniques themselves. Thus one can speak of a certain identity between mechanical means and the intellectual content they transmit.

This fundamental and essential equality of means, content, and expression provided the basis for an unlimited freedom of formal invention. Everything could enter the image. And this brings up another contradiction – the fact that such images, arrived at in spontaneous, often rapid alternation of forms and gestures, were always subject to a strict control nourished by doubt. Not only could the endless variety of pictorial solutions inherent in the collage process cause an indecision which prevented a picture from ever being finished; periods of rapid work, painting and pasting, testing and discarding, always alternated with long periods of contemplating the result – hours, often days. Once a painting had been considered, as Duchamp called it, "definitively unfinished," once it had been taken off the stretchers and stacked in some corner of the studio, as good as junked, it became an unknown object which, taken up again weeks later, had the power to stimulate the pictorial imagina-

tion. De Kooning might then completely rework it or continue where he had left off – as was the case with *Woman I*.[16]

An Urbanite Goes Suburban: Abstraction III

In de Kooning's painting, nature – landscape in the broadest sense – is both a pictorial motif and a subject open to contentual interpretation. It appeared in his earlier work, though not in the form of immediately recognizable imagery. Such titles from the late 1940s abstractions as *Dark Pond, Town Square, Attic,* and *Excavation* evoke experiences of the countryside or of townscapes. Even the abstractions from the later 1930s and early 1940s could, as we have seen, be perceived as landscape paraphrases. And landscape was a focus of interest, to the exclusion of almost every other subject, in the three alternating cycles of paintings done between 1955 and 1963: the Abstract Urban Landscapes (1955-58; Cats. 200-203), the Abstract Parkway Landscapes (1957-61; Cats. 204-210), and the Abstract Pastoral Landscapes (1960-63; Cats. 211, 213-215).

The urban landscape abstractions reveal at a glance that de Kooning has taken his pictorial vocabulary from the Women images and developed it further. That space around the figures which he called "no-environment" and which Hess characterized as typical of the big-city experience, now became the theme, in form and content, of urban landscape paintings. But women seem to have disappeared in the wilderness of the city, and rapidity of gestural transcription has advanced more than ever to the forefront of the image. De Kooning's dissecting and assembling eye, his rapidly changing point of view, giving us appearances only in glimpses – as he described it – may still locate an apparition of form in the weave of color and line, only to lose it a second later in the hectic activity of the whole.

The enclosing yet continually expanding grid of the pictorial space compels the viewer's eye onward, waywardly, in an attempt to perceive everything at once. We are suddenly bathed in light, then plunged back into darkness, as if we were walking or riding in a taxi through the city and our wandering attention had been caught for an instant by some insignificant happening outside the car window which the next moment was left behind, its magic gone.

Not only do these images correspond to the way we see and experience the city; they also, and to the same degree, mirror the inner mood of the artist who records it unfiltered, in the open, unfinished gestures of a transmuted "automatic writing." Present also in the pulsating movement of the separate elements are the equally transformed, interpenetrating space planes of Cubism, here translated into organically softened shapes. Moreover, the intellectual principle and the pictorial technique of collage have been absorbed into these images without a break, articulated in the interwoven, all-over patterned surface by multiple superimposition of form and by interrupted and resumed brushstrokes.

After the sustained effort of the Women paintings, de Kooning had achieved perfect mastery of these three techniques. Now he was able to employ them at will, lending more weight to one, then the other, to control and channel a continually changing and uninterrupted flow of pictorial ideas. More than ever before he now began to expose himself to sensory experience of the outside world. Yet despite the quality and sovereignty of his completely open and stylistically indetermi-

nate expressive means, de Kooning kept on questioning them, introducing irritants to goad unknown images and new realities into being.

In his Abstract Parkway Landscapes he finalized the spontaneous notation of automatism by expanding it to dramatic gestures that blazed across the canvas from edge to edge. At times these images resemble enlarged details from the urban landscapes, the result of an excerpting procedure which again suggests collage but which, above all, suggests that alienating, simultaneous vision from near and far that causes reality to dissolve.

With this liberation of the brushstroke for a space-defining, physical act came an autonomous interpenetration of pictorial planes dependent solely on color weight. Graphic dissolution gave way to fragmented superimpositions of color fields which merged into a scaffolding structure that yet remained full of motion. The image expanded beyond itself; it exploded out, yet simultaneously maintained a fragile equilibrium. The result was a paradoxical coexistence of violent expressiveness with a gentle, lyric mood.

These are images of "landscapes and highways and sensations ...outside the city – with the feeling of going to the city or coming from it."[17] Experiences of this kind led to still another change in de Kooning's store of pictorial approaches – not only were his purely abstract paint gestures charged with "meaning" on the level of physical expression, but they also came to serve as vehicles for allusive descriptions of real things: streets and highways, or blurred visions of trees, brooks, bridges, lawns, woods and inexorable suburbs. This process found natural support in the expressive possibilities of color. A fresher air, a rush of wind entered the picture, a light which bathed appearances in completely new, all-pervading yet ever-changing, cloud-shadowed hues.

Though de Kooning rejected the idea of style for his own work – "To desire to make a style is an apology for one's anxiety"[18] – the pictorial principles he developed nonetheless shaped a style. "Style is a fraud," he once said, "...you are with a group or movement because you cannot help it."[19] Nor could his scandalous Women keep his work from being co-opted; *Woman I* was purchased by the Museum of Modern Art even before it went on show at the Sidney Janis Gallery and soon became one of the most widely reproduced pictures in the United States. The extent to which his "style" set group trends, something which, as he complained, no artist could prevent, is clear from a glance at the work of Franz Kline, a friend of de Kooning's since 1939. Kline's 1959 painting *Provincetown II* (Fig. 9), to name only one, shows astonishing similarities to de Kooning's Abstract Parkway Landscapes, though there can be no doubt that each artist arrived at solutions of this kind out of the inner logic of his unique approach.

From 1959 on, de Kooning spent the summer months working in East Hampton, Long Island. He considered giving up his loft in New York to escape the hectic life, countless uninvited visitors, and the art scene in general. By 1962 he had begun to build a large studio with a house in the Springs, according to his own plans; two years passed before the project was far enough along to allow him to move in.

During this period he executed the Abstract Pastoral Landscapes, in which everything is suffused in colorful ever-changing light. In canvas after canvas, attempts to depict evanescent experiences in nature came to the fore, so that his perceptions of landscape took on a more abstract quality. The pictorial

Fig. 9. Franz Kline, *Provincetown II,* 1959. Estate of the artist.

weave of large, gently spreading color fields plunges the viewer into soft, delicately shimmering, almost breathing vistas; even the violent gestural marks have lost their distracted look. No longer disquieting or nervous or hectic, they merge with the mood of the image like the warming shimmer of reflected sun, a gay splash in a stream, or waves of grass in the summer wind.

The colors have all been cut with white; indeed, de Kooning has purposefully reduced his palette to white, pink, yellow, and sometimes a green or blue, which in the open, flowing order of the image take on almost naturalistic expressive qualities. Yet these paintings, like all his others, are far from being mere descriptions of nature. They are expressions of the emotions nature gives rise to – the vastness of sun-drenched countryside, green grass and dusty earth, a blinding yellow-white beach whose sand boils in the green of Atlantic breakers.

Hess has compellingly described *Pastorale* (Cat. 213) as an emotion-charged landscape impression. This was the last picture in the series, done just before de Kooning's final move to Long Island. And it was a farewell to New York, evoking so clearly a city-man's joy in fresh air, sun, wide-open spaces and sea. What this image also announces, if covertly, is the reappearance of the human form, which was soon to regain a central place in de Kooning's work.[20]

Joie de Vivre: The Human Image IV

Very soon after de Kooning's move to Long Island, the female figure again became the focus of his work, with drawings and small-format paintings occupying his interest for many months. Though pictorial signs evocative of landscape were not missing from these images, they were situated ambiguously somewhere between "urban" and "rural." In the large-format works

Woman, Sag Harbor and *Woman Accabonac* (Cats. 217, 222), he bypassed this unsolved problem of describing the figures' locale by choosing unusually narrow formats – he painted doors from a carpenter's shop. Though his painterly expression was now more closely related, in details, to the abstract landscapes than to the earlier, controversial Women, the bodies and faces of the women in these new images were just as violently distorted toward the demonic, even diabolic. Their torsos appear frontally and, in all disregard of anatomy, their extremities spread out on the surface like foldouts. Larger than life, the figures look as though they had been distorted and misshapen by the pressure exerted by the agitated, interwoven forces of the surrounding brushwork. Sections of the picture plane have been left unpainted or treated with highly varying intensity, further emphasizing the open, unfinished character of the images.

All of the pictorial techniques we have seen in de Kooning's previous work turn up here again, though in a different mixture and with many shifts of accent. In contrast to the witchlike women of the New York paintings, Hess has characterized these figures as "tragicomic heroines."[21]

Very soon, as in *Two Figures* (Cat. 219) or in the following series of Women in the Country (1965- c. 1972; Cats. 220-235), landscape elements came to be integrated physically with the figurative form. Human being and nature merged and dissolved in the structure of the image; a liberated, uninhibited use of gestural articulation transmuted them into pure painting.

In *Figure in Marsh Landscape* of 1966 (Cat. 220) even an observer familiar with de Kooning's work may at first recognize nothing but a wild battle of intensely glowing colors. Then, for an instant – as in the glimpses accorded him by the earlier Women – he may discern a pair of eyes, sphinxlike and veiled, tiny beneath huge eyebrows and a pile of blond hair; and the pinkish white that flows in streams across the surface will gel into a female body, limbs lasciviously intertwined in the depths of the image, gestural forms that merge imperceptibly with the background, whose abstract, ambiguous shapes describe moods evoked by nature. Erotic love, in all of these paintings, is experienced as involving all the senses at once. Human beings are identified fully with nature and vice versa; landscape may body out as if driven by a desire sometimes almost demonic in its intensity.

If we think back for a moment to the figures of men and women from 1935-45, we find then, as now, an identity in pictorial terms between man and environment. In the case of the Men, we had interpreted this all-engulfing insecurity of forms and their relationships as expressing a crisis of human identity. It is just as plausible to see, in these Women in the Country of thirty years later, exactly the opposite: no matter how conflicting or contradictory may be the relationships between multiple configurations, they bear witness to a single, unifying joy in life. Their desires are those of all created things – even in jeopardy. In the early series of Men, hopelessness and anxiety were given expression by the direct and autonomous pictorial means of *closed perspective;* in contrast, all of de Kooning's figure-landscape images of the 1960s are characterized by an *all-inclusive* perspective which recognizes in every detail a vital, ever-changing reflection of the whole. Death – disintegration of the image – no longer represents a threat but is part of the cycle of creation.

This view of the world is achieved, though in a completely new way, by means of a technique already discussed – the metamorphosis produced by overpainting. In *Two Figures in a Landscape* of 1967 (Cat. 224), it takes a great effort to distinguish even one figure in the wildly orgiastic, intertwined and interpenetrating swirl of forms; a second, smaller figure, shaped in broad, flesh-colored superimposed strokes, can be made out in the top left third of the image. As we have seen, overpainting and scraping off of paint, distortion of form and shifting of forms from one part of the image to another, were methods de Kooning developed out of collage to produce continually changing, never finalized formulations. Hence it is not surprising – and this holds for many other paintings of his as well – that the two figures of the title have gone through so many metamorphoses that they have almost disappeared. This is tantamount to saying that disappearance, as a process involved in the making of the image, finds its parallel in the content of the image – decline and death – and that thus again form and content coincide.

Nevertheless, the content of the title is very much present in *Two Figures in a Landscape*, present as an antithesis and expressed in terms of de Kooning's typical pictorial code. For in a glimpse of recognition – once the eye has penetrated the wildly agitated events of gesture, color, and form – we may recognize in the human form stretched out in the grass, *two* figures becoming one in the act of love.

Landscape as "Inscape": Abstraction IV

Just as the Abstract Urban Landscapes developed directly out of the Women series, the complete merger of human being and landscape seen in *Two Figures in a Landscape* represents a decisive step toward the long sequence of the first untitled works of 1975-79 (Cats. 236-250). In these paintings, the human image is contained completely in a pure painterly abstraction evocative of human experiences of nature. As in earlier cycles, here too the shapes created by the brush are identical to those which in the Women in the Country series still designated both figurative and landscape elements. In the untitled works, these elements are purely "abstract" and yet, as always with de Kooning, they remain charged with "meaning" and are thus significant of inner experiences and moods.

To execute this new series, de Kooning did not have to give up the technical and pictorial tools whose multiplicity we have described in connection with his earlier cycles of paintings. The pictorial principles remained the same: spontaneous transcription, corrected and controlled by means of deletion, superimposition and overpainting; and the interlocking, space-creating gestures which provide the painted passages with a graphic "framework." The impasto brushstrokes have merely become less agitated, more free-flowing, as though simultaneously held in suspension and gliding through space. The pervasive theme of these images seems to be the immaterial phenomena of nature – wind, light, sounds, smells.

The most diverse sensory experiences coalesce in these images – the distances and expanse of the countryside as well as its immediate physical presence; both waving grass and the infinite yet peaceful motion of the Atlantic swell; figures and landscape washed by the waters, caressed by the wind, lashed by rain, bathed in vibrating sunlight.

All of these contradictory experiences of simultaneous proximity and distance have been united in *Untitled V* of 1977

(Cat. 245): sky and sea, breakers, cliffs, and beach have become one. Artist and spectator stand *before* this painting and, at the same time, *in* it. The breathtaking, almost physical density of the images in this series permits no spatial referents by which man could define his place; he is within the image just as the image, a mirror of the outside world, is within him.

A similar experience and vision appear in Courbet's *The Wave* of 1870 (Fig. 10). Waves and clouds have been made to converge through abstraction; water mixes with sand, spray flies, the sky towers above. Two viewpoints which naturally exclude one another have been combined – we see the wave from below and, simultaneously, the dome of sky. Moreover, Courbet has applied the paint in thick impasto so that water, earth, and air become one in a material sense as well. Cézanne described the effect: "The great waves . . . with their foamy peaks, the tide that comes from the depths of time, a tattered sky and a pale sharp brilliance. . . .One shrinks back – the whole room is filled with spray."[22] This could well be a description of a de Kooning. The physical, sensuous emanations of his paintings are those of their means; subject matter and allusions to objects have ceased to play a role. The result corresponds to the immateriality of the natural phenomena which are the true subjects of the work.

In the second group of untitled paintings, begun in 1980 (Cats. 251-256), thick, layered paint has given way to delicate shimmering transparency. It is as though only the integument of the paint remained. The brushstrokes have become hovering elements, forms that recall *Pink Angels* (Cat. 156) and which merge to a gently breathing, gently expanding and contracting pictorial space.

The sensory experiences of nature visualized in 1975-79 untitled series were communicated with almost physical immediacy. In the images of the past three years, this complete being-in-the-world has gradually come to be shot through with flickering, almost transcendental light. The canvases are suffused with a blinding brilliance that transmutes color gestures into apparitions. Birth and death, dissolution and embodiment, as we have seen, were the covert themes for de Kooning as early as the Women in the Country sequence; the dissolution of their pictorial means evoked the unity of man and nature, making the images sensual metaphors of the cycle of life. Now, the creative force of eros is no longer in evidence, at least not on the surface. It has merged with the flux of a shapeless magma of light and unbound matter drifting toward congealment into form. Mists and gases obscure these happenings; here the veil is torn aside, there a vector of color penetrates it; in other passages the currents of paint are held and channeled by broad blue-black lines as if controlled by dams. Out of painting as a translation of a sensual recognition that man and his birth and death are part of nature, illuminated images have arisen in which the senses

Fig. 10. Gustave Courbet, *The Wave,* 1870. Staatliche Museen Preußischer Kulturbesitz, Nationalgalerie, Berlin.

are expanded to encompass the cosmos. Yet the eye meets these infinities in the natural magic of what is most near – in light playing on water, in sifting rivulets of sand, the flight of a bird through a sky whose depths are obscured by low-hanging clouds.

Multiplicity in Unity

"De Kooning's paintings are based on contradictions kept contradictory in order to reveal the clarity of ambiguities, the concrete reality of unanswered questions, the unity of simultaneity and multiplicity."[23] This unity marks his entire œuvre and is the real motive force behind it, a force in which something that is completely unmistakable can simultaneously be something else – even in the same image. Very early on, de Kooning realized that "reality" is so multifarious and so full of contradictions that any portrayal of it must be equally complex. But only with reservations, for the chain of opposites is both endless and endlessly intertwined, like a net. That is why de Kooning's paintings, as far as he is concerned, are all "unfinished," and why he repeats and varies his themes in series. Nor is each series complete, exhaustive at any point in its development; something always arises within it which goes beyond it to become a new generative factor. Or a series may have been taken to such a pitch of energy that it triggers a reaction – the dark and melancholy early figures of men called forth the ero-

tic, garish early figures of women; both of these series generated the color and black/white abstractions of the later 1940s; and upon *Excavation* followed the magically demonic and shrilly banal Women. In every case it is opposition that spurred invention, without leading to solution or synthesis; each time, some completely distinct, unexpected quality emerged. The fact that contradictions remain, visualized differently in every image, is what makes de Kooning's painting so real and present both sensually and spiritually.

Looking back over five decades, de Kooning's œuvre appears not only as an adventurous, never-ending search rewarded by countless unexpected discoveries, but it recalls a wide, wandering river at whose mouth flotsam carried from the source may still surface at any moment. Everything is always in the current as a possibility, to be taken up or let pass; and once a find has been shaped into a precise tool, used, and then discarded, it may turn up later, in gratuitous beauty, a familiar object on the delta shore.

The work of the city-dweller de Kooning is pervaded by the sights and sounds of the country. And if nature has since become the sole subject of his art, this is because nature for him means life, and not some poetic backdrop for man; nature is physical presence and existentially a shaping force. It is this insatiable hunger for life that drives de Kooning to discover its shapes, to trace its endless metamorphoses through to the tiniest change and yet to see it whole. Painting has always been his instrument, an instrument of self-insight, for "painting is a way of living."

Notes

1 "Willem de Kooning," organized by the Museum of Modern Art, New York, in 1968; see Exhibition History.
2 Willem de Kooning, "A Desperate View" (talk delivered at "The Subjects of the Artist: A New School" in New York, February 18, 1949), in Thomas B. Hess, *Willem de Kooning, exhibition catalogue (New York: The Museum of Modern Art,* 1969), pp. 15-16.
3 Hess, *Willem de Kooning,* p. 27:
 a. Early high-key color abstractions, 1934-44 (Cats. 134, 135, 137, 141, 142, 147, 154)
 b. Early figures (Men), 1935-40 (Cats. 136, 138-140, 144, 146, 148)
 c. Early figures (Women), 1938-45 (Cats. 145, 149, 151, 153, 155)
 d. Color abstractions, 1945-50 (Cats. 157-162, 171-173, 176, 178, 179)
 e. Largely black with white abstractions, 1945-49 (Cats. 164, 166, 167)
 f. Largely white with black abstractions, 1947-49 (Cats. 161, 169, 170, 175)
 g. Women, series II, 1947-49 (Cats. 168, 174, 177, 183)
 h. Women, series III, 1950-55 (Cats. 182, 190-199)
 i. Abstract urban landscapes, 1955-58 (Cats. 200-203)
 j. Abstract parkway landscapes, 1957-61 (Cats. 204-210)
 k. Abstract pastoral landscapes, 1960-63 (Cats. 211, 213-215)
 l. Women, series IV, 1960-63 (Cat. 212)
 m. Women, series V, since 1963 (Cats. 216-219)
 n. Women in the country, since 1965 (Cats. 220-234)
 o. Abstract countryside landscapes, since 1965 (Cat. 235)
 We can continue this classification with
 p. Untitled, series I, 1975-79 (Cats. 236-250)
 q. Untitled, series II, since 1980 (Cats. 251-256)
4 See Dore Ashton, *The New York School: A Cultural Reckoning* (New York: The Viking Press, 1972), p. 6: "W.P.A. stands for Work Projects Administration, a government agency, established in 1935 by President Roosevelt (and redesignated in 1939 as Works Progress Administration), which undertook extensive building and improvement programs to provide work for the unemployed. The Federal Art Project and Federal

Writers Project were two of its programs." De Kooning was assigned several mural and easel projects, including work with other artists on the model for a French Line pier mural (never executed), directed by Fernand Léger, and projects for a mural for the Williamsburg Federal Housing Project (never executed). In 1937, through Burgoyne Diller, de Kooning obtained a commission for one section of a three-part mural for the New York World's Fair Hall of Pharmacy.
5 See David Sylvester, "De Kooning's Women" (transcript of the BBC broadcast "Painting as Self-Discovery," December 30, 1960), *London Sunday Times Magazine,* December 8, 1968, pp. 44-57. Excerpts previously published as "Content Is a Glimpse," *Location,* 1 (Spring 1963), pp. 49-53.
6 Harold Rosenberg, *Willem de Kooning (New York: Harry N. Abrams,* 1974), p. 17.
7 Willem de Kooning, "What Abstract Art Means to Me" (talk delivered in conjunction with the exhibition "Abstract Painting and Sculpture" at the Museum of Modern Art, New York, February 5, 1951), *Bulletin of the Museum of Modern Art,* 18 (Spring 1951), p. 7.
8 With this painting, together with the *Demoiselles d'Avignon* and *Girl Before a Mirror,* the Museum of Modern Art, New York, began to build its comprehensive collection of Picasso's work; see "Die Geschichte der Gemälde- und Skulpturensammlung," in *Das Museum of Modern Art, New York zu Gast im Kunstmuseum Bern und Museum Ludwig, Köln, exhibition catalogue (New York, Bern, Cologne,* 1978), p. 71.
9 Rosenberg, *Willem de Kooning,* pp. 34-35.
10 For the conception of painting and its image rooted in European tradition – especially of the School of Paris – see Jörn Merkert, "Geste, Zeichen und Gestalt – Zum Werk von Hans Hartung," in *Hans Hartung – Malerei, Zeichnung, Photographie,* exhibition catalogue (Düsseldorf: Städtische Kunsthalle Düsseldorf, 1981).
11 Thomas B. Hess, "De Kooning Paints a Picture," *Art News,* 52 (March 1953), pp. 30-33, 64-67.
12 See "Content Is a Glimpse."

13 Hess, "De Kooning Paints a Picture," p. 31.

14 "Content Is a Glimpse."

15 Hess, *Willem de Kooning,* p. 79.

16 It was the art historian Meyer Schapiro who asked de Kooning to show him the painting *Woman I.* Through this visit de Kooning's interest in the canvas revived and he began to work again; see Hess, "De Kooning Paints a Picture," p. 30, and Rudi Blesh and Harriet Janis, *De Kooning* (New York: Grove Press, 1960), p. 60.

17 "Content Is a Glimpse."

18 De Kooning, "A Desperate View," p. 15.

19 Ibid., pp. 15, 16.

20 See Thomas B. Hess, *De Kooning: Paintings and Drawings Since 1963,* exhibition catalogue (New York: Walker & Co. for M. Knoedler & Co., 1967), p. 14-16.

21 Ibid.

22 Quoted in André Fermigier, *Courbet* (Geneva: Skira, 1971), p. 112-114.

23 Thomas B. Hess, *Willem de Kooning* (New York: George Braziller, 1959), p. 7.

Paintings

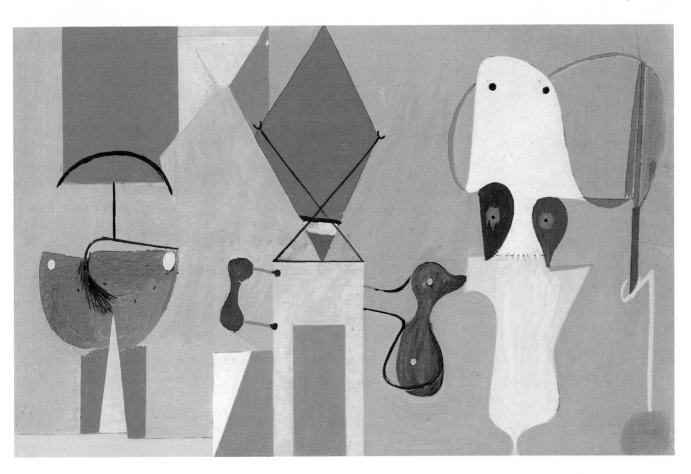

134
*Untitled, 1937
Oil on board
6 x 13½"
Private collection

135 ▽
Abstraction, 1938
Oil on paper mounted on canvas
9¼ x 15"
Private collection

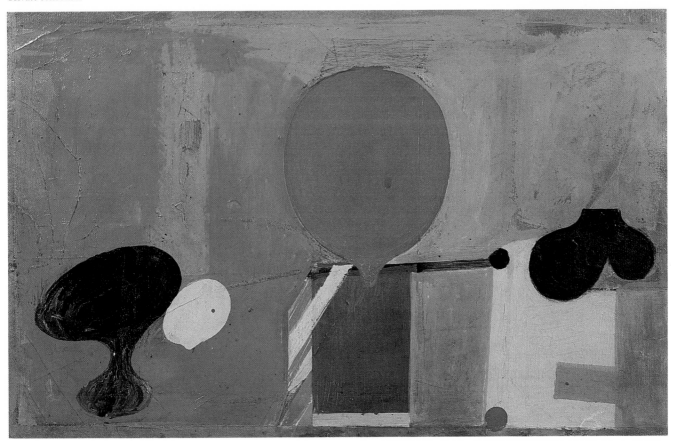

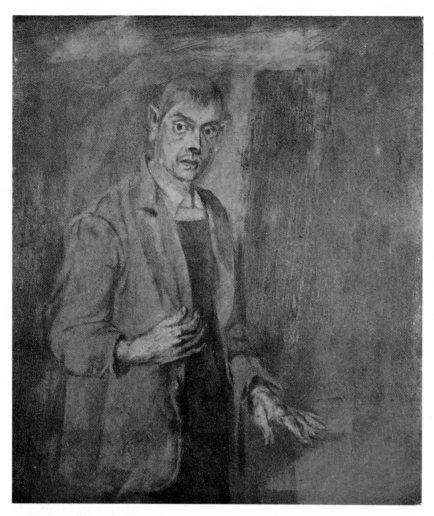

136
Man, c. 1939
Oil on paper mounted on composition board
11¼ x 9¾"
Private collection

138 ▷
Two Men Standing, c. 1938
Oil on canvas
61⅛ x 45⅛"
Private collection

137
Pink Landscape, c. 1938
Oil on composition board
24 x 36"
Private collection

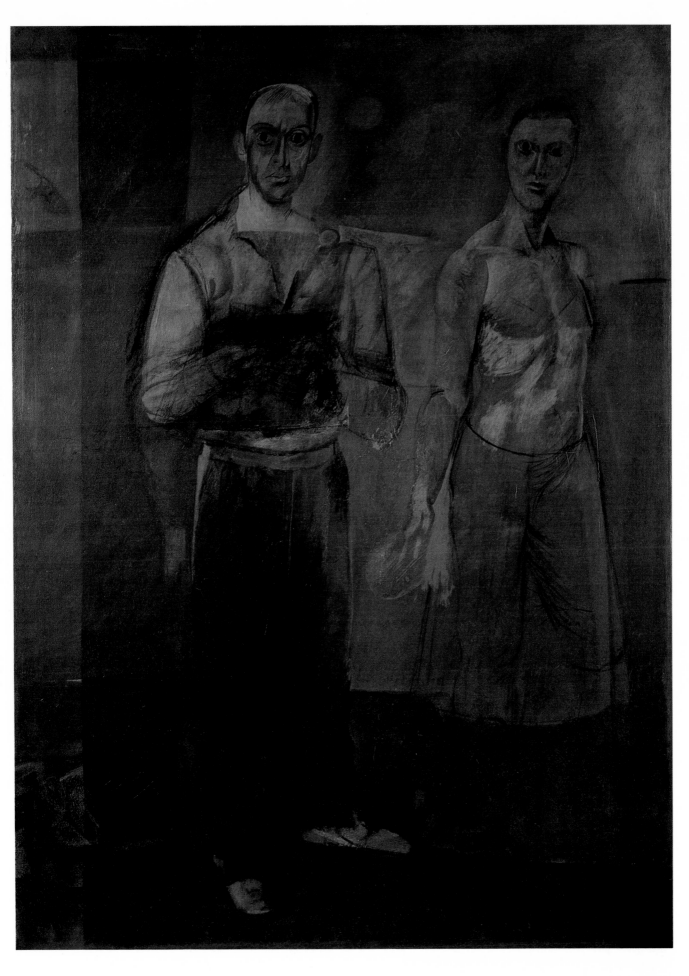

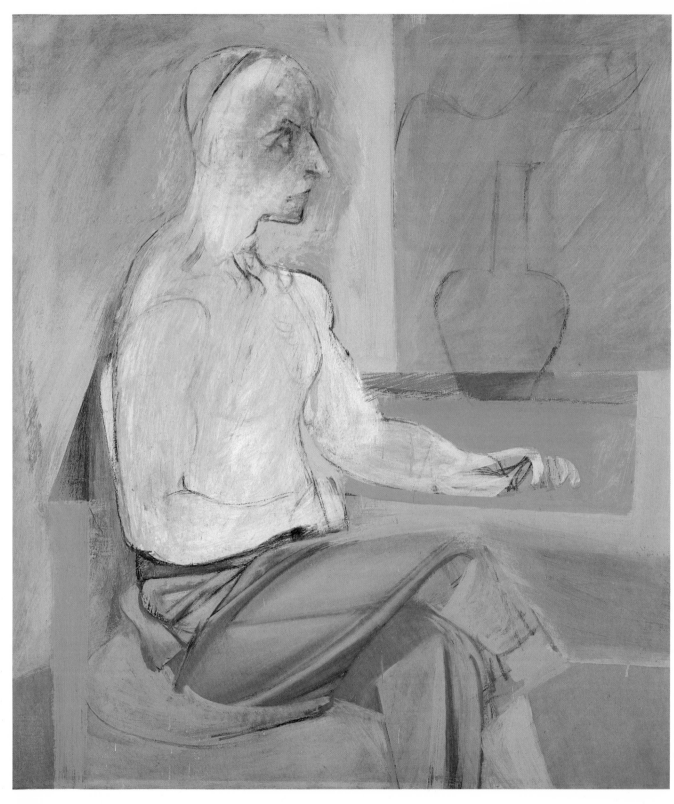

139
Seated Man, c. 1939

Oil on canvas
38¼x34¼"
Hirshhorn Museum and Sculpture Garden,
Smithsonian Institution, Washington, D.C.

140
Portrait of Rudolph Burckhardt, c. 1939

Oil on canvas
48x36"
Collection of Rudolph Burckhardt

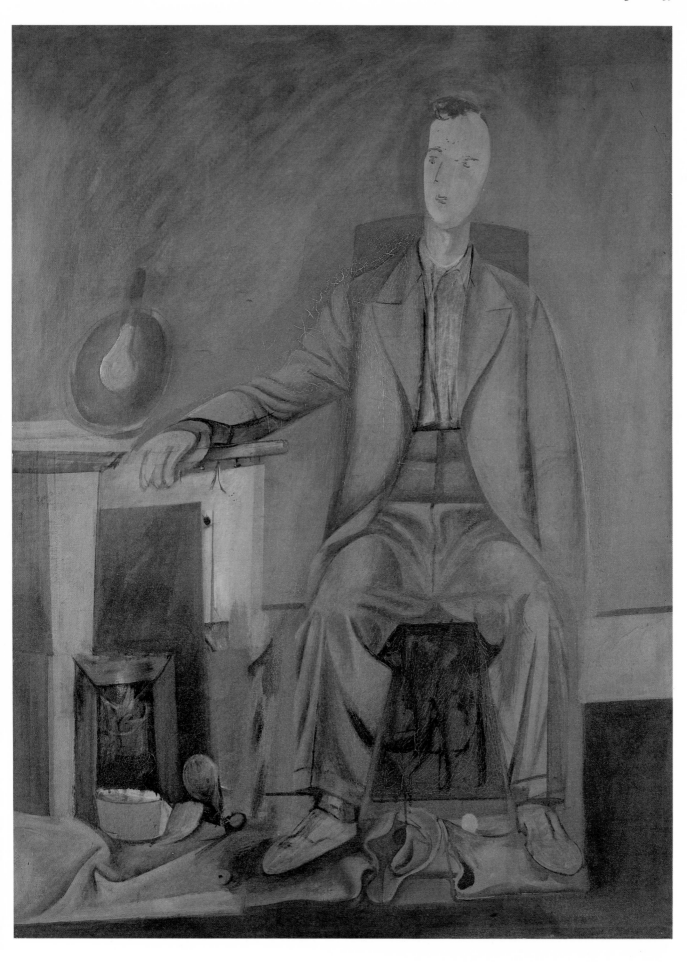

141
Elegy, c. 1939
Oil and charcoal on composition board
40¼ x 47⅞"
Collection of Mrs. Tyler G. Gregory

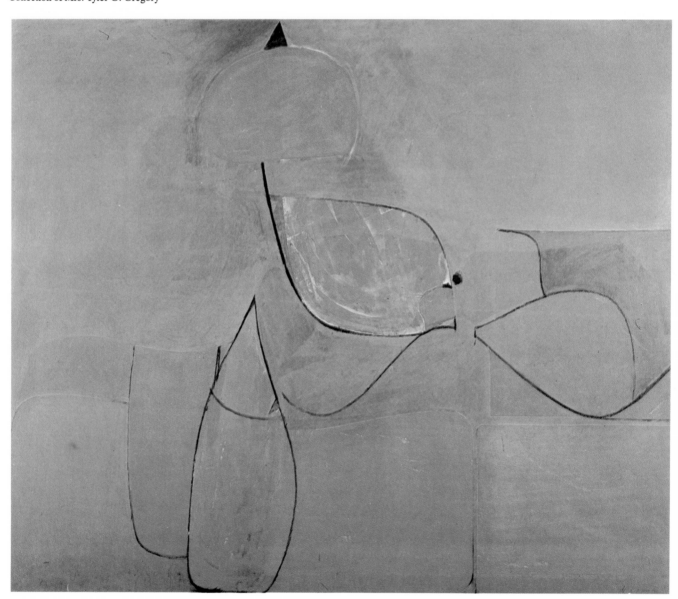

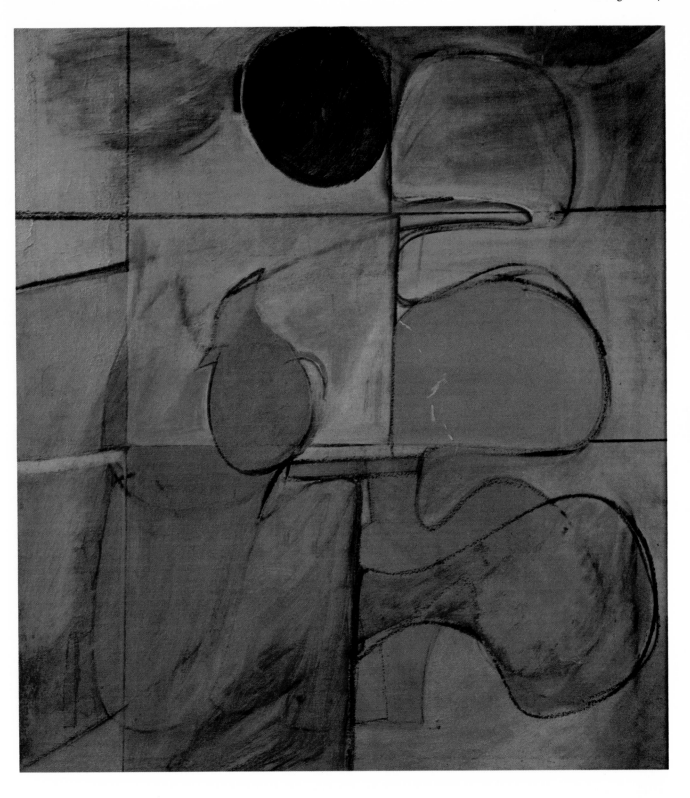

142
Abstract, 1939-40
Oil on canvas
36½ x 34″
Private collection

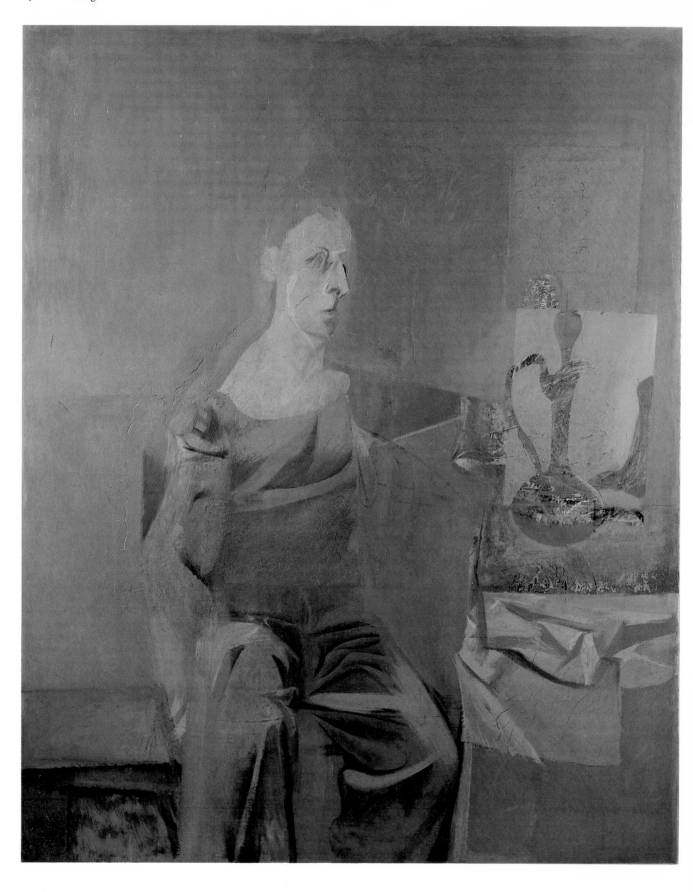

143
Glazier, c. 1940
Oil on canvas
54×44″
Private collection

144
Seated Figure (Classic Male), c. 1940
Oil and charcoal on plywood
54⅜×36″
Sarah Campbell Blaffer Foundation, Houston

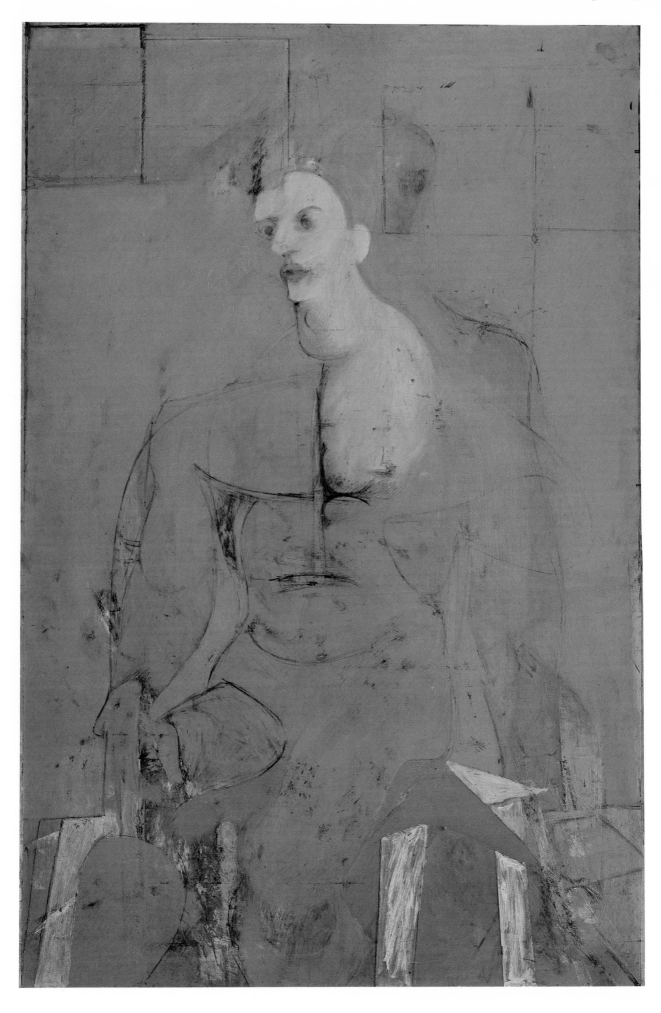

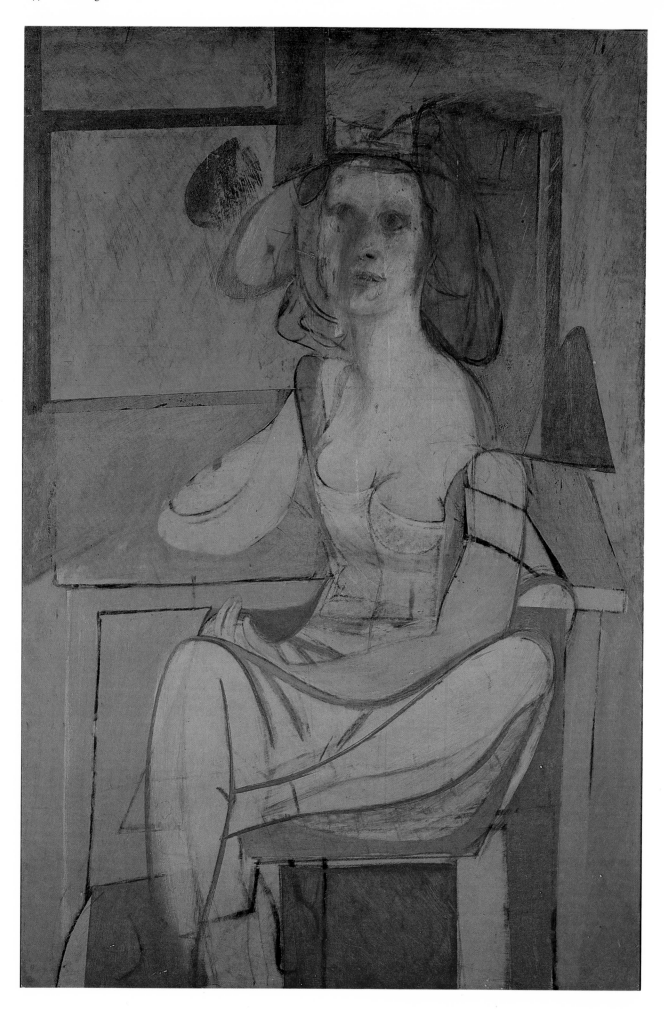

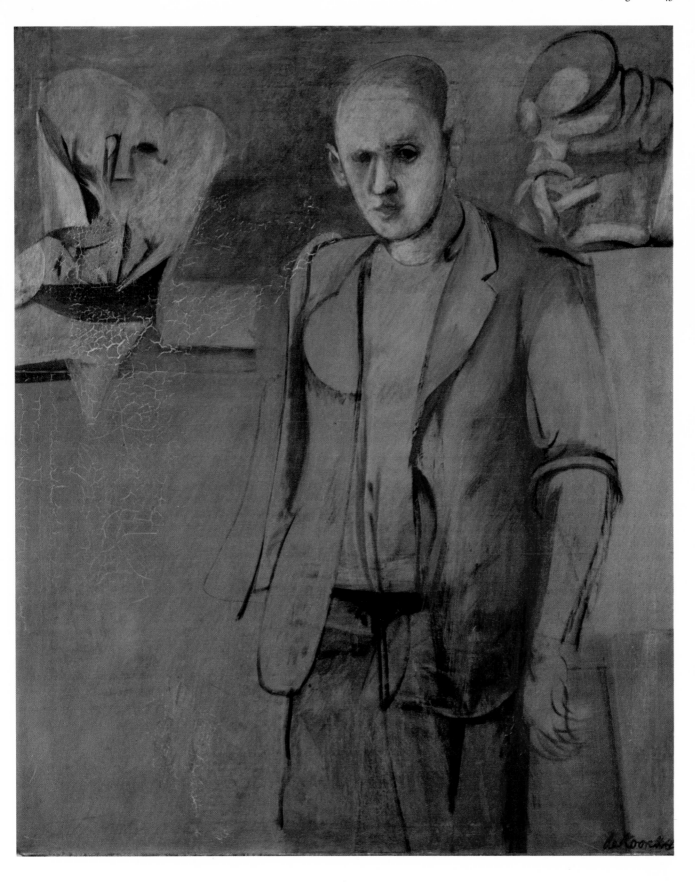

145
*Seated Woman, c. 1940

Oil and charcoal on composition board
54×36″
Philadelphia Museum of Art;
The Albert M. Greenfield and
Elizabeth M. Greenfield Collection

146
Standing Man, c. 1942

Oil on canvas
41⅛×34⅛″
Wadsworth Atheneum, Hartford;
The Ella Gallup Sumner and
Mary Catlin Sumner Collection

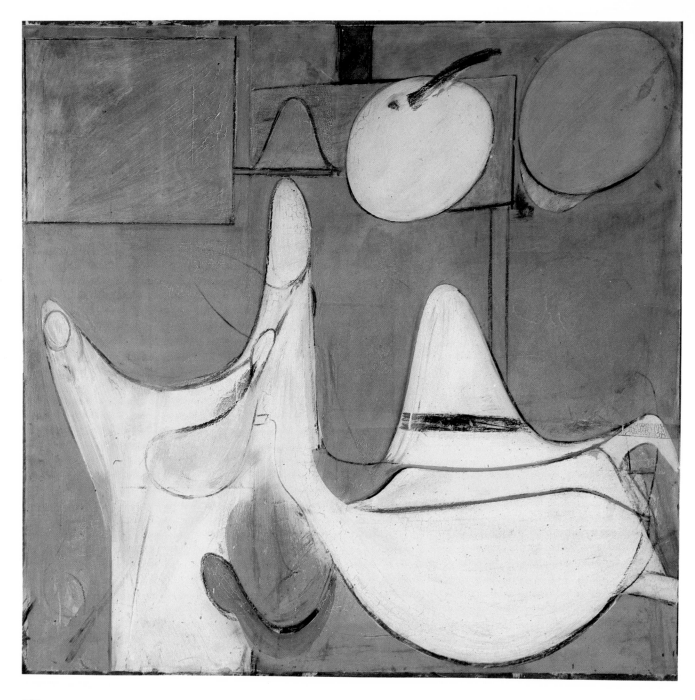

147
Untitled, c. 1942

Oil on canvas
46 x 46″
Private collection, courtesy Allan Stone Gallery, New York

148
Acrobat, c. 1942

Oil on canvas
35½ x 25½″
The Metropolitan Museum of Art, New York;
Gift of Thomas B. Hess in memory of Audrey Stern Hess, 1977

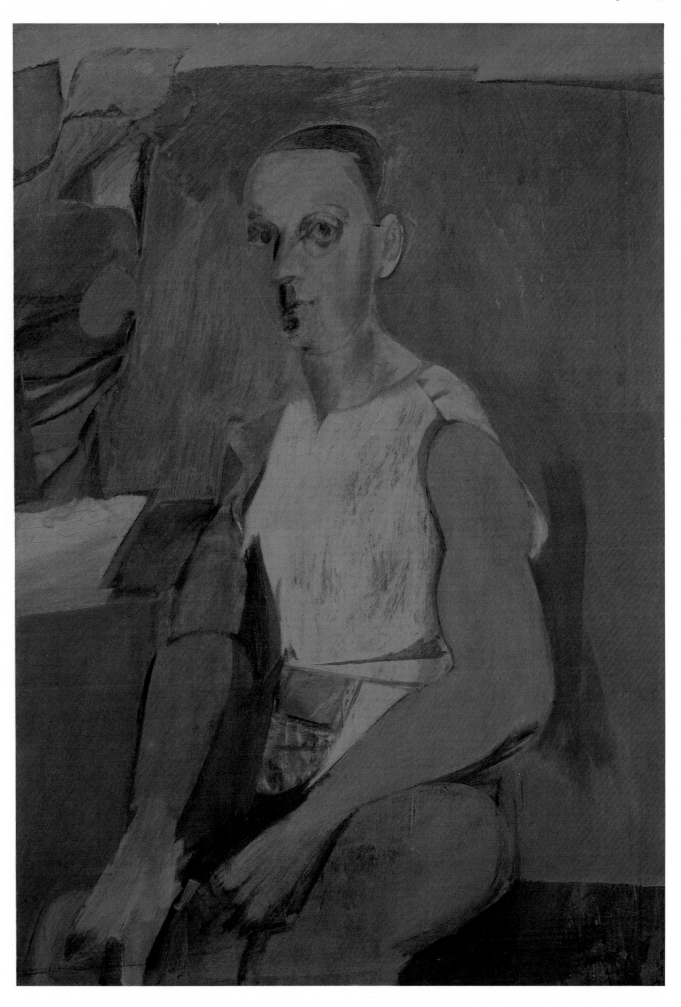

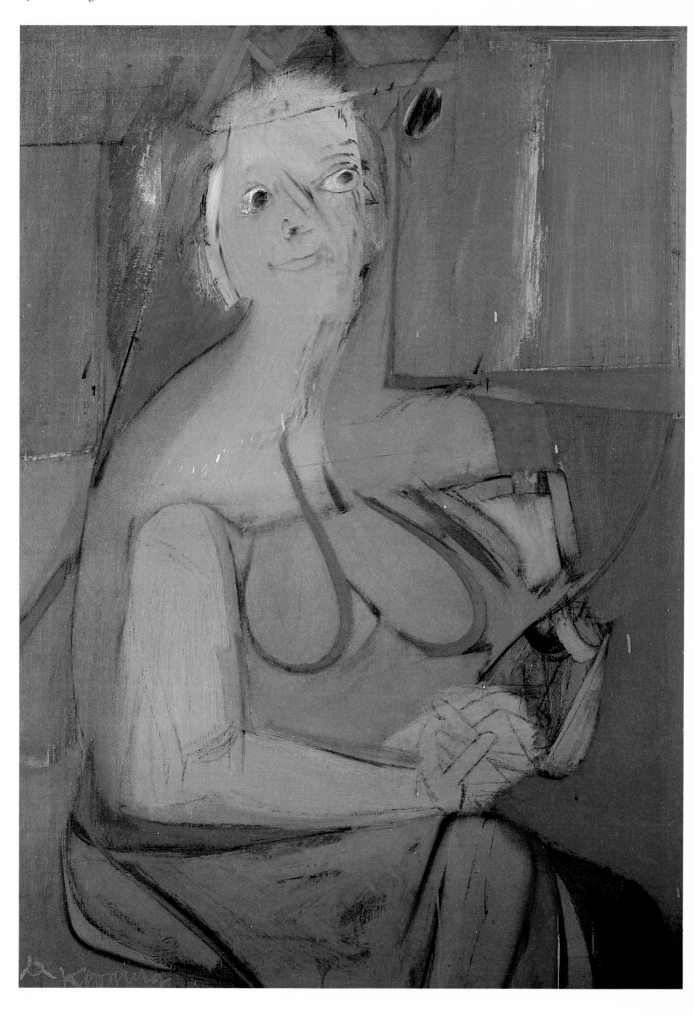

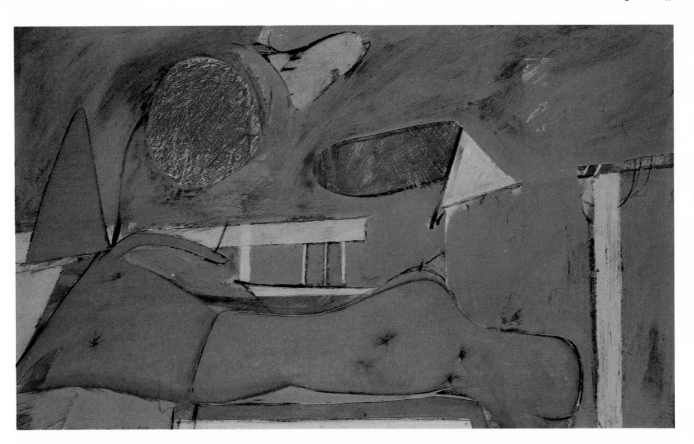

150
*Summer Couch, 1943
Oil on composition board
36x51″
Private collection, courtesy Allan Stone Gallery, New York

Following pages:

151
Queen of Hearts, c. 1943
Oil and charcoal on fiberboard
46⅛x27⅝″
Hirshhorn Museum and Sculpture Garden,
Smithsonian Institution, Washington, D.C.

149
Woman, 1942
Oil on canvas
41x29¾″
Private collection

152
Portrait of Max Margulis, 1944
Oil on board
46x28″
Private collection

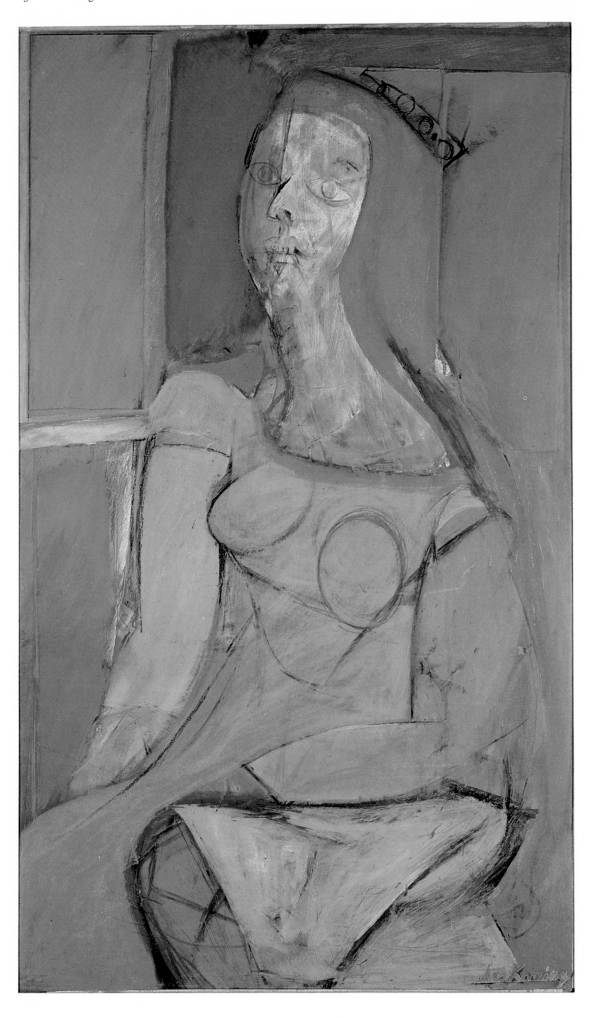

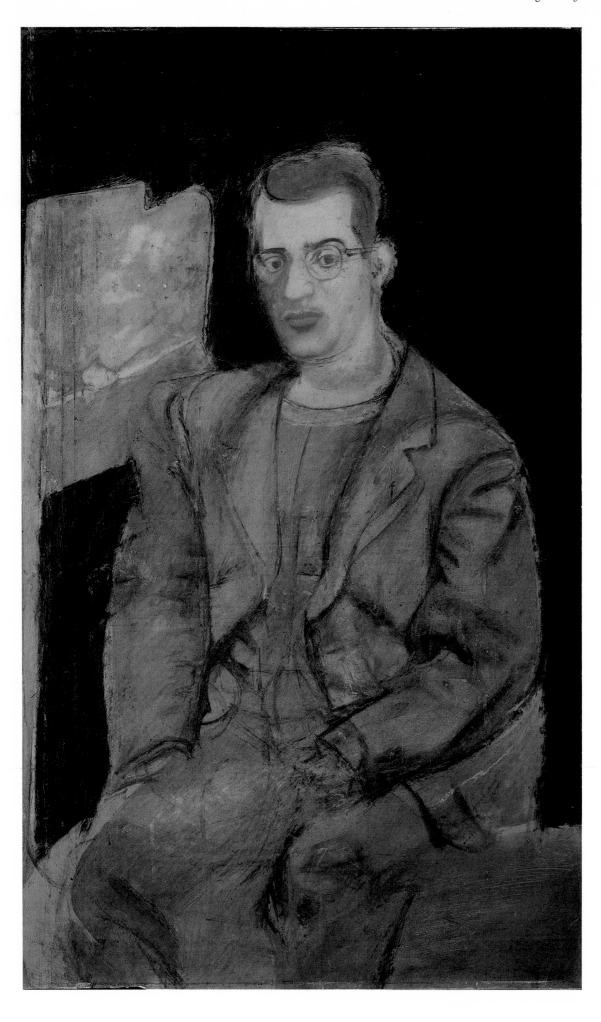

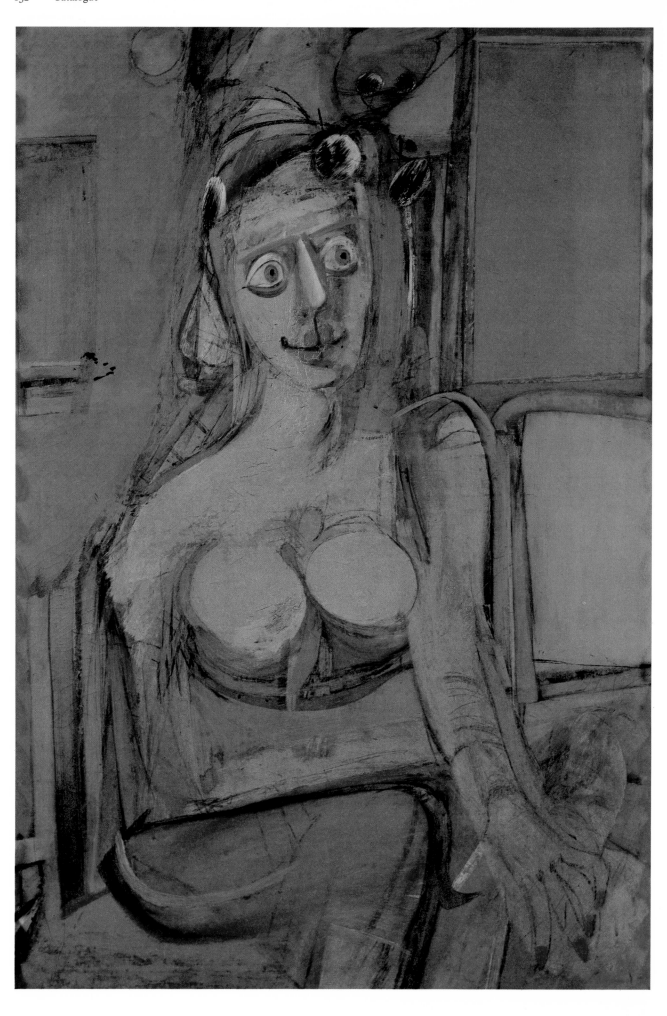

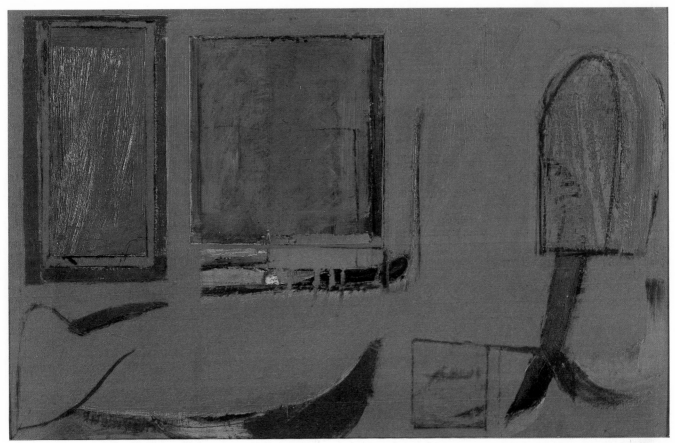

154
Untitled, c. 1944
Oil and charcoal on paper mounted on composition board
13½ x 21¼"
Collection of Mr. and Mrs. Lee V. Eastman

153
Woman, c. 1944
Oil and charcoal on canvas
46 x 32"
Private collection

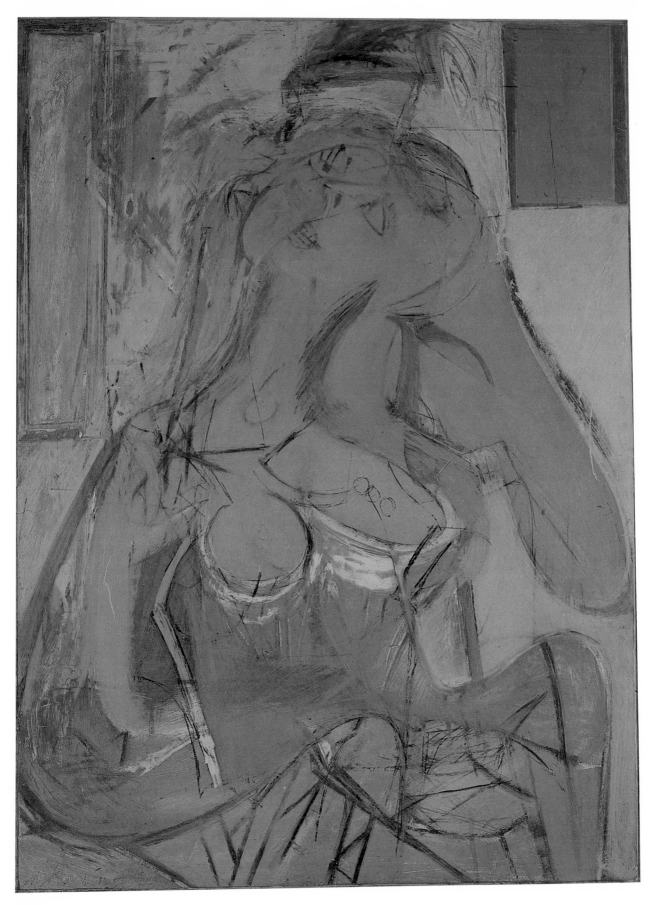

155
Pink Lady, c. 1944

Oil and charcoal on composition board
48⅜ x 35⅝″
Collection of Betty and Stanley K. Sheinbaum

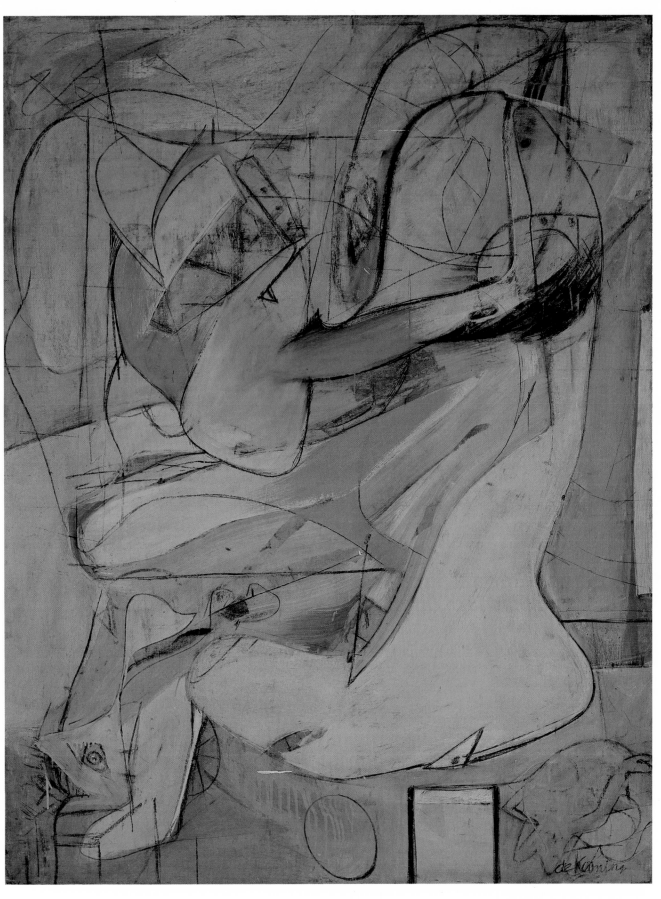

156
**Pink Angels, c. 1945
Oil and charcoal on canvas
52 x 40"
Collection of the Weisman Family

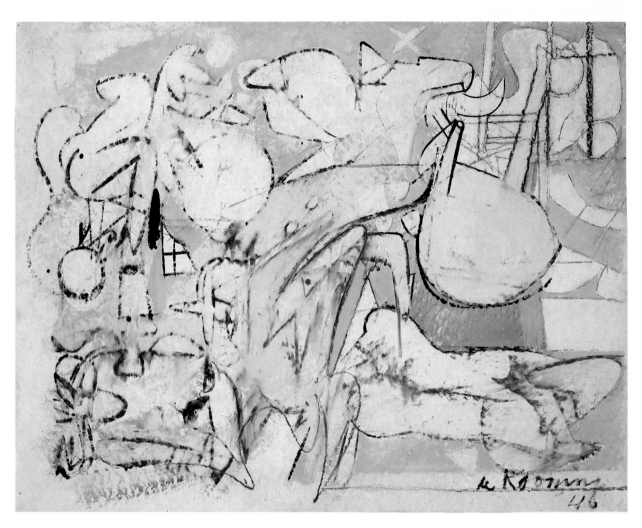

157
Special Delivery, 1946
Oil, enamel and charcoal on cardboard
23⅜ x 30″
Hirshhorn Museum and Sculpture Garden,
Smithsonian Institution, Washington, D.C.

158
Study for backdrop for Labyrinth, 1946
Oil and charcoal on paper
22⅛ x 28½″
Private collection

159
†Bill-Lee's Delight, 1946
Oil on paper mounted on composition board
27½ x 34½″
Collection of Mr. and Mrs. Lee V. Eastman

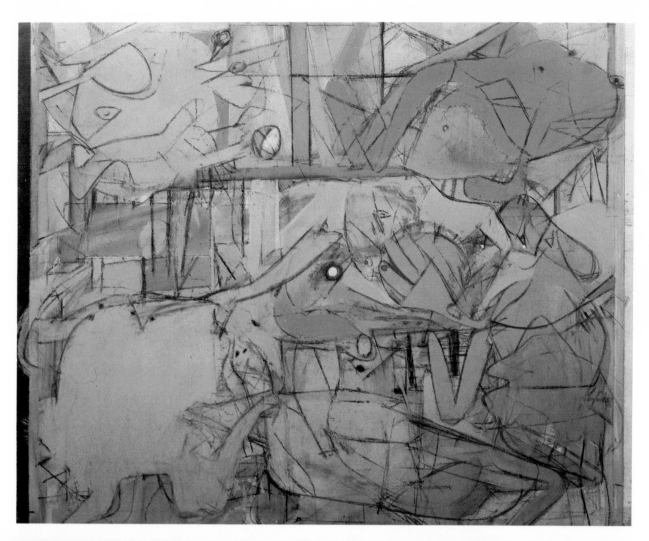

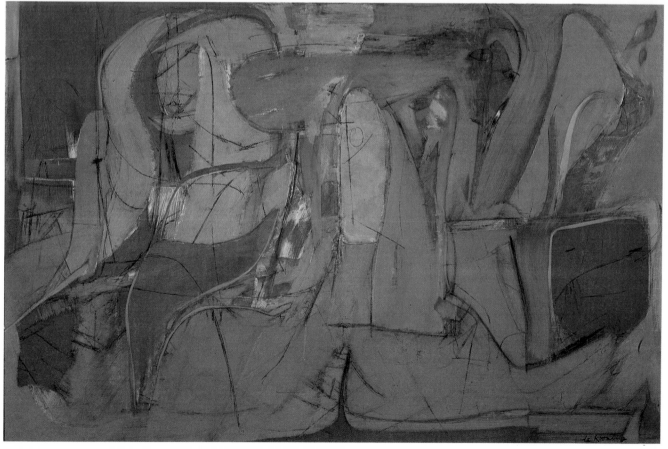

161
Zurich, 1947
Oil on paper
36¼ x 24¼"
Estate of Joseph H. Hirshhorn

160
Fire Island, 1946
Oil on paper
19½ x 27½"
Collection of Martin Z. Margulies

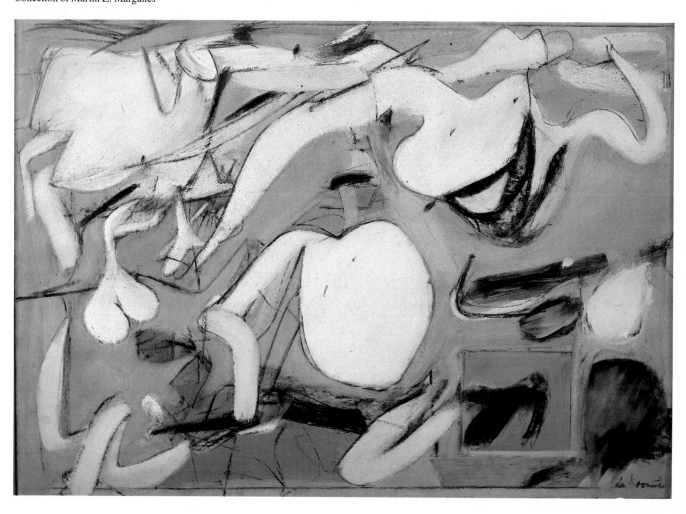

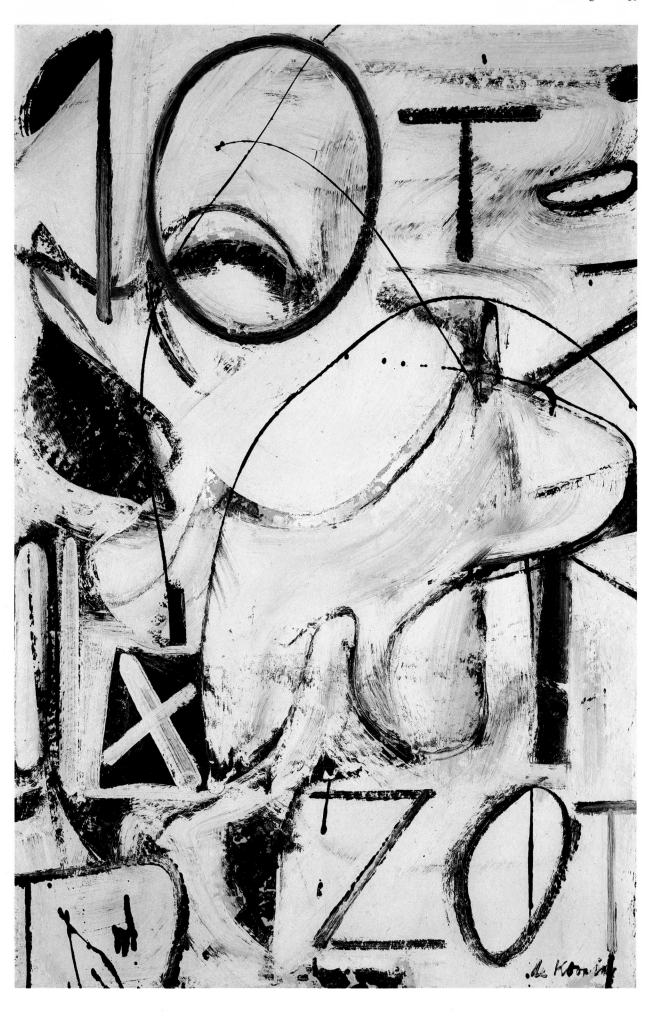

162
Untitled, 1947
Oil on board
23 x 29"
Private collection

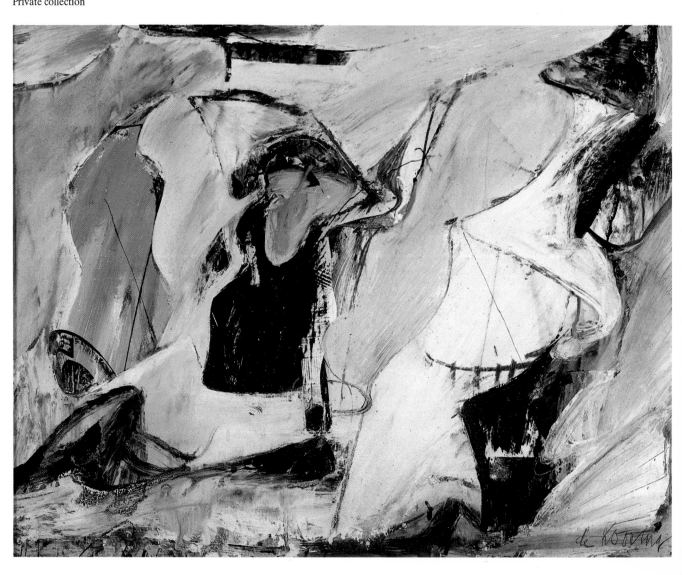

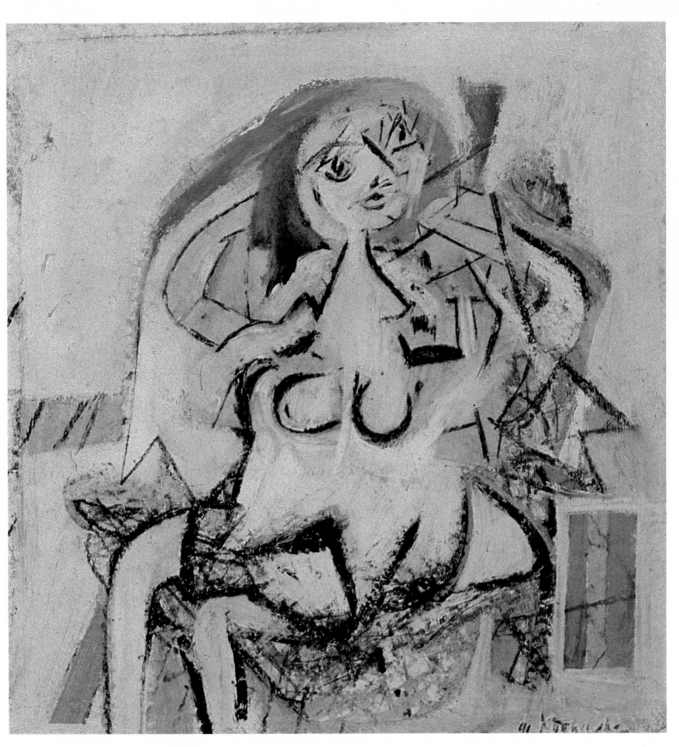

163
Woman, 1947
Oil on canvas
16 x 15½"
Courtesy American Broadcasting Companies, Inc.

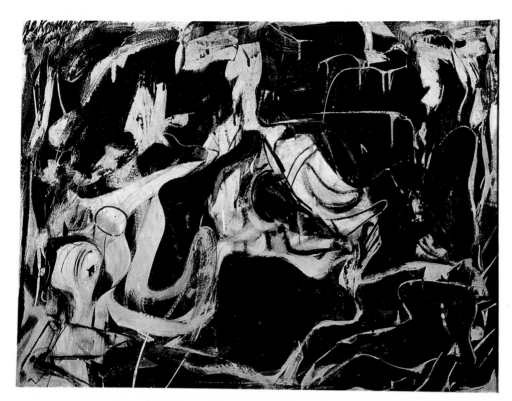

164
Untitled, 1948
Oil and enamel on paper
mounted on composition board
30×40″
Private collection

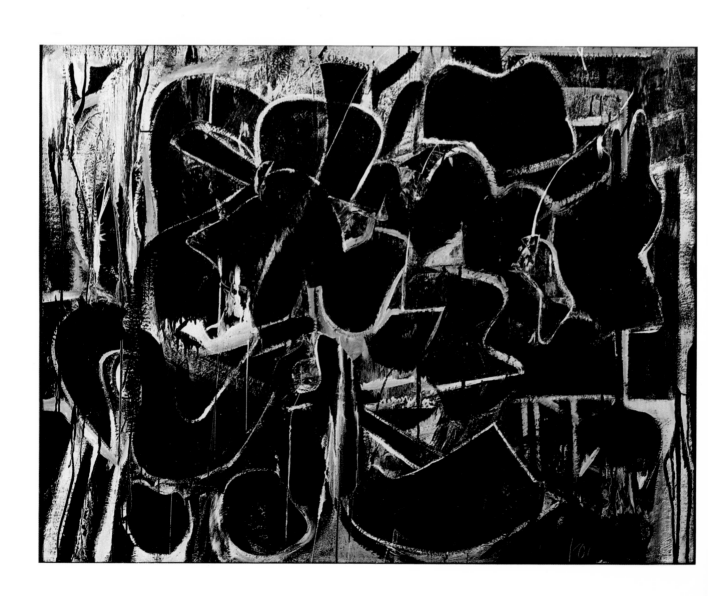

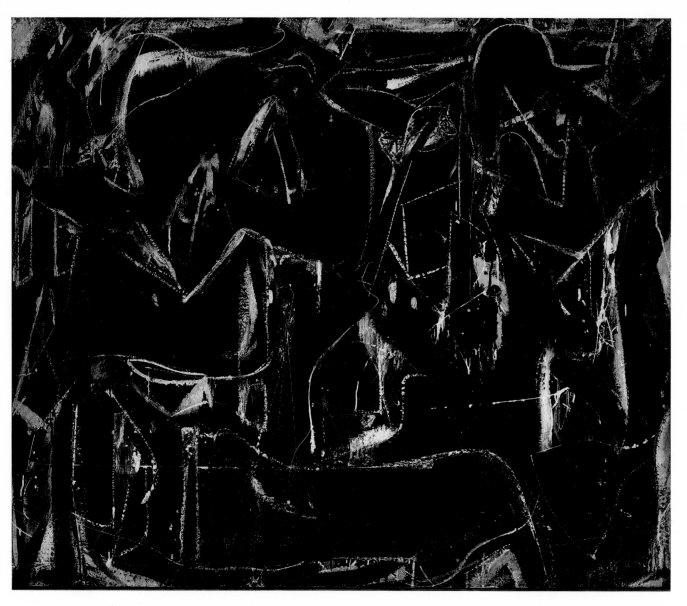

166
**Dark Pond, 1948
Enamel on composition board
46¾ x 55¾"
Collection of the Weisman Family

165
†Painting, 1948
Enamel and oil on canvas
42⅝ x 56⅛"
The Museum of Modern Art, New York; Purchase

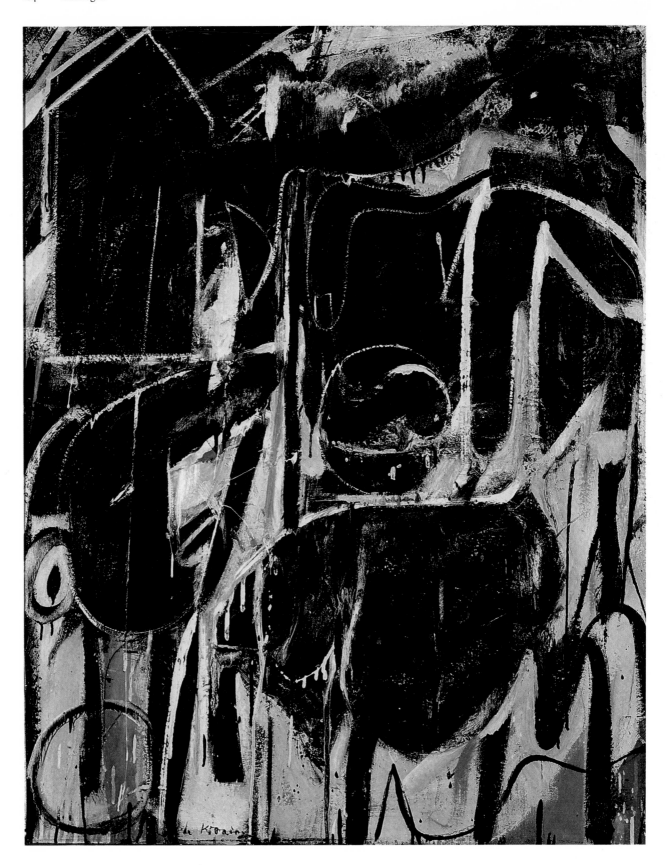

167

Black Friday, 1948

Oil and enamel on composition board
48x38"
Collection of Mrs. H. Gates Lloyd;
Partial gift to the Art Museum,
Princeton University, Princeton

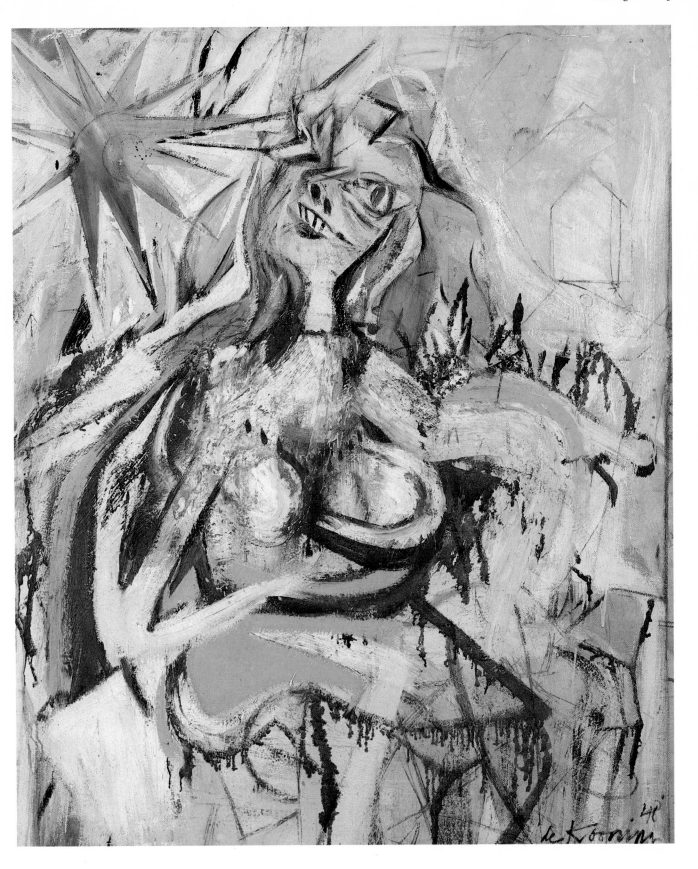

168
Woman, 1948
Oil and enamel on composition board
53⅝ × 44⅝″
Hirshhorn Museum and Sculpture Garden,
Smithsonian Institution, Washington, D.C.

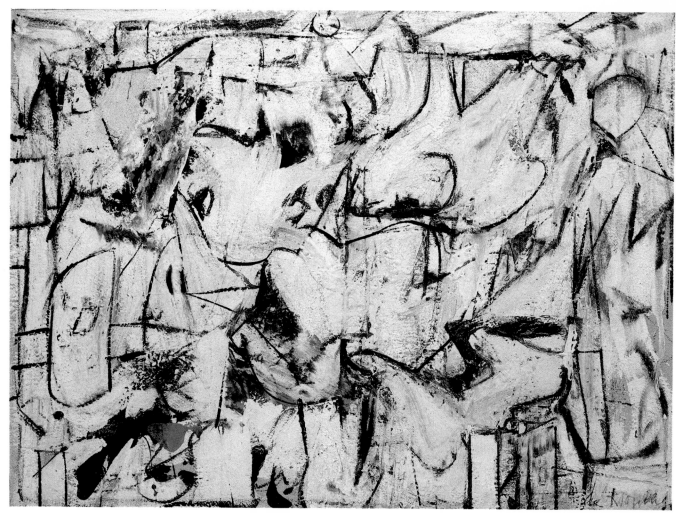

169
*Town Square, 1948

Oil on canvas
17 x 23½"
Richard E. and Jane M. Lang Collection

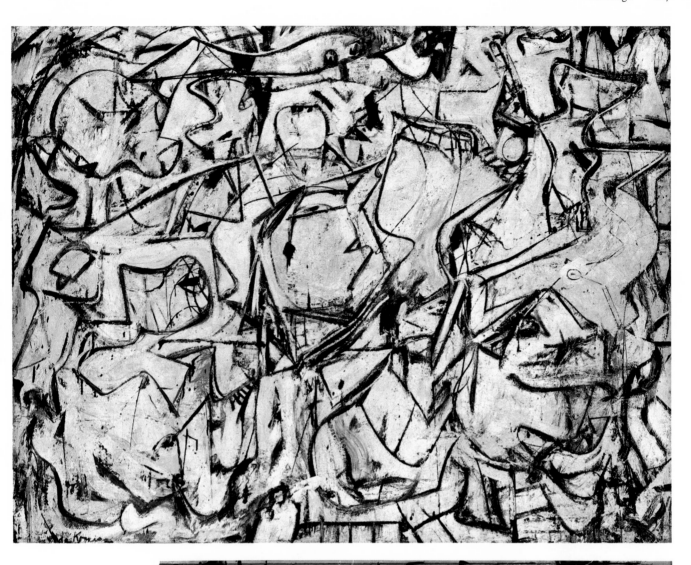

170 △

*Attic, 1949

Oil on canvas
61⅜ x 80¼"
Jointly owned by The Metro-
politan Museum of Art and
Muriel Kallis Newman, in
honor of her son Glenn David
Steinberg; The Muriel Kallis
Steinberg Newman Collection,
1982

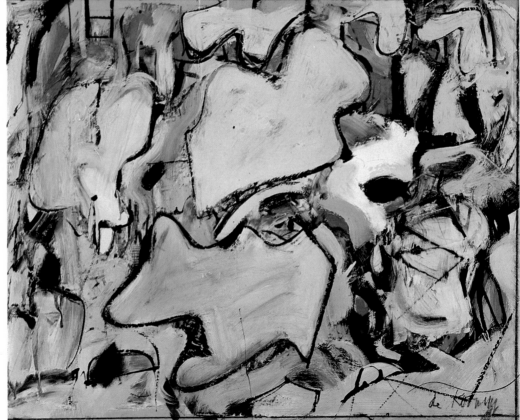

171 ▷

†Attic Study, 1949

Oil and enamel on buff paper
mounted on composition board
18⅞ x 23⅞"
Menil Foundation Inc., Houston

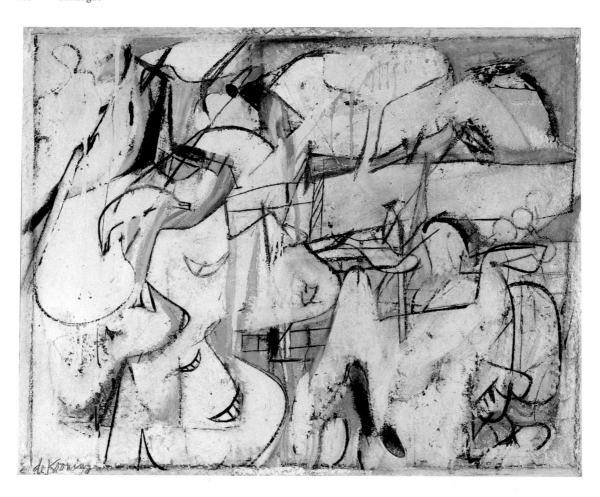

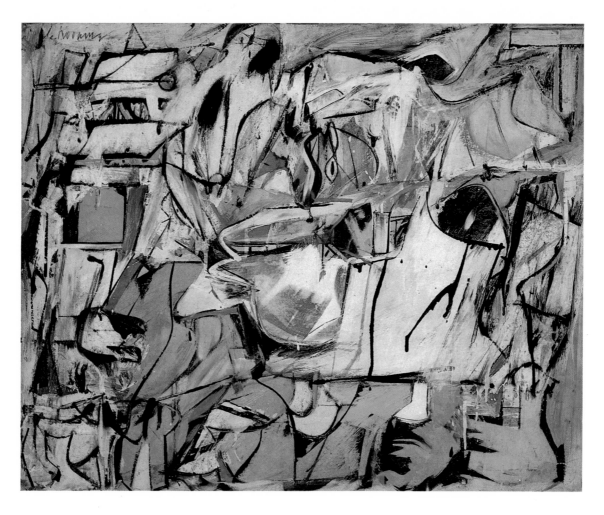

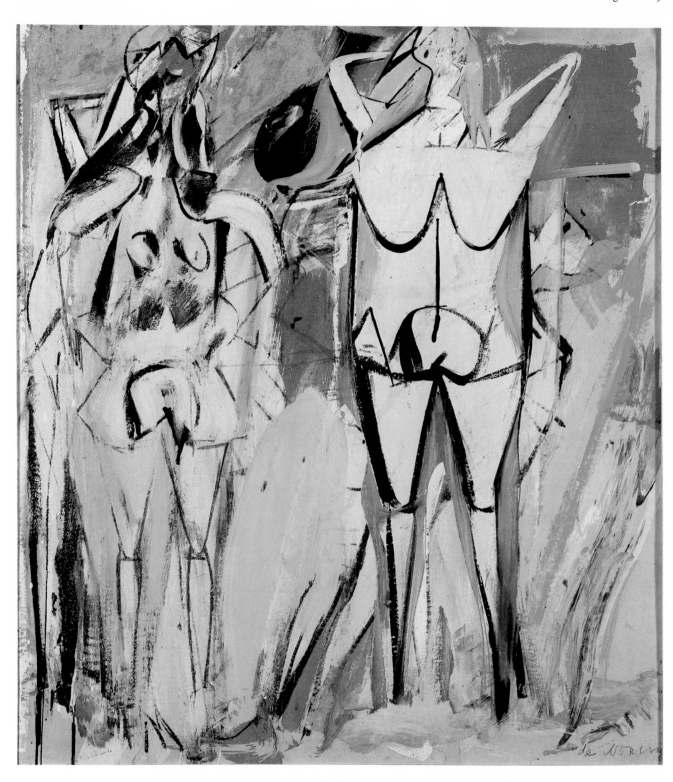

174
Two Standing Women, 1949
Oil on canvas
29½ x 26¼″
Collection of Mr. and Mrs. Irwin Green

172
*Mailbox, 1948
Oil, enamel and charcoal on paper mounted on composition board
23¼ x 30″
Collection of Edmund Pillsbury

173 ◁
Asheville, 1949
Oil and enamel on cardboard mounted on composition board
25⅝ x 32″
The Phillips Collection, Washington, D.C.

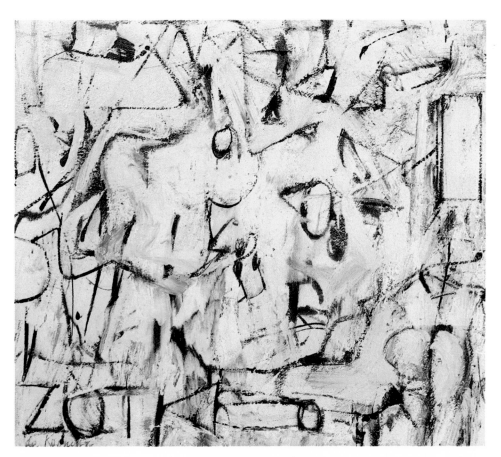

175
ZOT, 1949
Oil on paper
mounted on composition board
18 x 20½"
Private collection

176
Sail Cloth, 1949
Oil on canvas
24 x 30"
Collection of Donald
and Barbara Jonas

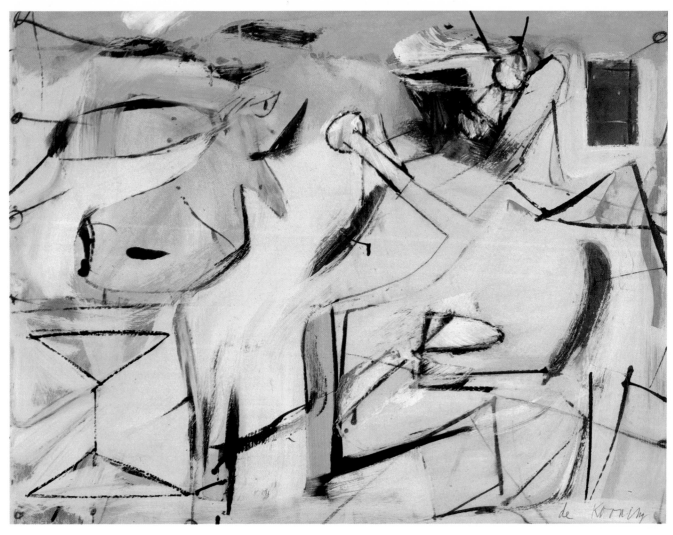

177
Two Women on a Wharf, 1949
Oil, enamel, pencil and collage on paper
24⁷⁄₁₆ x 24½"
Art Gallery of Ontario, Toronto;
Purchase, Membership Endowment Fund, 1977

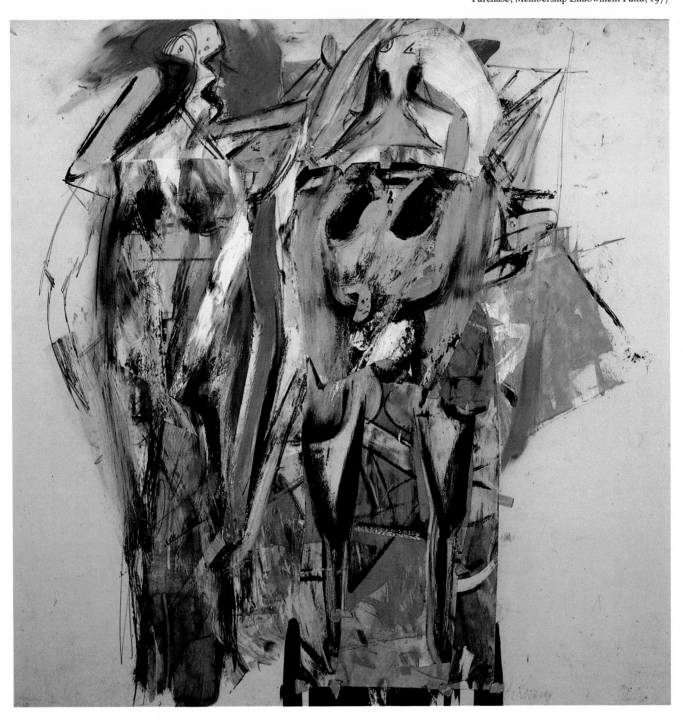

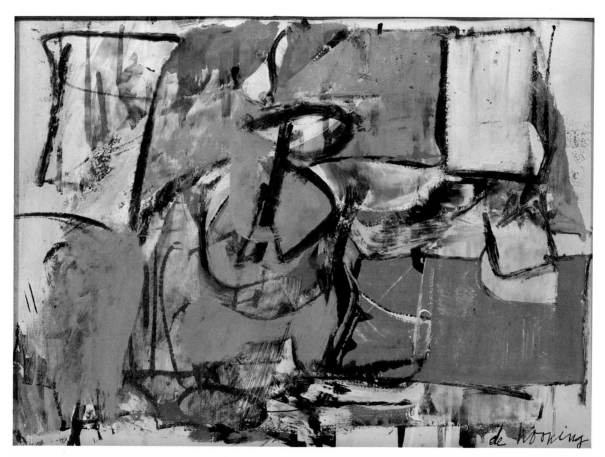

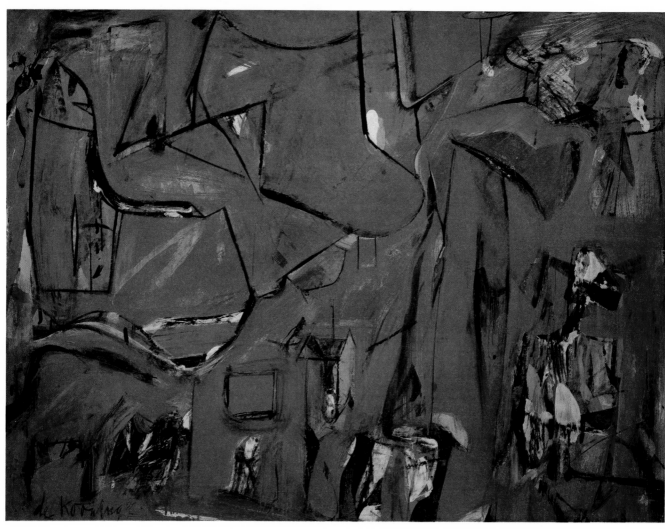

178 ◁
Boudoir, 1950
Oil and enamel on paper
15 x 20¾"
Private collection, courtesy Allan Stone Gallery, New York

180
†Excavation, 1950
Oil and enamel on canvas
6'8⅛" x 8'4⅛"
The Art Institute of Chicago;
Mr. and Mrs. Frank G. Logan Purchase Prize;
Gift of Mr. Edgar Kaufmann, Jr.
and Mr. and Mrs. Noah Goldowsky

179
*Gansevoort Street, c. 1949
Oil on cardboard
30 x 40"
Collection of Mr. and Mrs. Harry W. Anderson

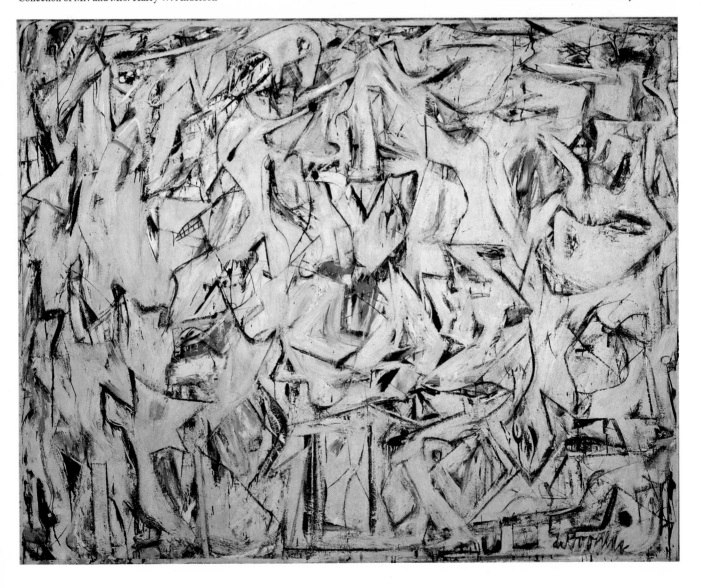

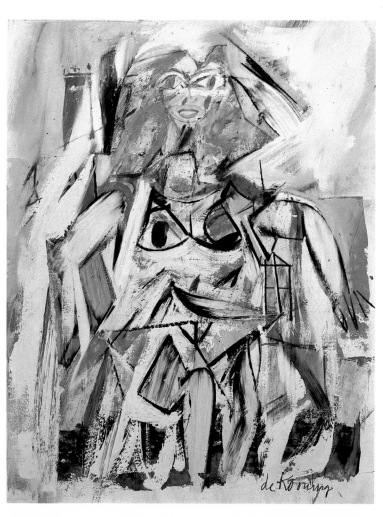

181
Study for Woman, 1950
Oil and enamel on paper with collage
14⅝ x 11⅝"
Private collection

183 ▷
Woman, 1949-50
Oil on canvas
64 x 46"
Weatherspoon Art Gallery,
University of North Carolina
at Greensboro ; Lena Kernodle
McDuffie Memorial Gift

182
Woman, Wind and Window I, 1950
Oil and enamel on paper mounted on board
24⅛ x 36"
Warner Communications, Inc., New York

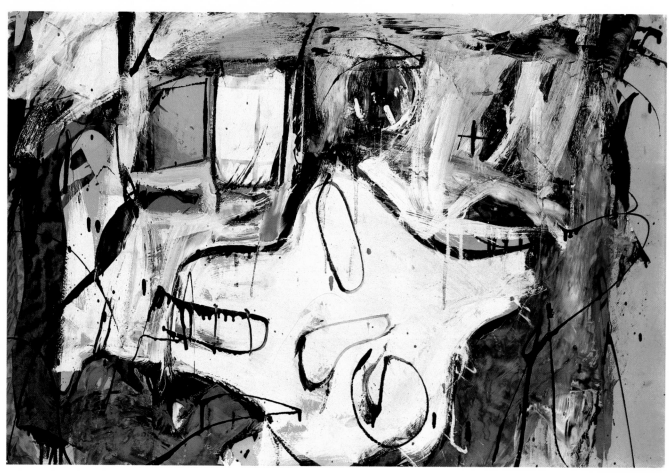

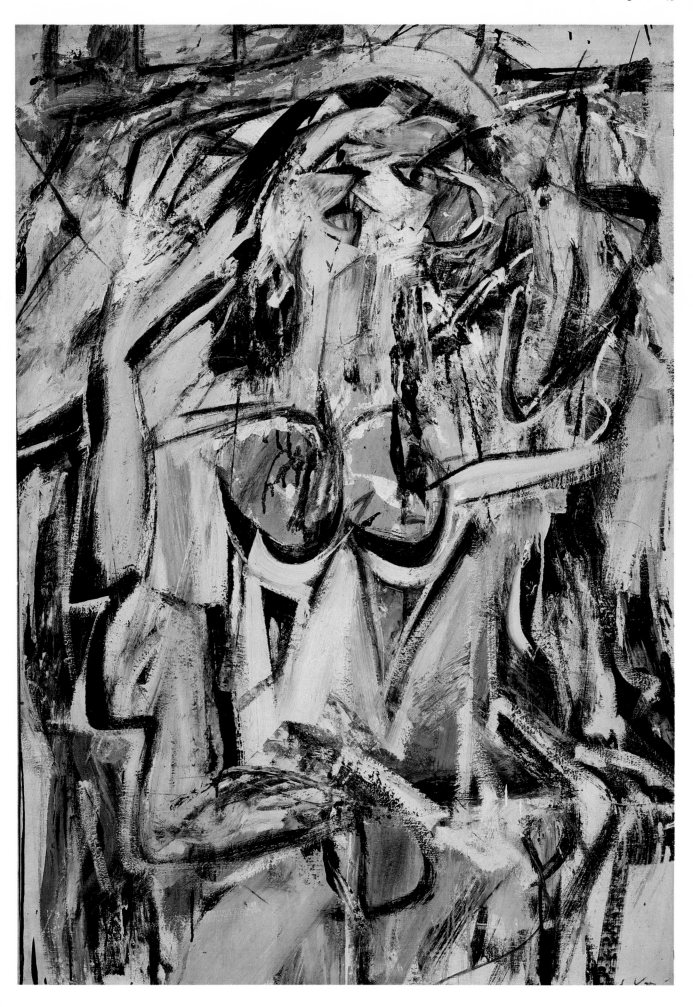

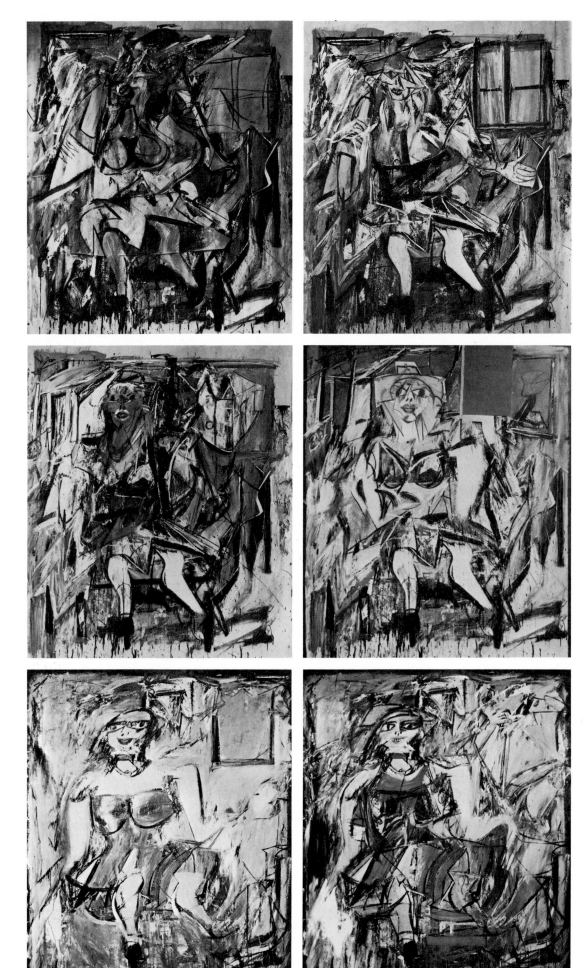

184-189
Six stages of
Women I,
1950-52
Photographed by
Rudolph Burckhardt

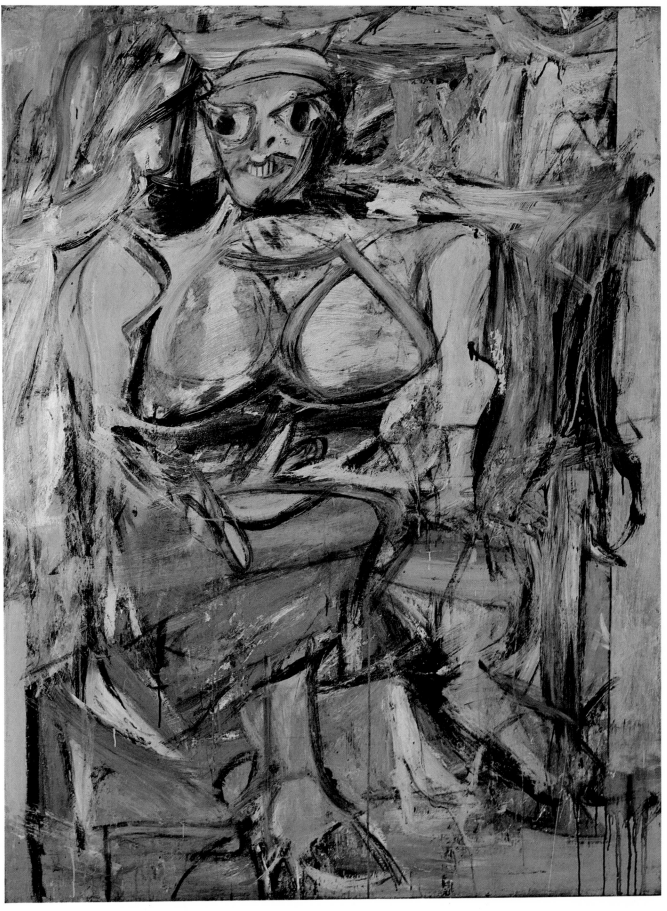

190

†Woman I, 1950-52

Oil on canvas

75⅞ x 58"

The Museum of Modern Art, New York; Purchase

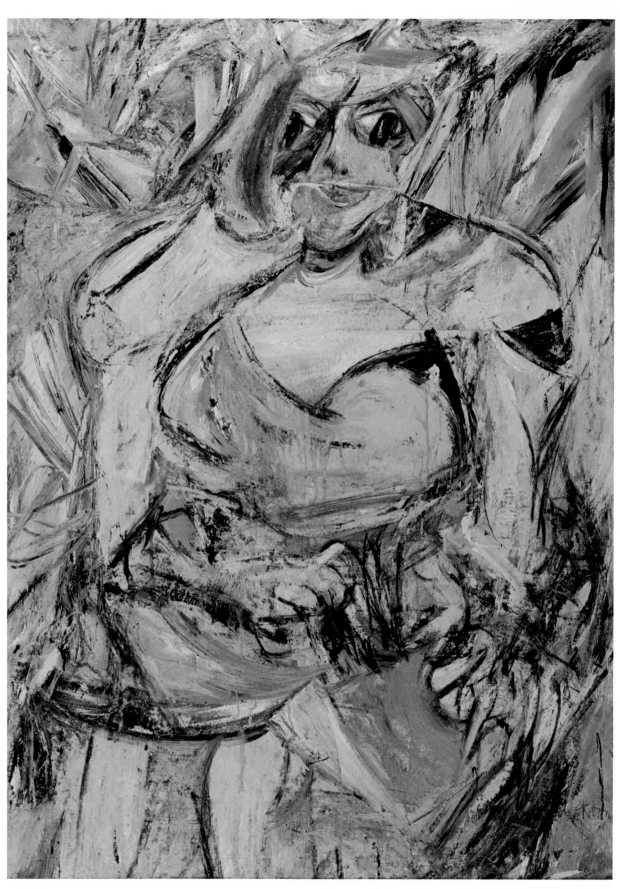

191
*Woman II, 1952

Oil on canvas
59×43″
The Museum of Modern Art, New York;
Gift of Mrs. John D. Rockefeller 3rd

192
Woman and Bicycle, 1952-53

Oil on canvas
76½×49″
Whitney Museum of American Art, New York;
Purchase 55.35

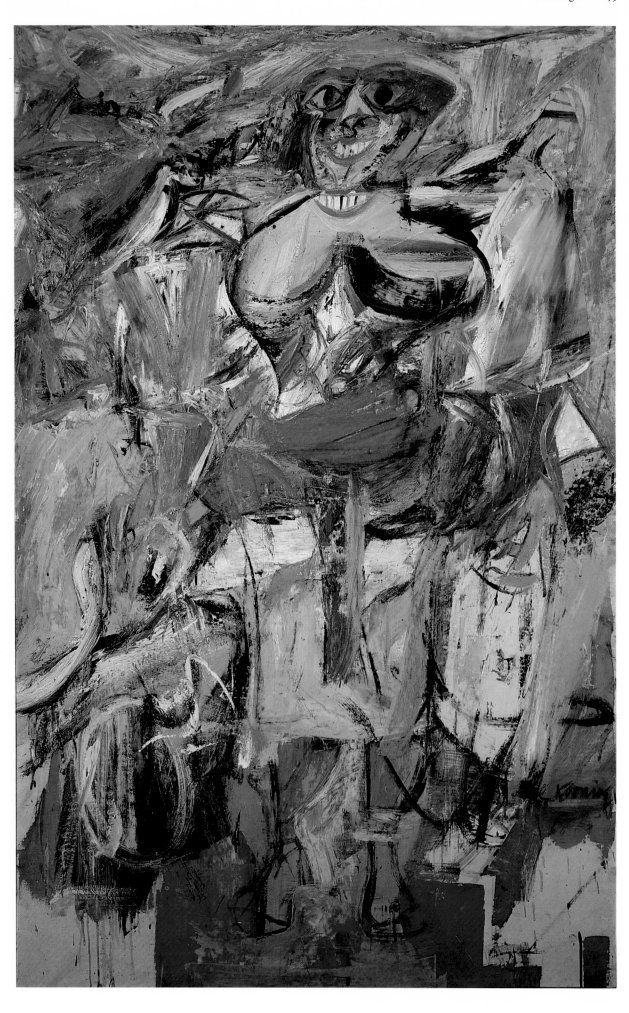

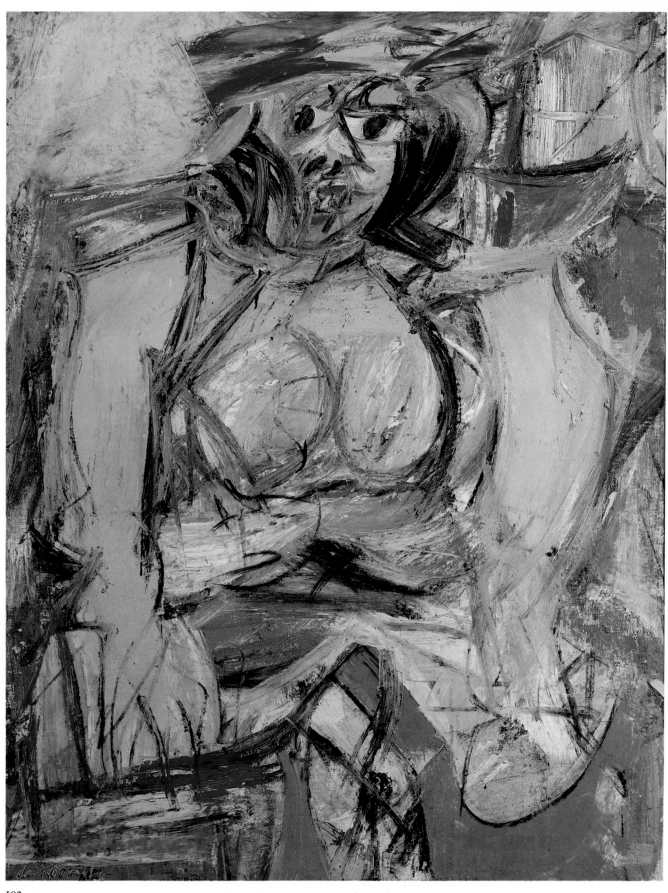

193
**Woman IV, 1952-53

Oil and enamel on canvas
56×46¼″
Nelson-Atkins Museum of Art, Kansas City, Missouri;
Gift of William Inge

194
†Woman III, 1952-53

Oil on canvas
68×48½″
Teheran Museum of Contemporary Art

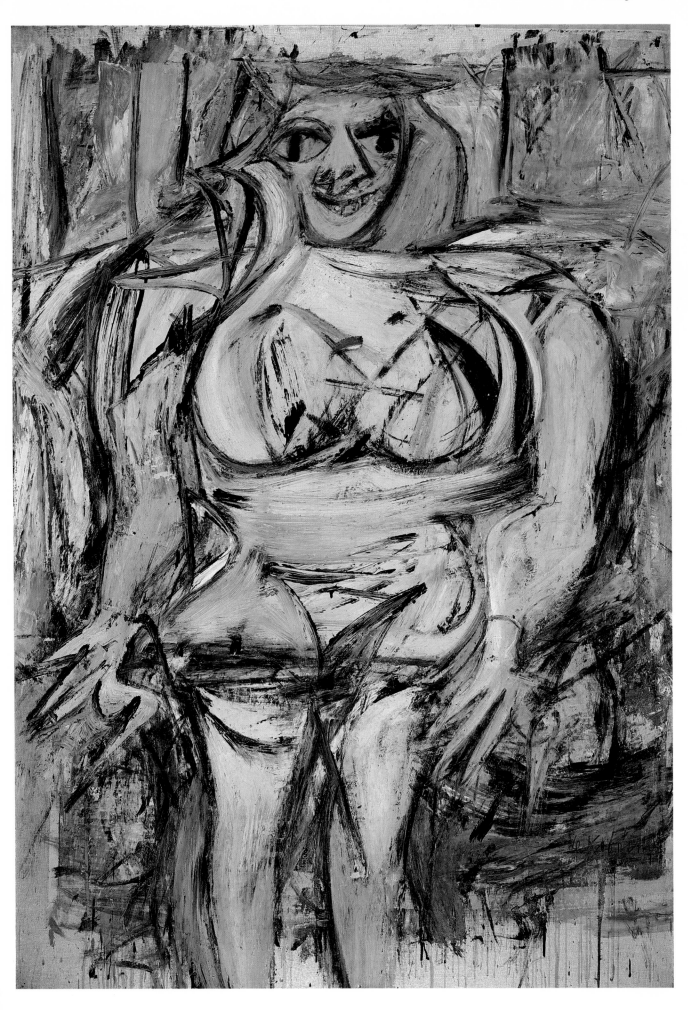

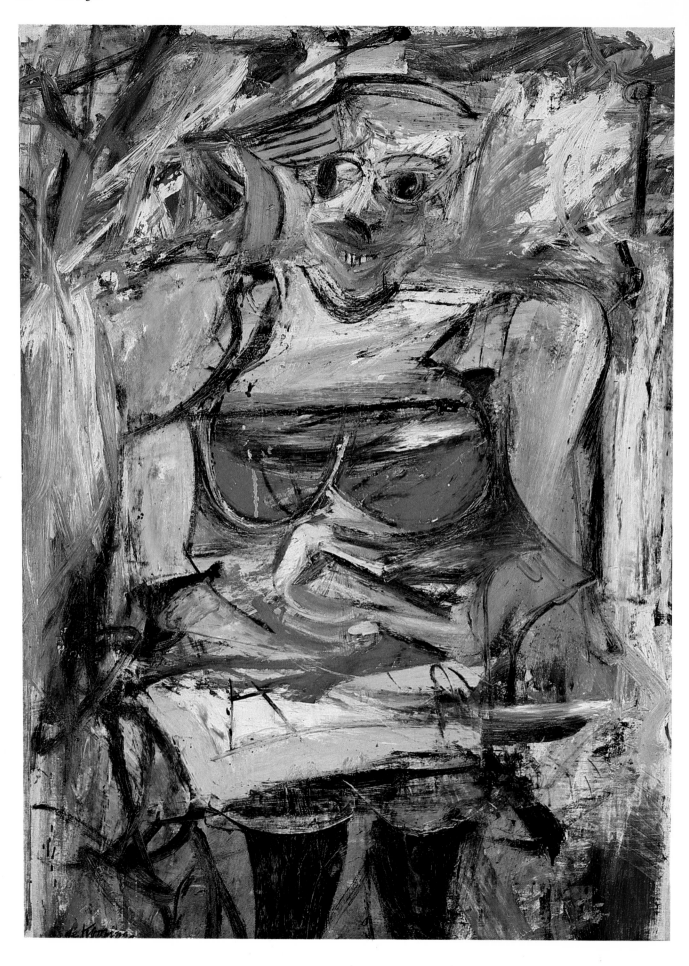

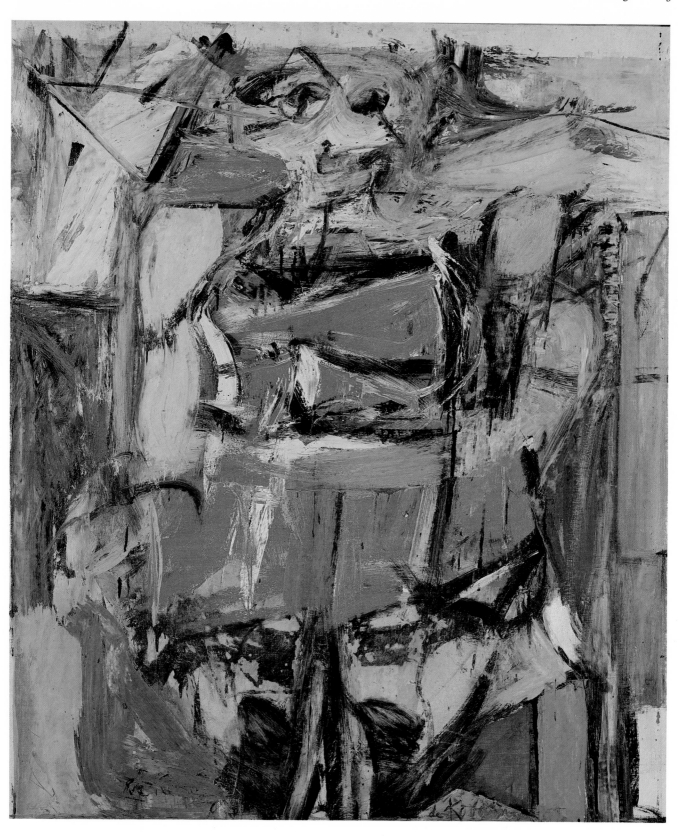

195
†Woman V, 1952–53
Oil on canvas
61×45″
Australian National Gallery, Canberra

196
Woman VI, 1953
Oil on canvas
68½×58½″
Museum of Art, Carnegie Institute,
Pittsburgh; Gift of G. David Thompson, 1955

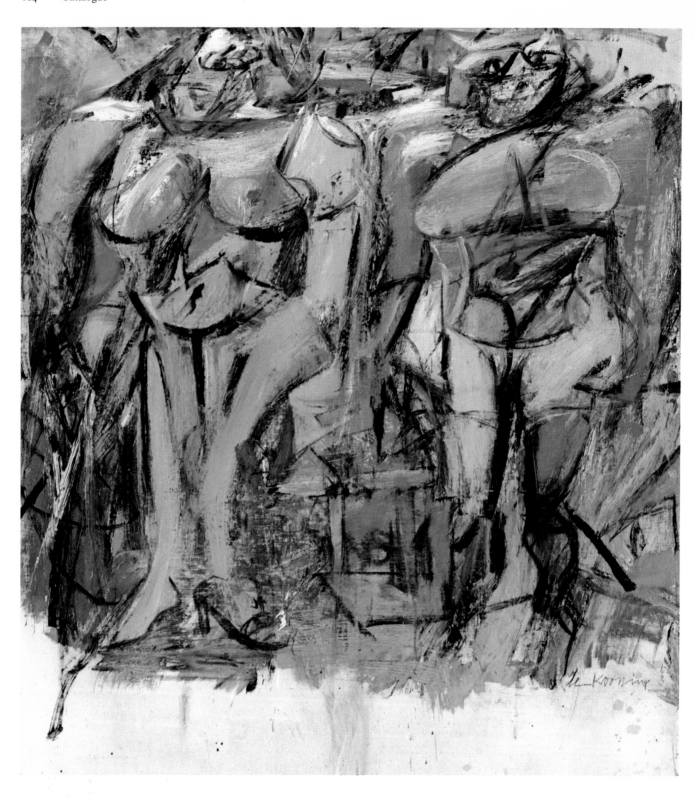

197
Two Women in the Country, 1954

Oil, enamel and charcoal on canvas
46⅛×40¾″
Hirshhorn Museum and Sculpture Garden,
Smithsonian Institution, Washington, D.C.

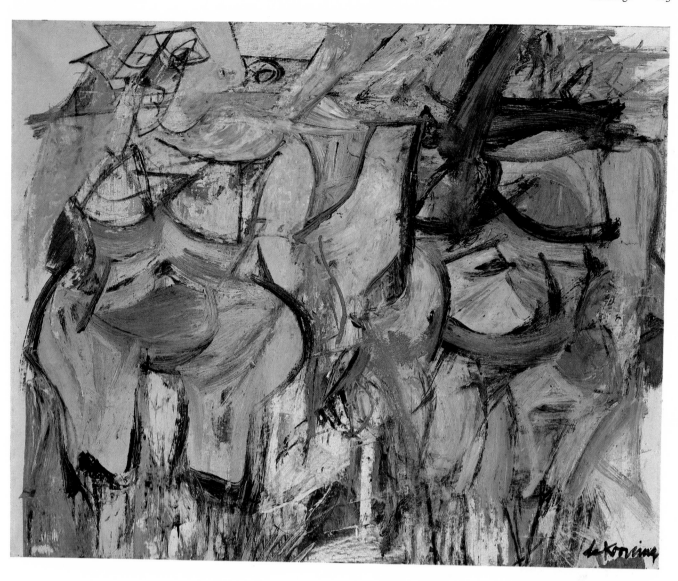

198
*Two Women, 1954-55
Oil and charcoal on canvas
40⅛ x 50″
Private collection

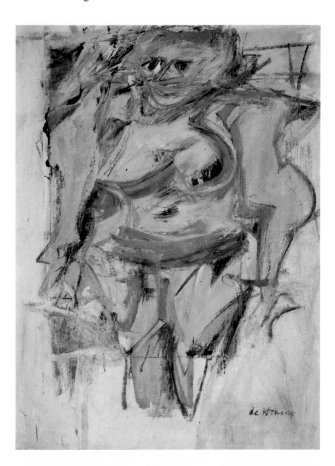

199
*Woman Standing Pink, 1954-55
Oil on canvas
48⅛ x 36⅛"
Collection of Mr. and Mrs. Harry W. Anderson

200
*Street Corner Incident, 1955
Oil on canvas
41 x 49"
Private collection, courtesy
Allan Stone Gallery, New York

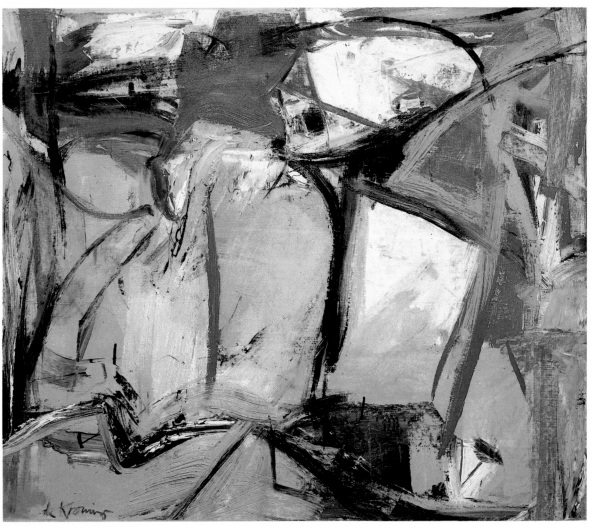

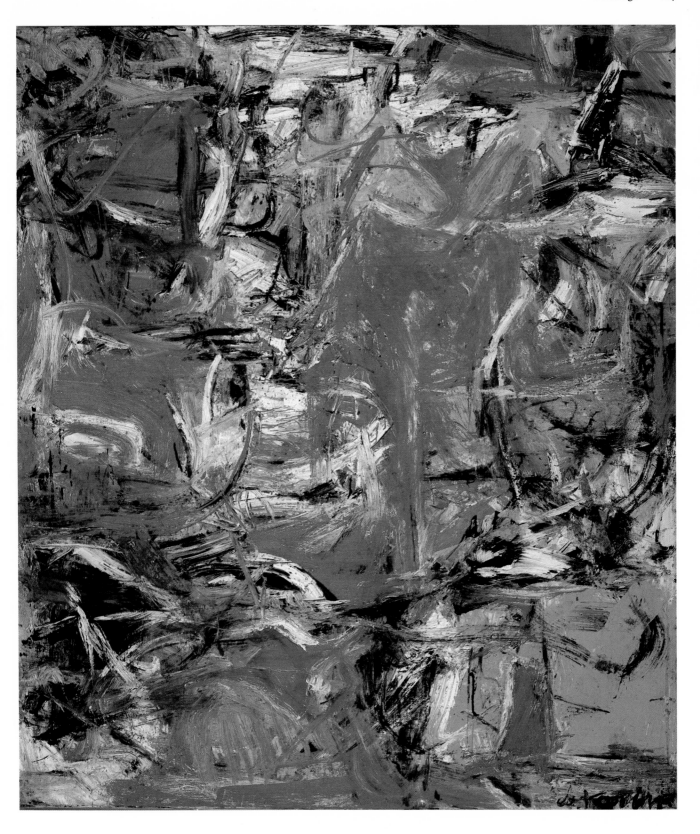

201
*Composition, 1955
Oil, enamel and charcoal on canvas
79¼ x 69¼"
The Solomon R. Guggenheim Museum, New York

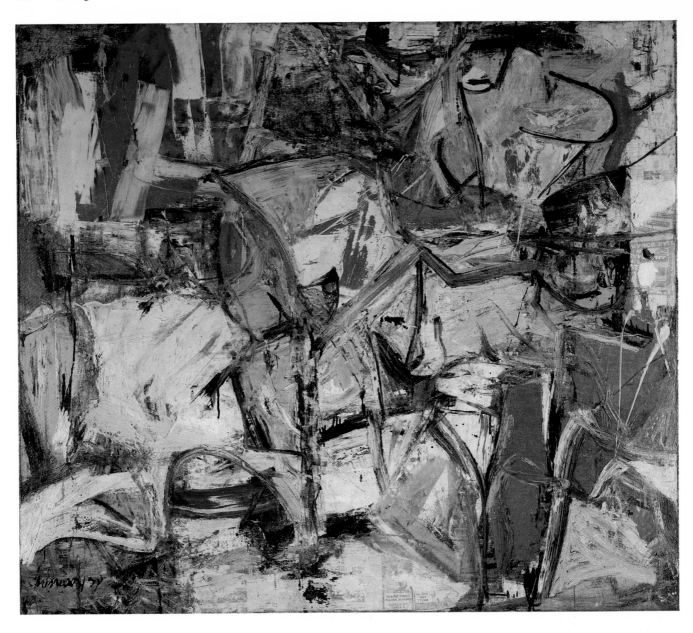

202
†Gotham News, 1955-56
Oil, enamel and charcoal on canvas
69½ x 79¾"
Albright-Knox Art Gallery, Buffalo

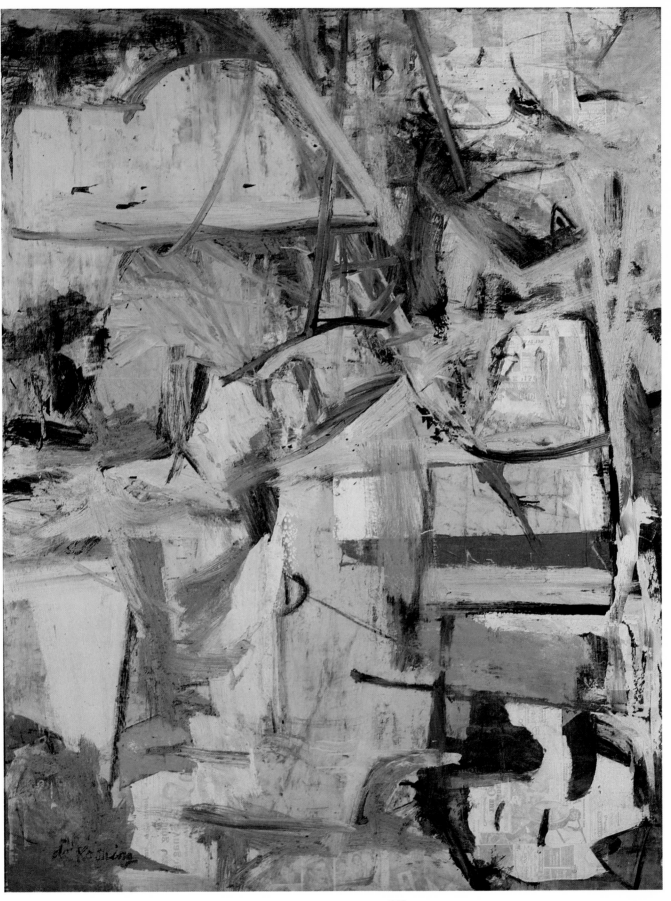

203
*Easter Monday, 1955-56

Oil of canvas
96¼ x 73⅞"
The Metropolitan Museum of Art, New York; Rogers Fund, 1956

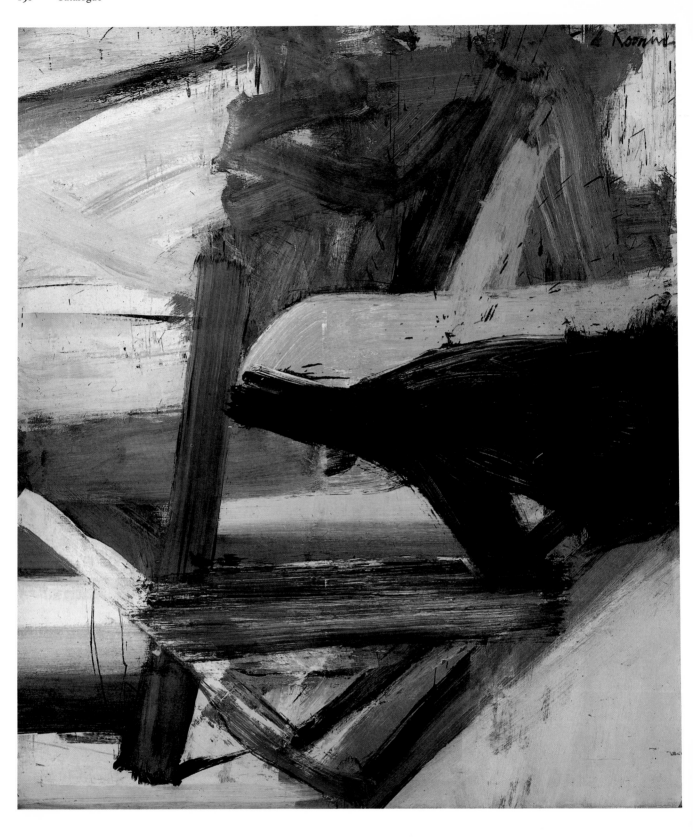

204

*Bolton Landing, 1957

Oil on canvas
83¾ x 74″
Inland Steel Company, Chicago

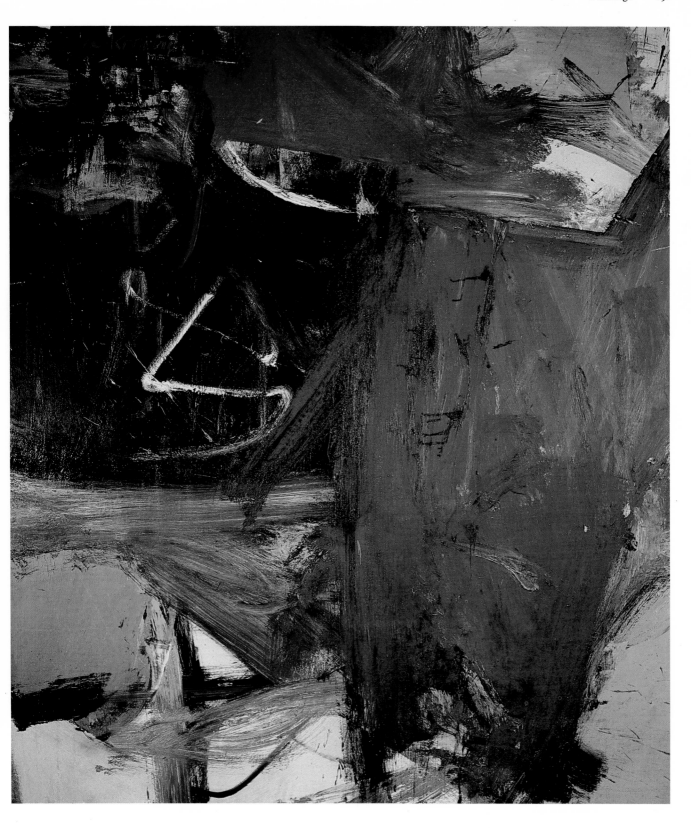

205
Parc Rosenberg, 1957
Oil on canvas
80 x 70"
Collection of Ben Heller

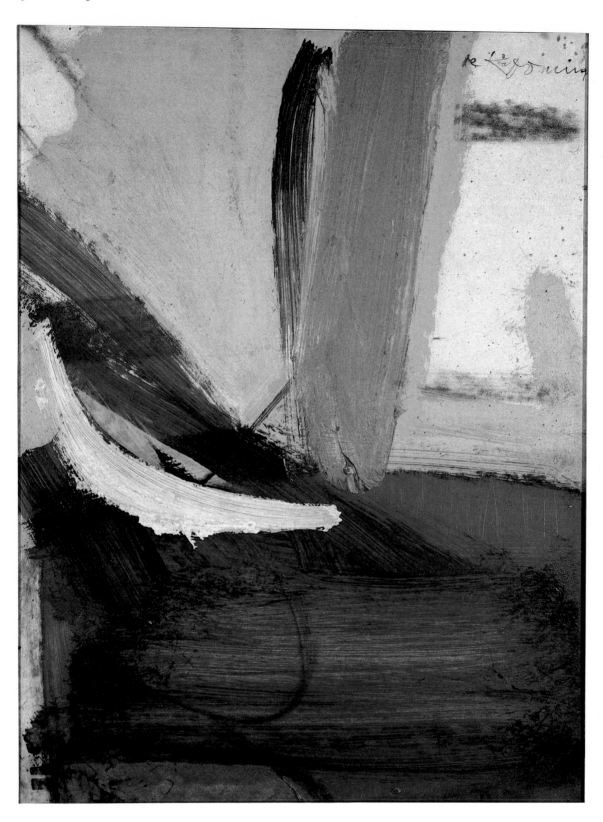

206

Untitled 9, 1957-58

Oil on paper
20½ x 15½"
Xavier Fourcade, Inc., New York

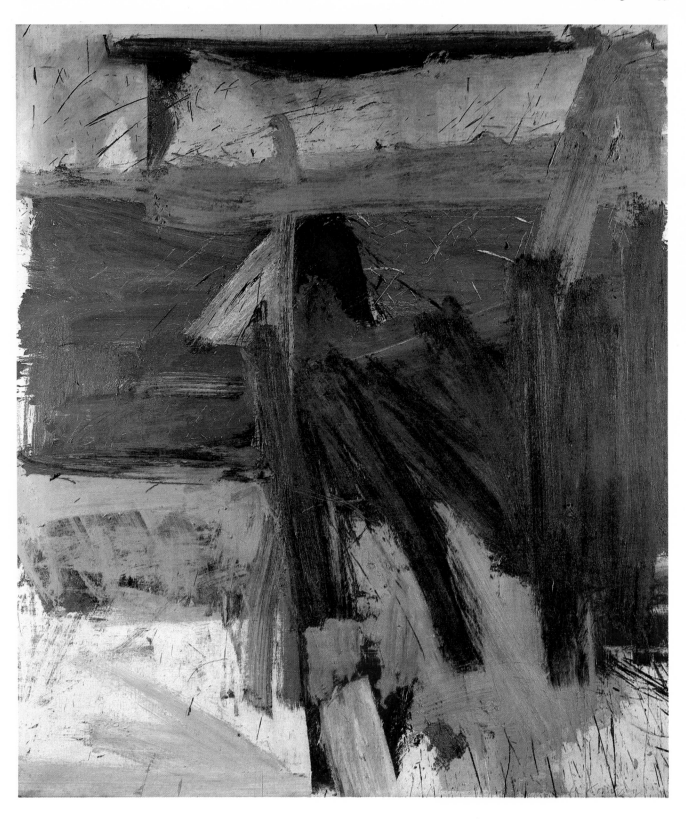

207
Ruth's Zowie, 1957
Oil on canvas
80¼ x 70⅛"
Private collection

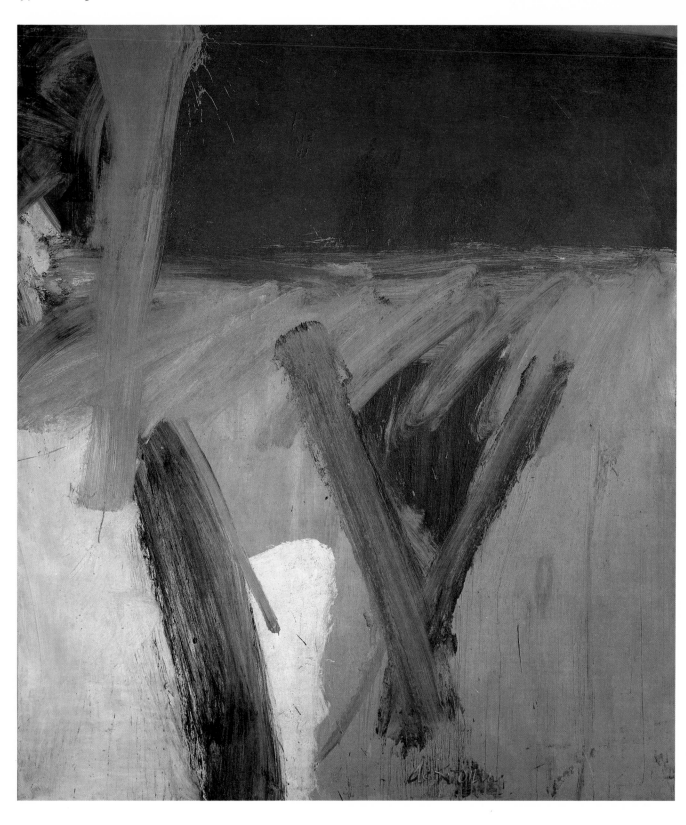

208

†Suburb in Havana, 1958

Oil on canvas
80 x 70″
Collection of Mr. and Mrs. Lee V. Eastman

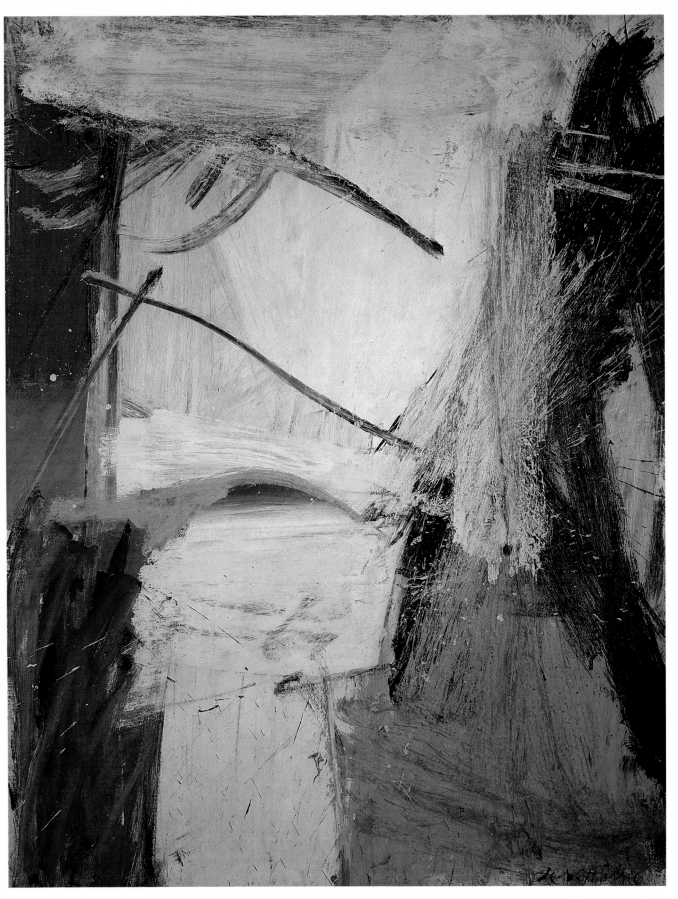

209
*September Morn, 1958
Oil on canvas
62⅞ x 49⅜"
Private collection

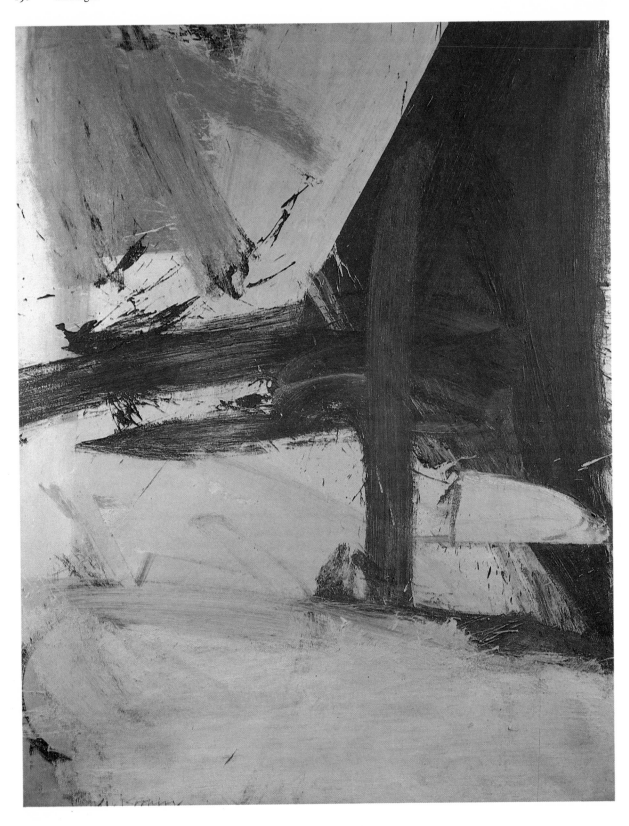

210

Souvenir of Toulouse, 1958

Oil on canvas
62 x 49½″
Private collection

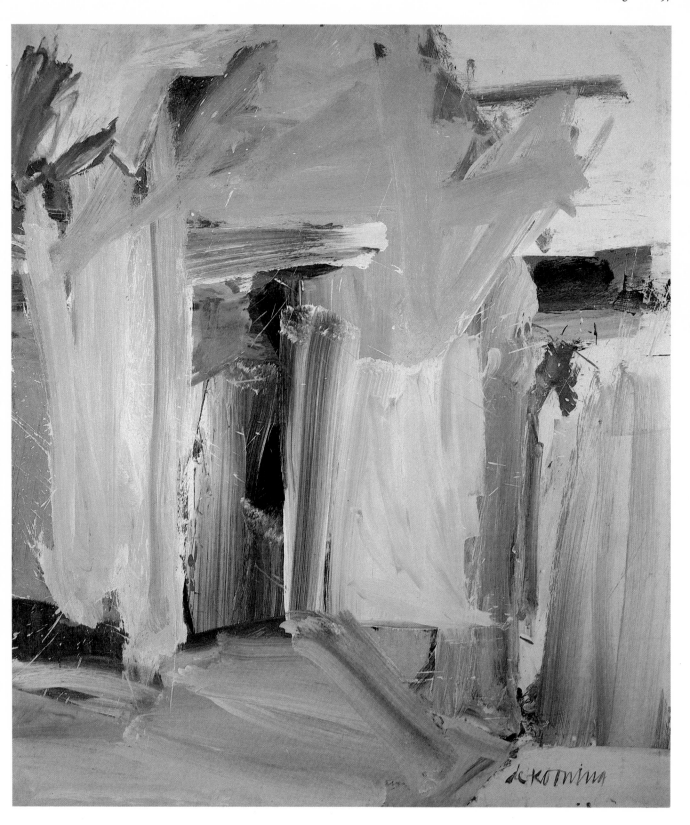

211
Door to the River, 1960

Oil on canvas
80 x 70″
Whitney Museum of American Art, New York;
Gift of the Friends of the Whitney Museum of American Art 60.63

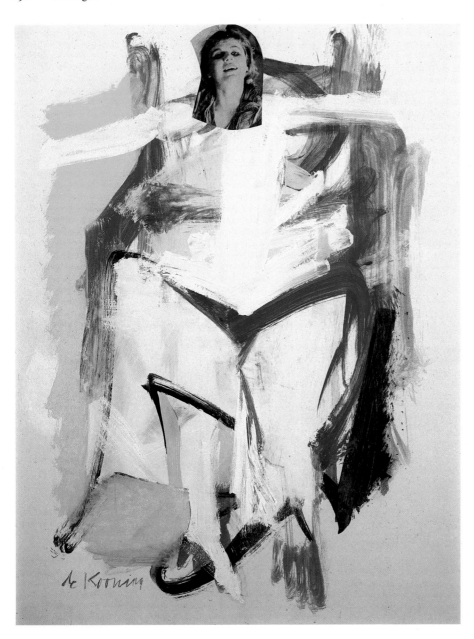

212
Woman I, 1961
Oil on paper with collage
29 x 22⅜"
Private collection

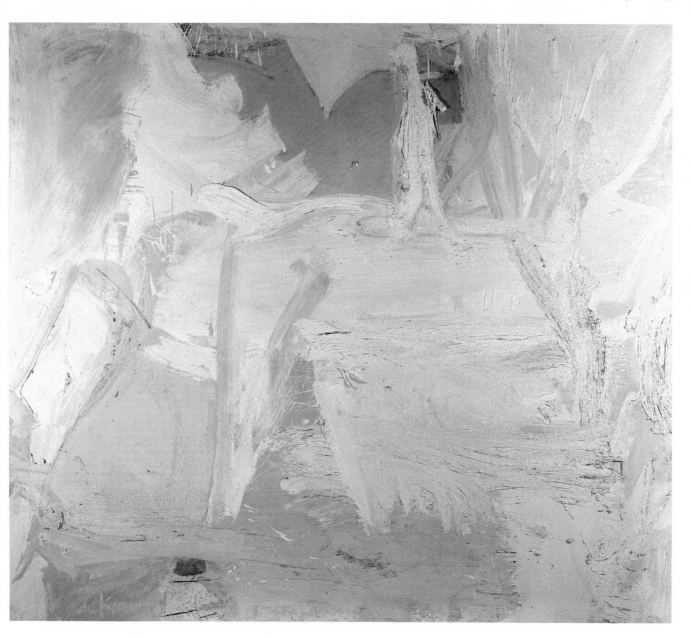

213
Pastorale, 1963
Oil on canvas
70 x 80″
Private collection

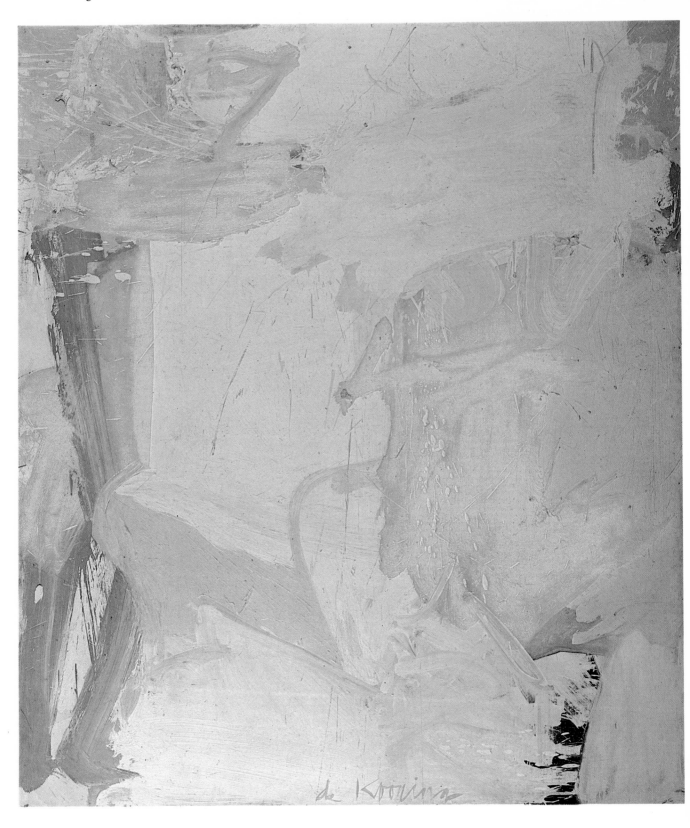

214

Rosy-Fingered Dawn at Louse Point, 1963

Oil on canvas
80⅛ x 70⅜"
Stedelijk Museum, Amsterdam

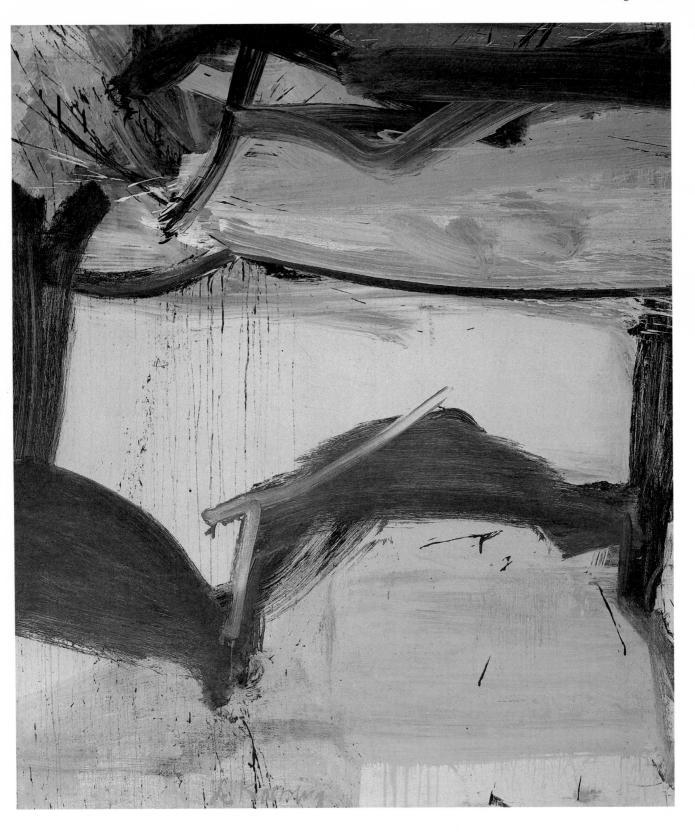

215
Untitled, 1963
Oil on canvas
80 x 70"
Hirshhorn Museum and Sculpture Garden,
Smithsonian Institution, Washington, D.C.

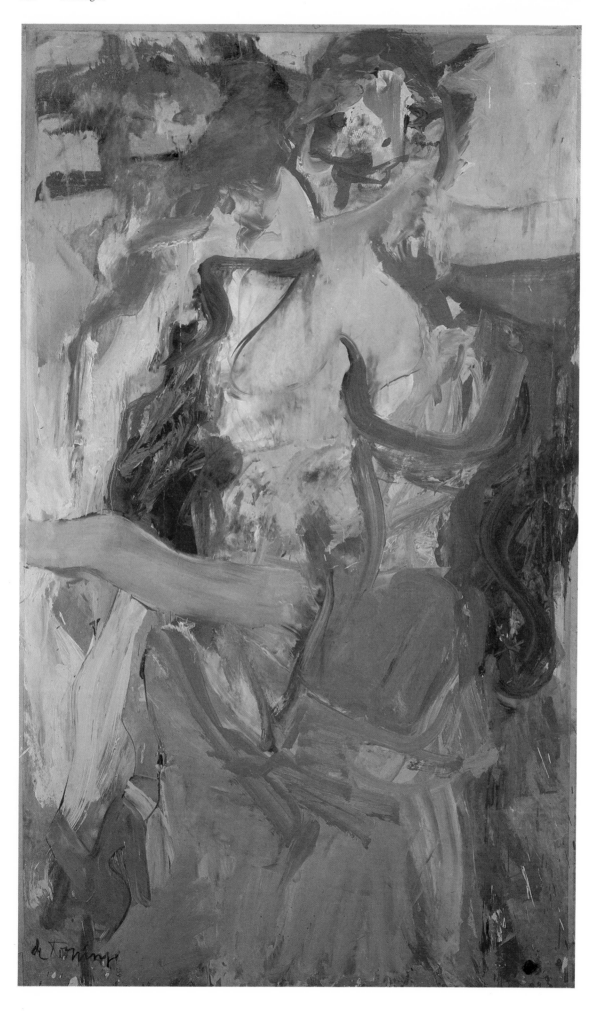

216
Two Women, 1964
Oil on paper mounted on canvas
60½ × 37″
Xavier Fourcade, Inc., New York

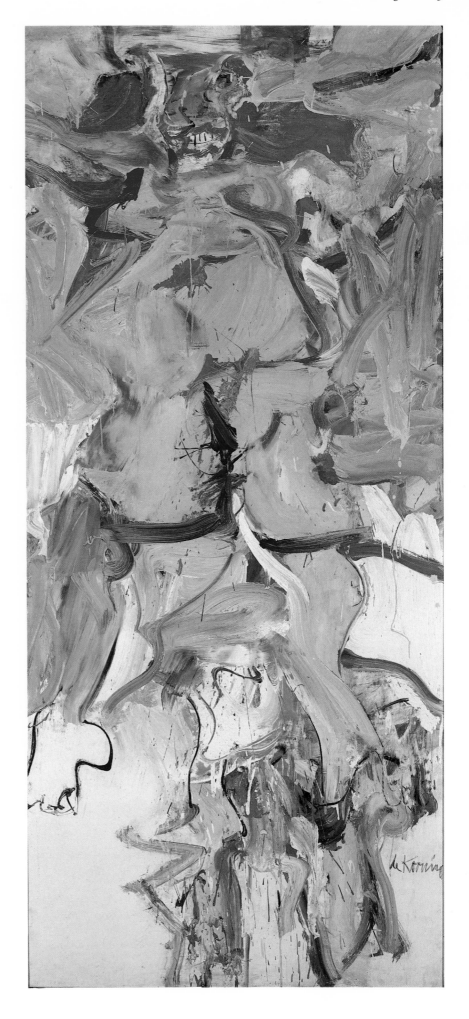

217 ▷
Woman, Sag Harbor, 1964
Oil on wood (door)
80 × 36″
Hirshhorn Museum and Sculpture Garden,
Smithsonian Institution, Washington, D.C.

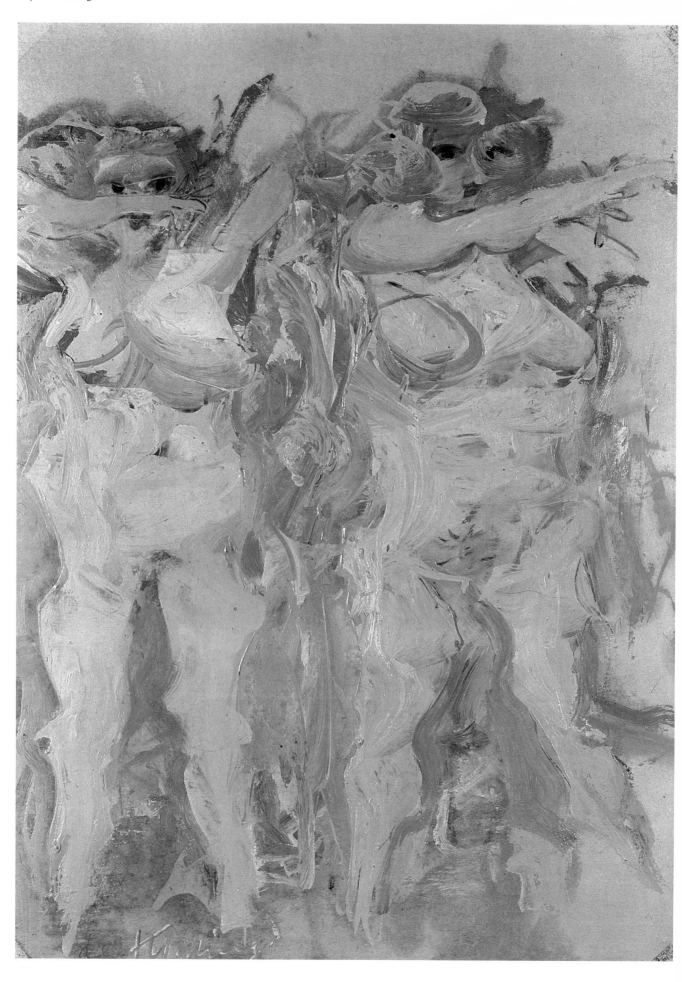

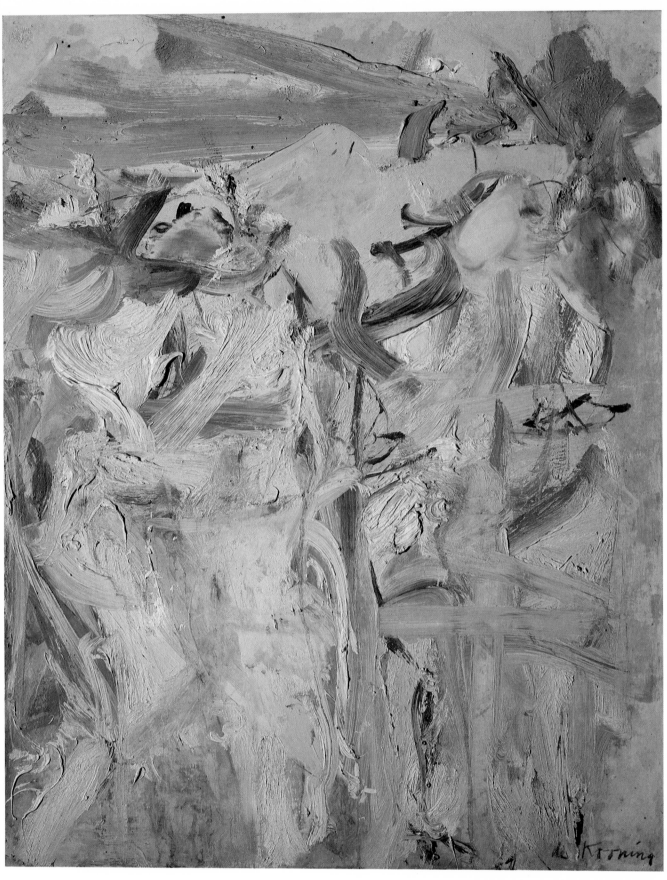

218
Clam Diggers, 1964
Oil on paper mounted on composition board
20¼ x 14½″
Collection of Mrs. Tyler G. Gregory

219
Two Figures, 1964
Oil on paper mounted on composition board
29⅜ x 23⅜″
Hirshhorn Museum and Sculpture Garden,
Smithsonian Institution, Washington, D.C.

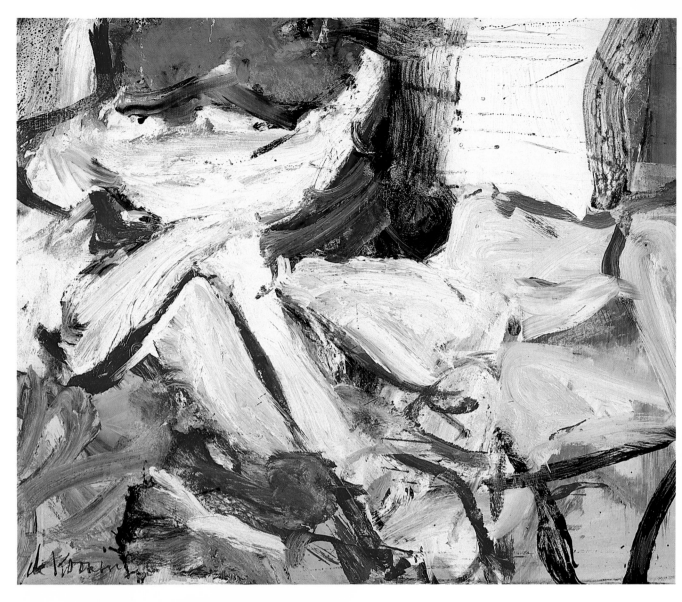

220

Figure in Marsh Landscape, 1966
Oil on canvas
25 x 30"
Moderna Museet, Stockholm

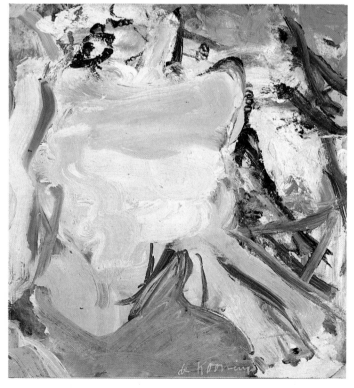

221

Running Figure, 1966
Oil on paper mounted on masonite
24 x 22½"
Collection of Mr. and Mrs. Harry Klamer

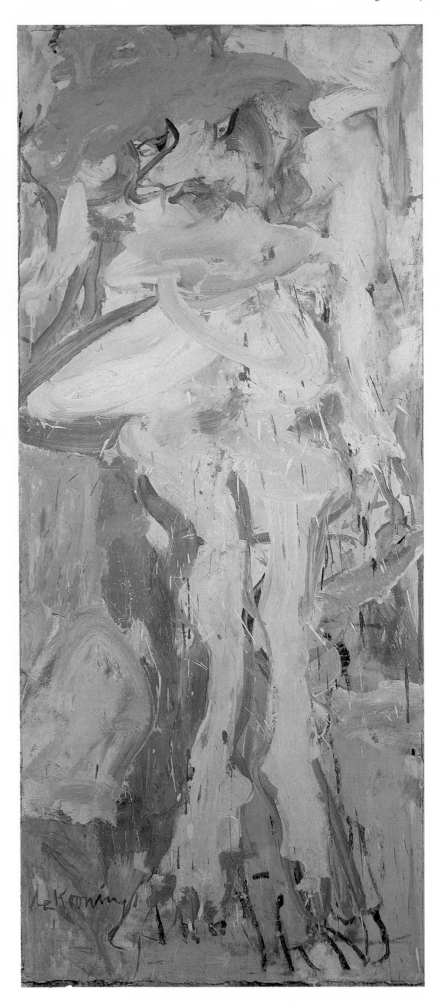

222

Woman Accabonac, 1966

Oil on paper mounted on canvas
79×35″
Whitney Museum of American Art, New York;
Gift of Mrs. Bernard F. Gimbel 67.75

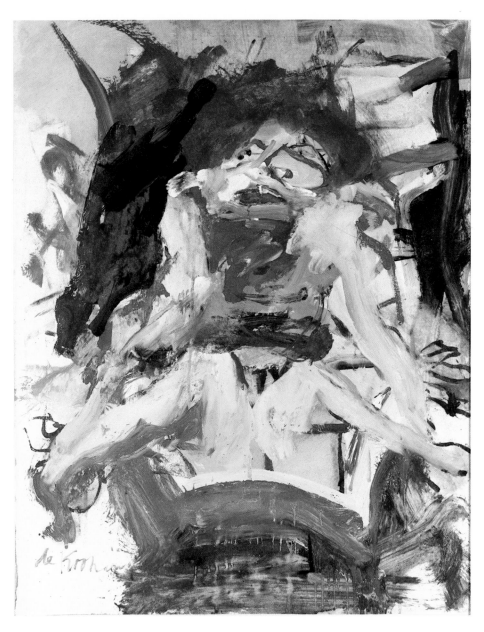

223
Woman in the Water, 1967

Oil on paper mounted on canvas
23 x 18¼"
Collection of Judy and Ken Robins

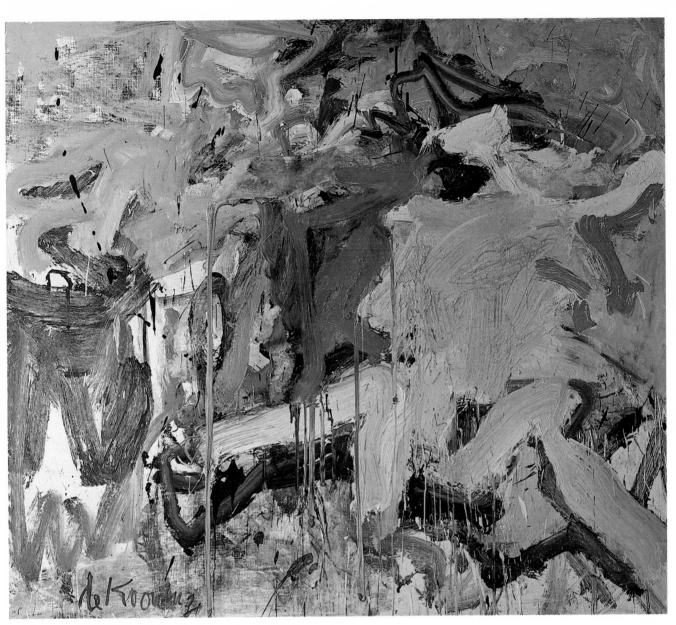

224
Two Figures in a Landscape, 1967
Oil on canvas
70 x 80"
Stedelijk Museum, Amsterdam

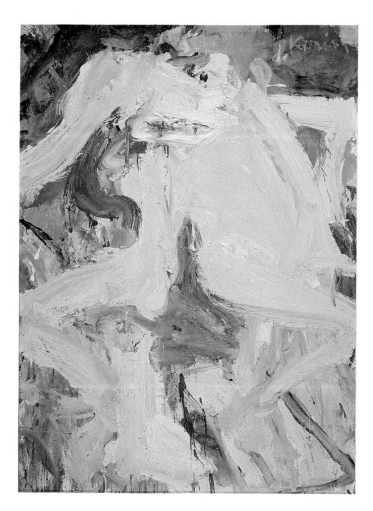

225
Man, 1967
Oil on paper mounted on canvas
56×44¾"
Private collection, courtesy Allan Stone Gallery, New York

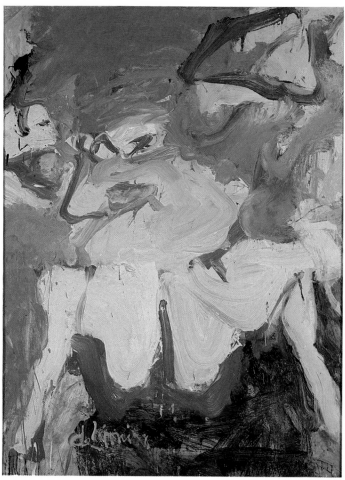

226
Woman on a Sign II, 1967
Oil on canvas
56×41½"
Private collection

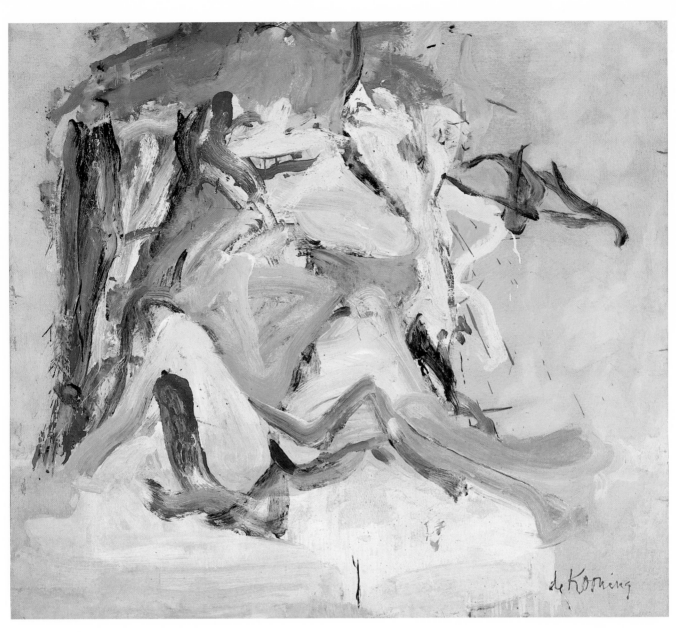

227
Woman on the Dune, 1967
Oil on paper mounted on canvas
48¼×54½"
Collection of Marielle L. Mailhot

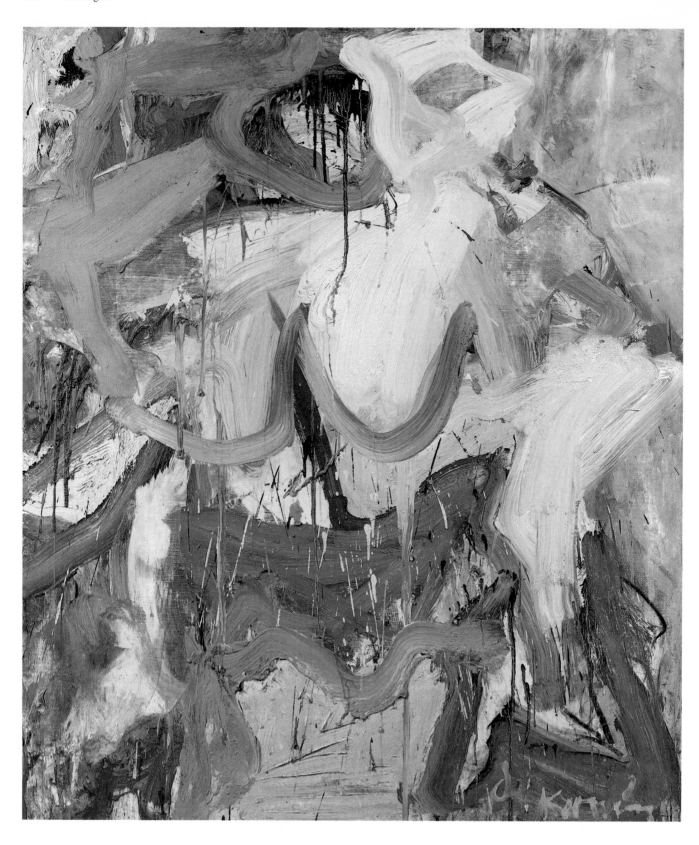

228

Woman in Landscape III, 1968

Oil on canvas
55½ x 48″
Private collection

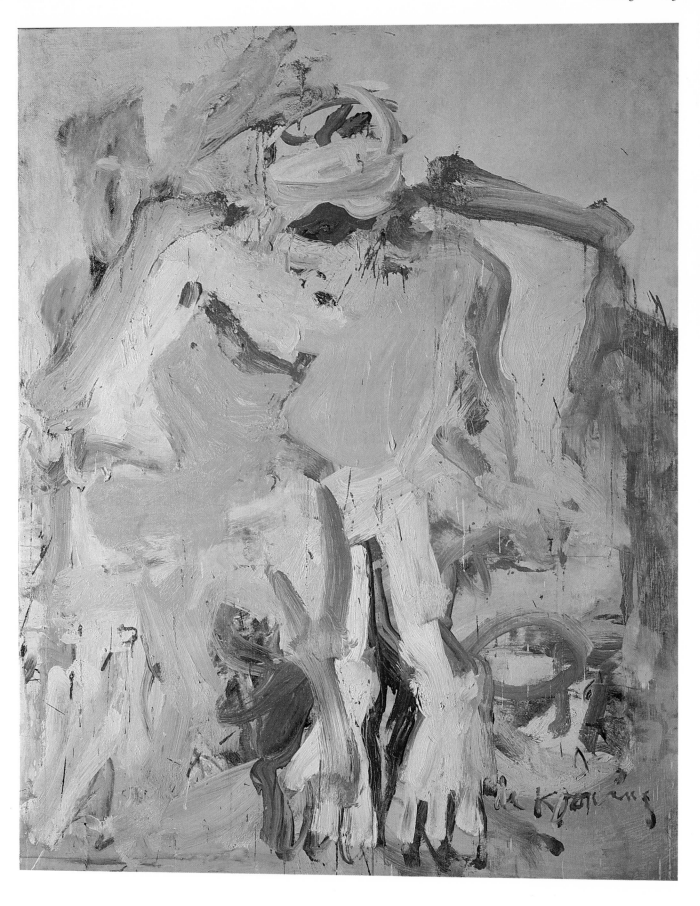

229
Woman in Landscape IV, 1968
Oil on canvas
59¾x48″
Private collection

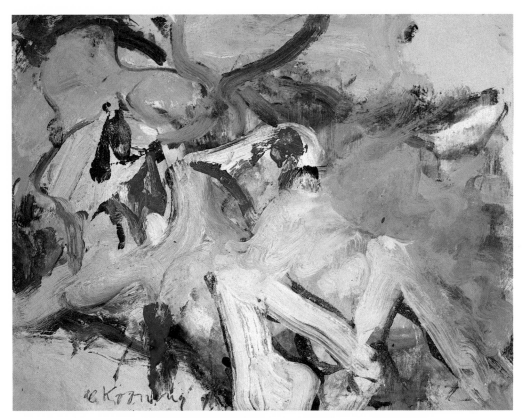

230
Woman in Landscape VII,
1968

Oil on paper mounted on canvas
18½ x 24"
Xavier Fourcade, Inc., New York

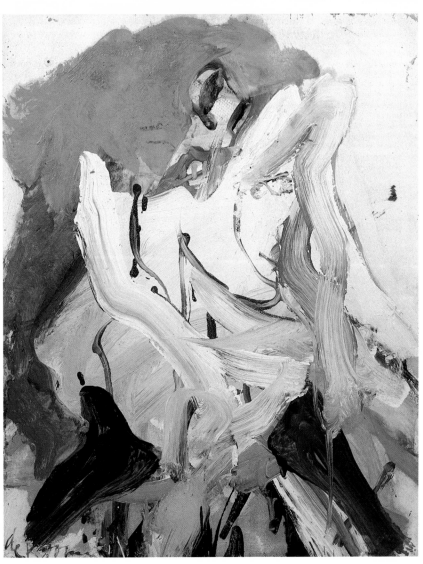

231
Woman, 1967-68

Oil on paper mounted on board
23 x 18½"
Private collection

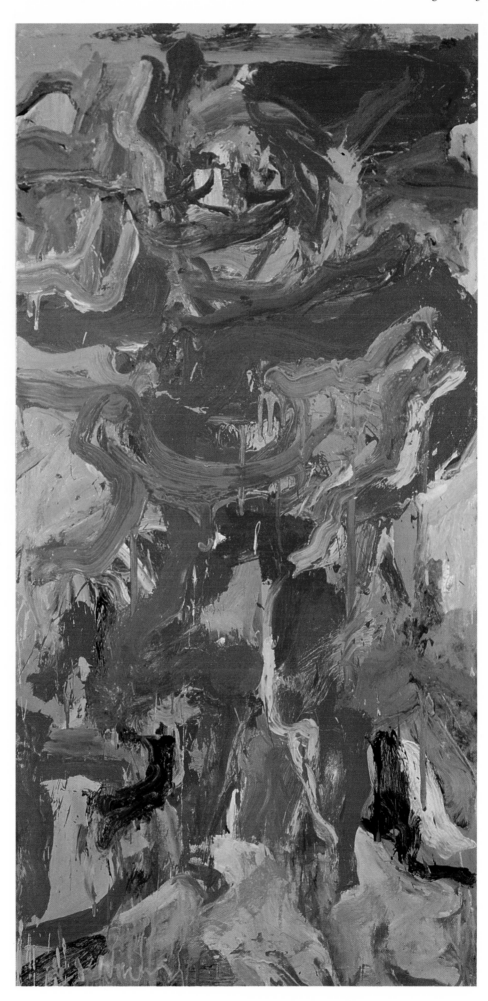

232
Red Man with Moustache, 1971
Oil on paper mounted on canvas
80 x 36″
Xavier Fourcade, Inc., New York

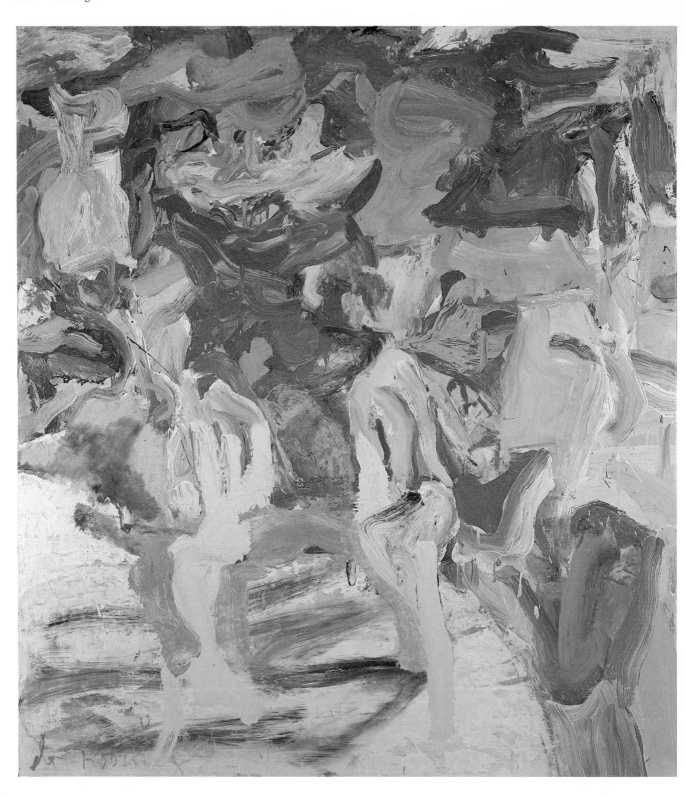

233
*Woman in the Water, 1972

Oil on canvas
59½ x 54"
Collection of Gertrude and Leonard Kasle

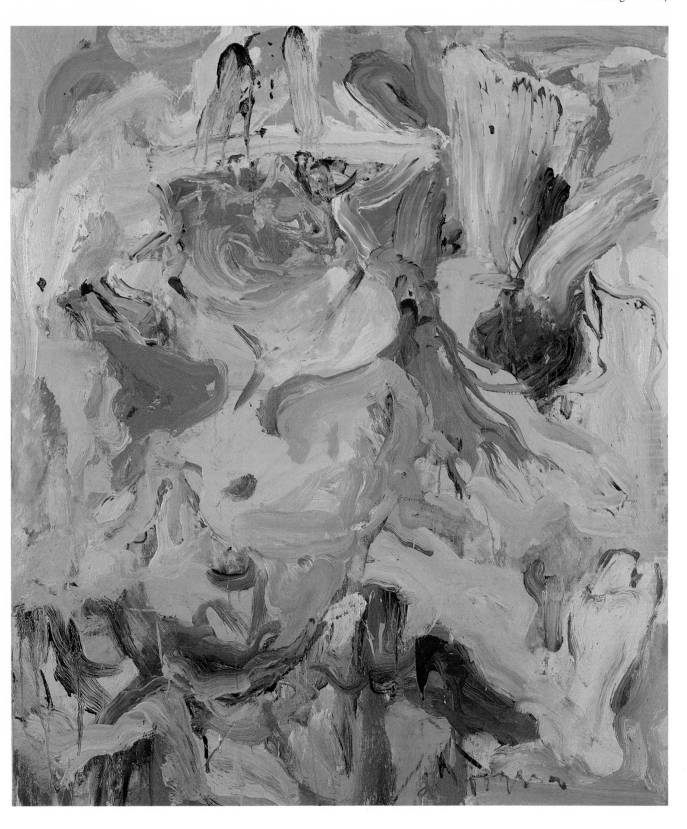

234
*La Guardia in Paper Hat, 1972
Oil on canvas
55¾x48″
Abrams Family Collection

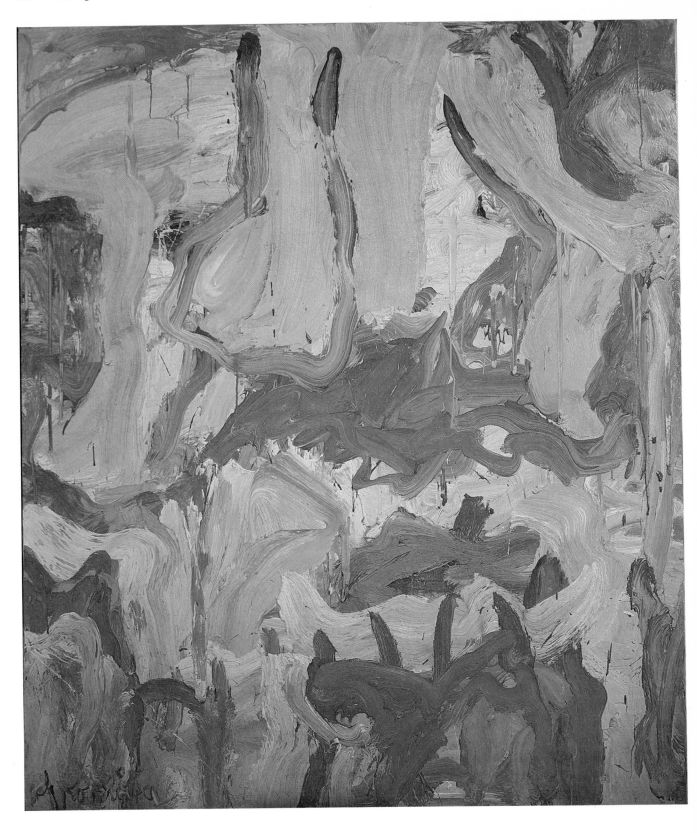

235
Landscape of an Armchair, 1971

Oil on canvas
80 x 70"
Private collection

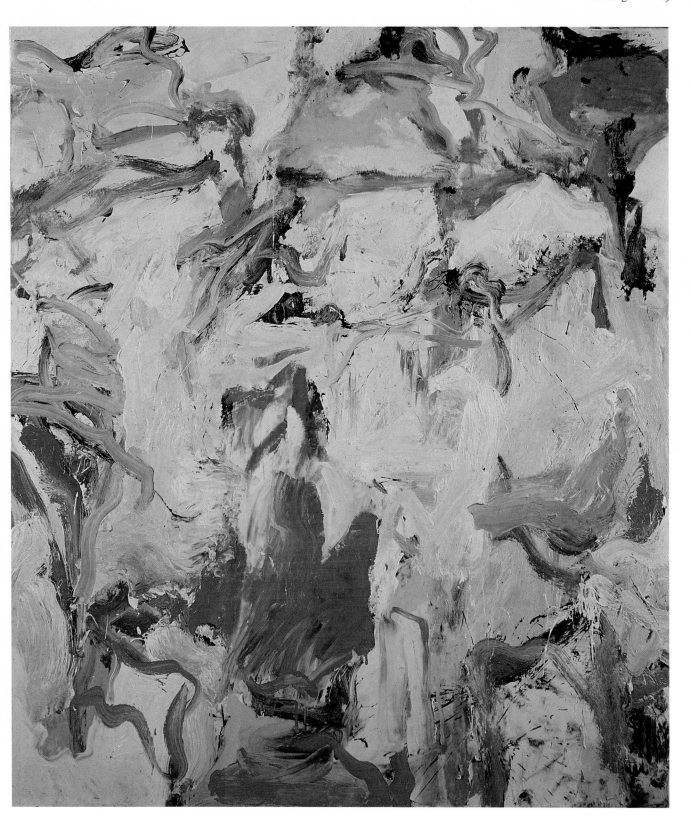

236
Untitled I, 1975
Oil on canvas
80 x 70"
Collection of Sue and David Workman

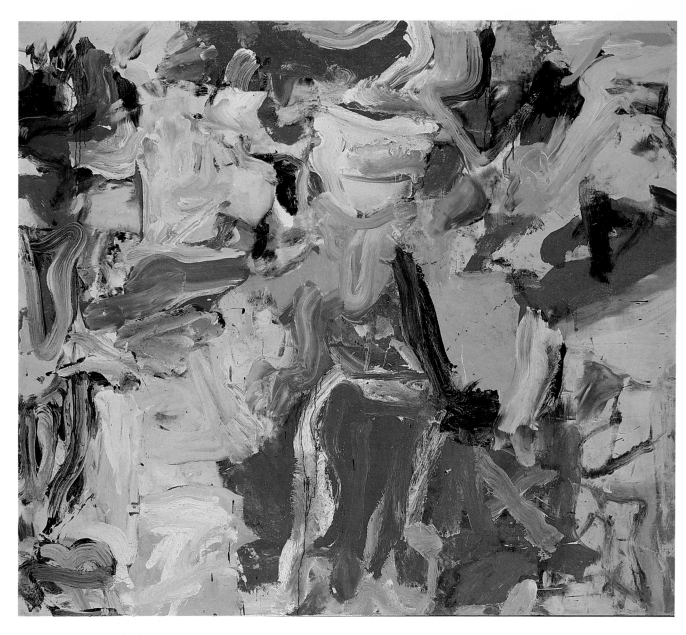

237
Untitled IX, 1975
Oil on canvas
70 x 80"
Stedelijk Museum, Amsterdam

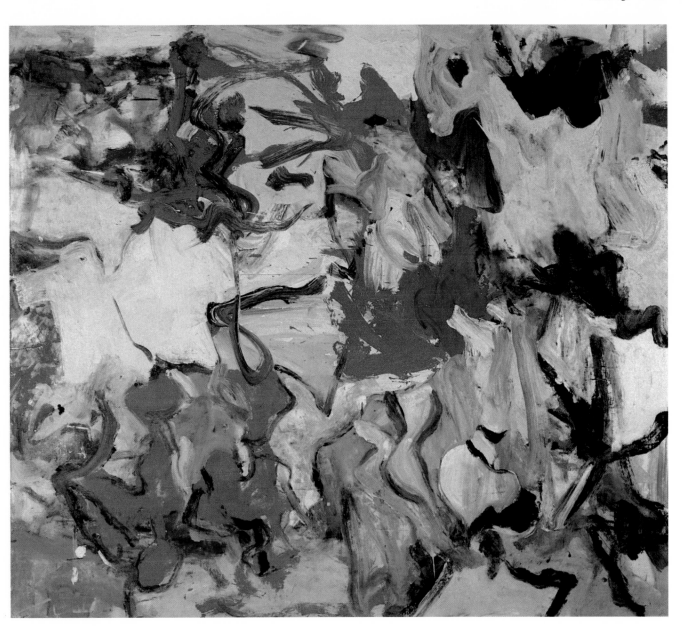

238
Untitled XI, 1975
Oil on canvas
77 x 88"
Xavier Fourcade, Inc., New York

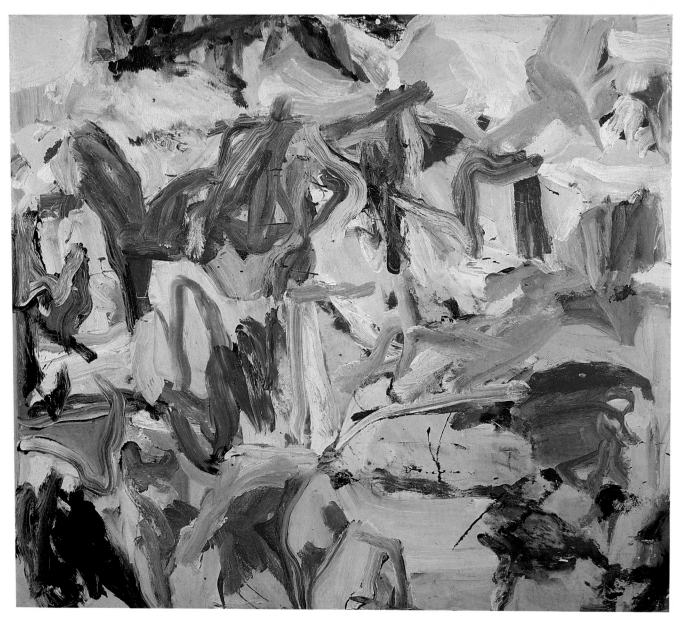

239
*Screams of Children Come from Seagulls, 1975

Oil on canvas
77 x 88"
Collection of Mr. and Mrs. Robert Mnuchin

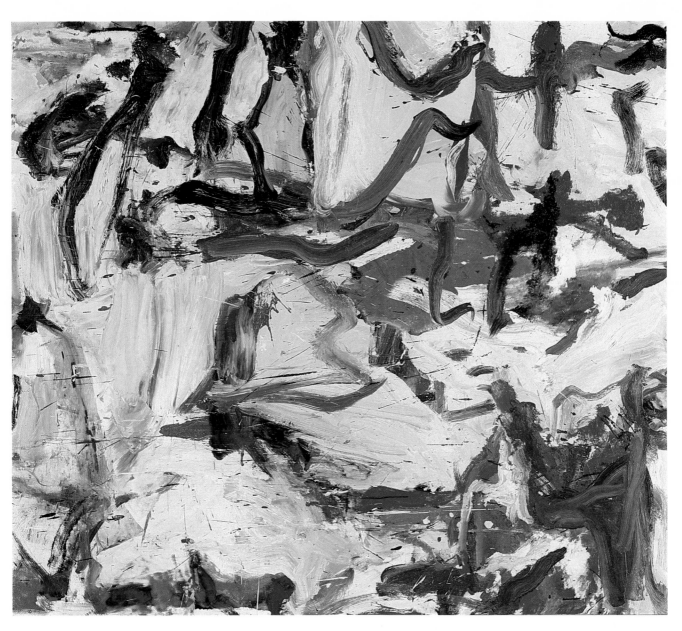

240
**. . . Whose Name Was Writ in Water, 1975
Oil on canvas
77 x 88"
The Solomon R. Guggenheim Museum, New York

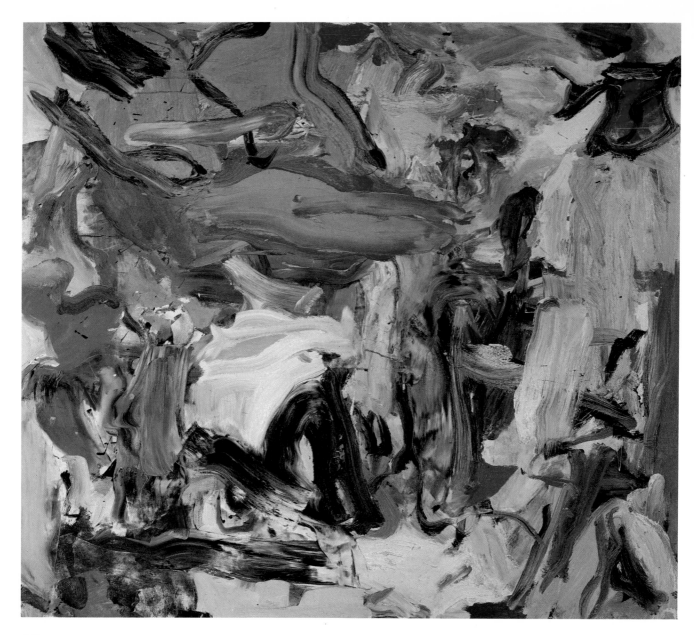

241
Untitled III, 1976

Oil on canvas
69½ x 79½"
Collection of Edgar Kaufmann, Jr.

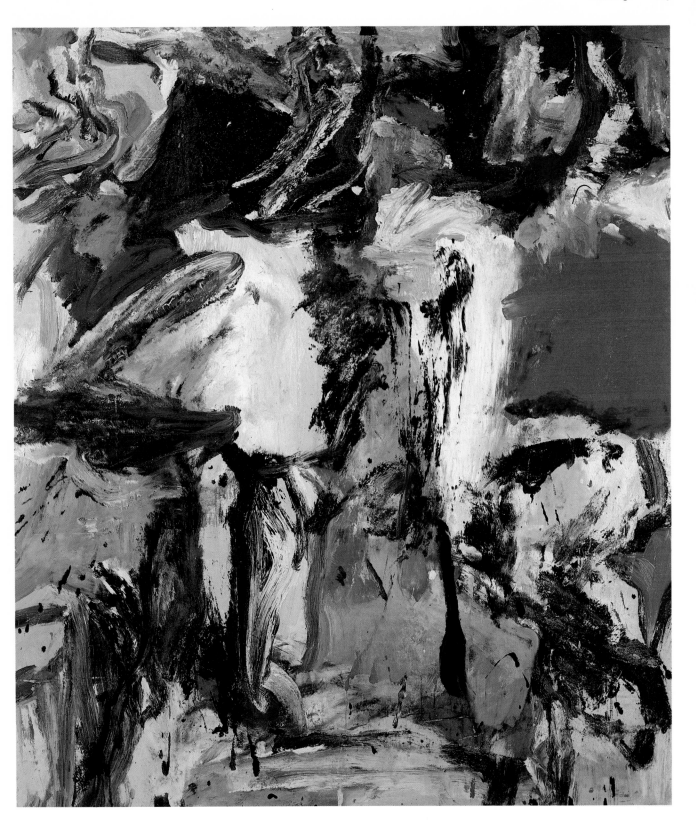

242
Untitled VI, 1976
Oil on canvas
80 x 70″
Collection of Graham Gund

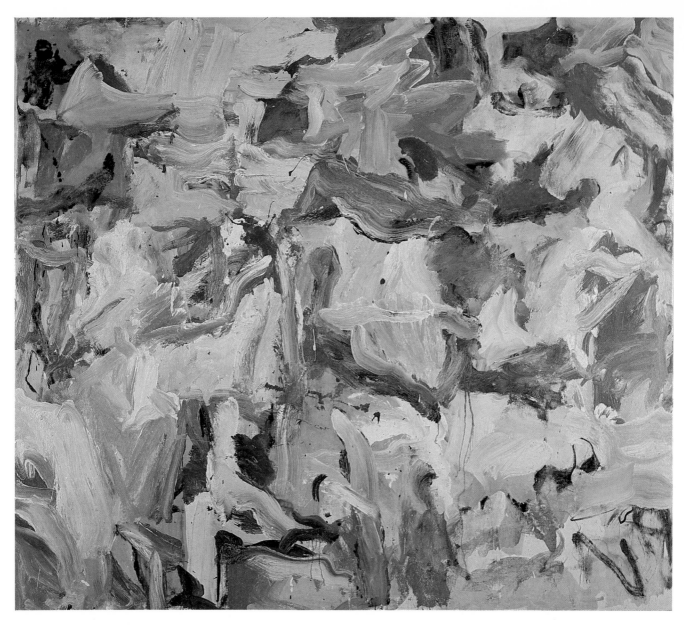

243
Untitled I, 1977

Oil on canvas
76½ x 87½"
Collection of Sue and David Workman

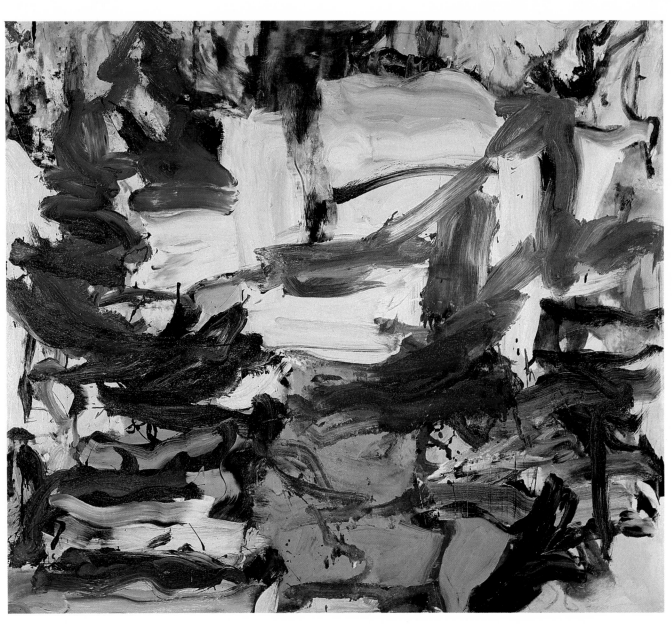

244
Untitled II, 1977
Oil on canvas
77 x 88"
Xavier Fourcade, Inc., New York

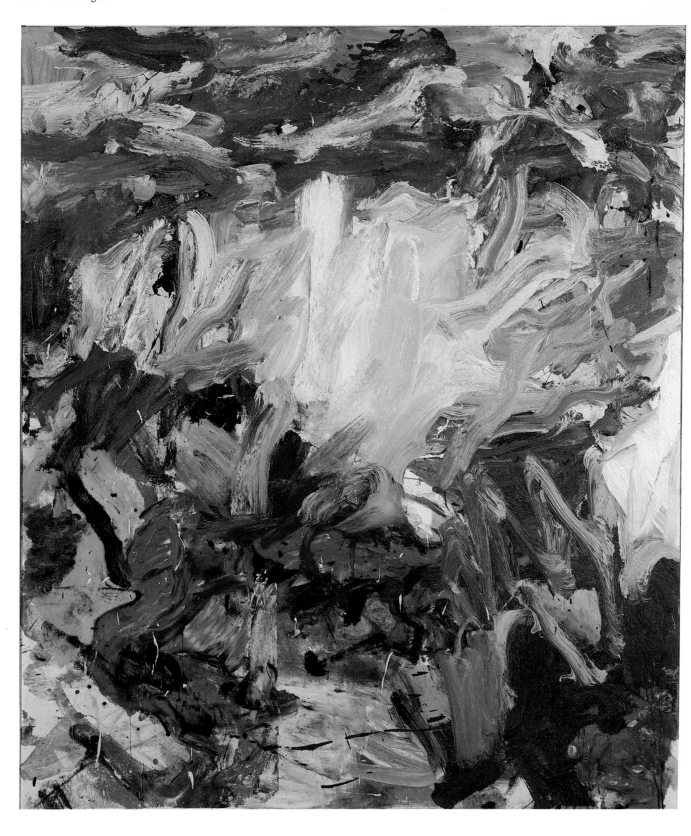

245
Untitled V, 1977

Oil on canvas
79½ x 69¼"
Albright-Knox Art Gallery, Buffalo;
Gift of Seymour H. Knox, 1977

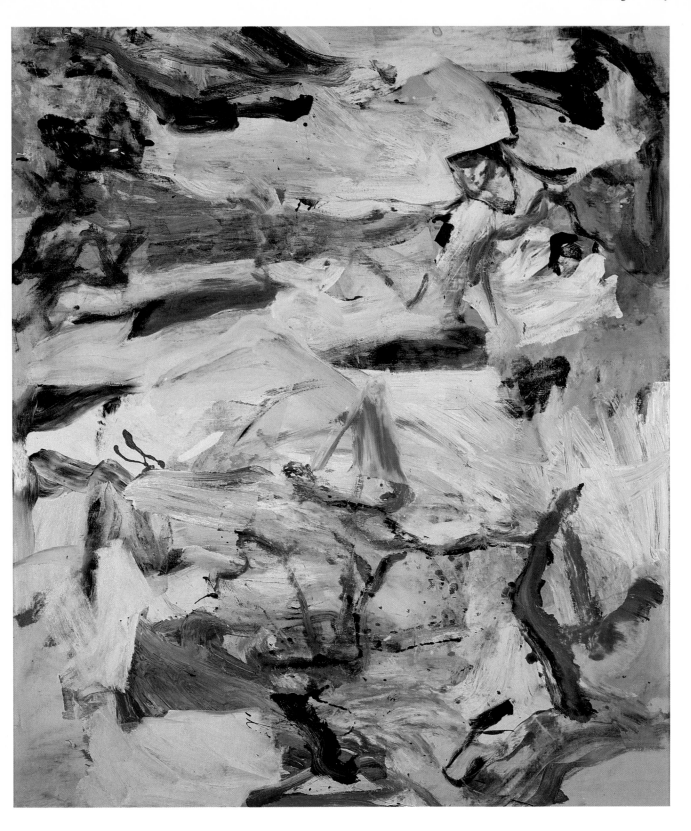

246
Untitled XVIII, 1977
Oil on canvas
80 x 70″
Stedelijk Museum, Amsterdam

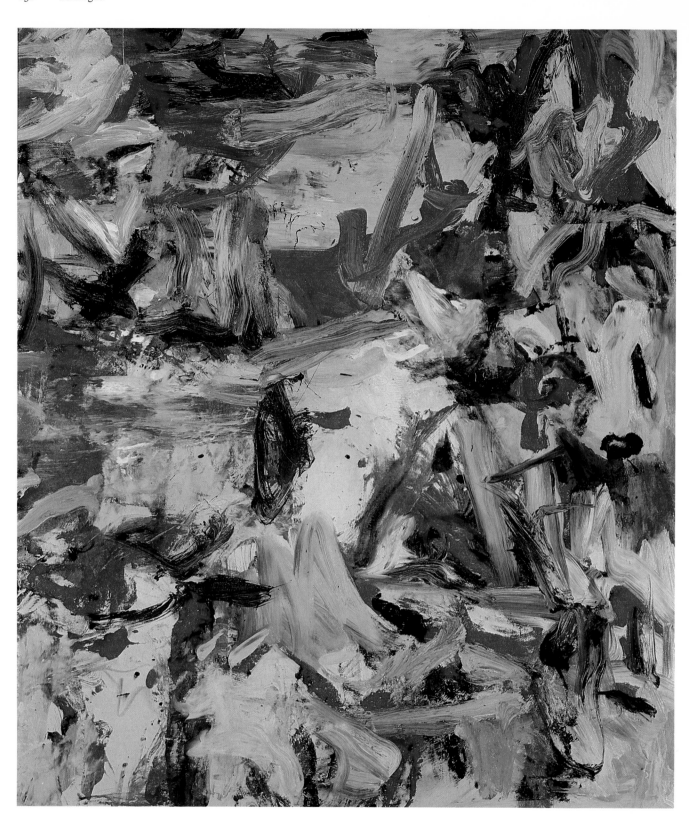

247
Untitled XIX, 1977
Oil on canvas
80 x 70"
Collection of Philip Johnson

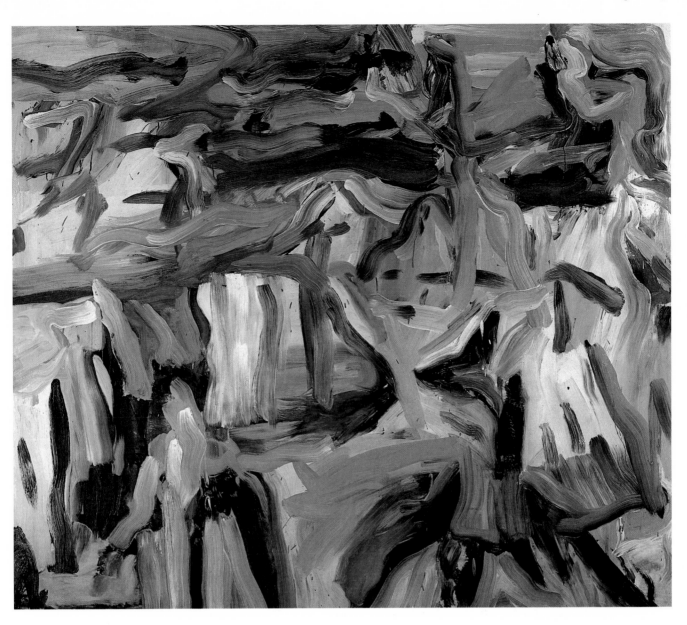

248
Untitled I, 1978
Oil on canvas
77 x 88"
Xavier Fourcade, Inc., New York

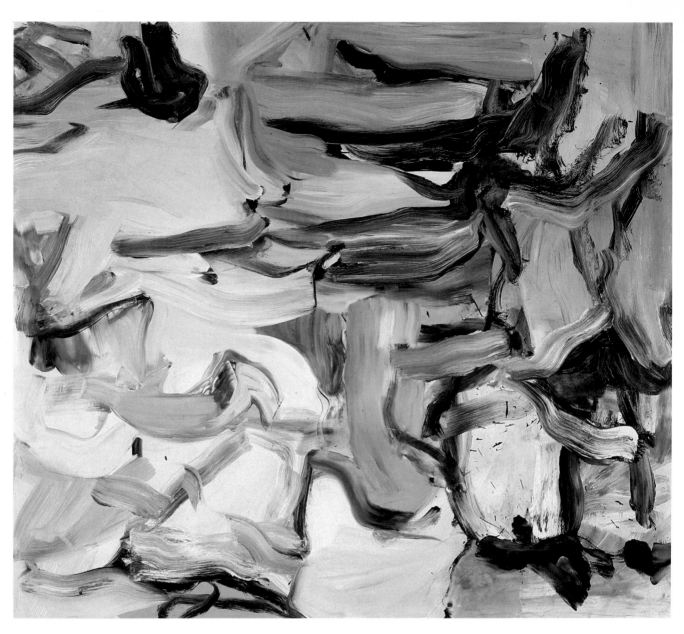

249
Untitled III, 1978

Oil on canvas
76⅝ x 87⅜″
Xavier Fourcade, Inc., New York

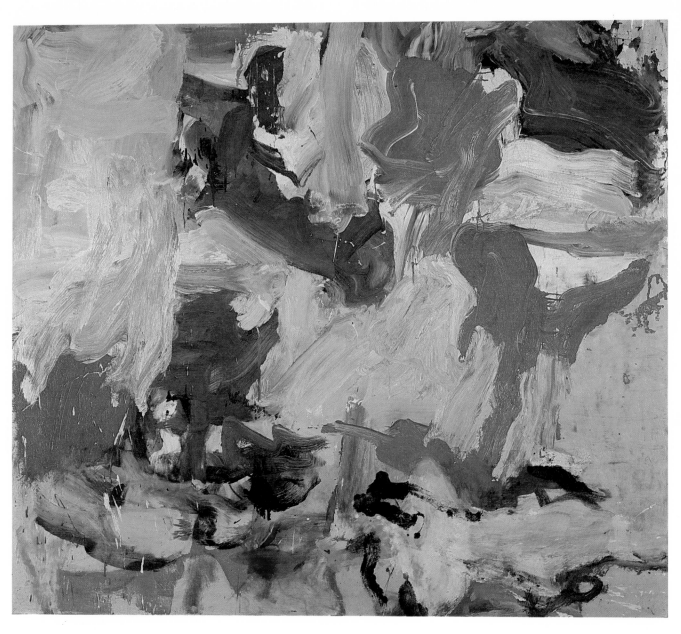

250
Untitled II, 1979
Oil on canvas
77 x 88"
Xavier Fourcade, Inc., New York

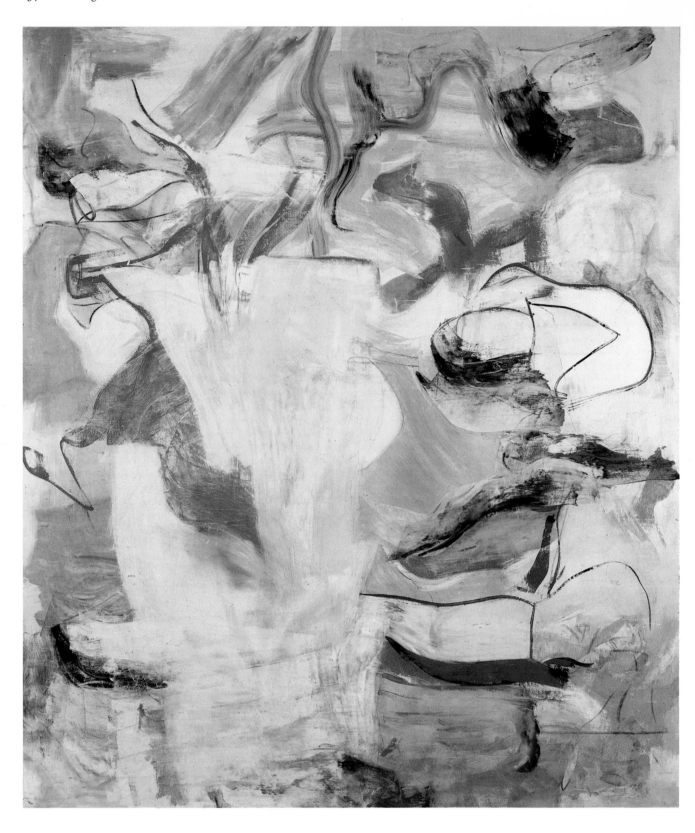

251
*Pirate, 1981

Oil on canvas
88 x 76¾″
The Museum of Modern Art, New York;
Sidney and Harriet Janis Fund, 1982

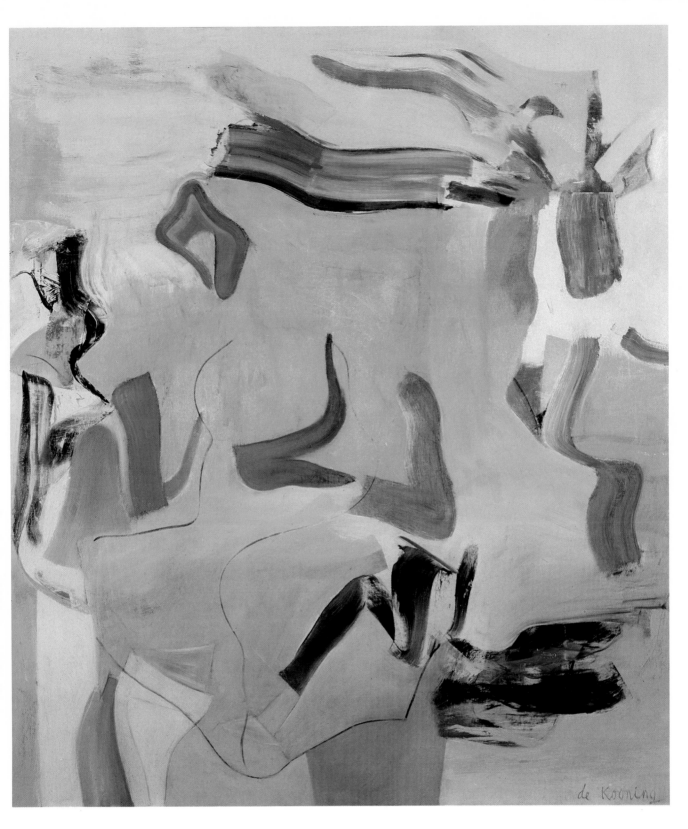

252
Untitled III, 1981

Oil on canvas
88 x 77$\frac{1}{16}$″
Hirshhorn Museum and Sculpture Garden,
Smithsonian Institution, Washington, D.C.

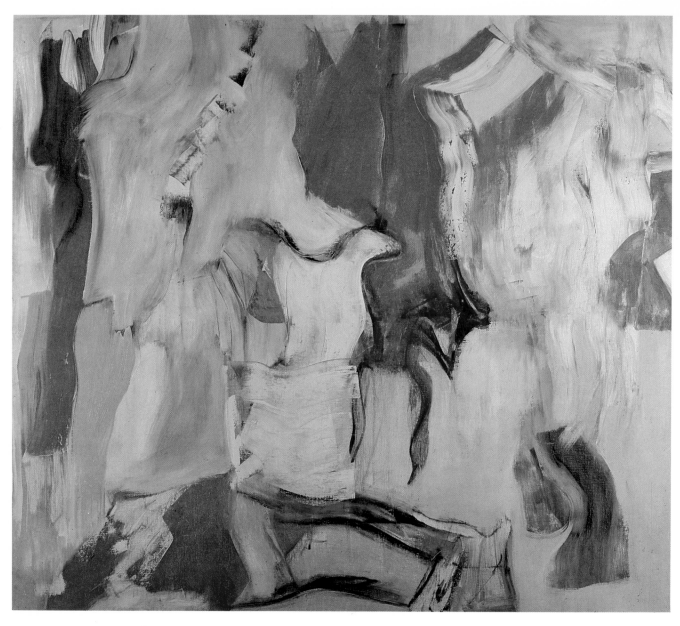

253
Untitled VI, 1981

Oil on canvas
77 x 88″
Warner Communications, Inc., New York

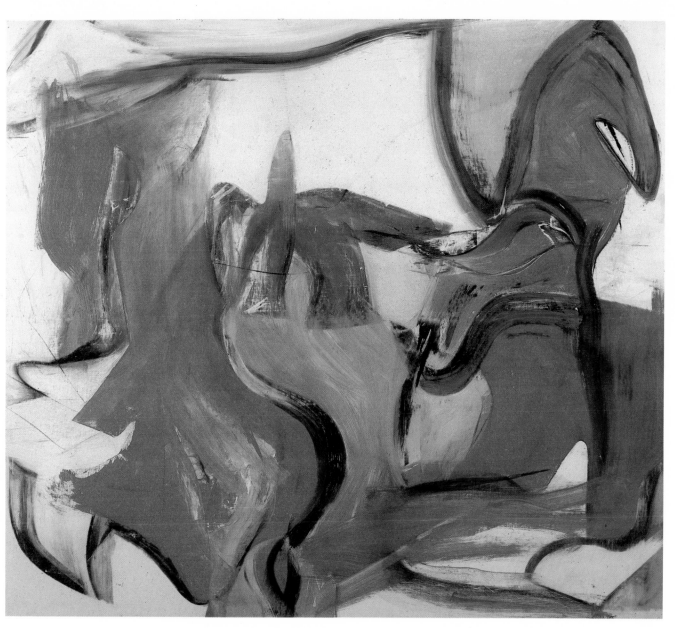

254
Untitled, 1982
Oil on canvas
70 x 80"
Xavier Fourcade, Inc., New York

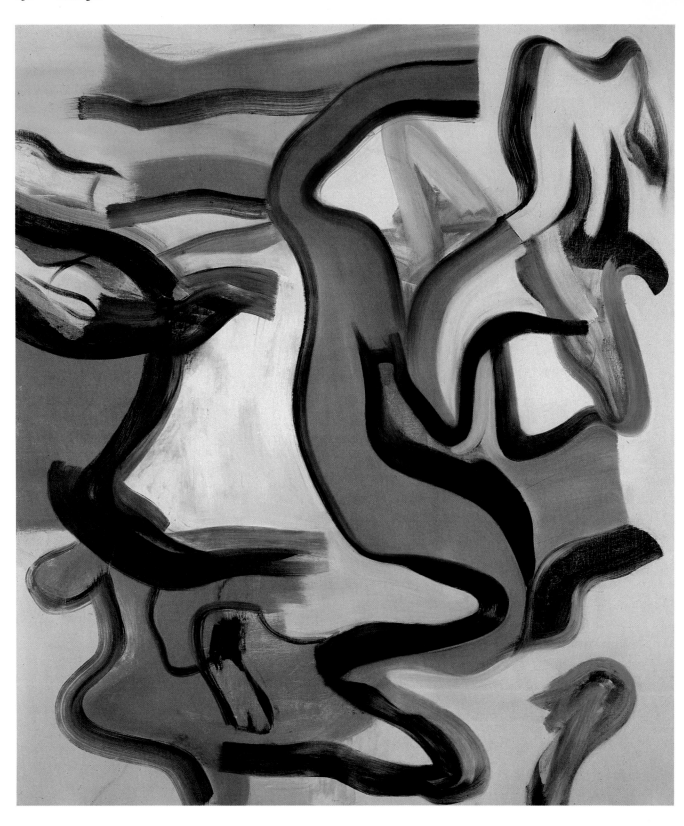

255
Untitled, 1982

Oil on canvas
80 x 70"
Xavier Fourcade, Inc., New York

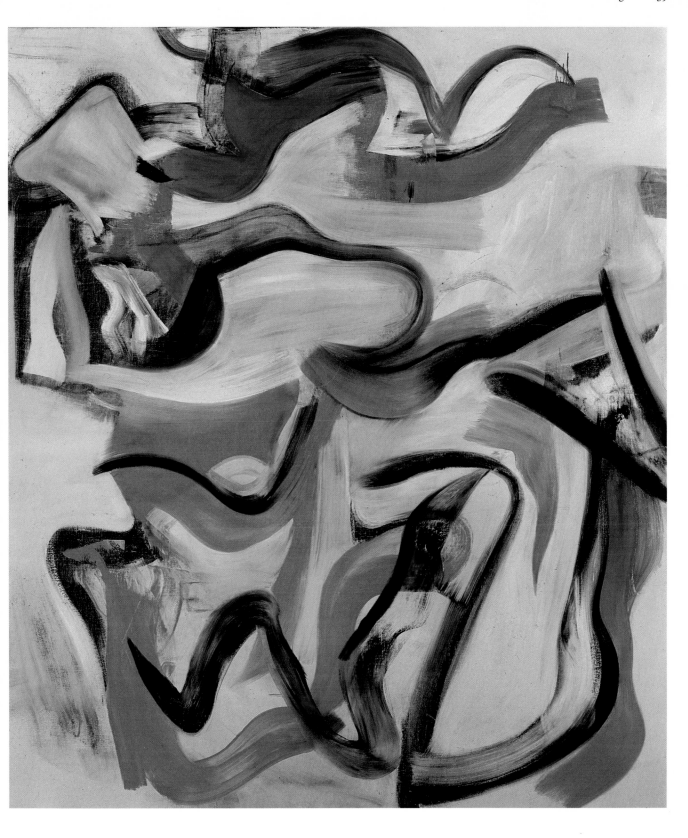

256
Untitled, 1982
Oil on canvas
80 x 70"
Xavier Fourcade, Inc., New York

Claire Stoullig

The Sculpture of Willem de Kooning

"Sculpture arises from the most basic gesture and its metamorphoses: dance, pantomime, sports, and all the controlled or moderated movements which impose on a body any perceptible cadence."[1] These words could define the sculpture of Willem de Kooning, a sculpture that evokes the art of play and of movement. De Kooning limited his adventure as a sculptor to the years 1969 to 1974 – a remarkably short period – and to twenty-five works, that emphasize the fortuitous and unexpected aspects of the sculptural process.

In the fall of 1969, during a two-month stay in Rome, de Kooning became interested in playing with terra-cotta after a visit from a sculptor friend, Herzl Emanuel, who owned a small foundry. Some of these first works evolved from ordinary objects he came upon randomly – a bottle of Coca-Cola (*Untitled III*, 1969; Cat. 259), an assemblage of wooden boards (*Seated Woman on a Bench*, 1972; Cat. 275), an electrical wall-plug – used as armature, the base, or the support for the work.

This playful combination of substance led de Kooning to conceive and then to realize a series of pieces in different scales that expresses the ancient oscillation of sculpture between the amulet and the monument. To knead, to manipulate the clay, to play with it by packing, piling up, amassing the balls or the crushed matter, to create the work partly with closed eyes – this is also the expression of rhythms inherent in the body. Like Mondrian, who was deeply fascinated by dance, de Kooning is absorbed by the experience of confronting his own body, as if he were face to face with another whom he tries to appropriate visually and tactilely, limb for limb, body for body, in order to guarantee the organic quality of the sculptures. This experience of self-confrontation produces a kind of kinesthesia which allows the artist to come back to his own self through the completed gesture.

This mode of rediscovering internal sensations through the movement of the body, of condensing and organizing them, suggests Matisse's relationship to sculpture (Figs. 2, 3):

> I took up sculpture because what interested me in painting was a clarification of my ideas... to put order into my feelings, and find a style to suit me. When I found it in sculpture, it helped me in painting. It was always in view of a complete possession of my mind, a sort of hierarchy of all my sensations, that I kept working in the hope of finding an ultimate method.[2]

The relationship between sculpture and painting often evoked in de Kooning's work is also a response to his desire for sim-plification. To grasp the painting fully in his hands, to construct it concretely, is to unite the two modes in order to assure precision and immediacy of expression.

The *Large Torso* (1974; Cat. 280), a piece built from the base to the head by the piling and heaping of aggregates of material, is submitted, as it were, to a kind of petrification born either of a seismic disaster, or of the slow recession of glaciers after the Ice Age. In *Large Torso,* each part lives off the others, exploits them, yet without seeking either coherence or independence. No form is dissociable from its neighboring volumes, but rather is amplified by them, contributing to the sense of weight. A structure of repetitions, a scaffolding of alternating masses, divides and schematizes itself in defiance of anatomy. The faces, often mutilated, are flattened out and thus do not encourage movement around them. Again sculpture appropriates the constraints of painting, as also in the series of heads, particularly *Head I, III,* and *IV* (1972-73; Cats. 273, 276, 277).

Rising from the chaos, torso and head remain welded without distinctive demarcation, simple components of a magma of material. Only the extremities are developed, and these excessively – highly distorted as if no muscle were responding to its function. The hands are split, exaggerated, terminated, while imperiously marking the space where the sculpture ends. Here again the reciprocal relationship between de Kooning's painting and sculpture is articulated: painting, where the decisive event seems to occur at the outer boundaries of the human body, in the overflowing of the female figure's contours within the core of the pictorial scene; sculpture, with its abrupt exaggeration of extremities – feet and hands – or more simply as in *Small Seated Figure* (1973) with its two legs set, side by side, on the left.

None of de Kooning's sculptural figures seem to reach figural maturity; they are incapable of liberating or disengaging themselves from their material origins. Indecisive and imprecise, they bespeak both life and death. De Kooning reinvests sculpture with its potential to invoke anew the birth of humanity, the myth of creation from chaos. The artist reveals inert matter yielding to life, the very act of metamorphosis beyond or beneath anthropomorphic forms. The sculptural process could be registered here as a manifestation of the pulsation of life struggling against death.

Thus, with merciless fingers – more cruel than any brush-stroke or slash of a knife because more direct – de Kooning fondles and violates this mass of clay until all of it has been ripped open, ploughed through, broken up. Inanimate, apathe-

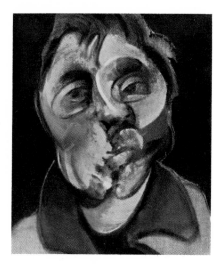

Fig. 1.
Francis Bacon:
Self-portrait, 1969.

tic matter is struck by life, exasperated by this tortured expression, retaining the marks of obsessing or obsessional thoughts, of an incessantly repeating practice or – quite simply – retaining painterly gestures.

The work exposes itself suddenly with the same savage brutality as raw art, until it creates a kind of malaise, as if the spectator were inside the statue, enclosed and possessed by it. Developing space in order to fill it with the vital energy sought by the sculptor of African art, de Kooning creates a similar "phantom effect," the sign of an excessive presence. This is probably the characteristic which led to Baudelaire's description of sculpture: "brutal and positive as nature herself, it is at the same time a certain vagueness and ambiguity, because it exhibits too many surfaces at once."[3]

The participle of this astonishing presence is the human figure, masculine or feminine, always isolated, whose drama and pathos can suppress all distance. It is represented either by the head, often in profile, sunken into the chest, a mutilated face of which a part seems torn out (*Head I*); or by the standing figure, appearing as if buried in a heap of flesh or matter, without contours or attributes. Nothing is really represented, nothing can be named. The human forms only rise up; they emerge from fragments and scraps where every sign of erosion, every break offers unique possibilities.

The exaggerated forms, flat or hollow, restore the sense of crude violence inherent in de Kooning's sculptural process: the pressure of the finger digging large paths, tracks, or crevices in the clay. The catastrophic character of *Clamdigger* (1972; Cat. 270), which evokes equally a Neanderthal man and the last survivor of a nuclear war, confirms that the art of sculpture has the potential for illusion or transposition – a process whereby the internal system of the work prevails over the real forms of the model. A common laborer, this clamdigger is weighed down by the burden of things, by a heaviness that radiates all the way to the hands, to the spaces between his fingers. He is one with the weight of his work, which has left its marks, here and there, in the hollows of his hands, in the depressions on his thighs, and in the excrescences of his feet. "One can read there, if not the symbols of past and future things, then at least the trace of them and, like the memories of our lives that are otherwise forgotten, perhaps even some more distant heritage . . . One can dream about any figure."[4]

This same power of suggestion informs Rodin's bronze statuette *Nijinsky* (1912) and appears in de Kooning's *Floating Figure* (1972; Cat. 272). Rodin's statue, unfinished, also in clay,

expresses a primitive violence which catches the instant and the movement and freezes them into the semblance of a caricature. Rodin's inspired insight about what generates movement in sculpture aptly describes de Kooning's bronze:

> . . . an image in which the arms, the legs, the trunk, and the head are each taken at a different instant, an image which therefore portrays the body in an attitude which it never at any instant really held and which imposes fictive linkages between the parts, as if this mutual confrontation of incompressibles could, and could alone, cause transition and duration to arise in bronze and on canvas.[5]

In *Hostess* (1973; Cat. 278), fingers and arms multiply as if tracking a movement which is not contained by the figure, a series of still frames that recalls certain aspects of Boccioni's sculpture. *Cross-Legged Figure* (1972; Cat. 271) and *Floating Figure* keep moments open which the concept of time immediately closes up, thus suppressing the duration of time.

Another effect of the figure is to indicate the external part of movement. Unlike Henry Moore's *Draped Torso* (1953), in which the clothing, pasted to the body like a wet tunic, reveals its transparency by showing the skin, in de Kooning's sculpture the flesh is like skin turned inside out, resisting the light and the form of the surface. The hand, exploring from the surface, slips to the interior of this body in a way exactly determined by the surface. The sculpted figure here indicates equally the interior of the form represented. Expressing the idea of flesh as a sensitive surface, de Kooning questions the rejection of the body in the sculpture of the 1970s. Contrary to the linearity and planarity of Minimalist surfaces, he explores with pleasure convex and concave surfaces. The intrusive marks of fingers on clay multiply, superimpose, and confront each other in order to counteract or neutralize themselves or, on the contrary, to accentuate the organic actions shown: the statue becomes a clue.

The gestural quality of de Kooning's sculpture – abetted by rapid execution and by the unfinished character of the work (both features of Abstract Expressionism) – is revealed in the

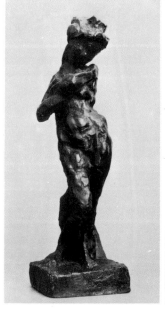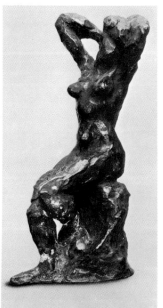

Fig. 2. Henri Matisse: *Madeleine*, 1903.
Fig. 3. Henri Matisse: *Seated Nude with Arms on Head*, 1904.

very technique of the modeling. According to the traditional concept of sculpture, modeling

> has all the qualities of sketching: that play in the execution, that first try, that eagerness, that zest, that truth to the idea which the slow process of completion invariably lessens. . . . In the modeling of clay, all procedures and all tools are acceptable, following the artist's skill and dexterity. But it can be said that the best chisel is still the thumb, because the thumb of the sculptor feels – in a way, sees – at the same time as it works.[6]

Setting aside all instruments, using neither the brush nor any other tool, de Kooning works directly by hand, producing an unbridled lyricism – the externalized trace or mark of the represented object or its structure which is then ruthlessly swept away, jostling the material in space in order to provide an indecipherable "image." It seems as if the sculpted object arises "from the working artist as the more or less mechanical transcriber of impulses that welled up from a realm over which he had little conscious control."[7]

As in photography, a contiguous relationship opens up between the material and the resulting image: the sense of distance normally present between an object and its representation on canvas is annulled. This collapsing into one of signifier and signified renders the sculptural sign transitive, as if the sculpted image were its own internal support. The image becomes part of the sculpture through an absolute integration. De Kooning's sculpture is not representational. Rather, it is a reference in so far as it is defined as "the sign that refers to the object which it denotes by the fact that it is truly simulated by that object."[8]

The shift from icon to sign is determined by de Kooning's repetition of and indifference to the subject. Always based on reality, often located in a familiar context (the clamdigger who inspired the 1972 bronze was conceived by the artist as being in the small harbor in Montauk, seen against an intense light), the work of formation nevertheless ignores the immediate present and thus transcends the shock value of singular facts.

> Like many figurative painters, he doesn't work from nature, nor does he propose to copy it. One perceives it to be more than a conceptual act; the hand – the gesture of drawing or painting, the "touch" – moves through a direct emotion. The hand is subverted, as it were, which subverts the motif.[9]

The uniqueness of de Kooning's sculpture thus rests in its refusal to define itself within the framework of figuration or the

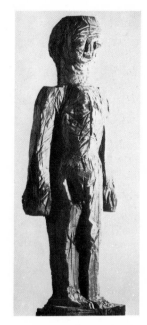

Fig. 4.
Georg Baselitz: *Untitled*, 1982.

icon. Nevertheless, if de Kooning's work approaches the sculptural tradition in its privileged representation of the human figure, he perhaps finds reassurance in these forms, sometimes grotesque or demonic, in any case excessive. But it is surely equally – and especially – a way of diverting attention from the iconographic referent to that which it signals: the gesture or the posture.

This manner of contradicting the trends of the sculpture of the 1970s, this artistic licence, contributes to a certain disdainful neglect on the part of the spectator, engendered by a dissonance which Georg Baselitz (Fig. 4) formulated:

> I find these sculptures very unique, very irritating . . . because they don't respect the principles of sculpture. They have neither muscles, nor bones, nor skin. They have only a surface which contains nothing.[10]

Although expressed negatively, this description of de Kooning's sculpture by the German artist is a kind of recognition. The painters who in 1983 try their hands at sculpture inherit the presence of the figure, in one way or another the figuration of things, which is treated in de Kooning's art as a sign capable of multiplying correspondences and of renewing the means of expression. They are "never immune to this kind of turning back or to the least expected convergences . . . *because they were sculptors* – that is to say, enmeshed in a single, identical network of Being."[11]

Notes

1 Luc Benoist, *La sculpture française,* coll. "Le Lys d'Or" (Paris: P.U.F., 1963).

2 Quoted in Albert E. Elsen, *The Sculpture of Matisse* (New York: Harry N. Abrams, Publishers, [1971]), p. 45.

3 Jonathan Mayne, trans., *The Mirror of Art: Critical Studies by Charles Baudelaire* (Garden City, N.Y.: Doubleday & Co., 1956), p. 120.

4 Henri Focillon, *La Vie des formes* (Paris: P.U.F., 1964).

5 Auguste Rodin, *L'Art* (interviews collected by Paul Gsell, 1911), as translated in Maurice Merleau-Ponty, "Eye and Mind" ("L'Oeil et l'esprit," 1961), trans. Carelton Dallery, in Merleau-Ponty, *The Primacy of Perception and Other Essays . . .,* ed. James M. Edie (Evanston, Ill.: Northwestern University Press, 1964), p. 185.

6 *Dictionnaire Larousse* (Paris: 1874).

7 Rosalind Krauss, "Reading Photographs as Text," in *Pollock Painting: Photographs by Hans Namuth,* ed. Barbara Rose (New York: Agrinde Publications, Ltd., 1978), unpaginated.

8 Oswald Ducrot und Tzvetan Todorov, *Dictionnaire encyclopédique des sciences du langage* (Paris: Seuil, 1972).

9 Michel Leiris in *Francis Bacon,* exh. cat. (Paris: Grand Palais, 1971).

10 Georg Baselitz, "Entretiens avec Jean-Louis Froment et Jean-Marc Poinsot," in *Georg Baselitz: sculptures,* exh. cat. (Bordeaux: C.A.P.C., 1983).

11 Merleau-Ponty, "Eye and Mind," p. 189.

Sculpture

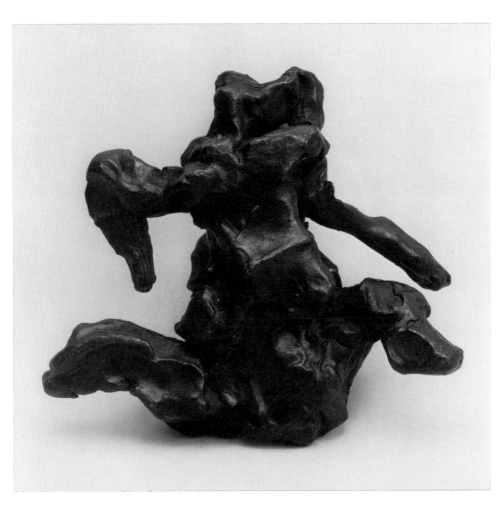

257
Untitled I, 1969
Bronze
7 x 8 x 5½"
Xavier Fourcade, Inc., New York

258
Untitled II, 1969
Bronze
6¾ x 10¾ x 3"
Xavier Fourcade, Inc., New York

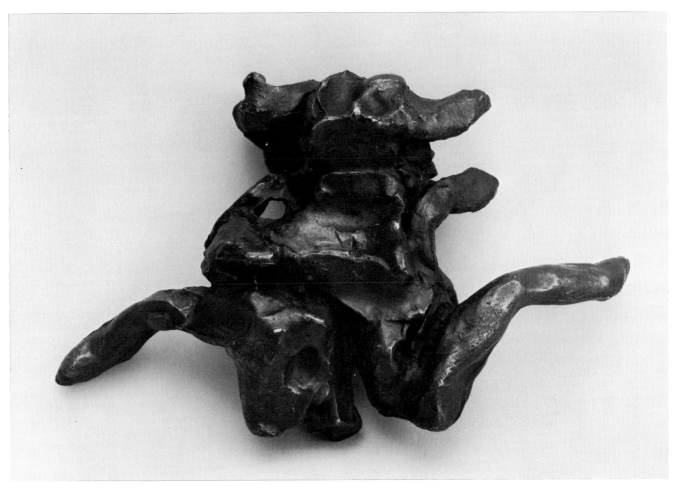

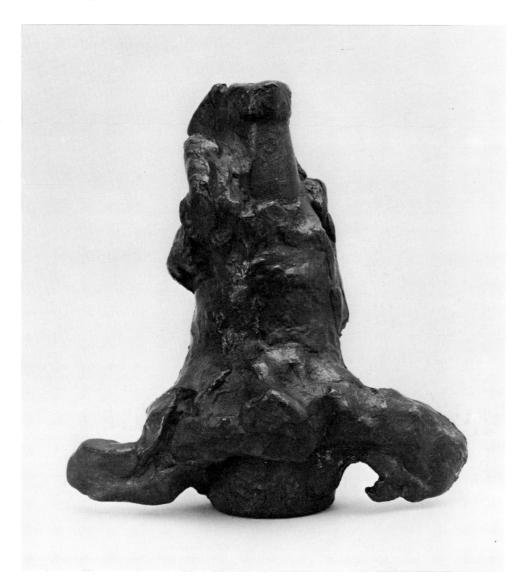

259
Untitled III, 1969
Bronze
8 x 7½ x 4¾"
Xavier Fourcade, Inc., New York

260
Untitled IV, 1969
Bronze
4 x 8 x 5½"
Xavier Fourcade, Inc., New York

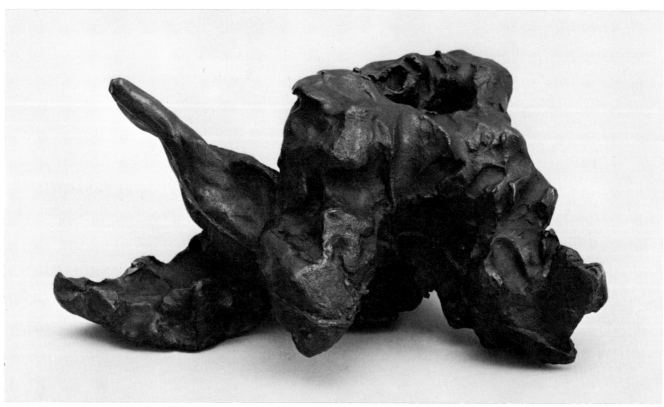

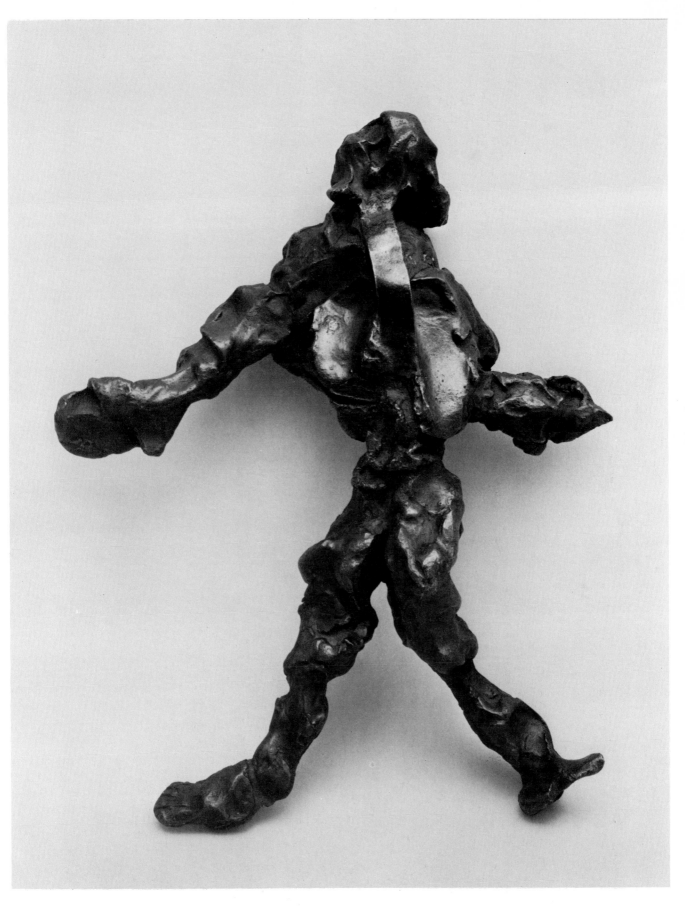

261
Untitled V, 1969
Bronze
13¼ x 11 x 2½″
Xavier Fourcade, Inc., New York

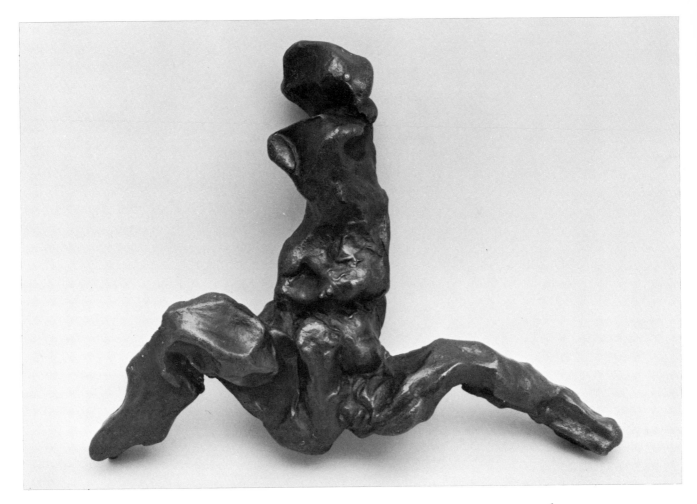

262
Untitled VI, 1969
Bronze
7½ x 10 x 2½"
Xavier Fourcade, Inc., New York

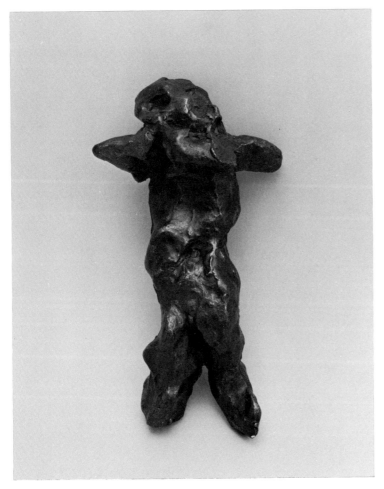

263
Untitled VII, 1969
Bronze
7 x 3¾ x 2¼"
Xavier Fourcade, Inc., New York

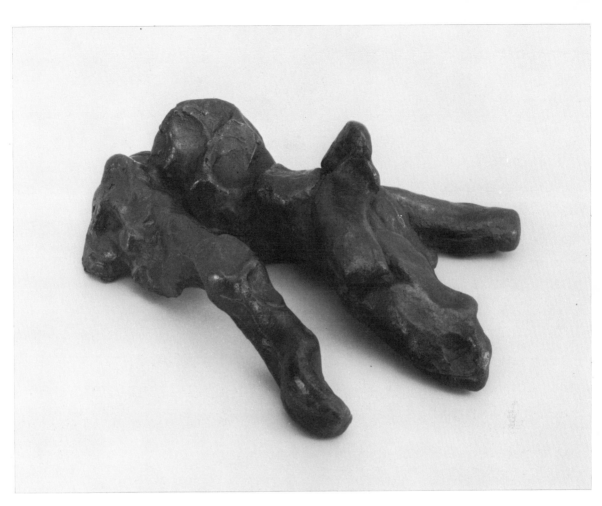

264 △
Untitled VIII, 1969
Bronze
2½ x 6½ x 8″
Xavier Fourcade, Inc., New York

265
Untitled IX, 1969
Bronze
1⅛ x 3½ x 11″
Xavier Fourcade, Inc., New York

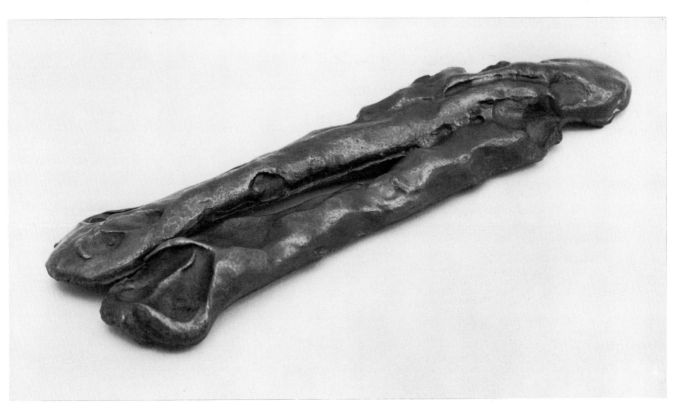

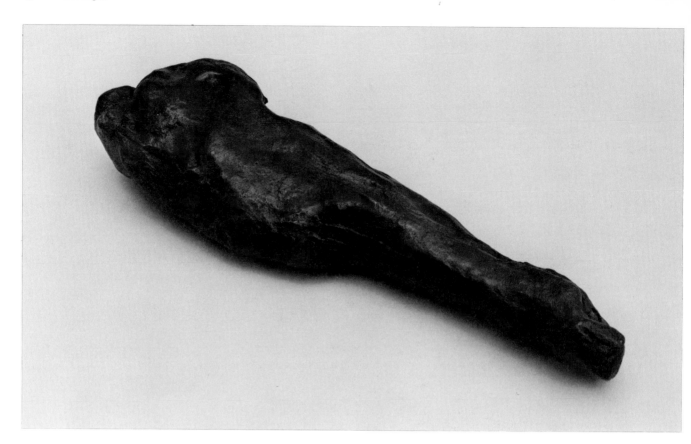

266
Untitled X, 1969
Bronze
1½ x 2½ x 8¼"
Xavier Fourcade, Inc., New York

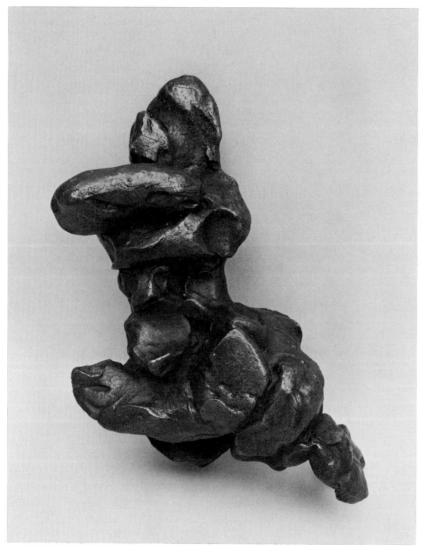

267
Untitled XI, 1969
Bronze
7 x 5½ x 3"
Xavier Fourcade, Inc., New York

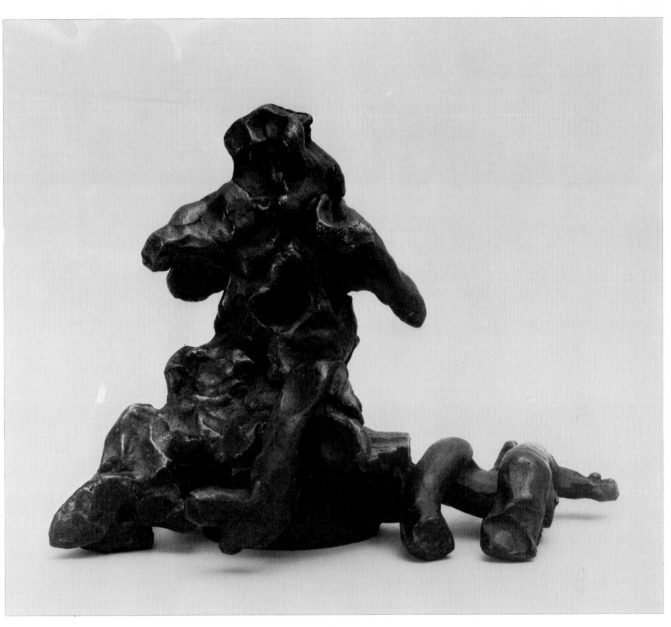

268
Untitled XII, 1969
Bronze
6½ x 8½ x 5½"
Xavier Fourcade, Inc., New York

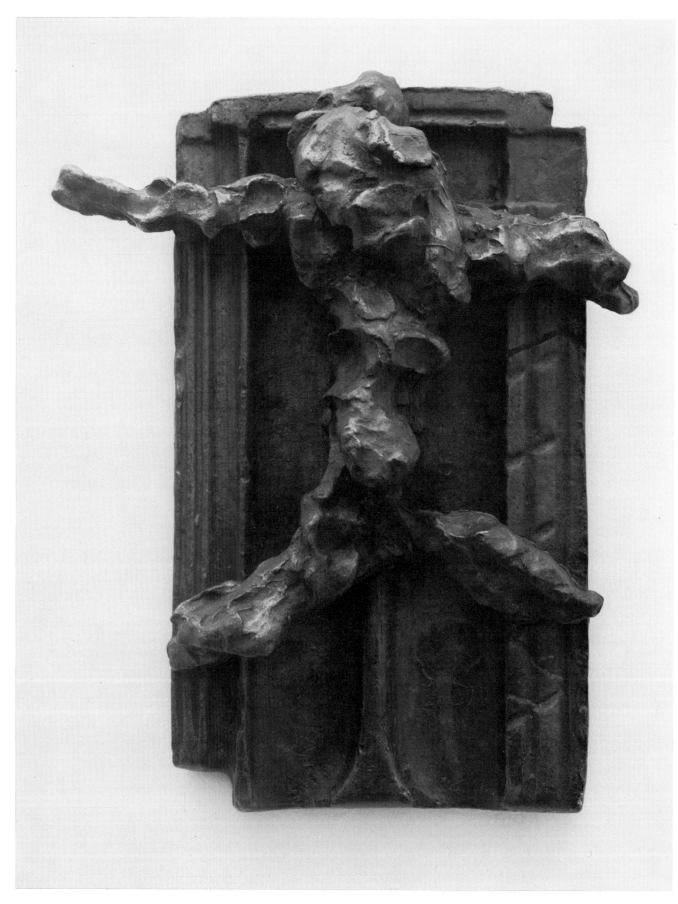

269
Untitled XIII, 1969
Bronze
15½ x 12 x 4½″
Xavier Fourcade, Inc., New York

270
Clamdigger, 1972
Bronze
57½ x 27 x 21″
Whitney Museum of American Art, New York;
Promised and partial gift of Mrs. H. Gates Lloyd P. 4.81

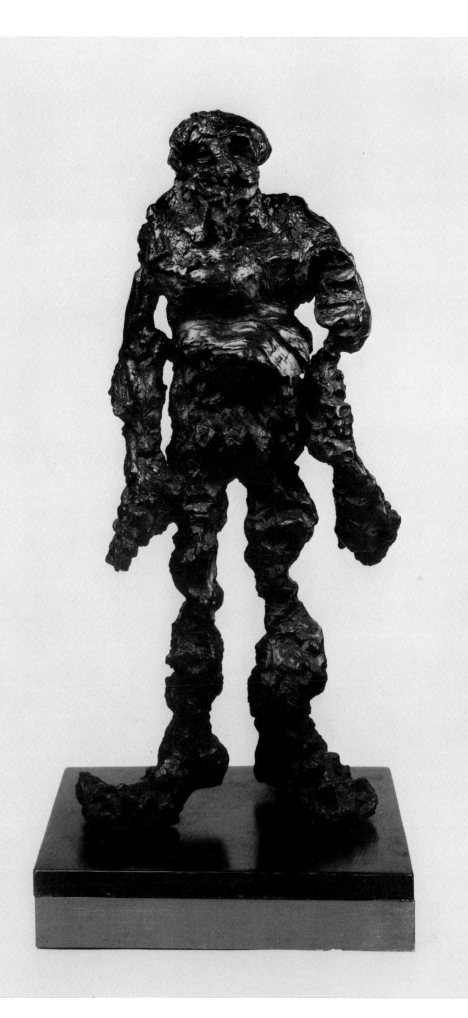

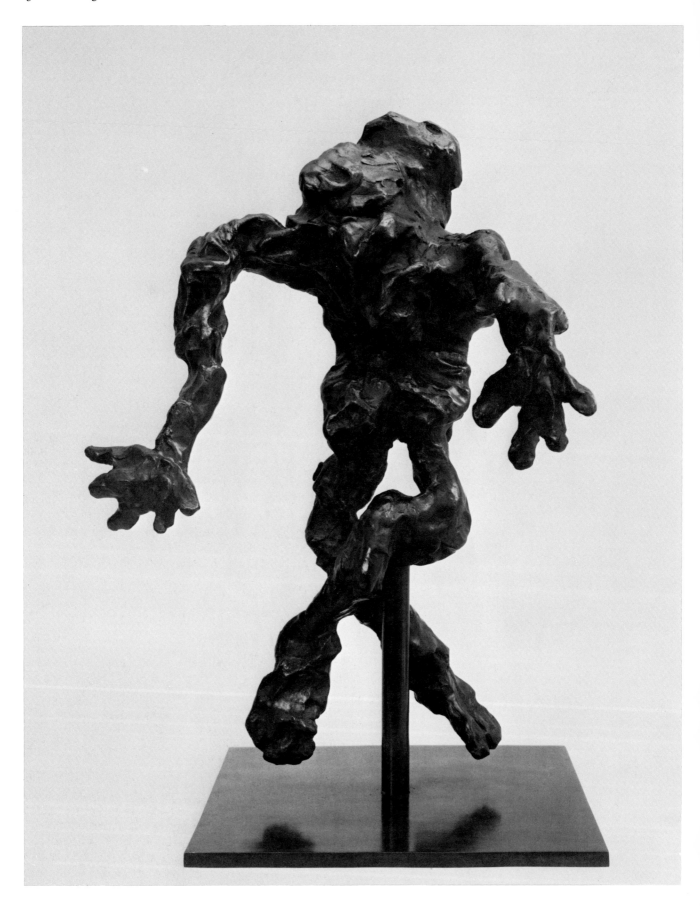

271
Cross-Legged Figure, 1972
Bronze
24 x 17 x 16″
Collection of David T. Owsley

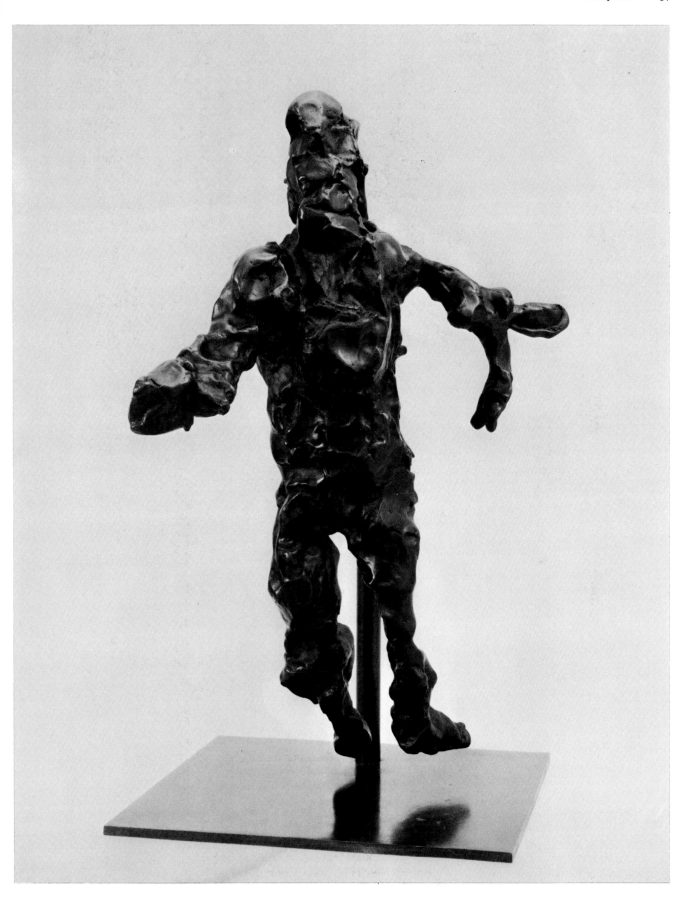

272
Floating Figure, 1972
Bronze
24 x 13 x 12"
Xavier Fourcade, Inc., New York

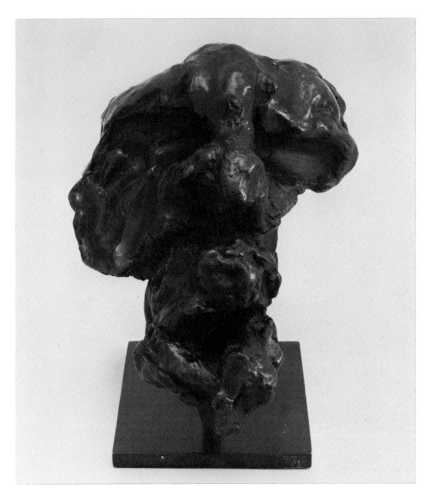

273
Head I, 1972
Bronze
9x8x9½"
Collection of Mr. and Mrs. Alain Kirili

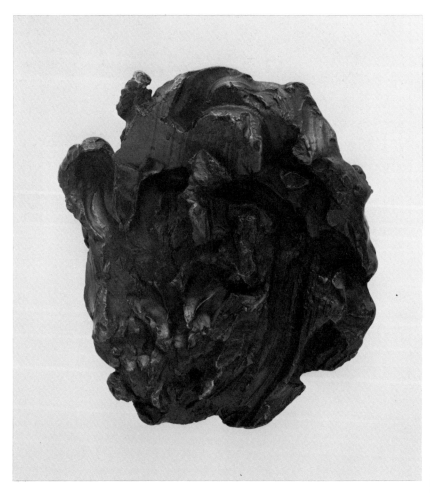

274
Head II, 1972
Bronze
14½x13x4"
Xavier Fourcade, Inc., New York

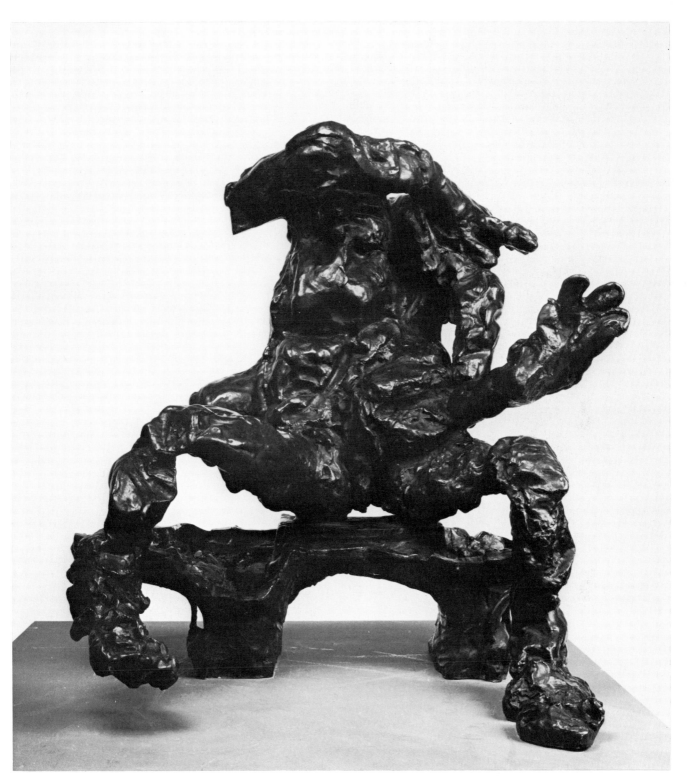

275
Seated Woman on a Bench, 1972
Bronze
37½×37×30″
Xavier Fourcade, Inc., New York

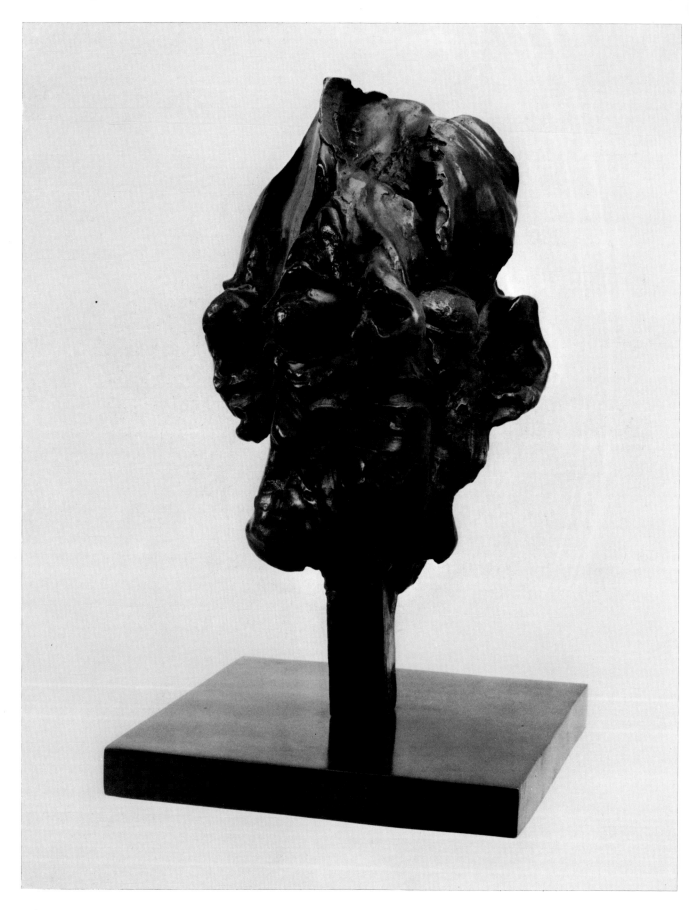

276
Head III, 1973
Bronze
18 x 10 x 11″
Xavier Fourcade, Inc., New York

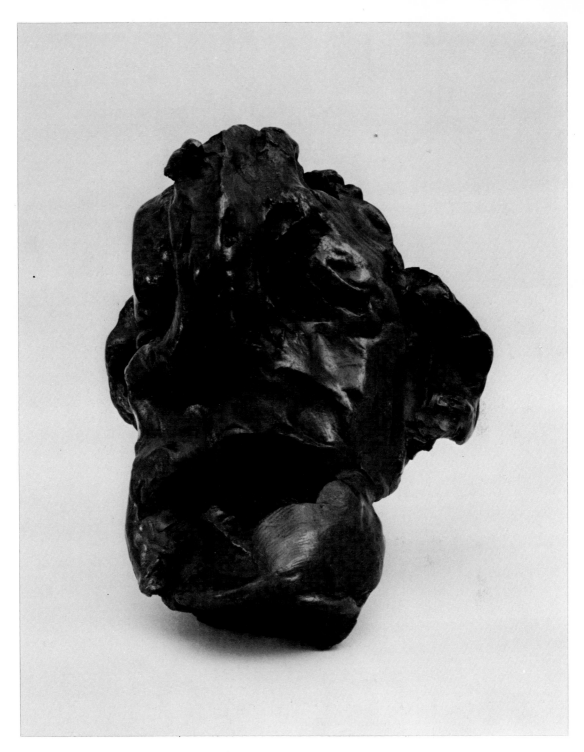

277
Head IV, 1973
Bronze
10½ × 10 × 11″
Xavier Fourcade, Inc., New York

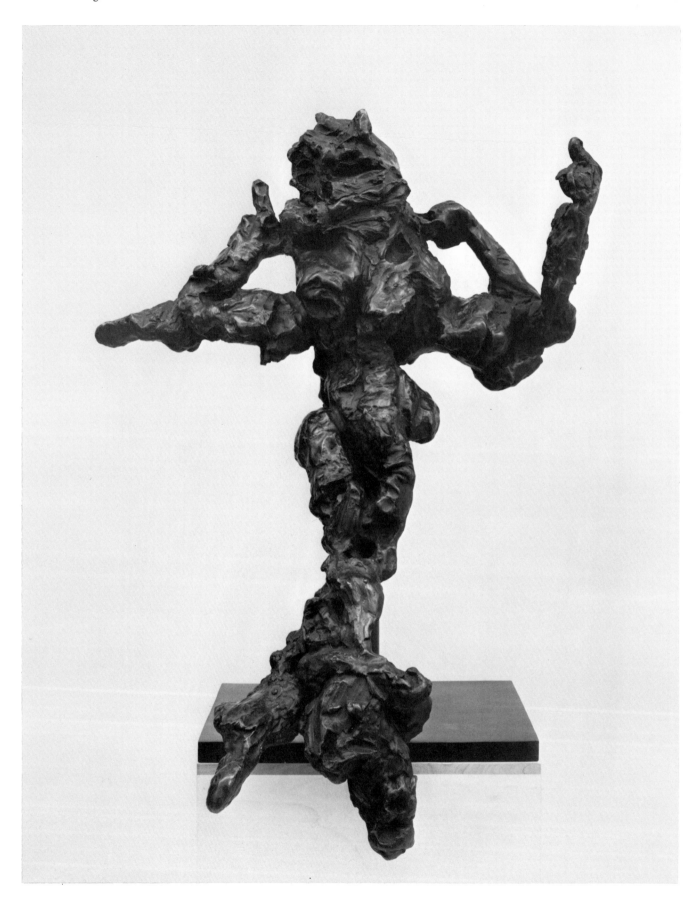

278
Hostess, 1973
Bronze
49 X 37 X 29"
Xavier Fourcade, Inc., New York

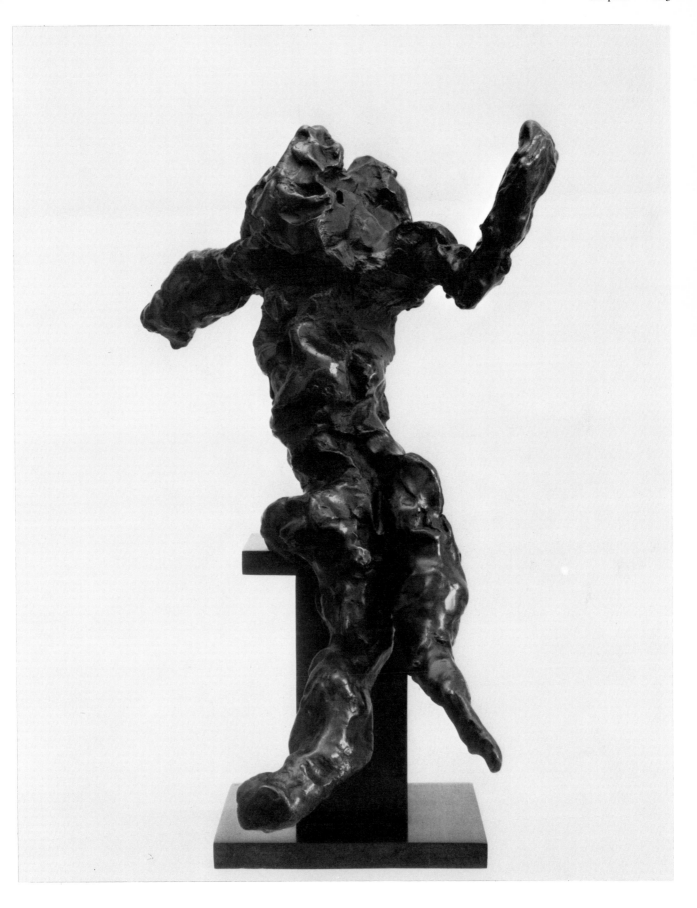

279
Small Seated Figure, 1973
Bronze
20 x 12 x 12"
Xavier Fourcade, Inc., New York

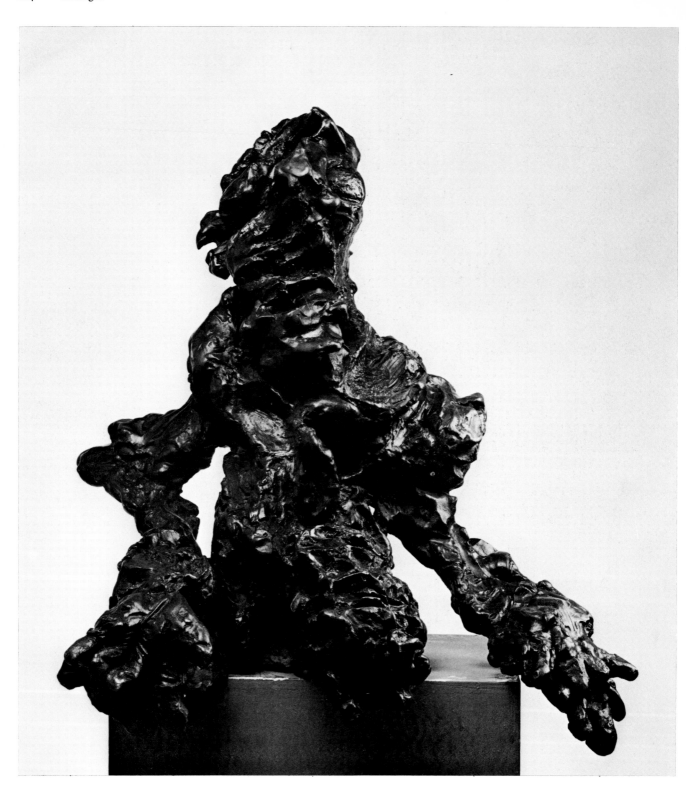

280
Large Torso, 1974
Bronze
36 x 31 x 26½"
Xavier Fourcade, Inc., New York

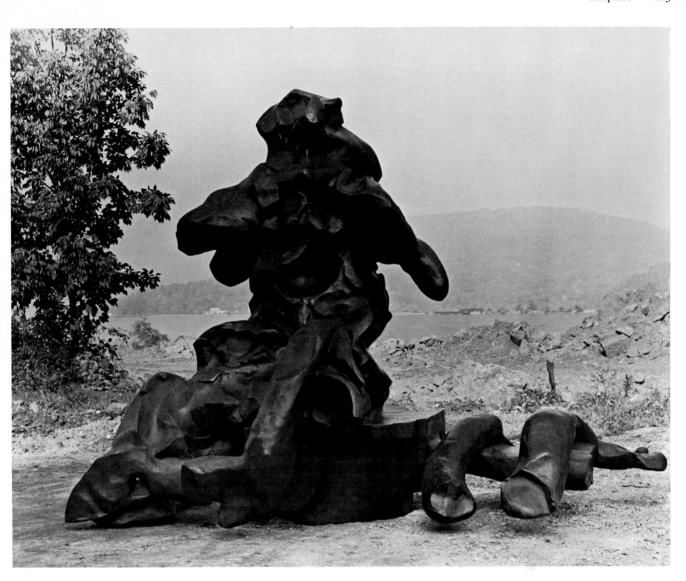

281
†Seated Woman, 1968-80
Bronze
113×147×94″
Xavier Fourcade, Inc., New York

Chronology

1904

April 24. Born in Rotterdam, Holland, to Cornelia Nobel and Leendert de Kooning. Father is a wine, beer, and soft-drink distributor; mother owns a bar.

1909

Parents are divorced. Court assigns Willem to his father, but his mother fights the decision and later appeals successfully to the court.

1916

Apprenticed to the commercial art and decorating firm of Jan and Jaap Gidding; remains for four years.

Enrolls in the Rotterdam Academy of Fine Arts and Techniques, taking night classes in both fine arts and guild techniques for the next eight years. Influenced by a teacher named Jongert.

1916-24

Becomes familiar with the school of Paris masters, Jan Toorop's decorative work, Mondrian, and Frank Lloyd Wright. Wins the State Academy Award and Silver Medal, Academy of Plastic Arts.

1920

Leaves the Giddings to work with Bernard Romein, an art director and designer for a Rotterdam department store, who

Willem de Kooning (right) and Dutch friend on a ferryboat between New York and Hoboken, New Jersey, 1926.

Willem de Kooning at Stevens Institute of Technology, Hoboken,
New Jersey, 1926.

worked in a late art-nouveau style. Learns from him about the
de Stijl group.

1924

Travels to Belgium with student friends; studies at the
Académie Royale des Beaux-Arts, Brussels, and the van Schel-
ling Design School, Antwerp. Supports himself painting signs,
designing window displays, and drawing cartoons.

1925

Returns to Rotterdam, where he finishes his studies at the
academy, graduating as a certified artist and craftsman.
Decides to leave Holland.

1926

Leo Cohan, a friend, helps him immigrate to the United States
without legitimate papers, as a wiper in the engine room of the
S.S. *Shelley*. Arrives first at Newport News, Virginia, on

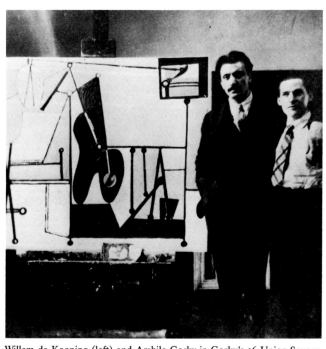

Willem de Kooning (left) and Arshile Gorky in Gorky's 36 Union Square
studio, New York, 1934.

August 15; then hires onto a coaler going to Boston. Disem-
barks with proper landing papers and goes to Hoboken, New
Jersey, where Cohan arranges for him to stay at a Dutch sea-
men's boardinghouse.

1927

Moves to a New York City studio on West Forty-fourth Street.

1927-35

Paints on weekends while earning his living as a commercial
artist, making signs, arranging window displays for the A. S.
Beck shoe stores, doing carpentry and furniture design, and
painting murals for night clubs. Works briefly for Eastman
Bros. and also paints murals for the residences of Norman K.
Winston and Vladimir and Matty Erlington.

1928

Spends the summer in Woodstock, New York.

1929

April. Meets John Graham at the opening of an exhibition of
Graham's paintings at the Dudensing Gallery, New York.
Begins friendship with Nini Diaz.

1930

John Graham introduces him to David Smith.

1930-31

Meets Arshile Gorky at Mischa Resnikoff's studio; Gorky
introduces him to Sidney Janis.

1934

Begins a series of color abstractions; continues to work on
these through 1944, concurrently with figurative imagery.
The Artists' Union is formed in New York; de Kooning joins.

1935

August. The W.P.A. Federal Art Project is established with
Holger Cahill as director. De Kooning joins the mural division;
Harold Rosenberg is assigned as his assistant. Works on a pro-
posed mural for the Williamsburg Federal Housing Project,
Brooklyn (three studies extant; mural never executed).
Begins a long series of paintings of standing and seated men in
interiors; influenced by the Surrealism of Pablo Picasso and
Arshile Gorky. Draws and paints semi-self-portraits and por-
traits of friends.

1936

Moves to 143 West Twenty-first Street. Meets the dance critic
and poet Edwin Denby, who lives at 145 West Twenty-first
Street, and the photographer Rudolph Burckhardt.
Lives for a short time with Juliet Browner, who later marries
Man Ray.

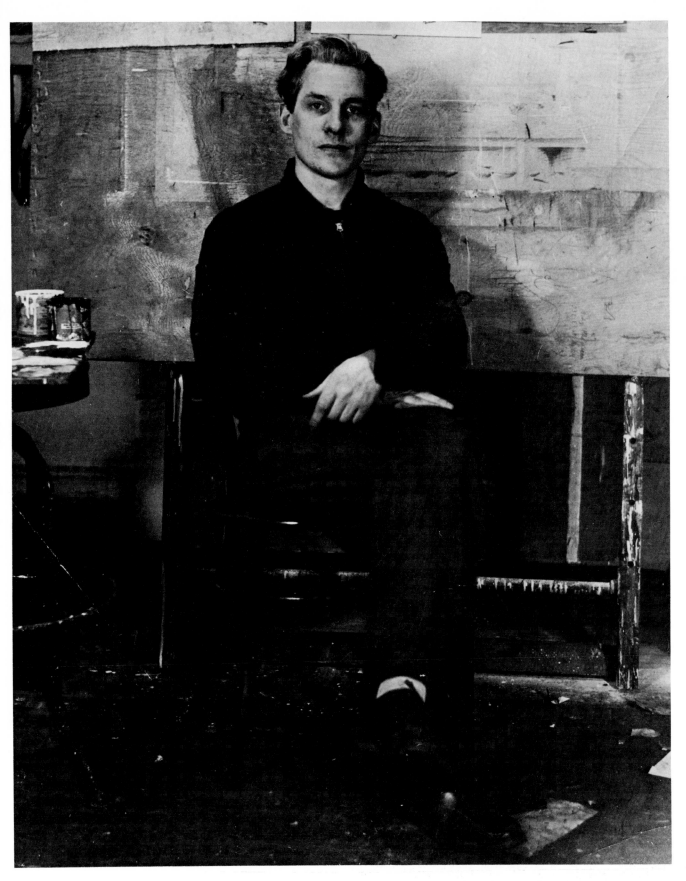

Willem de Kooning, 1930s.

Willem de Kooning, Hall of Pharmacy mural at the New York World's Fair, 1939. Photograph, collection of Peter M. Warner.

September. First group exhibition, "New Horizons in American Art," at the Museum of Modern Art, New York; organized by Holger Cahill. Includes a study (*Abstraction,* now destroyed) for the Williamsburg Federal Housing Project. Other artists include Ilya Bolotowsky, Byron Browne, Francis Criss, Stuart Davis, Arshile Gorky, Balcomb Greene, Jan Matulka, and George McNeil.
Leaves the W.P.A. because he is not a United States citizen.
Continues to support himself by odd jobs and commercial art,

Willem de Kooning, mural in the library of the S.S. *President Jackson,* c. 1941, detail.

but the experience of painting full-time on the Federal Art Project has changed his attitude.

1937

Through Burgoyne Diller obtains a commission for one ninety-foot section of a three-part mural, *Medicine,* for the Hall of Pharmacy at the 1939 New York World's Fair; the other two artists are Michael Loew and Stuyvesant Van Veen. The mural is executed by professional mural painters in 1939.
Moves to a Twenty-second Street loft.
Meets Max Margulis, a vocal coach and writer.
Paints schematic still lifes. Arshile Gorky and de Kooning attend an early organizational meeting of the American Abstract Artists, but neither joins.

1938-44

Paints early figures of women, culminating in *Pink Lady* (c. 1944).

1938

Meets Elaine Fried, an art student.

1939

Meets Fairfield Porter through Edwin Denby.

1939-40

Meets Franz Kline.

1940

Receives a commission through Edwin Denby to design sets and costumes for Nini Theilade's ballet *Les Nuages* (set to music by Debussy), performed by the Ballets Russes de Monte Carlo at the Metropolitan Opera House, New York, on April 9.
His fashion illustrations are published in the March issue of *Harper's Bazaar.*
Works under Fernand Léger on plans for a French Line pier mural (mural never executed).

1941

Commissioned by the United States Maritime Administration to execute a set of four murals, *Legend and Fact,* for the library of the S.S. *President Jackson.*

1942

January. First gallery exhibition; selected by John Graham for "American and French Paintings" at McMillen, Inc., New York. Other artists include Stuart Davis, Lee Krasner, and Jackson Pollock as well as Picasso, Braque, and Matisse. The *Art Digest* review ("Congenial Company") is his first critical mention.
Meets Jackson Pollock in connection with the McMillen exhibition.

1943

February. Selected by George Keller for "Twentieth Century Paintings" at the Bignou Gallery, New York. Exhibits a draw-

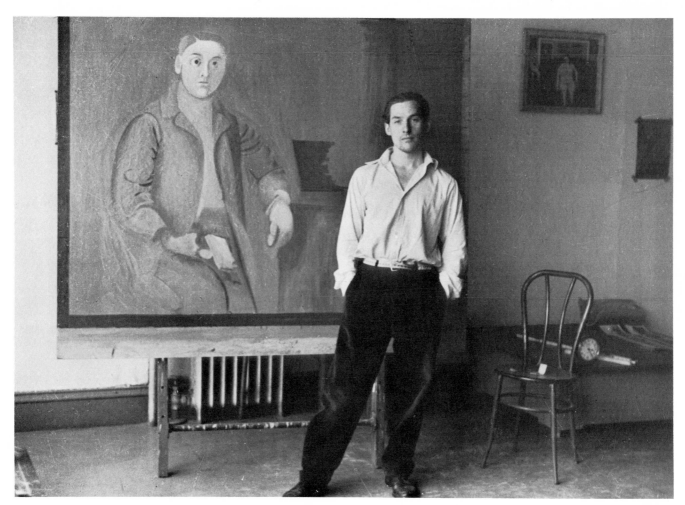

Willem de Kooning in his studio, Twenty-second Street, New York, c. 1938.

ing of Elaine and two paintings, *Pink Landscape* (c. 1938) and *Elegy* (c. 1939); the latter is bought by Helena Rubinstein.
December 10. Marries Elaine Fried. Max Margulis is best man. The couple continues to live at the Twenty-second Street loft for a short while, but in 1944 they are forced to move to Carmine Street. Willem works in a separate studio at 88 Fourth Avenue, between Tenth and Eleventh streets.

1944

November. Sidney Janis groups him with the abstract artists in "Abstract and Surrealist Art in America" at the Mortimer Brandt Gallery New York, a show organized by Janis to coincide with the publication of his book of the same title. Other artists include William Baziotes, Adolph Gottlieb, Robert Motherwell, and Mark Rothko.

1946

Designs the backdrop for a dance by Marie Marchowsky entitled *Labyrinth,* performed at New York Times Hall on April 5. The design is enlarged to a seventeen-foot-square canvas painted with the help of Milton Resnick.

late 1940s

Begins association with William Baziotes, Adolph Gottlieb, Hans Hofmann, and Clyfford Still.

1947-49

Second series of women paintings.

1948

April. First one-man exhibition, "De Kooning," at the Egan Gallery, New York. The black-and-white abstractions shown there establish his reputation as a major painter. The Museum of Modern Art, New York, purchases the largest painting from the Egan exhibition, *Painting* (1948). Meets Thomas B. Hess.
Teaches at the summer institute of Black Mountain College, North Carolina, under the direction of Josef Albers. Other teachers include Buckminster Fuller, John Cage, Merce Cunningham, Richard Lippold, Peter Grippe, and Beaumont Newhall.
Fall. William Baziotes, Robert Motherwell, Mark Rothko, and David Hare begin a small cooperative school called the Subjects of the Artist, which gives Friday-night symposia at 35 East Eighth Street. These continue until May 1949. The activities are renewed by Tony Smith, Robert Iglehart, and Hale Woodruff of New York University in the fall of 1949 as Studio 35, and continue until April 1950. De Kooning attends occasionally and prepares two lectures.
November. Participates for the first time in an Annual Exhibition of the Whitney Museum of American Art, New York, exhibiting *Mailbox* (1947). Subsequently included in the Annuals of 1949, 1950, 1963, 1965, 1967, 1969, and 1972, and the Biennial of 1981.

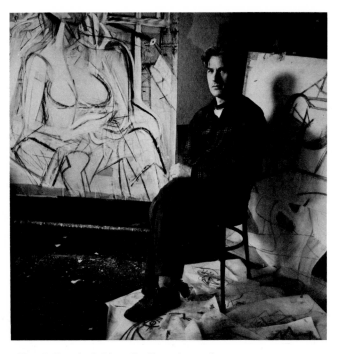

Willem de Kooning in his studio, November 1946.

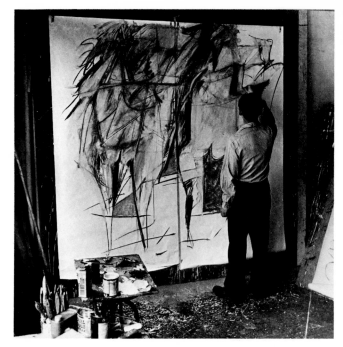

Willem de Kooning in his studio making an early study for *Woman I,* 1950.

1949

February 18. Delivers the talk "A Desperate View" at a Subjects of the Artist symposium.

September. Participates with Elaine in "Artists: Man and Wife" at the Sidney Janis Gallery, New York. Other artists include Jackson Pollock and Lee Krasner; Jean Arp and Sophie Taeuber-Arp; Ben Nicholson and Barbara Hepworth. Moves into a loft studio at 88 East Tenth Street.

Fall. A group of artists (including Philip Pavia, Franz Kline, Conrad Marca-Relli, Milton Resnick, and Landes Lewitin) which often met at the old Waldorf Cafeteria on Sixth Avenue in the early 1940s decides to collect dues, rent a loft at 39 East Eighth Street and call itself the Club. They meet Wednesday nights for group discussions and lectures until the late 1950s. De Kooning is a charter member and often participates.

1950

February. Robert Motherwell delivers de Kooning's talk "The Renaissance and Order" at Studio 35.

April 21-23. Series of panel discussions, subsequently called Artists' Sessions at Studio 35. This marks the end of the Studio 35 Friday-night symposia.

May 22. The *New York Times* prints a letter from "The Irascible Eighteen" protesting the Metropolitan Museum of Art's choice of juries for its upcoming exhibition of contemporary American painting.

Selected by Alfred H. Barr, Jr., to be one of the six artists given one-man exhibitions surrounding a large John Marin retrospective at the 25th Venice Biennale. Subsequently included in the Biennales of 1954 and 1956.

June. Finishes *Excavation* for the Venice Biennale; immediately begins working on *Woman I.*

Teaches during the fall semester at the School of Fine Arts, Yale University, New Haven, Connecticut, under the direction of Josef Albers.

1951

February 5. Andrew Carnduff Ritchie delivers de Kooning's talk "What Abstract Art Means to Me" at a Museum of Modern Art symposium in conjunction with the exhibition "Abstract Painting and Sculpture in America."

April. Second one-man exhibition, "Willem de Kooning," at the Egan Gallery, later reconstituted at the Arts Club of Chicago as a three-man exhibition with J. Pollock and B. Shahn.

May. First "9th Street Show." Includes work by de Kooning, Pollock, Kline, Hofmann, Motherwell, Esteban Vicente, Jack Tworkov, David Smith, Ad Reinhardt, Marca-Relli, and many others. The exhibition is presented in an empty storefront at 60 East Ninth Street and installed by Leo Castelli.

October. Exhibits in the first Bienal do Museu de Arte Moderna de São Paulo. Subsequently included in the Bienal of 1953.

October. Exhibits in "Sixtieth Annual American Exhibition: Paintings and Sculpture" at the Art Institute of Chicago. *Excavation* (1950) wins the Logan Medal (first prize) of $2,000 to go toward the $5,000 purchase price. Subsequently included in the American exhibitions of 1954 and 1976.

December. Sidney Janis organizes "American Vanguard Art for Paris" at the invitation of the Galerie de France; shown briefly at the Sidney Janis Gallery, New York, before traveling to Paris in January 1952.

1952

After eighteen months of work, stops painting *Woman I* (1950-52) because he is unsatisfied with it; Meyer Schapiro sees it a few months later and convinces de Kooning that it is finished. De Kooning proceeds to paint five more women paintings for the March 1953 exhibition at the Sidney Janis Gallery.

October. Exhibits for the first time in the Pittsburgh International Exhibition at the Museum of Art, Carnegie Institute. Subsequently included in the Internationals of 1955, 1958, 1961, 1964, and 1970, and has a one-man exhibition in 1979.

1953

March. Exhibits "Paintings on the Theme of the Woman" at the Sidney Janis Gallery; the Museum of Modern Art purchases *Woman I* (1950-52). Subsequently has exhibitions at the Sidney Janis Gallery in 1956, 1959, 1962, and 1972.
April. First retrospective exhibition, at the School of the Museum of Fine Arts, Boston. Exhibition travels to the Workshop Art Center, Washington, D.C.

1954

May 19. Participates in the panel discussion "Ideas in the Art of the Past Decade" at the Club.
June. "2 Pittori: de Kooning, Shahn; 3 Scultori: Lachaise, Lassaw, Smith" at the 27th Venice Biennale; organized by Andrew Carnduff Ritchie.

1955

May. H. Hartford publishes a full-page letter, "The Public Be Damned?," in most major American newspapers. The letter, directed against the modern abstract artists, mentions de Kooning specifically and thereby gives him nation-wide publicity.
November. "Recent Oils by Willem de Kooning" at the Martha Jackson Gallery, New York.

1956

April. "Willem de Kooning: Recent Paintings" at the Sidney Janis Gallery, New York. This and the Martha Jackson Gallery exhibition the year before establish de Kooning's reputation among collectors, who now begin to buy regularly.
Separates from Elaine.
Daughter Lisa is born.

1957

Makes his first print, an etching for Harold Rosenberg's poem "Revenge"; published in 1960 by the Morris Gallery, New York, in the portfolio *21 Etchings and Poems*.

1957-61

Paints large landscape abstractions.

1958

Moves to a larger loft at 831 Broadway.
Makes a brief trip to Venice.
The International Council of the Museum of Modern Art organizes "The New American Painting," an exhibition which travels extensively in Europe before being shown at the Museum of Modern Art in May 1959.

1958-59

Begins to have more time and leisure for travel; visits David Smith in Bolton Landing, New York, and Josef Albers in New Haven, Connecticut.

1959

July. Exhibits at Documenta II, in Kassel. Subsequently included in the Documentas of 1964 and 1977.
Robert Rauschenberg erases a de Kooning drawing.
December. Travels to Italy. In his friend Afro's studio in Rome, makes torn-paper drawings using black enamel. Returns to New York in January.

Franz Kline, Howard Kanovitz and Willem de Kooning, East Hampton, Long Island, mid-1950s.

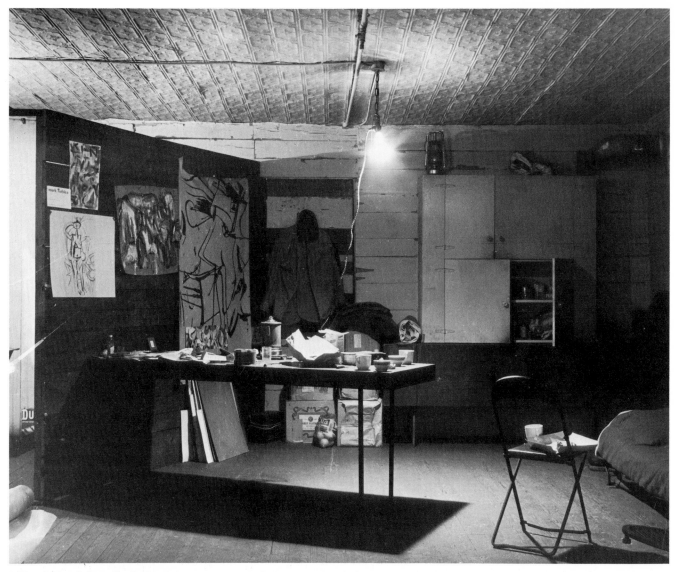

Willem de Kooning's studio, January 1950.

Doorbells at de Kooning's Tenth Street studio, early 1950s.

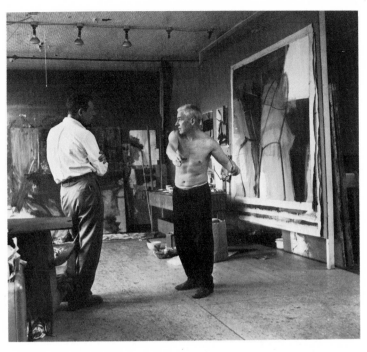

Willem de Kooning in the Cedar Bar, New York, May 1957, with Mercedes Matter and George Spaventa.

Willem de Kooning in his studio with Thomas B. Hess, early 1950s.

Willem de Kooning (top of stairs, center) with novelist Noel Clad on Tenth Street, next door to the Tanager Gallery, early 1950s (© 1982 Fred W. McDarrah).

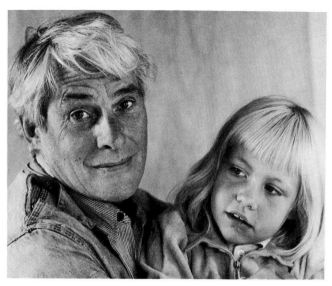

Willem de Kooning and his daughter Lisa, 1962 (© 1983 Hans Namuth).

1960

Begins fourth series of women paintings; continues through 1963.
Makes first lithographs; invited by Nathan Oliveira and George Mayasaki to the University of California, Berkeley, where he makes two black-and-white prints.
May. Elected to the National Institute of Arts and Letters.

1961

June. Exhibits in "Mostra di Disegni Americani Moderni" at the IV Festival dei Due Mondi, Spoleto, Italy.
Summer. Buys a cottage from his brother-in-law, Peter Fried, in the Springs, in East Hampton, Long Island, New York; begins planning a new studio nearby.

1962

March 13. Becomes a United States citizen.
October. Two-man exhibition with Barnett Newman at the Allan Stone Gallery, New York. Subsequently has exhibitions at the gallery in 1964, 1966, 1971, and 1972.

1963

June. Moves permanently from his Broadway loft in New York to the Springs, on Long Island.
Begins his fifth women series.

1964

September 14. Receives the Presidential Medal of Freedom from Lyndon B. Johnson.

1965

March 30. Files suit against the Sidney Janis Gallery.
April. First major retrospective exhibition, "Willem de Kooning: A Retrospective Exhibition from Public and Private

Party at John Gruen's, Water Mill, Long Island, summer 1961:
Back row, left to right: Lisa de Kooning, Frank Perry, Eleanor Perry, John B. Myers, Anne Porter, Fairfield Porter, Angelo Torricini, Arthur Gold, Jane Wilson, Kenward Elmslie, Paul Brach, Jerry Porter, Nancy Ward, Katherine Porter, friend of Jerry Porter. Second row, left to right: Joe Hazen, Clarice Rivers, Kenneth Koch, Larry Rivers, Miriam Shapiro, Robert Fizdale, Jane Freilicher, Joan Ward, John Kacere, Sylvia Maizell. Kneeling on the right, back to front: Alvin Novak, Willem de Kooning, Jim Tommaney. Front row: Stephen Rivers, William Berkson, Frank O'Hara, Herbert Machiz.

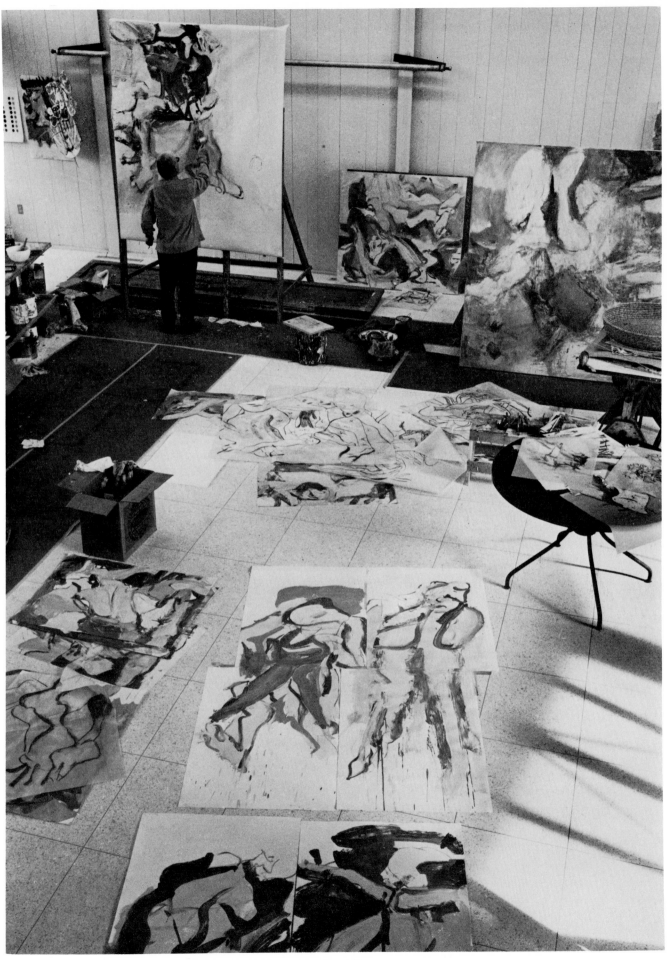

Willem de Kooning in his East Hampton studio, October 1968 (© 1982 Dan Budnick).

Collections," at the Smith College Museum of Art, Northampton, Massachusetts. In conjunction with the retrospective, gives the 3rd Louise Lindner Eastman Memorial Lecture during the week of April 5.

1967

November. "De Kooning: Paintings and Drawings Since 1963" at M. Knoedler & Co., New York. Subsequently has an exhibition at the gallery in 1969.

1968

January. Travels to Paris with Thomas B. Hess and Xavier Fourcade before his first one-man exhibition in Europe, "De Kooning: peintures récentes," at M. Knoedler & Cie, Paris. Visits the Louvre and Fontainebleau for the first time. Returns to the United States via London, where he meets Francis Bacon.
September. Returns to Holland for the first time since 1926, to attend the opening of his large retrospective, "Willem de Kooning," at the Stedelijk Museum, Amsterdam, where he is awarded the first Talens Prize International. The retrospective had been organized by Thomas B. Hess for the Museum of Modern Art, New York.

1969

January. Visits Japan with Xavier Fourcade; becomes interested in Japanese drawing methods and materials.
June. Travels to Spoleto, Italy, for the one-man exhibition "De Kooning: Disegni" at the XII Festival dei Due Mondi. Travels to Rome, where he executes his first small sculptures, in clay, later cast with the help of Herzl Emanuel, who had recently bought a small foundry.
October. "New York Painting and Sculpture, 1940-1970" at the Metropolitan Museum of Art, New York; organized by Henry Geldzahler.

1970

Begins work on life-size sculptures based on figures.
Begins series of black-and-white lithographs at the Hollander Workshop, New York.

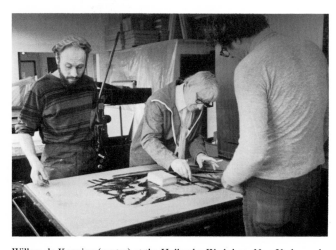

Willem de Kooning (center) at the Hollander Workshop, New York, working on a lithograph with Fred Jenis and Irwin Hollander, c. 1971.

1972

August. "Willem de Kooning: Paintings, Sculpture and Works on Paper" at the Baltimore Museum of Art.
October. "Willem de Kooning: Selected Works" at the Sidney Janis Gallery, New York, part of the settlement of his 1965 suit against that gallery.

1974

Receives the Brandeis University 17th Annual Creative Arts Award, with $1,000 honorarium.
Fourcade, Droll, New York, organizes a traveling exhibition, "Lithographs, 1970-72: Willem de Kooning," which opens in March at the Art Gallery, University of Alabama, Tuscaloosa, and travels throughout the United States through February 1977.
March. "De Kooning: Drawings/Sculptures" opens at the Walker Art Center, Minneapolis, and travels in the United States through June 1975.
September. The Australian National Gallery pays $850,000 for Woman IV (1952-53), a record amount at that time for a work by a living American artist.

1975

Awarded the Edward MacDowell Medal for "outstanding contribution to the arts" by the MacDowell Colony.
Awarded the Gold Medal for Painting by the American Academy of Arts and Letters, New York.
Organizes the Rainbow Foundation with Romare Bearden, Jacob Lawrence, and Bill E. Caldwell.
September. "Willem de Kooning" at the Fuji Television Gallery, Tokyo.
October. "De Kooning: New Works – Paintings and Sculpture" at Fourcade, Droll, New York.

1976

February. Exhibition of sculpture and lithographs, "Willem de Kooning: beelden en lithos," organized by the Stedelijk Museum, Amsterdam; travels with changes and additions to Duisburg, Geneva, and Grenoble.

1977

June. "Paris-New York" at the Musée National d'Art Moderne, Centre National d'Art et de Culture Georges Pompidou, Paris.
The International Communication Agency of the United States Government and the Hirshhorn Museum and Sculpture Garden, Smithsonian Institution, Washington, D.C., organize "Willem de Kooning: Paintings and Sculpture," which opens in October at the Museum of Contemporary Art, Belgrade, and travels in eight European countries through the summer of 1979.
The Arts Council of Great Britain organizes "The Sculpture of de Kooning with Related Paintings, Drawings and Lithographs" and "The Modern Spirit: American Painting, 1908-1935." Both exhibitions are shown in London and Edinburgh.

1978

February. "Willem de Kooning in East Hampton" at the Solomon R. Guggenheim Museum, New York; organized by Diane Waldman.

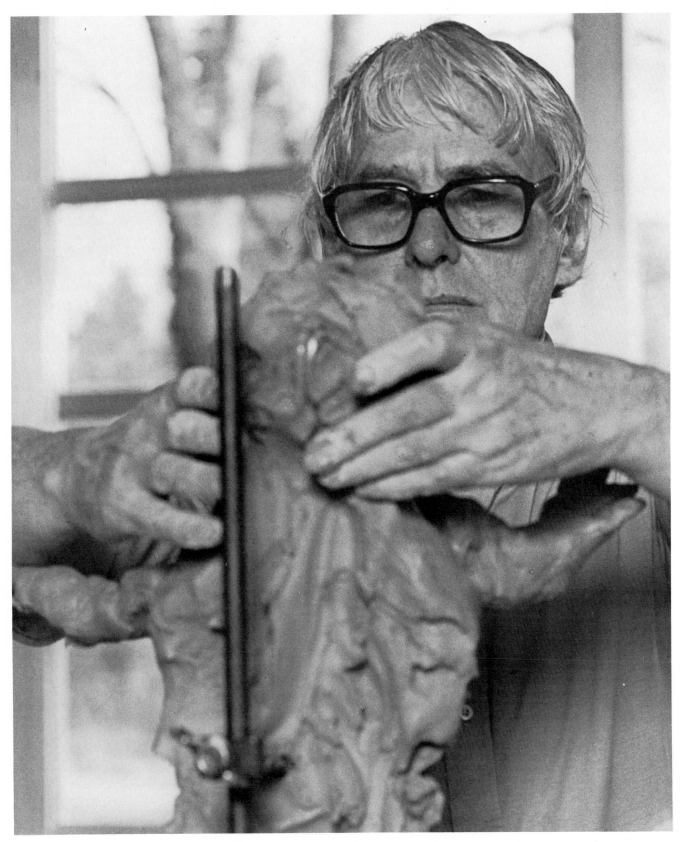

Willem de Kooning, working on a large sculpture, March 1972 (© 1983 Hans Namuth).

Willem de Kooning on Long Island, mid 1970s (© 1983 Hans Namuth)

June. Named "Artist of the Year" for the Fairfield Arts Festival, organized by the Museum of Art, Science and Industry, Bridgeport, Connecticut.

Willem de Kooning in his East Hampton studio, March 1975.

October. "De Kooning, 1969-78" at the University of Northern Iowa Gallery of Art, Cedar Falls; organized by Jack Cowart and Sanford Sivitz Shaman. Travels to St. Louis, Cincinnati, and Akron.

1979

April 24. On his seventy-fifth birthday, the Dutch government makes him an Officer of the Order of Orange-Nassau.
May 23. Elected a member of the American Academy and Institute of Arts and Letters; exhibition of work by award winners and new members.
October. Carnegie Institute, Pittsburgh, jointly awards de Kooning and Eduardo Chillida the Andrew W. Mellon Prize of $ 50,000 as part of the Pittsburgh International Series; both have exhibitions.

1981

November. "Amerikanische Malerei, 1930-1980" at the Haus der Kunst, Munich; organized by Tom Armstrong.

1982

April 25. Shows his work to Queen Beatrix of Holland during her visit to New York.
June. Elected a member of the Akademie der Künste, West Berlin.
Becomes Associate Elect, National Academy of Design, New York.

Made an honorary member of the Royal Academy for the Visual Arts, the Hague, on the occasion of its tercentenary.

1983

May. "Willem de Kooning: The North Atlantic Light, 1960-1983" at the Stedelijk Museum, Amsterdam.

May 11. Allan Stone pays $1.2 million for *Two Women* (1954-55) in an auction at Christie's, New York.

December. "The Drawings of Willem de Kooning" and "Willem de Kooning Retrospective Exhibition" (the latter organized by the Akademie der Künste, West Berlin) at the Whitney Museum of American Art, New York. Both exhibitions travel to West Berlin and Paris.

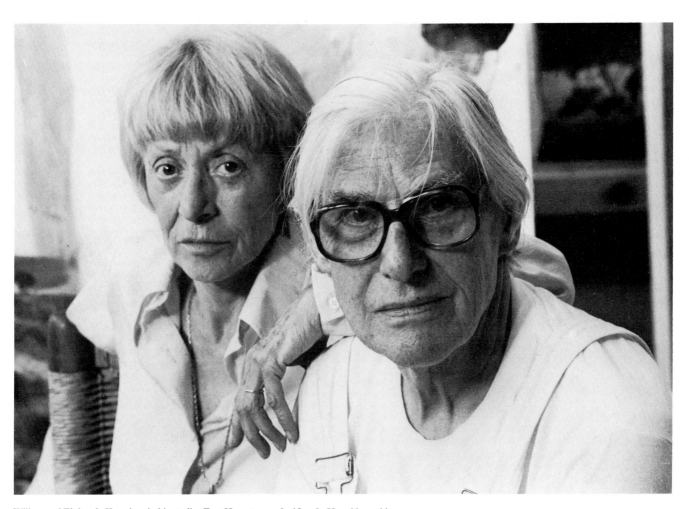

Willem and Elaine de Kooning, in his studio, East Hampton, 1980 (© 1983 Hans Namuth).

Bibliography

Monographs, Catalogues of One-Man and Two-Man Exhibitions

Agee, William C. "Willem de Kooning." Unpublished three-volume scrapbook of photographs, handwritten critical commentaries, and notes, compiled in 1962. Library, The Museum of Modern Art, New York.

Artist of the Year (exhibition catalogue). Bridgeport, Conn.: Museum of Art, Science and Industry, 1978.

Ashton, Dore. *Willem de Kooning: A Retrospective Exhibition from Public and Private Collections* (exhibition catalogue). Statement by de Kooning. Northampton, Mass.: Smith College Museum of Art, 1965.

Bell, Marja-Liisa. *Willem de Kooning* (exhibition catalogue). Helsinki: Helsingen Kaupungin Taidekokoelmat, 1978.

Blesh, Rudi, and Harriet Janis. *De Kooning*. Evergreen Gallery Book no. 8. New York: Grove Press, 1960.

Carandente, Giovanni. *De Kooning: Disegni* (exhibition catalogue). Spoleto, Italy: XII Festival dei Due Mondi, 1969.

Cowart, Jack, and Sanford Sivitz Shaman. *De Kooning, 1966-78* (exhibition catalogue). Cedar Falls, Iowa: University of Northern Iowa Gallery of Art, 1978.

De Kooning/Cornell (exhibition catalogue). New York: Allan Stone Gallery, 1964.

De Kooning Drawings. Statement by de Kooning. New York: Walker & Co., 1967.

De Kooning, January 1968-March 1969 (exhibition catalogue). New York: M. Knoedler & Co., 1969.

De Kooning: Late Paintings and Drawings (exhibition catalogue). Chicago: Richard Gray Gallery, 1980.

De Kooning: New Paintings and Sculpture (exhibition catalogue). Seattle: Seattle Art Museum, 1976.

De Kooning: New Paintings, 1976 (exhibition checklist). New York: Xavier Fourcade, 1976.

De Kooning: New Works – Paintings and Sculpture (exhibition checklist). New York: Fourcade, Droll, 1975.

De Kooning – Newman (exhibition catalogue). Text by Allan Stone. New York: Allan Stone Gallery, 1962.

De Kooning: Paintings, Drawings, Sculpture, 1967-75 (exhibition catalogue). West Palm Beach, Fla.: Norton Gallery and School of Art, 1975.

De Kooning's Women (exhibition catalogue). New York: Allan Stone Gallery, 1966.

Drudi, Gabriella. *Willem de Kooning*. Milan: Fratelli Fabbri, 1972.

An Exhibition by de Kooning Introducing His Sculpture and New Paintings (exhibition checklist). New York: Sidney Janis Gallery, 1972.

Goodman, Merle. *"Woman" Drawings by Willem de Kooning* (exhibition catalogue). Buffalo: James Goodman Gallery, 1964.

Greenberg, Clement. Catalogue of de Kooning retrospective. Boston: School of the Museum of Fine Arts, 1953.

Hess, Thomas B. *Willem de Kooning*. The Great American Artist Series. New York: George Braziller, 1959.

____. *De Kooning: Paintings and Drawings Since 1963* (exhibition catalogue). New York: Walker & Co. for M. Knoedler & Co., 1967. Essay reprinted in Thomas B. Hess. *De Kooning: peintures récentes* (exhibition catalogue). Paris: M. Knoedler & Cie., 1968.

____. *De Kooning: peintures récentes* (exhibition catalogue). Statements by de Kooning. Paris: M. Knoedler & Cie., 1968.

____. *Willem de Kooning* (exhibition catalogue). Texts by Thomas B. Hess and E. de Wilde in English and Dutch; interview with de Kooning by Bert Schierbeck; reprints of earlier statements by de Kooning. Amsterdam: Stedelijk Museum, 1968.

____. *Willem de Kooning* (exhibition catalogue). New York: The Museum of Modern Art for the Arts Council of Great Britain, 1968.

____. *Willem de Kooning* (exhibition catalogue). Statement by and interview with de Kooning. New York: The Museum of Modern Art, 1969.

____. *Willem de Kooning Drawings*. Greenwich, Conn.: New York Graphic Society, A Paul Bianchini Book, 1972.

Hunter, Sam. *De Kooning* (exhibition catalogue). Paris: Galerie des Arts, 1975. Essay reprinted in *Willem de Kooning:*

sculptures, lithographies, peintures (exhibition catalogue). Geneva: Cabinet des Estampes, Musée d'Art et d'Histoire, 1977.

Larson, Philip, and Peter Schjeldahl. *De Kooning: Drawings/Sculptures* (exhibition catalogue). Minneapolis: Walker Art Center; New York: E.P. Dutton, 1974. Revised version of essay by Schjeldahl printed in *De Kooning: Paintings, Drawings, Sculpture, 1967-75* (exhibition catalogue). West Palm Beach, Fla.: Norton Gallery and School of Art, 1975.

Miller-Keller, Andrea. *Matrix: A Changing Exhibition of Contemporary Art – Willem de Kooning/Matrix 15*. Hartford: Wadsworth Atheneum, 1975. Essay reprinted in "Matrix: A Changing Exhibition of Contemporary Art – Willem de Kooning/Matrix 12." *Calendar* (Berkeley, University Art Museum, University of California), October 1978, p. 14.

Plastik-Grafik de Kooning (exhibition catalogue). Foreword by Siegfried Salzmann; essay by Peter Schjeldahl. Duisburg, West Germany: Wilhelm-Lehmbruck-Museum der Stadt Duisburg, 1977.

Recent Oils by Willem de Kooning (exhibition catalogue). Foreword by K. Sawyer. New York: Martha Jackson Gallery, 1955.

Recent Paintings by Willem de Kooning (exhibition catalogue). Introduction by Thomas B. Hess. New York: Sidney Janis Gallery, 1962.

Rosenberg, Harold. *Willem de Kooning*. Statements by and interview with de Kooning. New York: Harry N. Abrams, 1974.

Sylvester, David. *The Sculpture of de Kooning with Related Paintings, Drawings and Lithographs* (exhibition catalogue). Texts by David Sylvester and Andrew Forge; excerpt from interview with de Kooning by Harold Rosenberg. London: Arts Council of Great Britain, 1977.

Waldman, Diane. *Willem de Kooning in East Hampton* (exhibition catalogue). New York: The Solomon R. Guggenheim Museum, 1978.

Welling, Dolf. *Willem de Kooning* (exhibition catalogue). Amsterdam: Collection d'Art, 1976.

Willem de Kooning (exhibition checklist). New York: Sidney Janis Gallery, 1959.

Willem de Kooning (exhibition catalogue). Essay by Clifford Odets. Beverly Hills, Calif.: Paul Kantor Gallery, 1961.

Willem de Kooning (exhibition catalogue). Preface by William Inge. Beverly Hills, Calif.: Paul Kantor Gallery, 1965.

Willem de Kooning (exhibition catalogue). Texts by Sam Hunter and Yoshiaki Tono in English and Japanese. Tokyo: Fuji Television Gallery, 1975.

Willem de Kooning: beelden en lithos (exhibition catalogue). Foreword by E. de Wilde; essay by Peter Schjeldahl. Amsterdam: Stedelijk Museum, 1976.

Willem de Kooning: Drawings of the 70's (exhibition checklist). Houston: Janie C. Lee Gallery, 1981.

Willem de Kooning, 1941-1959 (exhibition catalogue). Excerpt of interview with de Kooning by Harold Rosenberg. Chicago: Richard Gray Gallery, 1974.

Willem de Kooning: Paintings and Sculpture (exhibition catalogue). Washington, D.C.: International Communication Agency of the United States Government and the Hirshhorn Museum and Sculpture Garden, Smithsonian Institution, 1977.

Willem de Kooning: Paintings on the Theme of the Woman (exhibition checklist). New York: Sidney Janis Gallery, 1953.

Willem de Kooning: Pittsburgh International Series (exhibition catalogue). Preface by Leon Arkus; statements by de Kooning; reprint of interview with de Kooning by Harold Rosenberg. Pittsburgh: Museum of Art, Carnegie Institute, 1979.

Willem de Kooning: Recent Paintings (exhibition checklist). New York: Sidney Janis Gallery, 1956.

Willem de Kooning: Recent Paintings (exhibition checklist). London: Gimpel Fils, 1976.

Willem de Kooning Retrospective: Drawings, 1936-63 (exhibition catalogue). New York: Allan Stone Gallery, 1964.

Willem de Kooning: sculptures, lithographies, peintures (exhibition catalogue). Texts by Marie Claude Beaud and Rainer Michael Mason; excerpt of interview with de Kooning by Harold Rosenberg; reprint of text by Sam Hunter. Geneva: Cabinet des Estampes, Musée d'Art et d'Histoire, 1977.

Willem de Kooning: The North Atlantic Light, 1960-1983 (exhibition catalogue). Foreword by E. de Wilde; essays by E. de Wilde and Carter Ratcliff. Amsterdam: Stedelijk Museum, 1983.

Wolfe, Judith. *Willem de Kooning: Works from 1951-1981* (exhibition catalogue). Photographs of de Kooning by Hans Namuth. East Hampton, N.Y.: Guild Hall, 1981.

Yard, Sally E. *"Willem de Kooning: The First Twenty-six Years in New York, 1927-1952."* Ph. D. dissertation, Princeton University, 1980.

Catalogues of Group Exhibitions

Abstract Expressionism: A Tribute to Harold Rosenberg (exhibition catalogue). Texts by Richard Born and Suzanne Gehz; extracts from various essays by Harold Rosenberg. Chicago: David and Alfred Smart Gallery, University of Chicago, 1979.

Abstract Expressionism and Pop Art (exhibition checklist). New York: Sidney Janis Gallery, 1972.

Abstract Expressionism: Works from the Collection of the Whitney Museum of American Art (exhibition catalogue). Introduction and text by Tom Horowitz. Miami: Miami-Dade Community College, 1976.

Acquisition Priorities: Aspects of Postwar Painting in America (exhibition catalogue). New York: The Solomon R. Guggenheim Museum, 1976.

Agee, William C. *The 1930's: Painting and Sculpture in America* (exhibition catalogue). New York: Whitney Museum of American Art, 1968.

Amaya, Mario. *The Obsessive Image, 1960-1968* (exhibition catalogue). Forewords by Robert Melville and Roland Penrose. London: Institute of Contemporary Arts, 1968.

America (exhibition catalogue). Basel: Galerie Beyeler, 1971.

America, America (exhibition catalogue). Introduction by Reinhold Hohl in German and English. Basel: Galerie Beyeler, 1976.

America and Europe: A Century of Modern Masters from the Thyssen-Bornemisza Collection (exhibition catalogue). Introduction by Henry Thyssen-Bornemisza; text by Eric M. Zafran. Sydney: Australian Gallery Directors Council, 1979.

American Art: Third Quarter Century (exhibition catalogue). Text by Jan van der Marck. Seattle: Seattle Art Museum, 1973.

American Abstract Expressionists and Imagists (exhibition catalogue). Introduction by H. H. Arnason. New York: The Solomon R. Guggenheim Museum, 1961.

American Abstract Painting in the 1950's (exhibition checklist). Text by Barbara Diver. Boston: Harcus Krakow Gallery, 1979.

American Drawing in Black and White, 1970-1980 (exhibition checklist). Text by Gene Baro. Brooklyn: The Brooklyn Museum, 1980.

American Drawing, 1927-77 (exhibition catalogue). Prologue by Miriam B. Lein; essay by Paul Cummings; notes by Sandra L. Lipshultz. St. Paul: Minnesota Museum of Art, 1977.

American Drawings (exhibition catalogue). Essay by Lawrence Alloway. New York: The Solomon R. Guggenheim Museum, 1964.

American Figure Painting, 1950-1980 (exhibition catalogue). Norfolk, Va.: The Chrysler Museum, 1980.

American Painting Annual (exhibition catalogue). San Francisco: California Palace of the Legion of Honor, 1951.

American Painting, 1910-1960 (exhibition catalogue). Foreword by Earl Enyeart Harper; Introduction by Henry R. Hope. Bloomington, Ind.: Indiana University Art Museum, 1964.

American Paintings, 1945-1957 (exhibition catalogue). Introduction by Stanton L. Catlin. Minneapolis: The Minneapolis Institute of Arts, 1957.

American Vanguard Art for Paris (exhibition checklist). New York: Sidney Janis Gallery, 195[

American Works on Paper, 1944 to 1974 (exhibition checklist). New York: William Zierler, 1974.

L'Amérique aux indépendants (exhibition catalogue). Paris: Grand Palais, 1980.

Armstrong, Tom. *Amerikanische Malerei, 1930-1980* (exhibition catalogue). Munich: Prestel-Verlag for Haus der Kunst, 1981.

Arnason, H. H. *Vanguard American Painting* (exhibition catalogue). London: U.S.I.S. Gallery, United States Embassy, 1962.

The Art Institute of Chicago. *Sixtieth Annual American Exhibition: Paintings and Sculpture* (exhibition catalogue), 1951.

———. *Sixty-first American Exhibition: Paintings and Sculpture* (exhibition catalogue), 1954.

———. *Seventy-second American Exhibition* (exhibition catalogue), 1976. Introduction by A. James Speyer; text by Anne Rorimer.

Artists and East Hampton: A 100-Year Perspective (exhibition catalogue). Foreword by Enez Whipple; essay by Phyllis Braff. East Hampton, N.Y.: Guild Hall, 1976.

Artists: Man and Wife (exhibition checklist). New York: Sidney Janis Gallery, 1949.

Artists of Suffolk County, Part II: The Abstract Tradition (exhibition catalogue). Foreword by Eva Ingersoll Gatling. Huntington, N.Y.: Heckscher Museum, 1970.

Artists of Suffolk County, Part IV: Contemporary Prints (exhibition catalogue). Introduction by Ruth B. Solomon. Huntington, N.Y.: Heckscher Museum, 1972.

Artists of Suffolk County, Part X: Recorders of History (exhibition catalogue). Introduction by Ruth B. Solomon. Huntington, N.Y.: Heckscher Museum, 1976.

Art Since 1950: American and International (exhibition catalogue). Foreword by Norman Davis; Introductions by Sam Hunter and William Sandberg. Seattle: Seattle World's Fair, 1962.

Art USA: The Johnson Collection of Contemporary American Painting (exhibition catalogue). Milwaukee: Milwaukee Art Center, 1962.

L'Art vivant aux Etats-Unis (exhibition catalogue). Essay by Dore Ashton. Paris: Fondation Maeght, 1970.

Ashton, Dore, and Kenneth Donahue. *The Sidney Janis Painters* (exhibition catalogue). Sarasota, Fla.: John and Mable Ringling Museum of Art, 1961.

Baur, John I. H. *Nature in Abstraction: The Relation of Abstract Painting and Sculpture to Nature in Twentieth-Century American Art* (exhibition catalogue). Artists' biographies by Rosalind Irvine. New York: The Macmillan Co. for the Whitney Museum of American Art, 1958.

———. *Between the Fairs: 25 Years of American Art, 1939-1964* (exhibition catalogue). Foreword by Lloyd Goodrich. New York: Frederick A. Praeger for the Whitney Museum of American Art, 1964.

———. *American Painting, 1900-1976* (exhibition catalogue). Katonah, N.Y.: The Katonah Gallery, 1975.

Baur, John I. H., ed., and Rosalind Irvine. *The New Decade: 35 American Painters and*

Sculptors (exhibition catalogue). New York: The Macmillan Co. for the Whitney Museum of American Art, 1955.

Baur, John I. H., and Ann Wiegert. *American Masters of the Twentieth Century* (exhibition catalogue). Foreword by Lowell Adams. Oklahoma City: Oklahoma Art Center, 1982.

Bermingham, Peter. *The Art of Poetry* (exhibition catalogue). Washington, D.C.: National Collection of Fine Arts, Smithsonian Institution, 1976.

Black and White (exhibition catalogue). Texts by Ben Heller, Robert Motherwell, and Alan Solomon. New York: The Jewish Museum, 1963.

Black and White Are Colors: Paintings of the 1950s-1970s (exhibition catalogue). Texts by D. Steadman and D. S. Rubin. Claremont, Calif.: Montgomery Art Gallery, Pomona College; Lang Art Gallery, Scripps College, 1979.

Blum, Jane. *The Figure of 5* (exhibition catalogue). Miami: The Gallery, Miami-Dade Community College, 1979.

Boorstin, Daniel J., and Cynthia Jaffee McCabe. *The Golden Door: Artist-Immigrants of America, 1876-1976* (exhibition catalogue). Washington, D.C.: Smithsonian Institution Press for the Hirshhorn Museum and Sculpture Garden, 1976.

Brown, Milton W. *The Modern Spirit: American Painting, 1908-1935* (exhibition catalogue). Foreword by Joanna Drew. London: Arts Council of Great Britain, 1977.

Cahill, Holger. *New Horizons in American Art* (exhibition catalogue). New York: The Museum of Modern Art, 1936.

Carandente, Giovanni. *Mostra di Disegni Americani Moderni* (exhibition catalogue). Rome: De Luca Editore, 1961.

Carmean, E. A., Jr., and Eliza E. Rathbone. *American Art at Mid-Century: The Subjects of the Artists* (exhibition catalogue). Foreword by J. Carter Brown. Washington, D.C.: National Gallery of Art, 1978.

Cathcart, Linda L. *American Painting of the 1970's* (exhibition catalogue). Buffalo: Albright-Knox Art Gallery, 1979.

Challenge and Defy: Extreme Examples by XX Century Artists, French and American (exhibition checklist). New York: Sidney Janis Gallery, 1950.

Coe, Ralph T. *The Logic of Modern Art* (exhibition catalogue). Kansas City, Mo.: William Rockhill Nelson Gallery and Atkins Museum of Fine Arts, 1961.

Contemporary American Painting (exhibition catalogue). Columbus, Ohio: Columbus Gallery of Fine Arts, 1960.

Contemporary Painting (exhibition catalogue). Northampton, Mass.: Smith College Museum of Art, 1963.

Contemporary Trends (exhibition catalogue). Osaka: Expo Museum of Fine Arts, 1970.

The Corcoran Gallery of Art, Washington, D.C. *28th Biennial Exhibition of Contemporary American Painting* (exhibition catalogue), 1963.

———. *34th Biennial Exhibition of Contemporary American Painting* (exhibition catalogue), 1975. Text by Roy Slade.

———. *36th Biennial Exhibition of Contemporary American Painting: Willem de Kooning, Jasper Johns, Ellsworth Kelly, Roy Lichtenstein, Robert Rauschenberg* (exhibition catalogue), 1979. Text by Jane Livingston and Linda Crocker Simmons.

Cummings, Paul. *Abstract Drawings, 1911-1981* (exhibition checklist). New York: Whitney Museum of American Art, 1982.

Diehl, Gaston. *XXIIIᵉ Salon de mai* (exhibition catalogue). Paris: Musée d'Art Moderne de la Ville de Paris, 1967.

Dillenberger, Jane, and John Dillenberger. *Perceptions of the Spirit in Twentieth-Century American Art* (exhibition catalogue). Indianapolis: Indianapolis Museum of Art, 1977.

Directions in Twentieth Century American Painting (exhibition catalogue). Foreword by Terry Bywaters. Dallas: Dallas Museum of Fine Arts, 1961.

Dix Ans d'art vivant, 1955-1965 (exhibition catalogue). Text by François Wehrlin. St. Paul-de-Vence, France: Fondation Maeght, 1967.

Documenta II: Kunst nach 1945 – Internationale Ausstellung (exhibition catalogue). Kassel: Museum Fridericianum, 1959.

Documenta III: Internationale Ausstellung (exhibition catalogue), vol. 1: *Malerei, Skulptur*. Texts by Arnold Bode and Werner Haftmann. Cologne: Verlag M. DuMont Schauberg for Museum Fridericianum, 1964.

Documenta 6 (exhibition catalogue), vol. 1: *Malerei, Plastik/Environment, Performance*. Texts by Klaus Honnef, Evelyn Weiss, and Lothar Lang. Kassel: Paul Dierichs for Museum Fridericianum, 1977.

Documents, Drawings and Collages: 50 American Works on Paper from the Collection of Mr. and Mrs. Stephen D. Paine. Essays by Stephen D. Paine, Franklin Kelly, Stephen Eisenman, and Hiram Carruthers Butler. Williamstown, Mass.: Williams College Museum of Art, 1979.

Drawings & (exhibition catalogue). Foreword by D. B. Goodall; Introduction by M. Matter. Austin, Tex.: University Art Museum, University of Texas, 1966.

Drawings in St. Paul from the Permanent Collection of the Minnesota Museum of Art (exhibition catalogue). Essay by A. Hyatt Mayor. St. Paul: Minnesota Museum of Art, 1971.

Drawings in St. Paul: Selections from the Miriam B. and Malcolm E. Lein Collection (exhibition catalogue). Introduction by Dean Swanson. St. Paul: Minnesota Museum of Art, 1980.

Drawings 1916/1966: An Exhibition on the Occasion of the Fiftieth Anniversary of the Arts Club of Chicago (exhibition catalogue). Chicago: Arts Club of Chicago, 1966.

8 American Painters (exhibition catalogue). New York: Sidney Janis Gallery, 1959.

8 Americans (exhibition checklist). New York: Sidney Janis Gallery, 1957.

11 Abstract Expressionist Painters (exhibition checklist). Text by Herman Warner Williams, Jr. New York: Sidney Janis Gallery, 1963.

Exhibition: Ben Shahn, Willem de Kooning, Jackson Pollock (exhibition catalogue). Chicago: Arts Club of Chicago, 1951.

Exhibition of Work by Newly Elected Members and Recipients of Honors and Awards (exhibition checklist). New York: American Academy and Institute of Arts and Letters, 1979.

Expressionism in American Painting (exhibition catalogue). Foreword by Edgar C. Schenck; Introduction by Edgar C. Schenck, Patrick J. Kelleher, and Roger Squire; essay by Bernard Myers. Buffalo: Albright Art Gallery, Buffalo Fine Arts Academy, 1952.

The Expressionist Image: American Art from Pollock to Today (exhibition checklist). New York: Sidney Janis Gallery, 1982.

5th Anniversary Exhibition: 5 Years of Janis (exhibition checklist). New York: Sidney Janis Gallery, 1953.

Five Distinguished Alumni: The W.P.A. Federal Art Project (exhibition catalogue). Essay by Judith Zilczer; statements by the artists. Washington, D.C.: Hirshhorn Museum and Sculpture Garden, Smithsonian Institution, 1982.

Five Action Painters of the Fifties (exhibition brochure). Essay by Harold Rosenberg (reprint of "The American Action Painters." *Art News*, 51 [December 1952], pp. 48-50). New York: The Pace Gallery, 1979.

Focus on the Figure: Twenty Years (exhibition checklist). Text by Barbara Haskell. New York: Whitney Museum of American Art, 1982.

Fourteen Paintings: De Kooning, Dubuffet, Ossorio, Pollock, Still (exhibition checklist). Foreword by Guy Gowrie. London: Thomas Gibson Fine Art, 1976.

Frank O'Hara: A Poet Among Painters (exhibition checklist). New York: Whitney Museum of American Art, 1974.

From Foreign Shores: Three Centuries of Art by Foreign-Born American Masters (exhibition catalogue). Text by I. Michael Danoff. Milwaukee: Milwaukee Art Center, 1976.

Geldzahler, Henry. *New York Painting and Sculpture, 1940-70* (exhibition catalogue). Texts by Michael Fried, Clement Greenberg, Harold Rosenberg, Robert Rosenblum, and William Rubin (reprints of and excerpts from various earlier texts). New York: The Metropolitan Museum of Art, 1970.

Goldwater, Robert. *Space and Dream* (exhibition catalogue). New York: Walker & Co. for M. Knoedler & Co., 1967.

Goodrich, Lloyd. *Art of the United States, 1670-1966* (exhibition catalogue). New York: Whitney Museum of American Art, 1966.

Goodyear, Frank H. *Seven on the Figure: Jack Beal, William Beckman, Joan Brown, John DeAndrea, Willem de Kooning, Stephen DeStaebler, Ben Kamihira* (exhibition catalogue). Philadelphia: Pennsylvania Academy of the Fine Arts, 1979.

Guggenheim International Award, 1964 (exhibition catalogue). Introduction by Lawrence Alloway. New York: The Solomon R. Guggenheim Museum, 1963.

Henning, Edward B. *Paths of Abstract Art* (exhibition catalogue). Preface by Sherman E. Lee. Cleveland: The Cleveland Museum of Art; New York: Harry N. Abrams, 1960.

Hills, Patricia, and Roberta K. Tarbell. *The Figurative Tradition and the Whitney Museum of American Art: Paintings and Sculpture from the Permanent Collection* (exhibition catalogue). Foreword by Tom Armstrong.

New York: Whitney Museum of American Art; Newark, Del.: University of Delaware Press, 1980.

Hobbs, Robert Carleton, and Gail Levin. *Abstract Expressionism: The Formative Years* (exhibition catalogue). Introduction by Thomas W. Leavitt and Tom Armstrong. New York: Whitney Museum of American Art; Utica, N.Y.: Herbert F. Johnson Museum of Art, Cornell University, 1978. Reprint, Utica, N.Y.: Cornell University Press, 1981.

Homage to Marilyn Monroe by Leading International Artists (exhibition checklist). New York: Sidney Janis Gallery, 1967.

Hunter, Sam, ed. *Monumenta: A Biennial Exhibition of Outdoor Sculpture* (exhibition catalogue). Newport, R.I.: Monumenta Newport, 1974.

The Ideographic Picture (exhibition catalogue). Foreword by Barnett Newman. New York: Betty Parsons Gallery, 1947.

The Image in American Painting and Sculpture, 1950-1980 (exhibition catalogue). Preface by I. Michael Danoff; Introduction by Carolyn Kinder Carr. Akron: Akron Art Museum, 1981.

The International Council of the Museum of Modern Art, New York. *Cuatro maestros contemporáneos: Giacometti, Dubuffet, de Kooning, Bacon* (exhibition catalogue). Text by Alicia Legg. Caracas: Museo de Bellas Artes, 1973; Bogotá: Museo de Arte Moderno, 1973.

——. *Cuatro maestros contemporáneos del arte figurativo: Giacometti, Dubuffet, de Kooning, Bacon* (exhibition catalogue). Text by Alicia Legg. Mexico City: Museo de Arte Moderno, 1973.

——. *4 mestres contemporâneos: Jean Dubuffet, Alberto Giacometti, Willem de Kooning, Francis Bacon* (exhibition catalogue). Texts by Alicia Legg, Heloise Aleixo Lustosa, and P. M. Bardi. São Paulo: Museu de Arte Moderna de São Paulo, 1973.

I. Internationale der Zeichnung (exhibition catalogue). Essay by Dore Ashton. Darmstadt: Mathildenhoehe, 1964.

Janis, Sidney. *Abstract and Surrealist Art in the United States* (exhibition catalogue). San Francisco: San Francisco Museum of Art, 1944. Reprinted as Sidney Janis. *Abstract and Surrealist Art in America*. New York: Reynal & Hitchcock, 1944.

Jubilation: American Art During the Reign of Elizabeth II (exhibition catalogue). Cambridge, England: The Fitzwilliam Museum, 1977.

King, Susan. *Selection, 1967: Recent Acquisitions in Modern Art* (exhibition catalogue). Berkeley: University of California Art Museum, 1967.

Kokkinen, Eila. *Drawings by Five Abstract Expressionist Painters: Arshile Gorky, Philip Guston, Franz Kline, Willem de Kooning, Jackson Pollock* (exhibition catalogue). Cambridge, Mass.: Hayden Gallery, Massachusetts Institute of Technology, 1975; Chicago: Museum of Contemporary Art, 1976.

Kompass 3: Schilderkunst na 1945 uit New York/Painting After 1945 in New York (exhibition catalogue). Text by Jean Leering in English

and Dutch. Eindhoven, Holland: Stedelijk van Abbemuseum, 1967.

Kompass New York: Malerei nach 1945 aus New York/Painting After 1945 in New York (exhibition catalogue). Text by Jean Leering in English and German. Frankfurt: Frankfurter Kunstverein, 1967.

Kootz, Samuel, and Harold Rosenberg. *The Intrasubjectives* (exhibition catalogue). New York: Samuel Kootz Gallery, 1949.

Kosinsky, Dorothy M. *Heritage of Freedom: A Salute to America's Foreign-Born Artists* (exhibition catalogue). Huntington, N.Y.: Heckscher Museum, 1976.

Kozloff, Max. *Twenty-five Years of American Painting, 1948-1973* (exhibition catalogue). Preface by James Demetrion. Des Moines: Des Moines Art Center, 1973.

Krauss, Rosalind. *Within the Easel Convention: Sources of Abstract Expressionism* (exhibition catalogue). Cambridge, Mass.: Fogg Art Museum, Harvard University, 1964.

Langui, Emile. *50 Ans d'art moderne* (exhibition catalogue). Foreword by Marquis de La Boessière-Thiennes. Brussels: Palais Internationale des Beaux-Arts, 1958.

Lieberman, William S., ed. *An American Choice: The Muriel Kallis Steinberg Newman Collection* (exhibition catalogue). Foreword by Philippe de Montebello. New York: The Metropolitan Museum of Art, 1981.

Lithographs by de Kooning, Fairfield Porter, and Paul Waldman (exhibition brochure). New York: M. Knoedler & Co., 1971.

Loan Exhibition of Seventy XX Century American Paintings . . . for a Special Purchase Fund of the Whitney Museum of American Art. (exhibition catalogue). Introduction by Hermon More. New York: Wildenstein Gallery, 1952.

Metzger, Robert. *Abstract Expressionism Lives!* (exhibition catalogue). Stamford, Conn.: Stamford Museum and Nature Center, 1982.

Modern Art in Advertising (exhibition catalogue). Essays by Carl O. Schniewind, Fernand Léger, and Walter P. Paepcke. Chicago: The Art Institute of Chicago, 1945.

Modern Portraits: The Self and Others (exhibition catalogue). Texts by Kirk T. Varnedoe et al. New York: Wildenstein Gallery, 1976.

Moss, Jacqueline, and Ida E. Rubin, ed. *Sculpture 76: An Outdoor Exhibition of Sculpture by Fifteen Living American Artists* (exhibition catalogue). Essay by Ida E. Rubin; commentaries by Jacqueline Moss. Greenwich, Conn.: Greenwich Arts Council, 1976.

Motherwell, Robert. *Black or White: Paintings by European and American Artists* (exhibition catalogue). New York: Samuel Kootz Gallery, 1950.

Muller, Marc H. *Selection of 19th and 20th Century Works from the Hunt Foods and Industries Museum of Art Collection* (exhibition catalogue). Irvine, Calif.: University of California, 1967.

Museu de Arte Moderna de São Paulo. *I Bienal do Museu de Arte Moderna de São Paulo: Catálogo* (exhibition catalogue), 1951.

——. *II Bienal do Museu de Arte Moderna de São Paulo: Catálogo geral* (exhibition catalogue),

1953. Introduction to U.S. section by René d'Harnoncourt.

The Museum and Its Friends: Eighteen Living American Artists Selected by the Friends of the Whitney Museum (exhibition catalogue). Foreword by Milton Lowenthal; essay by David M. Solinger; statements by the artists. New York: Whitney Museum of American Art, 1959.

The Museum and Its Friends: Twentieth-Century American Art from Collections of the Friends of the Whitney Museum (exhibition catalogue). Foreword by Flora Whitney Miller; Prefaces by Milton Lowenthal and David M. Solinger. New York: Whitney Museum of American Art, 1958.

Museum of Art, Carnegie Institute, Pittsburgh. *The 1952 Pittsburgh International Exhibition of Contemporary Painting* (exhibition catalogue), 1952.

——. *The 1955 Pittsburgh International Exhibition of Contemporary Painting* (exhibition catalogue), 1955.

——. *The 1958 Pittsburgh International Exhibition of Painting and Sculpture* (exhibition catalogue), 1958.

——. *The 1961 Pittsburgh International Exhibition of Contemporary Painting and Sculpture* (exhibition catalogue), 1961.

——. *The 1964 Pittsburgh International Exhibition of Contemporary Art* (exhibition catalogue), 1964.

——. *The 1970 Pittsburgh International Exhibition of Contemporary Art* (exhibition catalogue), 1970.

Nederlands bijdrage: tot de internationale ontwikkeling sedert 1945 (exhibition catalogue). Amsterdam: Stedelijk Museum, 1962.

The New American Painting and Sculpture: The First Generation (exhibition checklist). New York: The Museum of Modern Art, 1969.

The New American Painting: As Shown in Eight European Countries (exhibition catalogue). Foreword by René d'Harnoncourt; essay by Alfred H. Barr, Jr. New York: International Council of the Museum of Modern Art, 1959.

New Directions in American Painting (exhibition catalogue). Introduction by Sam Hunter. Waltham, Mass.: The Poses Institute of Fine Arts, Brandeis University, 1963.

A New Spirit in Painting (exhibition catalogue). Foreword by Hugh Casson; Preface by Christo M. Joachimides, Norman Rosenthal, and Nicholas Serota; essay by Christo M. Joachimides. London: Royal Academy of Arts, 1981.

New York and Paris: Painting in the Fifties (exhibition catalogue). Essays by Bernard Dorival and Dore Ashton. Houston: The Museum of Fine Arts, 1959.

The New York School, Four Decades: Guggenheim Museum Collection and Major Loans (exhibition brochure). New York: The Solomon R. Guggenheim Museum, 1982.

9 American Painters (exhibition checklist). New York: Sidney Janis Gallery, 1960.

9 American Painters Today (exhibition checklist). New York: Sidney Janis Gallery, 1954.

1943-1953: The Decisive Years (exhibition catalogue). Philadelphia: Institute of Contemporary Art, University of Pennsylvania, 1965.

XIX and XX Century Master Paintings (exhibition checklist). New York: Acquavella Galleries, 1979.

The Nude in American Painting (exhibition catalogue). Brooklyn: The Brooklyn Museum, 1961.

Painting and Sculpture in the World of Tomorrow: Fair-Commissioned Mural Painting (exhibition prospectus). Commentary by Michael Loew. New York: Department of Feature Publicity, New York World's Fair, 1937.

Painting and Sculpture of a Decade, 54-64 (exhibition catalogue). Text by Alan Bowness, Lawrence Gowing, and Philip James. London: Tate Gallery, 1964.

Painting and Sculpture Today, 1974 (exhibition catalogue). Introduction by Richard L. Warrum; Preface by Carl J. Weinhardt, Jr. Indianapolis: Contemporary Art Society of the Indianapolis Museum of Art, 1974.

Painting and Sculpture Today, 1976 (exhibition catalogue). Indianapolis: Contemporary Art Society of the Indianapolis Museum of Art, 1976.

Painting as Painting (exhibition catalogue). Preface by Donald B. Goodall; Introduction by Dore Ashton; essays by George McNeil and Louis Finkelstein. Austin, Tex.: University Art Museum, University of Texas, 1968.

Paris-New York: un album (exhibition catalogue). Foreword by Pontus Hulten. Paris: Musée National d'Art Moderne, Centre National d'Art et de Culture Georges Pompidou, 1977.

Passloff, Patricia, ed. *The 30's: Painting in New York* (exhibition catalogue). Includes memoir of de Kooning by Edwin Denby; letter to de Kooning from Agnes Phillips Gorky; photograph of de Kooning by Rudolph Burckhardt. New York: Poindexter Gallery, 1957.

Peinture américaine en Suisse, 1950-1965 (exhibition catalogue). Essay by Charles Goerg in English and French. Geneva: Musée d'Art et d'Histoire, 1976.

Plous, Phyllis. *Five American Painters: Recent Work by de Kooning, Mitchell, Motherwell, Resnick, Tworkov* (exhibition catalogue). Santa Barbara, Calif.: Art Galleries, University of California, 1974.

Princeton Alumni Collections: Works on Paper (exhibition catalogue). Introduction by Allan Rosenbaum; essay by A. Hyatt Mayor; memorial to A. Hyatt Mayor by Lincoln Kirstein. Princeton, N.J.: The Art Museum, Princeton University, 1981.

Rasmussen, Waldo, Lucy Lippard, Irving Sandler, and Gene Swenson. *Two Decades of American Painting* (exhibition catalogue). Victoria, Austria: National Gallery, 1967; New York: International Council of the Museum of Modern Art, 1966.

Recent Paintings by 7 Americans (exhibition checklist). New York: Sidney Janis Gallery, 1956.

Riggs, Timothy A. *Two Decades of American Printmaking, 1957-1977* (exhibition catalogue). Worcester, Mass.: Worcester Art Museum, 1978.

Ritchie, Andrew Carnduff. *Abstract Painting and Sculpture in America* (exhibition catalogue).

New York: The Museum of Modern Art, 1951.

The Romantic Agony: From Goya to de Kooning (exhibition catalogue). Houston: Contemporary Arts Museum, 1959.

Rosc, Bernice. *A Century of Modern Drawing from the Museum of Modern Art, New York* (exhibition catalogue). London: British Museum Publications, 1982.

Rosc '67: The Poetry of Vision (exhibition catalogue). Texts by Jean Leymarie, William Sandburg, and James Johnson Sweeney. Dublin: Royal Dublin Society, 1967.

Rozensweig, Phyllis. *The Fifties: Aspects of Painting in New York* (exhibition catalogue). Washington, D.C.: Hirshhorn Museum and Sculpture Garden, Smithsonian Institution, 1980.

Rueppel, Merrill Clement. *200 Years of American Painting* (exhibition catalogue). St. Louis: City Art Museum of St. Louis, 1964.

Schwartz, Constance. *The Abstract Expressionists and Their Precursors* (exhibition catalogue). Essays by Max Kozloff and Dore Ashton. Roslyn, N.Y.: Nassau County Museum of Fine Art, 1981.

Sculpture in the 70s: The Figure (exhibition catalogue). Introduction by Ellen Schwartz. Brooklyn: Department of Exhibitions, Pratt Institute, 1980.

Second Williams College Alumni Loan Exhibition: In Celebration of the 50th Anniversary of the Williams College Museum of Art and in Honor of President John W. Chandler and Professor S. Lane Faison, Jr. (exhibition catalogue). Introduction by S. Lane Faison, Jr. Williamstown, Mass.: Williams College Museum of Art, 1976.

Seitz, William C. *The Art of Assemblage* (exhibition catalogue). New York: The Museum of Modern Art, 1961.

Selected Works from 2 Generations of European and American Artists: Picasso to Pollock (exhibition checklist). New York: Sidney Janis Gallery, 1967.

A Selection of 20th Century Art of 3 Generations (exhibition checklist). New York: Sidney Janis Gallery, 1964.

Selections from the John G. Powers Collection (exhibition catalogue). Ridgefield, Conn.: Larry Aldrich Museum, 1966.

Selz, Peter. *New Images of Man* (exhibition catalogue). Preface by Paul Tillich. New York: The Museum of Modern Art, 1959.

———. *Seven Decades, 1895-1965: Crosscurrents in Modern Art* (exhibition catalogue). New York: Public Education Association, 1966.

17 Abstract Artists of East Hampton: The Pollock Years, 1946-56 (exhibition catalogue). Foreword by Ronald G. Pissano; Introduction by Virginia M. Zabriskie; essay by Dore Ashton. Southampton, N.Y.: The Parrish Art Museum, 1980.

Seventies Painting (exhibition catalogue). Text by Janet Kardon. Philadelphia: Philadelphia College of Art Gallery, 1978.

Shapiro, David, and Dianne Perry Vanderlip. *Poets and Painters* (exhibition catalogue). Denver: Denver Art Museum, 1979.

The Sidney and Harriet Janis Collection (exhibition catalogue). Introduction by Alfred H. Barr, Jr. New York: The Museum of Modern Art, 1968.

Sidney and Harriet Janis Collection (exhibition catalogue). Introduction by Alfred H. Barr, Jr., in German. Basel: Kunsthalle Basel, 1970.

Six Peintres américains: Gorky, Kline, de Kooning, Newman, Pollock, Rothko (exhibition checklist). Paris: M. Knoedler & Cie., 1967.

60 American Painters, 1960 (exhibition catalogue). Essay by H. H. Arnason. Minneapolis: Walker Art Center, 1960.

'60-'80: Attitudes/Concepts/Images – A Selection from Twenty Years of Visual Arts (exhibition catalogue). Forewords by Edy de Wilde and George Weissman; Introduction by Ad Petersen; essays by Edy de Wilde, Gijs van Tuyl, Wim Beeren, Antje von Graevenitz, and Cor Blok; all in English and Dutch. Amsterdam: Stedelijk Museum, 1982.

Solomon, Alan. *Painting in New York, 1944-1969* (exhibition catalogue). Pasadena, Calif.: The Pasadena Art Museum, 1970.

Some Paintings from the E. J. Powers Collection (exhibition catalogue). Essay by Lawrence Alloway. London: Institute of Contemporary Arts, 1958.

Subjects of the Artists: New York Painting, 1941-1947 (exhibition brochure). New York: Whitney Museum of American Art, Downtown Branch, 1975.

Surrealität, Bildrealität, 1924-1974 – In den unzähligen Bildern des Lebens (exhibition catalogue). Texts by Jürgen Harten, Bernhard Kerber, John Matheson, Katherina Schmidt, and Schuldt; excerpt from earlier text by André Breton. Düsseldorf: Städtische Kunsthalle Düsseldorf, 1975.

Sweeney, James Johnson. *American Painting, 1950* (exhibition catalogue). Foreword by Leslie Cheek, Jr. Richmond, Va.: Virginia Museum of Fine Arts, 1950.

10 American Abstract Masters: de Kooning, Frankenthaler, Gottlieb, Hofmann, Kline, Louis, Motherwell, Pousette-Dart, Rothko, Stella (exhibition checklist). New York: Marisa del Re Gallery, 1981.

10 American Painters (exhibition checklist). New York: Sidney Janis Gallery, 1961.

10 American Painters (exhibition checklist). New York: Sidney Janis Gallery, 1962.

10th Anniversary Exhibition: X Years of Janis (exhibition checklist). New York: Sidney Janis Gallery, 1958.

Three Decades of American Art: Selected by the Whitney Museum (exhibition catalogue). Essay by Barbara Haskell in Japanese. Tokyo: Seibu Museum of Art, 1976.

Tuchman, Maurice. *Van Gogh and Expressionism* (exhibition catalogue). New York: The Solomon R. Guggenheim Museum, 1964.

Tuchman, Maurice, ed. *New York School, The First Generation: Paintings of the 1940s and 1950s* (exhibition catalogue). Essays by Lawrence Alloway, Robert Goldwater, Harold Rosenberg, William Rubin, and Meyer Schapiro; bibliography by Lucy Lippard; statements by the artists. Los Angeles: Los Angeles County Museum of Art, 1965. Revised ed., Greenwich, Conn.: New York Graphic Society, 1971.

Tucker, James E. *Selected Works from the Dillard Collection* (exhibition catalogue).

Greensboro, N.C.: Weatherspoon Art Gallery, University of North Carolina, 1975.

Twentieth Century American Drawing: Three Avant-Garde Generations (exhibition catalogue). Text by Diane Waldman. New York: The Solomon R. Guggenheim Museum, 1976.

Twentieth Century American Masters (exhibition catalogue). South Bend, Ind.: The Art Center, 1978.

Twentieth Century American Paintings from the Metropolitan Museum of Art (exhibition catalogue). Essay by Henry Geldzahler; biographical notes by Helen A. Harrison. Southampton, N.Y.: The Parrish Art Museum, 1977.

20th Century Master Drawings (exhibition catalogue). Introduction by Emily Rauh; essay by Sidney Simon; biographical and catalogue notes by Emily Rauh and Sidney Simon. Cambridge, Mass.: Fogg Art Museum, Harvard University, 1963.

Twentieth Century Paintings and Sculpture: Matisse to de Kooning (exhibition checklist). New York: Xavier Fourcade, 1977.

Twentieth Century Works on Paper (exhibition catalogue). Introduction by James Monte. Irvine, Calif.: Art Gallery, University of California, 1968.

Twenty Years of Acquisition: Evolution of a University Study Collection – The Grunwald Center for the Graphic Arts (exhibition catalogue). Foreword by Charles E. Young; Introduction by E. Maurice Bloch. Los Angeles: Grunwald Center for the Graphic Arts, 1974.

25 Years of Janis, Part 2: From Pollock to Pop, Op and Sharp-Focus Realism (exhibition catalogue). New York: Sidney Janis Gallery, 1974.

2 Generations: Picasso to Pollock (exhibition checklist). New York: Sidney Janis Gallery, 1964.

Untitled, 1968 (exhibition catalogue). Foreword by Gerald Nordland; Introduction by Wesley Chamberlain. San Francisco: San Francisco Museum of Art, 1968.

Venice XXV Biennale Catalogo (exhibition catalogue). Introduction to American section by Alfred H. Barr, Jr. Venice: Alfieri Editore for 25th Venice Biennale, 1950. Introduction reprinted as Alfred H. Barr, Jr. "Seven Americans Open in Venice: de Kooning." *Art News,* 49 (June 1950), pp. 22-23, 60.

Venice XXVII Biennale – 2 Pittori: de Kooning, Shahn; 3 Scultori: Lachaise, Lassaw, Smith (exhibition catalogue). Preface by René d'Harnoncourt; comment by Andrew Carnduff Ritchie; statements by the artists; all in English and Italian. New York: The Museum of Modern Art for the 27th Venice Biennale, 1954.

Venice XXVIII Biennale – American Artists Paint the City (exhibition catalogue). Foreword by Lionello Venturi; text by Katherine Kuh. Chicago: The Art Institute of Chicago for the 28th Venice Biennale, 1956.

Wagstaff, Samuel, Jr., *Continuity and Change* (exhibition catalogue). Hartford: Wadsworth Atheneum, 1962.

Weller, Allen S. *Contemporary American Painting and Sculpture, 1967* (exhibition catalogue). Urbana, Ill.: University of Illinois, 1967.

Whitney Museum of American Art, New York. *1948 Annual Exhibition of Contemporary American Painting* (exhibition catalogue), 1948.

——. *1949 Annual Exhibition of Contemporary American Painting* (exhibition catalogue), 1949.

——. *1950 Annual Exhibition of Contemporary American Painting* (exhibition catalogue), 1950. Foreword by Hermon More.

——. *Annual Exhibition, 1963: Contemporary American Painting* (exhibition catalogue), 1963.

——. *1965 Annual Exhibition of Contemporary American Painting* (exhibition catalogue), 1965.

——. *1967 Annual Exhibition of Contemporary American Painting* (exhibition catalogue), 1967.

——. *1969 Annual Exhibition: Contemporary American Painting* (exhibition catalogue), 1969. Foreword by John I. H. Baur.

——. *1972 Annual Exhibition: Contemporary American Painting* (exhibition catalogue), 1972. Foreword by John I. H. Baur.

——. *1981 Biennial Exhibition* (exhibition catalogue), 1981. Foreword by Tom Amstrong; Preface by John G. Hanhardt, Barbara Haskell, Richard Marshall, and Patterson Sims.

Yale Faculty, 1950-78 (exhibition catalogue). Introduction by Andrew Forge. New York: Harold Reed Gallery, 1978.

Young Painters in U.S. and France (exhibition checklist). New York: Sidney Janis Gallery, 1950.

Younger American Painters (exhibition catalogue). New York: The Solomon R. Guggenheim Museum, 1954.

200 Jahre Amerikanische Malerei, 1776-1976 (exhibition catalogue). Texts by Joshua C. Taylor and Ann C. Devanter. Bonn: Rheinisches Landesmuseum, 1976.

2 Jahrzehnte Amerikanische Malerei, 1920-1940 (exhibition catalogue). Essays by Peter Selz and Dore Ashton. Düsseldorf: Städtische Kunsthalle Düsseldorf, 1979.

General Books

Alloway, Lawrence. *Topics in American Art Since 1945.* New York: W. W. Norton & Co., 1975.

American Painting, 1900-1970. New York: Time-Life Books, 1970.

Arnason, H. H. *History of Modern Art: Painting, Sculpture, Architecture.* New York: Harry N. Abrams, 1968.

Ashton, Dore. *The Unknown Shore: A View of Contemporary Art.* Boston and Toronto: Little, Brown & Co., 1962.

——. *A Reading of Modern Art.* Cleveland: Case Western Reserve University, 1969. Reprint, Ann Arbor, Mich.: University Microfilms, 1979.

——. *Modern American Painting.* New York: Mentor-UNESCO, 1970.

——. *The New York School: A Cultural Reckoning.* New York: The Viking Press, 1972.

Bann, Stephen. *Experimental Painting: Construction, Abstraction, Destruction, Reduction.* New York: Universe Books, 1970.

Barr, Alfred H., Jr. *Masters of Modern Art.* New York: The Museum of Modern Art, 1954.

——. *What is Modern Painting?* New York: The Museum of Modern Art, 1956.

Barr, Alfred H., Jr., and William Rubin. *Three Generations of Twentieth-Century Art: The Sidney and Harriet Janis Collection of the Museum of Modern Art* (collection catalogue). New York: The Museum of Modern Art, 1972.

Battcock, Gregory, ed. *Minimal Art: A Critical Anthology.* New York: E. P. Dutton, 1968.

Batterberry, Michael. *Twentieth Century Art.* Discovering Art Series. New York: McGraw-Hill Book Co., 1961.

Baur, John I.H. *Revolution and Tradition in Modern American Art.* New York: Praeger Publishers, 1951. Reprint, Cambridge, Mass.: Harvard University Press, 1959.

——. *New Art in America: Fifty Painters of the 20th Century.* Greenwich, Conn.: New York Graphic Society in cooperation with Praeger Publishers, 1957.

Baur, John I. H., and Lloyd Goodrich. *American Art of Our Century.* New York: Praeger Publishers, 1961.

Bayl, Friedrich. *Bilder unserer Tage.* Cologne: DuMont Schauberg, 1960.

Becker, Jurgen, and Wolf Vostell. *Happenings, Fluxus, Pop, Nouveau Realism.* Hamburg: Rowohlt Verlag, 1965.

Bihalji-Merin, Oto. *Adventures of Modern Art.* New York: Harry N. Abrams, 1966.

Blesh, Rudi. *Modern Art U.S.A.* New York: Alfred A. Knopf, 1956.

——. *Stuart Davis.* New York: Grove Press, 1960.

Blok, Cor. *Geschichte der abstrakten Kunst.* Cologne: DuMont Schauberg, 1975.

Brion, Marcel. *Art abstrait.* Paris: Editions Albin Michel, 1956.

Burger, John. *The Success and Failure of Picasso.* New York: Penguin Press, 1965.

Calas, Nicolas, and Elena Calas. *Icons and Images of the Sixties.* New York: E. P. Dutton, 1971.

Canaday, John. *Embattled Critic: Views on Modern Art.* New York: The Noonday Press, 1962.

——. *Mainstreams of Modern Art.* 2nd ed. New York: Holt, Rinehart & Co., 1981.

Celentano, Francis. "The Origins and Development of Abstract Expressionism in the United States." M.A. thesis, New York University, 1957.

Chipp, Herschel B., ed. *Theories of Modern Art: A Source Book by Artists and Critics.* Berkeley: University of California Press, 1968.

Cone, Michele. *The Roots and Routes of Art in the Twentieth Century.* New York: Horizon Press, 1975.

Cox, Annette. *Art-as-Politics: The Abstract Expressionist Avant-Garde and Society.* Ann Arbor, Mich.: UMI Research Press, 1977.

Cummings, Paul. *Current Biography Yearbook.* New York: H. W. Wilson, 1955.

____. *American Drawings: The 20th Century.* New York: The Viking Press, 1976.

____. *Twentieth-Century Drawings: Selections from the Whitney Museum of American Art.* New York: Dover Publications, 1981.

____. *Dictionary of Contemporary American Artists.* 4th ed. New York: St. Martin's Press, 1982.

Denby, Edwin. *In Public In Private.* Prairie City, Ill.: Decker, 1948.

____. *Dancers, Buildings and People in the Streets.* New York: Horizon Press, 1965.

Devanter, Ann C. *American Self-Portraits, 1670-1973.* Washington, D.C.: National Portrait Gallery, Smithsonian Institution, 1974.

Diehl, Gaston. *The Moderns: A Treasury of Painting Throughout the World.* New York: Crown Publishers, 1961.

Duberman, Martin. *Black Mountain: An Exploration in Community.* New York: E. P. Dutton, 1972.

Eliot, Alexander. *Three Hundred Years of American Painting.* New York: Time, 1958.

Elsen, Albert E. *Purposes of Art: An Introduction to the History and Appreciation of Art.* 2nd ed. New York: Holt, Rinehart, Winston & Co., 1967.

Feldman, Edmund Burke. *Art as Image and Idea.* Englewood Cliffs, N.J.: Prentice-Hall, 1967.

Finch, Christopher. *Pop Art: Object and Image.* New York: E. P. Dutton, 1968.

Flanagan, George A. *Understanding and Enjoying Modern Art.* New York: Thomas Y. Crowell Co., 1962.

Foster, Stephen C. *The Critics of Abstract Expressionism.* Ann Arbor, Mich.: UMI Research Press, 1980.

Friedman, B. H. *Jackson Pollock.* New York: McGraw-Hill Book Co., 1972.

Geldzahler, Henry. *American Painting in the Twentieth Century.* New York: The Metropolitan Museum of Art, 1965.

____. *New York Painting and Sculpture, 1940-70.* New York: E. P. Dutton, 1969.

Goodrich, Lloyd. *Three Centuries of American Art.* New York: Whitney Museum of American Art, 1968.

Graham, John. *System and Dialectics of Art.* New York: Delphic Studios, 1937. Revised, ed. Marcia Epstein Allentuck, Baltimore: The John Hopkins Press, 1971.

Greenberg, Clement. *Art and Culture.* Boston: Beacon Press, 1961.

Gruen, John. *The Party's Over Now.* New York: The Viking Press, 1972.

Haftmann, Werner. *Painting in the Twentieth Century.* 2 vols. New York: Praeger Publishers, 1961.

Hall, Lee. "Reality-Concepts Expressed in American Abstract Painting, 1945-1960." Ph.D. dissertation, New York University, 1965.

Hartt, Frederick. *A History of Painting, Sculpture, and Architecture.* 2 vols. New York: Harry N. Abrams, 1976.

Hess, Thomas B. *Abstract Painting: Background and American Phase.* New York: The Viking Press, 1951.

Hunter, Sam. *Art Since 1945.* New York: Harry N. Abrams, 1958.

____. *Modern American Painting and Sculpture.* New York: Dell Publishing Co., 1959.

____. *American Art of the Twentieth Century.* New York: Harry N. Abrams, 1972.

____, ed. *New York Around the World: Painting and Sculpture.* New York: Harry N. Abrams, 1966.

Janis, Harriet, and Rudi Blesh. *Collage: Personalities, Concepts, Techniques.* New York: Chilton Co., 1962.

Janis, Sidney. *Abstract and Surrealist Art in America.* New York: Reynal & Hitchcock, 1944.

Johannes, Christa Erika. "The Relationship Between Some Abstract Expressionist Painting and Samuel Beckett's Writing." Ph.D. dissertation, University of Georgia, 1974.

Johnson, Ellen H. *Modern Art and the Object: A Century of Changing Attitudes.* New York: Harper & Row, Publishers, Icon Editions, 1976.

Kashdin, Gladys S. "Abstract-Expressionism: An Analysis of the Movement Based Primarily upon Interviews with Seven Participating Artists." Ph.D. dissertation, Florida State University, 1965.

Kozloff, Max. *Renderings: Critical Essays on a Century of Modern Art.* New York: Simon & Schuster, 1968.

Langui, Emile. *50 Years of Modern Art.* Translated by Geoffrey Sainsbury and James Oliver. New York: Praeger Publishers, 1959.

Lerner, Abram, ed. *The Hirshhorn Museum and Sculpture Garden.* New York: Harry N. Abrams, 1974.

Levy, Julian. *Arshile Gorky.* New York: Harry N. Abrams, 1966.

Lucie-Smith, Edward. *Late Modern: The Visual Arts Since 1945.* New York: Praeger Publishers, 1969.

Lynton, Norbert. *The Modern World.* New York: McGraw-Hill Book Co., 1965.

McCoubrey, John W. *American Tradition in Painting.* New York: George Braziller, 1963.

McCurdy, Charles, ed. *Modern Art: A Pictorial Anthology.* New York: The Macmillan Co., 1958.

McDarrah, Fred W. *The Artist's World in Pictures.* New York: E. P. Dutton, 1961.

McKinzie, Richard D. *The New Deal for Artists.* Princeton, N.J.: Princeton University Press, 1973.

Melville, Robert. *Arshile Gorky: Paintings and Drawings.* London: Tate Gallery, 1965.

Mendelowitz, Daniel M. *A History of American Art.* New York: Holt, Rinehart & Winston, 1961.

Metro International Directory of Contemporary Art, 1964. Milan: Editoriale Metro, 1964.

Myers, Bernard S., ed. *Art and Civilization.* 2nd ed. New York: McGraw-Hill Book Co., 1967.

Neumeyer, Alfred. *The Search for Meaning in Modern Art.* Englewood Cliffs, N.J.: Prentice-Hall, 1964.

Nevelson, Louise. *Dawns + Dusks.* Taped conversations with Diana MacKown. New York: Charles Scribner's Sons, 1976.

Nordness, Lee, ed., and Allen S. Weller. *Art U.S.A. Now.* Lucerne: C. J. Bucher; New York: The Viking Press, 1962.

O'Connor, Francis V., and Eugene V. Thaw. *Jackson Pollock.* 2 vols. New Haven, Conn.: Yale University Press, 1978.

O'Doherty, Brian. *Object and Idea: An Art Critic's Journal, 1961-67.* New York: Simon & Schuster, 1967.

____. *American Masters: The Voice and the Myth.* New York: Random House, 1974.

Porter, Fairfield. *Fairfield Porter: Art in Its Own Terms – Selected Criticism, 1935-1975.* Edited by Rackstraw Downes. New York: Taplinger Publishing Co., 1979.

Pousette-Dart, Nathaniel, ed. *American Painting Today.* New York: Hastings House, 1956.

Protter, Eric, ed. *Painters on Painting.* New York: Grosset & Dunlap, 1963.

Rose, Barbara. *American Art Since 1900: A Critical History.* Revised ed., New York: Praeger Publishers, 1967.

____. *American Painting: The Twentieth Century.* Geneva: Skira, 1970.

____, ed. *Readings in American Art Since 1900: A Documentary Survey.* New York: Praeger Publishers, 1968.

Rosenberg, Harold. *The Tradition of the New.* New York: Horizon Press, 1959.

____. *Arshile Gorky.* New York: Horizon Press, 1962.

____. *The Anxious Object: Art Today and Its Audience.* New York: Horizon Press, 1964.

____. *Artworks and Packages.* New York: Horizon Press, 1969.

____. *Act and the Actor: Making the Self.* New York: World, 1970.

____. *The De-Definition of Art.* New York: Horizon Press, 1972.

____. *Discovering the Present: Three Decades in Art, Culture, and Politics.* Chicago: University of Chicago Press, 1973.

Rothschild, Leon. *Style in Art.* New York: Thomas Yoseloff, 1960.

Rubin, William S. *Dada and Surrealist Art.* New York: Harry N. Abrams, 1969.

Sandler, Irving. *The Triumph of American Painting: A History of Abstract Expressionism.* New York: Praeger Publishers, 1970.

Schwabacher, Ethel K. *Arshile Gorky.* New York: Macmillan & Co., 1957.

Seitz, William C. "Abstract-Expressionist Painting in America: An Interpretation Based on the Work and Thought of Six Key Figures." Ph.D. dissertation, Princeton University, 1955.

____. *Arshile Gorky.* New York: The Museum of Modern Art, 1962.

Seuphor, Michel. *L'Art abstrait.* Paris: Editions Maeght, 1959.

____. *Abstract Painting: 50 Years of Accomplishment, from Kandinsky to the Present.* New York: Dell Publishing Co., 1964.

Soby, James Thrall. *Modern Art and the New Past.* Norman, Okla.: University of Oklahoma Press, 1957.

Steinberg, Leo. *Other Criteria: Confrontations with Twentieth-Century Art.* London, Oxford, and New York: Oxford University Press, 1972.

Sylvester, David. *Modern Art: From Fauvism to Abstract Expressionism.* New York: Franklin Watts, 1965.

Tomkins, Calvin. *The Bride and the Bachelors.* New York: The Viking Press, 1965.

____. *Off the Wall: Robert Rauschenberg and the Art World of Our Time.* Garden City, N.Y.: Doubleday & Co., 1980.

Traba, Marta. *Los Cuatro Monstruos Cardinales.* Mexico City: Ediciones ERA, 1965.

Tuchman, Maurice, ed. *New York School, The First Generation: Paintings from the 1940s and 1950s.* Revised ed., Greenwich, Conn.: New York Graphic Society, 1971.

Vyerburg, Henry. *The Living Tradition: Art, Music, and Ideas in the Western World.* New York: Harcourt Brace Jovanovich, 1978.

Wilmerding, John, ed. *The Genius of American Painting.* New York: William Morrow & Co., 1973.

Works on Paper: American Art, 1945-1975. (catalogue collection). Essay by Rosalind Krauss. Seattle: Washington Art Consortium, 1977.

Articles and Reviews

"Abstract Expressionists." *Museum News* (The Toledo Museum of Art), 19, no. 4 (1977), unpaginated.

"Acquisitions." *The Museum of Modern Art Bulletin,* 17, nos. 2-3 (1950), pp. 1-32.

Adrian, Dennis. "New York: Exhibition at Allan Stone Gallery." *Artforum,* 4 (May 1966), pp. 49-50.

———. "The Nude – Now." *Artforum,* 5 (March 1967), p. 58.

Albright, Thomas. "The Focus Is on Quality, Not Quantity." *San Francisco Chronicle,* September 3, 1978.

Aldrich, Elizabeth. "De Kooning, Guild Hall." *Art/World,* 5 (May 23, 1981), pp. 1-3.

Alloway, Lawrence. "Sign and Surface: Notes on Black and White Painting in New York." *Quadrum,* no. 9 (1960), pp. 49-62.

———. "Iconography Wreckers and Maenad Hunters." *Art International,* 5 (April 1961), pp. 32-34, 47.

———. "The Biomorphic Forties." *Artforum,* 4 (September 1965), pp. 18-22.

———. "Art: Exhibition at the Museum of Modern Art." *The Nation,* March 24, 1969, pp. 380-81.

———. "De Kooning: Criticism and Art History." *Artforum,* 13 (January 1975), pp. 46-50.

———. "The Artist Count: In Praise of Plenty." *Art in America,* 65 (September-October 1977), pp. 105-9.

———. "Art: Exhibition at the Solomon R. Guggenheim Museum." *The Nation,* March 11, 1978, pp. 283-84.

"American Abstraction Abroad." *Time,* August 4, 1958, pp. 40-45.

Andelman, David A. "Belgrade Exhibit Is a Barometer of Decade's Art in East and West." *New York Times,* November 17, 1977, p. A2.

Anderson, Alexandra. "The New Bronze Age." *Portfolio,* 5 (March-April 1983), pp. 79-83.

Anderson, Laurie. "Galleries: de Kooning – Sidney Janis." *Arts Magazine,* 47 (November 1972), p. 70.

Anderson, Susan Heller. "De Kooning Has Meeting with Queen." *New York Times,* April 25, 1982, pp. 1+.

Apone, Carl. "Two-Man International." *Pittsburgh Press,* October 21, 1979, pp. 6-9.

Arb, Renée. "Spotlight on: de Kooning." *Art News,* 47 (April 1948), p. 33.

Arkus, Leon A. "The 1979 Pittsburgh International Series." *Carnegie Magazine,* October 1979, pp. 2-11.

Armstrong, Richard. "Abstract Expressionism Was an American Revolution." *Canadian Art,* 21 (September-October 1964), pp. 262-65.

Arnason, H. H., and Herbert Read. "Dialogue on Modern U.S. Painting." *Art News,* 59 (May 1960), pp. 32-36.

Arnim, G. von. "Long Island." *Art: das Kunstmagazin,* 1 (January 1981), pp. 20-39.

Ashbery, John. "William de Kooning: A Suite of New Lithographs Translates His Famous Brushstrokes into Black and White." *Art News Annual,* 37 (1971), pp. 117-28.

Ashton, Dore. "Exhibition of Twenty-one Works by de Kooning at the Martha Jackson Gallery." *Arts and Architecture,* 72 (December 1955), pp. 33-34.

———. "Art: Willem de Kooning Exhibition at the Janis Gallery." *Arts and Architecture,* 73 (June 1956), p. 10.

———. "Painting Today in New York." *Cimaise,* 3 (November-December 1956), pp. 7-8.

———. "Art: Sidney Janis' Recent Exhibition of Eight Painters." *Arts and Architecture,* 74 (June 1957), pp. 8-10.

———. "Art." *Arts and Architecture,* 76 (March 1959), pp. 8, 28-29.

———. "Art: Willem de Kooning." *Arts and Architecture,* 76 (July 1959), pp. 5, 30-31.

———. "Perspective de la peinture américaine." *Cahiers d'art,* 33-35 (1960), pp. 203-20.

———. "Willem de Kooning." *Paletten,* 20, no. 3 (1961), pp. 94-97.

———. "Art: Abstract Expressionists and Imagists." *Arts and Architecture,* 78 (December 1961), pp. 4-5.

———. "Art: Show at the Janis Gallery." *Arts and Architecture,* 79 (May 1962), p. 6.

———. "New York Commentary: de Kooning's Verve." *Studio International,* 163 (June 1962), pp. 216-17, 224.

———. "New York Report: Exhibition at the Allan Stone Gallery." *Kunstwerk,* 16 (November-December 1962), pp. 68-69.

———. "Art: Cosmos and Chaos at the Guggenheim." *Arts and Architecture,* 81 (March 1964), pp. 4-6.

———. "New York Commentary: De Kooning at Knoedler." *Studio International,* 175 (January 1968), p. 39.

———. "New York Commentary: de Kooning at the Museum of Modern Art and Knoedler." *Studio International,* 177 (May 1969), pp. 243-45.

———. "Willem de Kooning: Homo Faber." *Arts Magazine,* 50 (January 1976), pp. 58-61.

———. "1975/1976 NEW YORK." *Colóquio: Artes,* 29 (October 1976), pp. 14-19.

Baer, Martha. "Auctions: Christie's, New York." *Flash Art,* January-February 1980, p. 41.

Baldwin, Nick. "UNI's New Gallery of Art Opens with 'De Kooning, 1969-78.'" *Des Moines Sunday Register,* October 22, 1978, magazine section, pp. 16-18.

Bannard, Walter Darby. "Cubism, Abstract Expressionism, David Smith." *Artforum,* 6 (April 1968), pp. 22-32.

———. "Willem de Kooning's Retrospective at the Museum of Modern Art." *Artforum,* 7 (April 1969), pp. 42-49. Letter to the editor with rejoinder, F. Porter. *Artforum,* 7 (Summer 1969), p. 4.

Barr, Alfred H., Jr. "Seven Americans Open in Venice: De Kooning." *Art News,* 49 (Summer 1950), pp. 22-23, 60. Reprint of text of 35th Venice Biennale catalogue.

Barron, Stephanie. "De Kooning's *Woman,* ca. 1952: A Drawing Recently Acquired by the Museum." *Los Angeles County Museum of Art Bulletin,* 22 (1976), pp. 66-72.

Battcock, Gregory. "Big Splash." *Time,* May 18, 1959, p. 72.

———. "Willem de Kooning." *Arts Magazine,* 42 (November 1967), pp. 34-37.

Beatty, Frances. "De Kooning at the Guggenheim." *Art/World,* 2 (February 1978), p. 1.

Beeren, W.A.L. "Nieuw aspecten van het realisme." *Museumjournaal,* 10 (1964-65), pp. 70-81. (Includes French summary.)

Bell, Jane. "Arts Review: Group Exhibition at Noah Goldowsky Gallery." *Arts Magazine,* 49 (February 1975), p. 6.

———. "Willem de Kooning's New Work." *Arts Magazine,* 50 (November 1975), pp. 79-81.

Berenson, R. "Pair of Opposites: Exhibitions of Willem de Kooning at the Guggenheim Museum and Sol LeWitt at the Museum of Modern Art." *National Review,* 30 (March 31, 1978), pp. 418-19.

Berkson, Bill. "Art Chronicle." *Kulcher,* 2 (Fall 1962), pp. 31-36.

Berman, Avis. "Willem de Kooning: 'I Am Only Halfway Through.'" *Art News,* 81 (February 1982), pp. 68-73.

Betz, Margaret. "New York Reviews: Yale Faculty, 1950-78." *Art News,* 78 (January 1979), p. 141.

"Big City Dames." *Time,* April 6, 1953, p. 80.

Binkley, Timothy. "Piece: Contra Aesthetics." *Journal of Aesthetics and Art Criticism,* 35 (Spring 1977), pp. 265-77.

Blakeston, Oswell. "Titian v. Tradition." *What's On in London,* August 6, 1976, p. 33.

Bloch, S. R. "New York: Exhibition at Allan Stone Gallery." *Art and Artists,* 1 (May 1966), pp. 70-71.

Blok, Cor. "Willem de Kooning and Henry Moore." *Art International,* 12 (December 1968), pp. 44-52.

Bouche, R. "Portrait." *Art in America,* 46 (Winter 1958-59), p. 26.

Bourdon, David. "Art: Three Artists Draw on the Past." *The Village Voice,* November 10, 1975, p. 112.

Bowness, Alan. "American Invasion and the British Response." *Studio International,* 173 (June 1967), pp. 285-93.

Braff, Phyllis. "From the Studio." *East Hampton (N.Y.) Star,* December 4, 1975, p. 10.

———. "From the Studio." *East Hampton (N.Y.) Star,* July 2, 1981.

Breckenridge, James D., and Israel Rosen. "Toward a Definition of Abstract Expressionism." *Baltimore Museum of Art News,* 22 (February 1959), pp. 1-13.

Broyard, Anatole. "Seen in Slipping Glimpses" (review of *Willem de Kooning* by Harold Rosenberg). *New York Times,* October 14, 1974, p. 31.

Brown, Carolyn. "Painting and Sculpture: Willem de Kooning, 1969-78." *Dialogue*

(Akron Art Institute), March-April 1979, pp. 36-37.

Bry, Charlene. "De Kooning's Oil, Sculpture at Art Museum." *St. Louis Globe-Democrat*, February 2, 1979, p. D8.

Buettner, Stewart. "Arshile Gorky and the Abstract-Surreal." *Arts Magazine*, 50 (March 1976), pp. 86-87.

Burnside, Madeleine. "New York Reviews: Willem de Kooning." *Art News*, 76 (December 1977), pp. 132-33.

Burr, James. "The Netherlander of New York." *Apollo*, 88 (December 1968), p. 490.

____. "Round the Galleries: Amorphous Forces." *Apollo*, 104 (August 1976), p. 140.

Burrows, Carlyle. "De Kooning's Authority Felt in New Abstract Paintings." *New York Herald Tribune*, April 8, 1956.

Butler, H. C. "Downtown in the Fifties." *Horizon*, 24 (June 1981), pp. 15-29.

Butler, J. T. "Willem de Kooning Retrospective." *Connoisseur*, 173 (January 1970), pp. 72-74.

Cabanne, Pierre. "De Kooning et les femmes." *Combat*, July 8, 1968, p. 10.

Calas, Nicolas. "What is the Real Illusion?" *Art News*, 61 (Summer 1962), pp. 33-34.

____. "Venus: de Kooning and the Woman." *Arts Magazine*, 43 (April 1969), p. 22.

Campbell, Lawrence. "Willem de Kooning at Fourcade." *Art in America*, 70 (September 1982), p. 161.

Campbell, R. M. "Willem de Kooning and the European Tradition." *Seattle Post-Intelligencer*, February 15, 1976, p. G6.

____. "De Kooning's Proud Chaos Is Back." *Seattle Post-Intelligencer*, January 1980.

Canby, Vincent. "Screen: de Kooning." *New York Times*, April 23, 1982, section 3, p. 5.

Cardozo, Judith. "Reviews: Willem de Kooning, Xavier Fourcade Gallery." *Artforum*, 15 (January 1977), pp. 62-63.

Carlson, J. T. "Architectural Digest Visits: Willem de Kooning." *Architectural Digest*, 39 (January 1982), pp. 58-67.

Carmean, E. A. "American Art at Mid-Century: The Sandwiches of the Artist." *October*, 16 (Spring 1981), pp. 87-101.

"Carnegie Institute, Pittsburgh 'International.'" *Life*, November 21, 1955, pp. 134-37.

Carrier, David. "De Kooning at the Pittsburgh International." *Artforum*, 18 (January 1980), pp. 44-46.

Carter, E. Graydon. "People: McCartney and de Kooning." *Time*, February 8, 1982, p. 69.

"Cash Expressionism." *Newsweek*, April 12, 1965, p. 96.

Catoir, B. "Ausstellungen: Willem de Kooning – Plastiken und Grafiken." *Kunstwerk*, 30 (April 1977), p. 79.

Cavaliere, Barbara. "Arts Reviews: Five Action Painters of the Fifties." *Arts Magazine*, 54 (November 1979), p. 21.

____. "Flash Art, New York: Willem de Kooning." *Flash Art*, January-February 1980, p. 29.

____. "Arts Reviews: Willem de Kooning." *Arts Magazine*, 54 (February 1980), pp. 33-34.

"Chillida and De Kooning Share $50,000 Mellon Prize." *Artnewsletter*, October 3, 1978.

Close, Roy M. "Sketches, Sculptures Illuminate de Kooning." *Minneapolis Star*, March 14, 1974, p. D4.

Coates, Robert M. "Art Galleries: Exhibition of New Paintings by Willem de Kooning." *The New Yorker*, April 4, 1953, p. 96.

____. "Art Galleries: Variety." *The New Yorker*, May 16, 1959, pp. 165-67.

____. "Art Galleries: Hartley and de Kooning." *The New Yorker*, March 24, 1962, pp. 131-35.

Cole, Mary. "The Curve of a Grey Shape." *Art Digest*, 25 (April 15, 1951), p. 16.

"Congenial Company." *Art Digest*, 16 (January 15, 1942), p. 18.

Courthion, Pierre. "Situation de la nouvelle peinture américaine." *XXᵉ Siècle*, 34 (June 1970), pp. 9-15. (Includes English summary.)

Cowart, Jack. "De Kooning Today." *Art International*, 23 (Summer 1979), pp. 8-17.

Crehan, Hubert. "Woman Trouble." *Art Digest*, 27 (April 15, 1953), pp. 4-5.

"Cross Country: Art – Chillida and de Kooning." *Horizon*, 22 (October 1979), pp. 7-8.

Crossley, Mimi. "De Kooning: His Expressive Self." *Houston Post*, January 23, 1977.

Cullinen, Helen. "A Prize Pair." *Cleveland Plain Dealer*, November 4, 1979, p. D11.

Dalí, Salvador. "De Kooning's 300,000,000th Birthday." Translated by John Ashbery. *Art News*, 68 (April 1969), pp. 56-57, 62-63.

Davidson, Michael. "La Jolla: Literary Imagery and Visual Poetry." *Artweek*, November 8, 1980, p. 1.

Davis, Douglas. "De Kooning on the Upswing." *Newsweek*, September 4, 1972, pp. 70-73.

____. "What's in the Galleries." *Newsweek*, December 8, 1975, pp. 106-7.

Davis, Stuart. "Arshile Gorky in the 1930's: A Personal Recollection." *Magazine of Art*, 44 (February 1951), pp. 56-58.

"De Kooning: Drawings/Sculpture." *Albright-Knox Gallery Notes*, 39 (Annual Report 1974-75), p. 12.

"De Kooning in East Hampton." *Kunst Beeld*, 7 (May 1983), pp. 16-20. (In Dutch.)

"De Kooning Painting Aids Day School." *East Hampton* (N.Y.) *Star*, May 22, 1969.

"De Kooning Sets Record." *New York Post*, September 27, 1974.

"De Kooning Work Sold to Australia." *New York Times*, September 28, 1974, p. 27.

"De Kooning Works at Walker." *Minneapolis Tribune*, March 10, 1974.

"De Kooning/Chillida Exhibitions to Entice Art Connoisseurs." *Greensboro* (Pa.) *Tribune, Focus Magazine*, October 21, 1979, pp. 3-4.

"De Kooning's Backdrop for Labyrinth." *Arts*, 34 (June 1960), pp. 28-29.

"De Kooning's Derring-Do." *Time*, November 17, 1967, pp. 88-89.

"De Kooning's Exhibit Opens." *Palm Beach* (Fla.) *News*, December 7, 1975.

"De Kooning's Masterwork: Women of 1950-55." *Time*, March 7, 1969, p. 61.

"De Kooning's New Women: Prisoner of the Seraglio." *Time*, February 26, 1965, pp. 74-75.

"De Kooning's Year." *Newsweek*, March 10, 1969, pp. 88-93.

Denby, Edwin. "My Friend de Kooning." *Art News Annual*, 29 (1963), pp. 82-99. Reprinted as "Willem de Kooning," in Edwin Denby. *Dancers, Buildings and People in the Streets*. New York: Horizon Press, 1965.

Depuis, Georgia. "De Kooning – An Artist Reaching Out." *Palm Beach* (Fla.) *Post*, December 13, 1975, p. B1.

Deschamps, M. "Les Avant-Garde Américaines: l'action painting." *Art Press International*, November 1979, pp. 20-21.

Diamonstein, Barbaralee. "Caro, de Kooning, Indiana, Lichtenstein, Motherwell, and Nevelson on Picasso's Influence." *Art News*, 73 (April 1974), pp. 44-46.

____. "Exhibitions Abroad: Spoleto – Menotti's Worlds." *Art News*, 73 (May 1974), p. 89.

Dickerson, George. "The Strange Eye and Art of de Kooning." *The Saturday Evening Post*, November 21, 1964, pp. 68-71.

Downes, Rackstraw. "Fairfield Porter: The Painter as Critic." *Art Journal*, 37 (Summer 1978), pp. 306-12.

"Drawings, Sculptures by de Kooning at Walker Art Center." *Midwest Art*, April 1974, pp. 12-13.

Drweski, Alicia. "Gallery Guide: Paris – Exhibition at Knoedler & Cie." *Art and Artists*, 6 (January 1972), p. 55.

Duffy, Martha. "Rummaging the Warehouse." *Time*, June 28, 1976, p. 51.

Eliot, Alexander. "Under the Four Winds: The Venice Biennale." *Time*, June 28, 1954, pp. 74-76.

Ellenzweig, Allen. "Arts Reviews: Group Show at Fourcade, Droll Gallery." *Arts Magazine*, 50 (October 1975), p. 13.

____. "Arts Reviews: American Works on Paper, 1945-1975." *Arts Magazine*, 50 (January 1976), p. 23.

____. "Arts Reviews: Willem de Kooning." *Arts Magazine*, 51 (December 1976), p. 29.

____. "Arts Reviews: 20th Century Painting and Sculpture." *Arts Magazine*, 51 (June 1977), p. 31.

Esterow, Milton. "Willem de Kooning Files Suit Against Art Dealer." *New York Times*, March 31, 1965, p. 23.

"Exhibitions: Chillida and de Kooning." *Art Journal*, 39 (Fall 1979), p. 58.

"Explosive Images of a Dislodged and Ambiguous World." *Life*, November 16, 1959, pp. 80-81.

Faison, S. Lane, Jr. "Art: Exhibition at the Sidney Janis Gallery." *The Nation*, April 18, 1953, pp. 333-34.

Farber, Manny. "Art: Group Exhibition at the Sidney Janis Gallery." *The Nation*, November 11, 1950, pp. 445-46.

Feaver, William. "Figures of Clay." *London Observer*, December 11, 1977.

Feldman, Morton. "Give My Regards to Eighth Street." *Art in America*, 59 (March 1971), pp. 96-99. Reply, Clement Greenberg. Letter to the editor. *Art in America*, 59 (September 1971), p. 20.

____. "The Anxiety of Art." *Art in America*, 61 (September-October 1973), pp. 88-93.

Ferrari, Oreste. "Venticinque Anni di Pittura Americana." *Arte Figurativa*, 8 (March-April 1960), pp. 54-59.

ffrench-frazier, Nina. "Copious Notes on Three Group Exhibitions." *Art International*, 23 (December 1979), pp. 41-44.

Finkelstein, Louis. "Marin and de Kooning." *Magazine of Art*, 43 (October 1950), pp. 202-6.

____. "The Light of de Kooning." *Art News,* 66 (November 1967), pp. 28-31, 70-71.

____. "Gotham News, 1945-60." *Art News Annual,* 34 (1968), pp. 114-23.

____. "Thoughts About Painterly: Its Poetry Is at the Same Time Formal, Descriptive, Psychological, Metaphysical." *Art News Annual,* 37 (1971), pp. 9-24.

Fischer, Joseph O. "De Kooning Works Shown at Museum." *St. Louis Globe-Democrat,* January 20, 1979, p. D4.

Fitzsimmons, James. "Art: Exhibition at Sidney Janis Gallery." *Arts and Architecture,* 70 (May 1953), pp. 4, 6-8.

Folds, Thomas M. "Book Reviews: Thomas B. Hess's *Willem de Kooning, 1959.*" *Art Journal,* 20 (Fall 1960), pp. 52, 54, 56.

Forge, Andrew. "De Kooning's 'Women' at the Tate Gallery." *Studio International,* 176 (December 1968), pp. 246-51.

____. "De Kooning in Retrospect at the Museum of Modern Art." *Art News,* 68 (March 1969), pp. 44-47, 61-62, 64.

____. "Painting and the Struggle for the Whole Self." *Artforum,* 14 (September 1975), pp. 44-48.

Forgey, Benjamin. "De Kooning's Late Love and Our Good Luck." *Washington Star News,* September 15, 1974, pp. F1, F4.

____. "Corcoran Show Is Mostly Big." *Washington Star News,* February 21, 1975, pp. B1-B2.

____. "An All-Star Opening for Corcoran Exhibition." *Washington Star News,* February 23, 1979, pp. C9-C10.

Fox, Mary. "De Kooning: Images in His Shorthand." *Vancouver Sun,* January 21, 1976, p. 43.

Frankenstein, Alfred. "The de Kooning Figure Merely Went Underground." *San Francisco Chronicle, This World Magazine,* March 16, 1969, pp. 41, 43.

Franzhe, A. "Ausstellung: Plastik-Grafik: Wilhelm-Lehmbruck Museum, Duisburg." *Pantheon,* 35 (April 1977), pp. 156-57.

Fried, Michael. "New York Letter: Exhibition at the Allan Stone Gallery." *Art International,* 6 (December 1962), pp. 54-55, 57.

____. "New York Letter: Exhibition at the Allan Stone Gallery." *Art International,* 8 (April 1964), p. 59.

Friedman, B. H. "'The Irascibles': A Split Second in Art History." *Arts Magazine,* 53 (September 1978), pp. 96-102.

Fuchs, R. H. "Willem de Kooning: The Quest for the Grand Style." *Delta,* 13 (Spring 1970), pp. 29-44.

Gaugh, Harry. "Kline's Transitional Abstractions, 1946-50." *Art in America,* 62 (July-August 1974), pp. 43-46.

Geist, Sidney. "New York: De Kooning Studies and Paintings at the Janis Gallery." *Art Digest,* 26 (April 1, 1952), p. 15.

Genauer, Emily. "De Kooning a Puzzle." *New York-World Telegram,* May 4, 1948.

____. "Art and the Artist." *New York Post,* March 8, 1969, p. 46.

____. "Hanson and de Kooning on Exhibition." *New York Tribune,* February 10, 1978.

Gendel, Milton. "The Iron Curtain in the Glass-Factory." *Art News,* 55 (September 1956), pp. 22-27, 58-60.

"Give Me Your Tired, Your Poor: The Golden Door – Artist Immigrants of America, 1876-1976." *Apollo,* 104 (November 1976), p. 406.

Glass, Judith Samuel. "Willem de Kooning: Sculptures, Paintings, Drawings." *Artweek,* July 3, 1976, p. 7.

Glowen, Ronald. "De Kooning and Lichtenstein." *Artweek,* February 28, 1976, p. 3.

Glueck, Grace. "Blues and Greens on Reds." *New York Times,* February 21, 1965, p. X19.

____. "Art Notes: A Tenth Street Loft in the Woods." *New York Times,* July 25, 1965, section 2, p. 11.

____. "The Kiddie Can Kick in Pennies: Blue Chip." *New York Times,* January 29, 1967, p. D26.

____. "Trend Toward Trendlessness: New York Gallery Notes – Exhibition at Knoedler Gallery." *Art in America,* 55 (November 1967), p. 122.

____. "Previews: Exhibition at the Sidney Janis Gallery." *Art in America,* 60 (September-October 1972), p. 121.

____. "City Gets a Sculpture Garden." *New York Times,* September 16, 1977, pp. C1, C18.

____. "The Twentieth Century Artists Most Admired by Other Artists." *Art News,* 76 (November 1977), pp. 78-103.

"Goings on About Town." *The New Yorker,* October 25, 1976, p. 11.

Gold, Barbara. "De Kooning's Paintings in Bronze." *Baltimore Sun,* August 20, 1972, p. D7.

Goldin, Amy. "Abstract Expressionism: No Man's Landscape." *Art in America,* 64 (January-February 1976), pp. 77-79.

Goldwater, Robert. "Reflections on the New York School." *Quadrum,* no. 8 (1960), pp. 17-36.

____. "Master of the New." *Partisan Review,* 29 (Summer 1962), pp. 416-18.

Gray, Cleve. "The Guggenheim International." *Art in America,* 52 (April 1964), pp. 48-55.

Green, Denise. "In the Galleries: Exhibition at the Allan Stone Gallery." *Arts Magazine,* 46 (November 1971), p. 63.

Greenberg, Clement. "Art." *The Nation,* April 24, 1948, p. 448.

____. "Round-Table Discussion on Modern Art." *Life,* October 11, 1948, p. 62.

____. "Feeling Is All." *Partisan Review,* 19 (January-February 1952), p. 97.

____. "'American-Type' Painting." *Partisan Review,* 22 (Spring 1955), pp. 179-96. Reprinted in Clement Greenberg. *Art and Culture.* Boston: Beacon Press, 1961.

____. "New York Painting Only Yesterday." *Art News,* 56 (Summer 1957), pp. 58-59, 84-86.

____. "After Abstract Expressionism." *Art International,* 6 (October 1962), pp. 24-32.

____. "Poetry of Vision." *Artforum,* 6 (April 1968), p. 18-21.

____. Letter to the editor. *Art in America,* 59 (September 1971), p. 20. Reply to Morton Feldman. "Give My Regards to Eighth Street." *Art in America,* 59 (March 1971), pp. 96-99.

Gruen, John. "Art in New York: Finally, de Kooning." *New York Magazine,* March 10, 1969, p. 60.

____. "Thunderbolt from the Fifties." *Soho Weekly News,* October 30, 1975, p. 20.

Hale, Barrie. "Toronto: Willem de Kooning at Pollock Gallery." *Artscanada,* 31 (December 1974), pp. 116-17.

Hale, Nike. "The Virtue of Solitary Action." *Art World,* 4 (October 1979), pp. 1, 6.

____. "Art Freed from the Rules: de Kooning's New Work." *Art/World,* 6 (March 1982), pp. 1-4.

Hammacher, A. M. "Mondrian and de Kooning: A Contrast in Transformation." *Delta,* 2 (September 1959), pp. 67-71.

Hancock, Marianne. "Willem de Kooning." *Arts Magazine,* 45 (Summer 1971), p. 57.

"Harold Rosenberg Says 'Once You Know What Good Art Is, Why Care About Critics, Good or Bad?'" *Art News,* 72 (April 1973), pp. 64-66.

Harris, Neil. "Yesterday's World of Tomorrow." *Art News,* 78 (October 1979), pp. 69-73.

Harrison, Charles. "Abstract Expressionism." *Studio International,* 185 (January 1973), pp. 9-18.

____. "On Paper" (review of *Willem de Kooning Drawings* by Thomas B. Hess). *Studio International,* 185 (March 1973), pp. 139-40.

Harrison, Helen A. "De Kooning: 30 Years on the East End." *New York Times,* May 24, 1981, section 11, pp. 1+.

Hartford, Huntington. "The Public Be Damned?" *New York Times,* May 16, 1955, p. 48.

Hayot, Monelle. "L'Ecole de New York: Willem de Kooning." *L'Oeil,* October 1976, p. 34.

Heller, Ben. "The Roots of Abstract Expressionism." *Art in America,* 49, no. 4 (1961), pp. 40-49.

Hennessy, Richard. "Servant of Time." *Artforum,* 16 (Summer 1978), pp. 42-45.

Henning, Edward B. "Exhibition: Paths of Abstract Art." *Bulletin of the Cleveland Museum of Art,* 47 (October 1960), pp. 199-201.

____. "The Language of Art." *Bulletin of the Cleveland Museum of Art,* 51 (November 1964), pp. 210-31.

Henry, Gerrit. "De Kooning: Reconfirming the Apocalypse." *Art News,* 74 (November 1975), pp. 60-61.

Herrera, Hayden. "Le Feu Ardent: John Graham's Journal." *Archives of American Art Journal,* 14, no. 2 (1974), pp. 6-17.

____. "We Were the Cafeteria People." *Mulch,* Spring-Summer 1976, pp. 41-57.

____. "John Graham: Modernist Turns Magus." *Arts Magazine,* 50 (October 1976), pp. 100-5.

Hess, Thomas B. "The Whitney: Exhibit Abstract." *Art News,* 47 (December 1948), pp. 24-25, 59, 62.

____. "8 Excellent, 20 Good, 133 Others." *Art News,* 48 (January 1950), pp. 34-35, 57-58.

____. "Introduction to Abstract." *Art News Annual,* 20 (1950-51), pp. 127-58, 186-87.

____. "Four Stars for the Spring Season: Exhibition at the Egan Gallery." *Art News,* 50 (April 1951), pp. 24, 52.

____. "De Kooning Paints a Picture." *Art News,* 52 (March 1953), pp. 30-33, 64-67.

____. "U.S. Painting: Some Recent Directions." *Art News Annual,* 25 (1956), pp. 73-98, 174-80.

____. "Selecting from the Flow of Spring Shows: Like a New Race of People." *Art News,* 55 (April 1956), pp. 24, 100.

____. "Reviews and Previews: Willem de Kooning's Exhibition at Janis." *Art News*, 58 (May 1959), pp. 12-13.

____. "Six Star Shows for Spring." *Art News*, 61 (March 1962), pp. 40-41, 60-61.

____. "Willem de Kooning." *Art News*, 61 (March 1962), pp. 40-51, 60-61.

____. "Exhibition at the Stone Gallery: Willem de Kooning and Barnett Newman." *Art News*, 61 (December 1962), pp. 12, 43.

____. "De Kooning's New Women." *Art News*, 64 (March 1965), pp. 36-38, 63-65.

____. "Pinup and Icon." *Art News Annual*, 38 (1972), pp. 223-37.

____. "Art: Water Babes." *New York Magazine*, October 27, 1975, pp. 73-75.

____. "Art: The Great Paper Chase." *New York Magazine*, February 16, 1976, pp. 74-75.

____. "Art: Stella Means Star – Exhibition at Xavier Fourcade." *New York Magazine*, November 1, 1976, pp. 62-63.

____. "Four Pictures by de Kooning at Canberra." *Art and Australia*, 14 (January-April 1977), pp. 289-96.

____. "The Flying Hollander of East Hampton, L.I.: Guggenheim Exhibit." *The New Yorker*, February 20, 1978, pp. 68, 72.

____. "In de Kooning's Studio." *Vogue*, 168 (April 1978), pp. 234-39+.

Hobbs, Robert C., and Barbara Cavaliere. "Against a Newer Laocoon." *Arts Magazine*, 51 (April 1977), pp. 100-17.

Hobhouse, Janet. "De Kooning in East Hampton." *Art News*, 77 (April 1978), pp. 108-10.

Hoffeld, Jeffrey. "Lucas Samaras: The New Pastels." *Arts Magazine*, 49 (March 1975), pp. 60-61.

____. "Arshile Gorky: Collection and Connoisseurship." *Arts Magazine*, 50 (March 1976), pp. 106-7.

Holmes, Ann. "New York Art Scene: De Kooning's Dominance." *Houston Chronicle*, March 30, 1969.

Hooton, Bruce Duff. "De Kooning's New Work." *Art/World*, October 9, 1976, pp. 1+.

"How They Got That Way." *Time*, April 13, 1962, pp. 94-99.

Hughes, Robert. "Art: Slap and Twist." *Time*, October 23, 1972, p. 71.

____. "Art: The Painter as Draftsman – Traveling Exhibition of Drawings, Pastels and Bronzes." *Time*, June 17, 1974, pp. 52-54.

____. "Landscapes and the Bodies of Women." *Horizon*, 21 (February 1978), pp. 14-21. Reprinted in Japanese in *Trends*, 44, no. 4 (1979), pp. 25-35.

____. "Art: Softer de Koonings – Show at the Guggenheim Museum." *Time*, March 6, 1978, pp. 78-79.

____. "Art: The Tribal Style – Ab Ex at the Whitney Museum." *Time*, October 16, 1978, p. 102.

Hunter, Sam. "By Groups and Singly: De Kooning – Exhibition at Egan Gallery." *New York Times*, April 25, 1948, section 2, p. 11.

____. "Abstract Expressionism Then – and Now." *Canadian Art*, 21 (September-October 1964), pp. 266-69.

____. "de Kooning." *L'Oeil*, November 1975, pp. 74-75. Revised text of *De Kooning* (exhibition catalogue). Paris: Galerie des Arts, 1975.

Huset, France. "Made in U.S.A." *Le Nouvel Observateur*, August 19, 1977, pp. 90-91.

Hutchinson, Peter. "Willem de Kooning: The Painter in Times of Changing Belief." *Program Guide 13* (WNET, New York), November 1967, pp. 36-40.

____. "De Kooning's Reasoned Abstracts." *Art and Artists*, 3 (May 1968), pp. 24-27.

"Inflation-Conscious Australians Attack $850,000 Art Purchase." *New York Times*, October 14, 1974, p. 5.

"Institute of Art Picks 12 Members." *New York Times*, February 24, 1960, p. 74.

It Is, 1 (Spring 1958), pls. 6, 9.

It Is, 2 (Fall 1958), pl. 3.

Jacobs, J. "Collector: Joseph H. Hirshhorn." *Art in America*, 57 (July 1969), p. 68.

Janis, Sidney. "Abstract and Surrealist Art in America." *Arts and Architecture*, 61 (November 1944), pp. 16-19, 37. Excerpt from Sidney Janis. *Abstract and Surrealist Art in America*. New York: Reynal & Hitchcock, 1944.

Jeffrey, Ian. "Willem de Kooning." *Arts Review*, 28 (July 9, 1976), p. 351.

Johnson, Ray. "Abandoned Chickens." *Art in America*, 62 (November-December 1974), pp. 107-12.

Josephson, Mary. "New York Review: Exhibition at the Sidney Janis Gallery." *Art in America*, 61 (January-February 1973), p. 117.

Judd, Donald. "De Kooning: Exhibition at the Allan Stone Gallery." *Arts Magazine*, 38 (March 1964), pp. 62-63.

____. "In the Galleries: American Drawings." *Arts Magazine*, 39 (November 1964), p. 59.

Kangas, Matthew. "Murder and Creation: Willem de Kooning." *Vanguard* (The Vancouver Art Gallery), October 1980, pp. 6-9.

Karlins, Nancy F. "Art: Exhibition at Xavier Fourcade." *East Side* (N.Y.) *Express*, November 4, 1976, p. 11.

Kelder, Diane. "Tradition and Craftsmanship in Modern Prints." *Art News*, 70 (January 1972), pp. 56-59, 69-73.

Kenedy, Robert C. "London Letter: Exhibition at the Tate Gallery." *Art International*, 8 (February 1969), pp. 37-38.

King, Mary. "De Kooning at the Museum." *St. Louis Post Dispatch*, January 21, 1979, p. F5.

Kingsley, April. "Reviews: Willem de Kooning, Sidney Janis." *Artforum*, 11 (December 1972), p. 81.

____. "New York Letter: Exhibition at the Allan Stone Gallery." *Art International*, 17 (January 1973), pp. 65-66.

____. "De Kooning: The New Ones Are Good Too." *Soho Weekly News*, November 11, 1976, pp. 18+.

____. "Flesh Was the Reason Oil Paint Was Invented." *The Village Voice*, November 14, 1977, p. 101.

____. "De Kooning: Fragments in Focus." *The Village Voice*, April 17, 1978, p. 88.

____. "Artscape." *The Village Voice*, July 24, 1978.

Kiplinger, Suzanne. "Willem de Kooning." *The Village Voice*, October 21, 1959, pp. 5, 11.

Kissel, Howard. "Arts and People: de Kooning on de Kooning." *Women's Wear Daily*, April 16, 1982, p. 1.

Kokkinen, Eila, "John Graham During the 1940's." *Arts Magazine*, 51 (November 1976), pp. 99-103.

Kozloff, Max. "New York Letter: Exhibition at the Sidney Janis Gallery." *Art International*, 6 (May 1962), pp. 75-76.

____. "The Impact of de Kooning." *Arts Yearbook*, 7 (1964), pp. 77-88.

____. "The Many Colorations of Black and White." *Artforum*, 2 (February 1964), pp. 22-25.

____. "The Dilemma of Expressionism." *Artforum*, 3 (November 1964), pp. 32-35.

____. "An Interview with Friedel Dzubas." *Artforum*, 4 (September 1965), pp. 49-52.

____. "The Critical Reception of Abstract Expressionism." *Arts Magazine*, 40 (December 1965), pp. 27-32.

Kramer, Hilton. "Critics of American Painting." *Arts*, 34 (October 1959), pp. 26-31.

____. "De Kooning's Pompier Expressionism." *New York Times*, November 19, 1967, section 2, p. 31.

____. "De Kooning Survey Opens at the Modern." *New York Times*, March, 5, 1969, p. 36. Reply, Peter Selz. Letter to the editor. *New York Times*, March 23, 1969, section 2, p. 30.

____. "A Career Divided." *New York Times*, March 9, 1969, section 2, p. 25.

____. "30 Years of the New York School." *New York Times Magazine*, October 12, 1969, pp. 28-29+.

____. "Seven Large de Kooning Lithographs Are Shown." *New York Times*, January 1, 1972, p. 9.

____. "Art: Sculptures of Willem de Kooning Shown." *New York Times*, October 13, 1972, p. 32.

____. "Painting at the Limits of Disorder." *New York Times*, October 26, 1975, p. D31.

____. "Art: de Kooning of East Hampton." *New York Times*, February 10, 1978, p. C19.

____. "'Blockbuster' Art at National Gallery." *New York Times*, May 30, 1978, pp. C1, C6.

____. "A Refuge from the Vexing 70's." *New York Times*, March 25, 1979, pp. D30-D31, D34.

Krauss, Rosalind. "The New de Koonings." *Artforum*, 6 (January 1968), pp. 44-47.

Kritzwiser, Kay. "A Week to Focus on a Trio of Titans." *Toronto Globe and Mail*, October 19, 1974, p. 30.

Kroll, Jack. "American Painting and the Convertible Spiral." *Art News*, 60 (November 1961), pp. 34-37, 66-68.

Kuh, Katherine. "The Fine Arts: The Story of a Picture." *Saturday Review*, March 29, 1969, pp. 38-39.

____. "The Fine Arts: Denials, Affirmations, and Art." *Saturday Review*, May 31, 1969, pp. 41-42.

Kuspit, Donald. "Individual and Mass Identity in Urban Art: The New York Case." *Art in America*, 65 (September-October 1977), pp. 66-77.

Kutner, Janet. "Austin Exhibit Opens New Vistas for Student Artists." *Dallas Morning News*, October 31, 1976, p. C6.

Lacoste, M. Conil. "De Kooning à Paris." *Le Monde*, July 4, 1968, p. 15.

Lader, Melvin P. "Graham, Gorky, de Kooning, and the 'Ingres Revival' in America." *Arts Magazine*, 52 (March 1978), pp. 94-99.

Lanes, Jerrold. "Brief Treatise on Surplus Value: Or, The Man Who Wasn't There." *Arts*, 34 (November 1959), pp. 28-35.

____. "Knoedler's Show of Work by Willem de Kooning." *The Burlington Magazine*, 111 (May 1969), p. 324.

Laporte, Paul. "Turner to de Kooning: Non-Euclidian Geometry to Quantum Theory." *Bulletin of the New York Public Library*, 79 (Fall 1975), pp. 4-39.

Larson, Kay, "The Nation: Boston – Identity Crisis." *Art News*, 74 (May 1975), pp. 71-72.

____. "Art: de Kooning Adrift." *New York Magazine*, April 12, 1982, pp. 58-59.

Larson, Philip. "Willem de Kooning: The Lithographs." *The Print Collector's Newsletter*, 5 (March-April 1974), pp. 6-7.

Leider, Philip. "New York School: The First Generation." *Artforum*, 4 (September 1965), pp. 3-13.

____. "Modern American Art at the Met." *Artforum*, 8 (December 1969), pp. 62-65.

Leiser, Erwin. "Willem de Kooning und das Unerwartete/De Kooning at Work." *Du*, 471, no. 5 (1980), pp. 57-65. (Includes English summary.)

Lerman, Leo. "People Are Talking About. . . ." *Vogue*, 165 (December 1975), p. 160.

Levy, Mark. "The Last Survivor Alive and Well." *Seattle Sun*, February 14, 1980.

Lewis, Jo Ann. "'Setting Standards' at the Corcoran." *Art News*, 78 (April 1979), pp. 85, 88-89.

Lewis, Louise. "Los Angeles: A Preview of Museum Acquisitions." *Artweek*, January 6, 1979, p. 5.

Lichtblau, Charlotte. "Willem de Kooning and Barnett Newman." *Arts Magazine*, 43 (March 1969), pp. 28-33.

Linde, Ulf. "Rosenberg och action painting." *Konstrevy*, nos. 5-6 (1960), pp. 204-7.

Lippard, Lucy. "Three Generations of Women: de Kooning's First Retrospective." *Art International*, 9 (November 1965), pp. 29-31.

"Living Art and the People's Choice." *Horizon*, 2 (September 1958), pp. 108-13.

Louchheim, Aline B. "Conclusions from a Chicago Annual." *New York Times*, October 28, 1951, section 2, p. 9.

Lubell, Ellen. "Galleries: Willem de Kooning – Selected Works." *Arts Magazine*, 47 (December 1972-January 1973), p. 84.

McBride, Henry. "Abstract Report for April: Exhibition at the Sidney Janis Gallery." *Art News*, 52 (April 1953), pp. 16-19, 47.

McEwen, John. "Art and Paradox." *London Spectator*, July 31, 1976, pp. 29-30.

McMullen, Roy. "L'Ecole de New York: des concurrents dangereux." *Connaisance des arts*, September 1961, pp. 30-37.

Marchiori, Giuseppi. "De Kooning et l'Europe." *XXᵉ Siècle*, 40 (June 1973), pp. 110-15. (Includes English summary, p. 189.)

Marmer, Nancy. "Los Angeles Letter: Exhibition at the Paul Kantor Gallery." *Art International*, 9 (June 1965), pp. 40-41.

Marriott, Celia. "Iconography in de Kooning's 'Excavation.'" *Bulletin of the Art Institute of Chicago*, 69 (January-February 1975), pp. 14-18.

Martin, Carolyn. "Abstract Expressionist Shunned Style." *Columbus Missourian*, February 9, 1979, p. B5.

Martin, Judith. "A Record Price for an 'Ugly Woman.'" *Washington Post*, September 28, 1974, p. B1.

Masheck, Joseph. "Reviews: The Private Collection of Martha Jackson." *Artforum*, 12 (December 1973), pp. 79-81.

Meier, Kurt von. "Houston: Group Exhibition at the University of St. Thomas." *Artforum*, 5 (May 1967), pp. 59-60.

Mellow, James R. "On Art: A Passion for Destruction." *The New Leader*, 52 (March 31, 1969), pp. 30-31.

Metz, Tracy. "De Kooning: Painting's Prodigious Son." *Holland Herald*, 18, no. 5 (1983), pp. 58-59.

Metzger, Jeanne. "De Kooning Displays Virtuosity with Paint." *Washington Herald*, February 21, 1976.

Miller, Donald. "Last International Show for Museum Director." *Pittsburgh Post-Gazette*, October 23, 1979.

____. "The International: View of 2 Masters." *Pittsburgh Post-Gazette*, October 26, 1979, pp. 17-19.

Moser, Charlotte. "New de Koonings Bubble with Youth." *Houston Chronicle, Zest Magazine*, January 23, 1977, p. 11.

Nakov, Andrei B. "L'Exposition des artistes américaines jugée par deux critiques européens – une certaine nostalgie de l'histoire." *XXᵉ Siècle*, 32 (June 1970), pp. 3-8.

Namuth, Hans. "Willem de Kooning, East Hampton, Spring, 1964" (photograph essay). *Location*, 1 (Summer 1964), pp. 27-34.

"The Native Returns." *Newsweek*, October 7, 1968, pp. 115-16.

Neugass, Fritz. "New Records for Abstract Art." *Arts Magazine*, 63 (February 1965), p. 22.

____. "Figurative Abstraktion zur Willem de Kooning – Ausstellung in New York." *Handelsblatt*, March 21, 1978.

____. "Willem de Kooning." *Die Weltkunst*, April 1, 1978, pp. 746+.

Odets, Clifford. "Willem de Kooning." *The Critic*, October-November 1962, pp. 37-38.

O'Doherty, Brian. "De Kooning: Grand Style." *Newsweek*, January 4, 1965, pp. 56-57. Reprinted in Brian O'Doherty. *Object and Idea: An Art Critic's Journal, 1961-67*. New York: Simon & Schuster, 1967.

____. "Willem de Kooning: Fragmentary Notes Towards a Figure." *Art International*, 12 (Christmas 1968), pp. 21-29. Reprinted in Brian O'Doherty. *American Masters: The Voice and the Myth*. New York: Random House, 1974.

O'Hara, Frank. "Ode to Willem de Kooning." *Metro*, no. 3 (1961), pp. 18-21. (In English, Italian, and French.) Also printed in Frank O'Hara. *Odes*. New York: Tiber, 1960.

"Out of the Picture: Exhibition at the Sidney Janis Gallery." *Newsweek*, March 12, 1962, p. 100.

Overy, Paul. "Pictures for a Summer Day." *London Times*, July 6, 1976.

Paris, Jeanne. "30 Years of Vital Work." *Newsday* (Long Island, N.Y.), June 26, 1981.

"Passage Points: Chillida, de Kooning Exhibitions Open in Pittsburgh." *Passages* (Northwest Orient Airlines), October 1979, p. 17.

"People in the Arts: The National Institute of Arts and Letters." *Arts*, 34 (April 1960), p. 1

Pereda, Rosa M. "Exposición del expresionista abstracto Willem de Kooning." *El País*, January 19, 1979, p. 24.

Perreault, John. "De Kooning's Teeny Boppers" *The Village Voice*, November 23, 1967, p. 17.

____. "The New de Koonings." *Art News*, 68 (March 1969), pp. 48-49, 68-69.

____. "Art: De Kooning at the Springs." *New York Magazine*, March 17, 1969, pp. 44-47.

____. "Art: Willem de Kooning in East Hampton." *Vogue*, 168 (February 1978), p. 3

____. "Biennial Ballyhoo." *Soho Weekly News*, February 11, 1981, p. 27.

Perrone, Jeff. "Reviews: New York – Exhibition at Xavier Fourcade." *Artforum*, 18 (January 1980), pp. 66-67.

Petersen, Valerie. "U.S. Figure Painting: Continuity and Cliché." *Art News*, 61 (Summer 1962), pp. 36-38, 51-52.

____. "Three More Faces of Eve: Exhibition at the Allan Stone Gallery." *Art News*, 63 (March 1964), pp. 30, 65.

Phillips, Robert F. "Willem de Kooning, 1904 – *Lily Pond*." *Museum News* (The Toledo Museum of Art, Ohio), 19, no. 4 (1977), pp. 92-95.

Pincus-Witten, Robert. "The 1930's, Whitney Museum." *Artforum*, 7 (January 1969), pp. 55-57.

"Pittsburgh: Eduardo Chillida/Willem de Kooning at the Museum of Art, Carnegie Institute." *Muse* (Museum of Art and Archeology, University of Missouri, Columbia), no. 1 (1979), p. 8.

Plagens, Peter. "The Possibilities of Drawing." *Artforum*, 8 (October 1969), pp. 50-55.

Pohl, F. K. "An American in Venice: Ben Shahn and U.S. Foreign Policy at the 1954 Venice Biennale." *Art History*, 4 (March 1981), pp. 80-113.

Porter, Fairfield. "Reviews and Previews: Willem de Kooning's." *Art News*, 54 (November 1955), pp. 48-49.

____. "Art: Exhibition at the Sidney Janis Gallery." *The Nation*, June 6, 1959, pp. 520-21.

____. "Class Content in American Abstract Painting." *Art News*, 61 (April 1962), pp. 26-28, 48-49.

____. Letter to the editor, *Artforum*, 7 (Summer 1969), p. 4. Reply to Walter Darby Bannard. "Willem de Kooning's Retrospective at the Museum of Modern Art." *Artforum*, 7 (April 1969), pp. 42-49.

"Portrait of Dena." *Aperture*, 12, no. 4 (1965), p. 39.

Preston, Malcolm. "Art: A Special Selection." *Newsday* (Long Island, N.Y.), August 28, 1974, pp. A7+.

____. "Art: Drawing Power." *Newsday* (Long Island, N.Y.), February 26, 1976, pp. A8-A9.

____. "Art: An Intimate Setting for de Kooning." *Newsday* (Long Island, N.Y.), July 6, 1981.

Quantrill, Malcolm. "From London: Some Anglo-Saxon Contentions and Responses." *Art International*, 22 (February 1978), p. 84.

Rand, Harry. "Abstract Expressionism." *Arts Magazine*, 51 (November 1976), p. 4.

Ratcliff, Carter. "New York Letter: Exhibition at the Sidney Janis Gallery." *Art International* 16 (December 1972), p. 56.

___. "Willem de Kooning: New Paintings and Sculpture." *Art International*, 19 (December 1975), pp. 14-19, 73.

___. "New York Letter." *Art International*, 20 (April-May 1976), pp. 55-56, 74.

___. "Reviews of Exhibitions: Willem de Kooning at Xavier Fourcade." *Art in America*, 65 (January-February 1977), p. 129.

___. "New York Letter: Exhibition at Xavier Fourcade." *Art International*, 21 (December 1977), pp. 65-66, 71-72.

Raymont, Henry. "De Kooning Back in Netherlands." *New York Times*, September 20, 1968, p. 95.

Raynor, Vivien. "Art of the Americas at Andrew-Morris Gallery." *Arts Magazine*, 37 (December 1962), p. 46.

___. "In the Galleries: Joseph Cornell, Willem de Kooning – Exhibition at the Stone Gallery." *Arts Magazine*, 39 (March 1965), p. 53.

___. "Willem de Kooning." *New York Times*, October 28, 1977, section 3, p. 21.

___. "Art: An Anthology of American Nudes." *New York Times*, February 24, 1978, section 3, p. 19.

Read, Herbert. "Den Informellen Bildern." *Paletten*, 20, no. 4 (1960), pp. 106-9.

"Recent Acquisitions." *St. Louis Museum of Art Bulletin*, 2 (September-October 1966), pp. 4-5, 10.

Reise, Barbara M. "Greenberg and the Group: A Retrospective View." *Studio International*, 115 (May 1968), pp. 254-57.

Richard, Paul. "A New de Kooning." *Washington Post*, August 14, 1972, p. B1.

___. "The Mixed Blessings of Willem de Kooning." *Washington Post*, September 17, 1974, pp. B1, B11.

___. "Artistry Reaffirmed: 5 Masterful Painters." *Washington Post*, February 23, 1979, Tp. B1, B4.

___. "The Abstract Master: Winning in D.C." *Washington Post*, March 3, 1982, pp. D1, D3.

Rickey, Carrie. "Curatorial Conceptions: The Whitney's Latest Sampler." *Artforum*, 19 (April 1981), pp. 52-57.

Roberts, K. "Retrospective Exhibition of Paintings and Drawings by Willem de Kooning at the Tate Gallery." *The Burlington Magazine*, 111 (January 1969), p. 44.

Robertson, Bryan. "Arts: De Kooning's Pink Angels." *London Spectator*, December 6, 1968, p. 808.

___. "Art: Exhibition at Gimpel Fils, London." *Harper's and Queen*, August 1976, p. 6.

Robertson, Nan. "Dentist Fixes Painter's Teeth, Gets Paid in Art." *New York Times*, August 1, 1961, p. 25.

Robins, Corinne. "De Kooning" (review of *Willem de Kooning* by Harold Rosenberg). *New York Times Book Review*, December 1, 1974, pp. 104-5.

Romano, Lois. "De Kooning, Triumph and Exile: Premiere of the Portrait." *Washington Post*, March 3, 1982, pp. D1, D3.

Rose, Barbara. "The Second Generation." *Artforum*, 4 (September 1965), pp. 53-63.

___. "Art: De Kooning and the Old Masters." *Vogue*, 153 (May 1969), p. 134.

___. "Arshile Gorky and John Graham: Eastern Exiles in a Western World." *Arts Magazine*, 50 (March 1976), pp. 62-69.

___. "De Kooning and Hockney: New Approaches to Drawing." *Vogue*, 172 (July 1982), pp. 194, 250.

Rosemarch, Stella. "De Kooning on Clay." *Craft Horizons*, 32 (December 1972), pp. 34-35.

Rosenberg, Harold. "The American Action Painters." *Art News*, 51 (December 1952), pp. 48-50.

___. "Tenth Street: A Geography of Modern Art." *Art News Annual*, 28 (1959), pp. 120-43, 184-92.

___. "Action Painting: A Decade of Distortion." *Art News*, 61 (December 1962), pp. 42-44, 62-63.

___. "The Art World: Painting Is a Way of Living." *The New Yorker*, February 16, 1963, pp. 126-37. Reprinted in Harold Rosenberg. *The Anxious Object: Art Today and Its Audience*. New York: Horizon Press, 1964.

___. "De Kooning." *Vogue*, 149 (September 1964), pp. 146-49, 186-87. Reprinted in Harold Rosenberg. *The Anxious Object: Art Today and Its Audience*. New York: Horizon Press, 1964.

___. "The Art World: Art of Bad Conscience." *The New Yorker*, December 16, 1967, pp. 138-49. Reprinted in Harold Rosenberg. *Artworks and Packages*. New York: Horizon Press, 1969.

___. "The Art World: American Drawing and the Academy of the Erased de Kooning." *The New Yorker*, March 22, 1976, pp. 106-10.

___. "The Art World: Women and Water." *The New Yorker*, April 24, 1978, p. 132.

Rosenblum, Robert. "Gorky, Matta, de Kooning, Pollock at the Janis Gallery." *Art Digest*, 29 (June 1, 1955), p. 24.

___. "Willem de Kooning." *Arts*, 30 (May 1956), p. 50.

___. "Picasso's *Woman with a Book*." *Arts Magazine*, 51 (January 1977), pp. 100-5.

Rubin, William. "Arshile Gorky, Surrealism and the New American Painting." *Art International*, 7 (February 25, 1963), pp. 27-38.

___. "Toward a Critical Framework." *Artforum*, 5 (September 1966), pp. 36-55.

Russell, John. "Art: Drawing Reborn in de Kooning's Painted Women." *New York Times*, September 14, 1974, p. L24.

___. "Art: 2 Shows and 2 Kinds of Landscape – Nature in France, Human in de Kooning." *New York Times*, November 1, 1975, p. 27.

___. "This Season the Old is Making News." *New York Times*, August 29, 1976, section 2, p. 27.

___. "Invigorating Breezes of the Fall Season." *New York Times*, October 3, 1976, section 2, p. 31.

___. "Art: De Kooning's New Frontiers." *New York Times*, October 15, 1976, p. C16.

___. "Art: Crispo Shows an American Album." *New York Times*, July 22, 1977, section 3, p. 15.

___. "Art: Friends at Whitney Show 20th-Century Works." *New York Times*, August 5, 1977, p. C13.

___. "Art: Souvenirs from the 30's and 40's." *New York Times*, January 13, 1978, p. C16.

___. "De Kooning: 'I See the Canvas and I Begin.'" *New York Times*, February 5, 1978, section 2, p. 1.

___. "Two Artists Share the Carnegie International." *New York Times*, November 18, 1979, section 2, pp. 39-40.

___. "Art: Lively Competitor to the Old de Koonings." *New York Times*, April 16, 1982, section 3, p. 23.

Sandler, Irving H. "Reviews and Previews: Ten Americans at Janis." *Art News*, 60 (Summer 1961), p. 10.

___. "In the Art Galleries." *New York Post*, March 18, 1962, p. 12.

___. "Reviews: New York – Willem de Kooning, Solomon R. Guggenheim Museum." *Artforum*, 16 (Summer 1978), pp. 64-65.

___. "When MOMA Met the Avant-Garde." *Art News*, 78 (October 1979), pp. 114-18.

Sawyer, Kenneth B. "A Backyard on Tenth Street." *Baltimore Museum of Art News*, 20 (December 1956), pp. 3-7.

___. "Three Phases of Willem de Kooning." *Art News and Review*, 22 (November 22, 1958), pp. 4-16.

___. "Painting and Sculpture: The New York Season – Exhibition at the Sidney Janis Gallery." *Craft Horizons*, 22 (May-June 1962), p. 54.

___. "The Grossman Collection: U.S. Collectors of Modern Art, 2." *Studio International*, 69 (February 1965), pp. 82-87.

___. "The Artist as Collector: Alfonso Ossorio." *Studio International*, 169 (March 1965), pp. 106-11.

Schjeldahl, Peter. "New York Letter: Exhibitions at MOMA and Knoedler." *Art International*, 13 (May 1969), pp. 34-35.

___. "New York Letter: Group Exhibitions at MOMA and Knoedler." *Art International*, 13 (October 1969), p. 74.

___. "Willem de Kooning: Even His 'Wrong' Is Beautiful." *New York Times*, January 9, 1972, section 2, p. 23.

___. "De Kooning: Subtle Renewals." *Art News*, 71 (November 1972), pp. 21-23.

___. "De Kooning's Sculptures: Amplified Touch." *Art in America*, 62 (March-April 1974), pp. 59-63. Revised text from Philip Larson and Peter Schjeldahl. *De Kooning: Drawings/Sculptures* (exhibition catalogue). Minneapolis: Walker Art Center; New York: E. P. Dutton, 1974. Reply with rejoinder, Florence Hunter. Letter to the editor. *Art in America*, 62 (March-April 1974), pp. 6-7.

___. "Delights by de Kooning." *The Village Voice*, April 13, 1982, p. 79.

Schneider, Pierre. "De Kooning: enfin une vraie exposition!" *L'Express*, November 3, 1975, p. 24.

Schulze, Franz. "De Kooning in Retrospect." *Chicago Daily News, Panorama Magazine*, May 24, 1969, p. 9.

___. "The Nation: Chicago – Reflections on de Kooning." *Art News*, 73 (November 1974), pp. 46-47.

___. "A Consistently Discriminating Connoisseurship." *Art News*, 76 (April 1977), pp. 64-67.

Schurler, James. "Frank O'Hara: Poet Among Painters." *Art News*, 73 (May 1974), pp. 44-45.

Schwartz, Ellen. "Paris in September: Exhibitions at Knoedler & Cie." *Art International*, 15 (November 1971), p. 65.

____. "Chillida's Silent Music, de Kooning's Eloquent Ambivalence." *Art News*, 79 (March 1980), pp. 68-70.

Schwartz, Marvin D. "A Sidney Janis Selection." *Apollo*, 69 (March 1959), p. 93.

____. "Willem de Kooning at the Sidney Janis Gallery." *Apollo*, 69 (June 1959), p. 197.

Schwartz, Sanford. "Review of Books: Monographs" (review of *Willem de Kooning* by Harold Rosenberg). *Art in America*, 63 (November-December 1975), p. 25.

"Sculptures: Recent Works by Willem de Kooning." *Arts Magazine*, 47 (November 1972), pp. 62-63.

Seiberling, Dorothy. "The Varied Art of Four Pioneers: Part 2." *Life*, November 16, 1959, pp. 74-86.

Seitz, William C. "Spirit, Time, and Abstract Expressionism." *Magazine of Art*, 46 (February 1953), pp. 80-87.

____. "Mondrian and the Issue of Relationships." *Artforum*, 10 (February 1972), pp. 70-75.

Seldis, Henry. "Art Review: De Kooning, Gross Works Shown." *Los Angeles Times*, November 24, 1975, section 4, pp. 9, 17.

Seldis, Henry, and William Wilson. "Art Walk: A Critical Guide to the Galleries – La Cienega Area." *Los Angeles Times*, June 4, 1976, section 4, p. 6.

Selz, Peter. "Nouvelles Images de l'homme." *L'Oeil*, February 1960, pp. 46-53.

"Settlement." *New York Times*, June 11, 1972, section 2, p. 23.

Shaman, Sanford Sivitz. "Willem de Kooning, Abstract Expressionist." *See*, September-October 1978, pp. 4-6.

Sharp, Marynell. "Man and Wife." *Art Digest*, 24 (October 1, 1949), p. 12.

Shepard, Richard F. "Knoedler Opens de Kooning Show." *New York Times*, November 12, 1967, p. 86.

Shirey, David L. "Don Quixote in Springs." *Newsweek*, November 20, 1967, pp. 80-81.

____. "De Kooning and the Island's Spell." *New York Times*, February 5, 1978, Long Island section, p. 14.

Siegel, Jeanne. "Abstraction and Representation Made Visible." *Arts Magazine*, 51 (November 1976), pp. 70-73.

Smith, Griffin. "Norton Offers Intriguing Look at de Kooning's Recent Work." *Miami Herald*, December 28, 1975, p. 271.

Smith, Roberta. "Report from Washington: The '50s Revisited, Not Revised." *Art in America*, 68 (November 1980), pp. 47-51.

____. "Biennial Blues." *Art in America*, 69 (April 1981), pp. 92-101.

Snyder, Camilla. "The Contemporary Abstractions of Willem de Kooning." *Los Angeles Herald Examiner*, August 3, 1969, pp. 6-19.

Sollers, Philippe. "Pour de Kooning." *Art Press International*, October 1977, pp. 6-9. Reprinted in *Peinture américaine*. Paris: Editions Galilée et Art Press, 1980.

Spurling, John. "Minds' Eyes: Exhibition at Gimpel Fils, London." *New Statesman*, July 16, 1976.

Steefel, Lawrence, Jr. "Late de Kooning a Triumph." *The New Art Examiner*, 6 (February 1979).

Steegmuller, Francis. "A Stroll in the Art Galleries." *Holiday*, 26 (October 1959), pp. 90-91.

Steele, Mike. "Walker Takes Second Look at Art." *Minneapolis Tribune*, March 20, 1974.

Steinberg, Leo. "Month in Review: De Kooning Shows Recent Paintings in 'Woman' Series at Jackson Gallery." *Arts*, 30 (November 1955), pp. 46-47. Reprinted in Leo Steinberg. *Other Criteria: Confrontations with Twentieth-Century Art*. London, Oxford, and New York: Oxford University Press, 1972.

Stevens, Mark. "De Kooning in Bloom: Guggenheim Retrospective." *Newsweek*, February 20, 1978, pp. 92-93.

____. "Art: A Blossoming at the Met." *Newsweek*, June 22, 1981, p. 90.

Stiles, Knute. "'Untitled '68': The San Francisco Annual Becomes an Invitational." *Artforum*, 8 (January 1969), pp. 50-52.

Strelon, H. "Ausstellung: Willem de Kooning, Stedelijk Museum, Amsterdam." *Kunstwerk*, 22 (February 1969), p. 74.

Stuckey, Charles F. "Bill de Kooning and Joe Christmas." *Art in America*, 68 (March 1980), pp. 66-69.

Swain, Richard. "In the Galleries: Willem de Kooning." *Arts Magazine*, 40 (May 1966), p. 62.

Swenson, G. R. "Peinture américaine, 1946-1966." *Aujourd'hui*, 10 (January 1967), pp. 156-57. (Includes English summary.)

"Sydney, Australia: Government Purchase of de Kooning for $850,000." *New York Times*, October 14, 1974, p. 5.

Sylvester, David. "Counter Currents: Willem de Kooning." *New Society*, 30 (January 1969), pp. 179-80.

"Talk of the Town." *The New Yorker*, April 18, 1959, p. 34.

Talphir, Gabriel. "Modern Art in USA." *Gazith*, December 1959-March 1960. (In Hebrew; includes English summary.)

Tannous, David. "Report from Washington: Big-Name Biennial Plus. . . ." *Art in America*, 67 (July-August 1979), pp. 24-25.

"Thirty Receive Freedom Medal at the White House." *New York Times*, September 15, 1964, p. 15.

Thwaites, John Anthony. "Düsseldorf: Exhibition at Kunsthalle." *Art and Artists*, 10 (May 1975), pp. 44-45.

Tillim, Sidney. "Willem de Kooning." *Arts*, 33 (June 1959), pp. 54-55.

____. "Guggenheim Museum's Abstract Expressionists and Imagists." *Arts Magazine*, 36 (December 1961), pp. 42-43.

____. "Month in Review: Recent Exhibition at Sidney Janis." *Arts Magazine*, 36 (May-June 1962), pp. 82-83.

____. "Month in Review: Paintings by Willem de Kooning and Barnett Newman at the Allan Stone Gallery." *Arts Magazine*, 37 (December 1962), pp. 38-40.

____. "The Figure and the Figurative in Abstract Expressionism." *Artforum*, 4 (September 1965), pp. 45-48.

Tisdall, Caroline. "De Kooning." *Manchester Guardian*, December 13, 1977.

Tomkins, Calvin. "The Art World: Seminar." *The New Yorker*, June 7, 1982, pp. 124-25.

Tono, Yoshiaki. "Willem de Kooning." *Mizue*, August 1961, pp. 1-18. (In Japanese; includes English summary.)

____. "De Kooning's Metamorphosis of 'Woman.'" *Mizue*, November 1961, pp. 55-62. (In Japanese; includes English summary.)

"Toward a Definition of Abstract Expressionism." *Baltimore Museum News*, 22 (February 1959), pp. 11-13.

Tromp, Hansmaarten. "Willem de Kooning: 'Elke stijl is fraude.'" *De Tijd*, October 21, 1977, pp. 10-15.

Tsutakawa, Mayumi. "De Kooning's New Show Here Lives Up to His Lofty Reputation." *Seattle Times*, January 25, 1980.

"250 Works by Two Masters at Carnegie." *Johnstown* (Pa.) *Tribune-Democrat, Sunday Magazine*, October 21, 1979, pp. 8-9.

"200 Years of American Painting." *St. Louis Museum of Art Bulletin*, no. 1 (1964), p. 55.

Tyler, Ralph. "The Artist as Millionaire." *New York Times*, January 8, 1978, pp. 1, 24.

Vaizey, Marina. "Modern Masters." *London Sunday Times*, July 11, 1976.

Van den Broek, Joop. "Willem de Kooning Hollandse meester in Amerika." *De Telegraf Neuws van de Dag*, July 23, 1966, pp. 13-15.

"The 'Vasari' Diary: 'Dad, You'll Have to Draw a Dog.'" *Art News*, 78 (Summer 1979), pp. 18-22.

Vogel, Lise. "Erotica, The Academy, and Art Publishing: A Review of *Woman as Sex Object: Studies in Erotic Art, 1730-1970, New York, 1972*." *Art Journal*, 35 (Summer 1976), pp. 378-85.

Waldman, Diane. "Reviews and Previews: Willem de Kooning – Exhibition at the Allan Stone Gallery." *Art News*, 65 (March 1966), pp. 12-13.

Walker, Richard. "Willem de Kooning: Exhibition at the Tate Gallery." *Arts Review*, 20 (December 21, 1968), p. 824.

Wallach, Amei. "At Age 77, Paintings in Progress." *Newsday* (Long Island, N.Y.), May 31, 1981.

Wiederspan, Stan. "UNI Completes 'Triple Crown.'" *Cedar Rapids* (Iowa) *Gazette*, October 22, 1978, pp. C1, C5.

"Wild Ones." *Time*, February 20, 1956, pp. 70-75.

Wilkie, Ken. "Willem de Kooning: Portrait of a Modern Master." *Holland Herald*, 17, no. 3 (1982), pp. 22-33.

Willard, Charlotte. "Eye to I." *Art in America*, 54 (March-April 1966), pp. 49-59.

____. "De Kooning: The Dutch-Born U.S. Master Gathers in the International Honors." *Look*, May 27, 1969, pp. 54-58.

"Willem the Walloper." *Time*, April 30, 1951, p. 63.

"Willem de Kooning." *Magazine of Art*, 41 (February 1948), p. 54.

"Willem de Kooning." *New Mexico Quarterly*, 23 (Summer 1953), p. 176.

"Willem de Kooning: Exhibition at Xavier Fourcade." *Soho Weekly News*, November 8, 1979, p. 58.

Wingate, Adina. "Art Center Show Has Perspective." *Arizona Daily Star*, October 13, 1974, p. F2.

Wolff, Millie. "De Kooning Exhibit Evokes 'Feeling.'" *Palm Beach* (Fla.) *Daily*, December 16, 1976.

Wolff, Theodore. "Some Modern Giants Revisited and Rediscovered." *The Christian Science Monitor*, April 8, 1982, p. 18.

Wolfram, Eddie. "De Kooning's Un-American Activities." *Art and Artists,* 3 (January 1969), pp. 28-31.

"Work in Progress: Studies and Paintings at the Janis Gallery." *Art Digest,* 27 (April 1, 1953), p. 15.

Wright, Martha McWilliams. "Washington Letter: Subjects of the Artist." *Art International,* 22 (October 1978), pp. 59-63.

Yard, Sally E. "De Kooning's Women." *Arts Magazine,* 53 (November 1978), pp. 96-101.

———. "Willem de Kooning's Men." *Arts Magazine,* 56 (December 1981), pp. 134-43.

Young, Joseph E. "Jasper Johns: An Appraisal." *Art International,* 13 (September 1969), pp. 50-54.

———. "'Pages' and 'Fuses': An Extended View of Robert Rauschenberg." *The Print Collector's Newsletter,* 2 (May-June 1974), pp. 25-30.

Zimmer, William. "De Kooning at the Guggenheim: Women as Source." *Soho Weekly News,* February 23, 1978, p. 20.

———. "William de Kooning: Exhibition at Xavier Fourcade Gallery." *Soho Weekly News,* November 8, 1979, p. 58.

Artist's Statements and Interviews

"Artists' Sessions at Studio 35 (1950)" (excerpts of round-table discussions, Studio 35, New York, April 1950), edited by Robert Goodnough. In Robert Motherwell and Ad Reinhardt, eds. *Modern Artists in America.* New York: Wittenborn, Schultz, 1951.

Boudrez, Martha. "Originality and Greatness in Painting" (interview). *The Knickerbocker,* May 1950, p. 3.

de Kooning, Willem. Letter to the editor. *Art News,* 48 (January 1949), p. 6.

———. "A Desperate View" (talk delivered at "Subjects of the Artist: A New School," New York, February 18, 1949). In Thomas B. Hess. *Willem de Kooning.* New York: The Museum of Modern Art, 1969. Reprinted in *Willem de Kooning: Pittsburgh International Series* (exhibition catalogue). Pittsburgh: Museum of Art, Carnegie Institute, 1979.

———. "The Renaissance and Order" (talk delivered at Studio 35, New York, February 1950). In *Trans/formation,* 1, no. 2 (1951), pp. 85-87. Reprinted in: Dore Ashton, *Willem de Kooning: A Retrospective Exhibition from Public and Private Collections,* exhibition catalogue (Northampton, Mass.: Smith College Museum of Art, 1965); Thomas B. Hess, *De Kooning: peintures récentes,* exhibition catalogue (Paris: M. Knoedler & Cie., 1968); *Willem de Kooning: Pittsburgh International Series,* exhibition catalogue (Pittsburgh: Museum of Art, Carnegie Institute, 1979).

———. "What Abstract Art Means to Me" (talk delivered in conjuction with the exhibition "Abstract Painting and Sculpture," The Museum of Modern Art, New York, February 5, 1951). *Bulletin of the Museum of Modern Art,* 18 (Spring 1951), pp. 4-8. Reprinted in: *The Museum and Its Friends: Eighteen Living American Artists Selected by the Friends of the Whitney Museum,* exhibition catalogue (New York: Whitney Museum of American Art, 1959); Eric Protter, ed., *Painters on Painting* (New York: Grosset & Dunlap, 1963); Henry Geldzahler, *American Painting in the Twentieth Century* (New York: The Metropolitan Museum of Art, 1965); Maurice Tuchman, ed., *New York School, The First Generation: Paintings of the 1940's and 1950's,* exhibition catalogue (Los Angeles: Los Angeles County Museum of Art, 1965); Thomas B. Hess, *De Kooning: peintures récentes,* exhibition catalogue (Paris: M. Knoedler & Cie., 1968); Thomas B. Hess, *Willem de Kooning,* exhibition catalogue (Amsterdam: Stedelijk Museum, 1968); Barbara Rose, ed., *Readings in American Art Since 1900: A Documentary Survey* (New York: Praeger Publishers, 1968); Thomas B. Hess, *Willem de Kooning,* exhibition catalogue (New York: The Museum of Modern Art, 1969); Harold Rosenberg, *Willem de Kooning* (New York: Harry N. Abrams, 1974); *Willem de Kooning: Pittsburgh International Series,* exhibition catalogue (Pittsburgh: Museum of Art, Carnegie Institute, 1979).

———. Statement. In *De Kooning Drawings.* New York: Walker & Co., 1967.

Hess, Thomas B. "Is Today's Artist With or Against the Past?" (interview). *Art News,* 57 (Summer 1958), pp. 27, 56.

Hirsch, Storm de. "Interview with Willem de Kooning." *Intro Bulletin,* October 1955, pp. 1, 3.

Liss, Joseph. "Willem de Kooning Remembers Mark Rothko: His House Had Many Mansions" (interview). *Art News,* 78 (January 1979), pp. 41-44.

Mooradian, Karlen. "Interview with Willem de Kooning." *Ararat,* 12 (Fall 1971), pp. 48-52.

Rodgers, Gaby. "An Interview with Willem de Kooning," *Newsday* (Long Island, N.Y.), *Long Island Magazine,* April 21, 1978, p. 18.

Rodman, Selden. "Willem de Kooning" (interview). In *Conversations with Artists.* New York: Devin-Adair, 1957.

Rosenberg, Harold. "Interview with Willem de Kooning." *Art News,* 71 (September 1972), pp. 54-59. Reprinted in: Harold Rosenberg, *Willem de Kooning* (New York: Harry N. Abrams, 1974); *Willem de Kooning, 1941-1959,* exhibition catalogue (Chicago: Richard Gray Gallery, 1974); *The Sculptures of de Kooning with Related Paintings, Drawings and Lithographs,* exhibition catalogue (London: Arts Council of Great Britain, 1977); *Willem de Kooning: Pittsburgh International Series,* exhibition catalogue (Pittsburgh: Museum of Art, Carnegie Institute, 1979).

Sandler, Irving. "Willem de Kooning: Gesprek de Kooning's atelier, 16 juni 1959" (interview). *Museumjournaal,* 13, no. 6 (1968), pp. 285-90. (Includes English summary, p. 336.)

Schierbeck, Bert. Interview. In Thomas B. Hess. *Willem de Kooning* (exhibition catalogue). Amsterdam: Stedelijk Museum, 1968.

Snyder, Robert. *Sketchbook No. 1: Three Americans* (transcripts of film interviews by M. C. Sonnabend with de Kooning, Buckminster Fuller, and Igor Stravinsky). New York: Time, 1960.

Staats, M., and L. Mathiessen. "The Genetics of Art" (interview). *Quest/77,* 1 (March-April 1977), pp. 70-71.

Sylvester, David. "De Kooning's Women" (transcript of the BBC broadcast "Painting as Self-Discovery," December 30, 1960). *London Sunday Times Magazine,* December 8, 1968, pp. 44-57. Excerpts published as "Content Is a Glimpse," *Location,* 1 (Spring 1963), pp. 49-53, and reprinted in: Thomas B. Hess, *Willem de Kooning,* exhibition catalogue (New York: The Museum of Modern Art, 1969); Harold Rosenberg, *Willem de Kooning* (New York: Harry N. Abrams, 1974); *Willem de Kooning: Pittsburgh International Series,* exhibition catalogue (Pittsburgh: Museum of Art, Carnegie Institute, 1979).

Valliere, James T. "De Kooning on Pollock" (interview). *Partisan Review,* 34 (Fall 1967), pp. 603-5.

Films

Falkenberg, Paul, Richard Lanier, and Hans Namuth. *Willem de Kooning: The Painter,* 1961.

———. *De Kooning at the Modern,* 1969.

Gill, Michael (for BBC). *De Kooning,* 1964. Ten Modern Artists Series, no. 10.

Hantman, Sidney, Marvin Goldman, and Irving Sandler. Documentary film on de Kooning, 1956. Unreleased.

Leiser, Irwin. *De Kooning at Work,* 1979.

———. *Willem de Kooning and the Unexpected,* 1979.

Namuth, Hans. *The De Kooning Retrospective at the Museum of Modern Art,* 1969. Narrated by Gabriella Brudi.

Slate, Lane (for NET). *Willem de Kooning,* 1966. USA Artists Series, no. 10.

Snyder, Robert, *Sketchbook No. 1: Three Americans,* 1960. Interviews by M. C. Sonnabend with de Kooning, Buckminster Fuller, and Igor Stravinsky.

Zwerin, Charlotte. *de Kooning on de Kooning,* 1980. Interview by Cortney Sale with de Kooning.

Exhibition History

Catalogues of the exhibitions may be found in the Bibliography, listed by the names of the authors cited within the individual exhibition entries. If no author is given, the catalogue is listed by title; catalogues of annual and biennial exhibitions are listed by institution.

One-Man and Two-Man Exhibitions

1948 New York, Egan Gallery. "De Kooning." April 12-May 12.

1951 New York, Egan Gallery. "Willem de Kooning" (reconstituted at the Arts Club of Chicago as part of "Exhibition: Ben Shahn, Willem de Kooning, Jackson Pollock," 1951). April 1-30.

1953 New York, Sidney Janis Gallery. "Willem de Kooning: Paintings on the Theme of the Woman." March 16-April 11. Checklist.

New York, Sidney Janis Gallery. "Willem de Kooning: Paintings on the Theme of the Woman." March 16-April 11. Checklist.

Boston, School of the Museum of Fine Arts. Retrospective. April 21-May 8. Traveled to: Washington, D.C., Workshop Art Center. Catalogue by Clement Greenberg.

1955 New York, Martha Jackson Gallery. "Recent Oils by Willem de Kooning." November 9-December 3. Catalogue.

1956 New York, Sidney Janis Gallery. "Willem de Kooning: Recent Paintings." April 2-28. Checklist.

1959 New York, Sidney Janis Gallery. "Willem de Kooning." May 4-30. Checklist.

1961 Beverly Hills, Calif., Paul Kantor Gallery. "Willem de Kooning." April 3-29. Catalogue.

1962 New York, Sidney Janis Gallery. "Recent Paintings by Willem de Kooning." March 5-31. Catalogue.

New York, Allan Stone Gallery. "De Kooning–Newman." October 23-November 17. Catalogue.

1964 Buffalo, James Goodman Gallery. "'Woman' Drawings by Willem de Kooning." January 10-25. Catalogue by Merle Goodman.

New York, Allan Stone Gallery. "Willem de Kooning Retrospective: Drawings, 1936-1963." February 1-29. Catalogue.

1965 New York, Allan Stone Gallery. "De Kooning/Cornell." February 13-March 13. Catalogue.

Beverly Hills, Calif., Paul Kantor Gallery. "Willem de Kooning." March 22-April 30. Catalogue.

Northampton, Mass., Smith College Museum of Art. "Willem de Kooning: A Retrospective Exhibition from Public and Private Collections." April 8-May 2. Traveled to: Cambridge, Mass., Hayden Gallery, Massachusetts Institute of Technology. Catalogue by Dore Ashton.

1966 New York, Allan Stone Gallery. "De Kooning's Women." March 14-April 2. Catalogue.

1967 New York, M. Knoedler & Co. "De Kooning: Paintings and Drawings Since 1963." November 14-December 2. Catalogue by Thomas B. Hess.

1968 Paris, M. Knoedler & Cie. "De Kooning: peintures récentes." June 4-29. Catalogue by Thomas B. Hess.

Amsterdam, Stedelijk Museum. "Willem de Kooning." September 19-November 17. Traveled to: London, Tate Gallery (Arts Council of Great Britain); New York, The Museum of Modern Art; Chicago, The Art Institute of Chicago; Los Angeles, Los Angeles County Museum of Art. Catalogues (Amsterdam, New York, London) by Thomas B. Hess.

1969 New York, M. Knoedler & Co. "De Kooning, January 1968-March 1969." March 4-22. Catalogue.

Spoleto, Italy, XII Festival dei Due Mondi, Palazzo Ancaiani. "De Kooning: Disegni." June 28-July 13. Catalogue by Giovanni Carandente.

Berkeley, Powerhouse Gallery, University Art Museum, University of California. "De Kooning: The Recent Work." August 12-September 14.

1971 New York, Allan Stone Gallery. "Willem de Kooning: The 40's and 50's." October 17-November 1.

New York, The Museum of Modern Art. "Seven by de Kooning." December 30-February 28, 1972.

1972 Baltimore, The Baltimore Museum of Art. "Willem de Kooning: Paintings, Sculpture and Works on Paper." August 8-September 29.

New York, Sidney Janis Gallery. "An Exhibition by de Kooning Introducing His Sculpture and New Paintings." October 4-November 4. Checklist.

New York, Allan Stone Gallery. "Willem de Kooning: Selected Works." October 17-November 11.

Tokyo, American Center. "Lithographs by Willem de Kooning." November 14-24.

1973 Detroit, Gertrude Kasle Gallery. "Willem de Kooning: Paintings, Drawings, Sculpture." May 19-June 30.

1974 New York, Fourcade, Droll (organizer). "Lithographs, 1970-1972: Willem de Kooning." Traveling exhibition, opened March; itinerary: Tuscaloosa, Ala., Art Gallery, University of Alabama; Amarillo, Tex., The Amarillo Art Center; San Diego, Fine Arts Gallery of San Diego; Tucson, Ariz., The Tucson Museum of Art; Santa Barbara, Calif., The Santa Barbara Museum of Art; Indianapolis, Indianapolis Museum of Art; Omaha, The Joslyn Art Museum; Syracuse, N.Y., Everson Museum of Art; Athens, Ga., Georgia Museum of Art, University of Georgia; Los Angeles, Grunwald Center for the Graphic Arts, University of California, Los Angeles; Burnaby, British Columbia, Simon Fraser University; San Jose, Calif., San Jose Museum of Art; Champaign, Ill., Krannert Art Museum, University of Illinois; Austin, Tex., University Art Museum, University of Texas; Houston, Sarah Campbell Blaffer Gallery, University of Houston.

Minneapolis, Walker Art Center. "De Kooning: Drawings/Sculptures." March 10-April 21. Traveled to: Ottawa,

National Gallery of Canada;
Washington, D.C., The Phillips
Collection; Buffalo, Albright-Knox Art
Gallery; Houston, The Museum of Fine
Arts; St. Louis, Washington University
Gallery of Art. Catalogue by Phillip
Larson and Peter Schjeldahl.

Munich, Galerie Biedermann. "Willem
de Kooning: Grafiken 1970/71."
September 26-November 9.

Chicago, Richard Gray Gallery. "Willem
de Kooning, 1941-1959." October 4-
November 16. Catalogue.

Toronto, Pollock Gallery. "De Kooning:
Major Paintings and Sculpture."
October 15-November 15.

Toronto, Pollock Gallery. "De Kooning:
Recent Lithographs." November 17-
December 5.

1975 Tokyo, Fuji Television Gallery. "Willem
de Kooning." September 5-October 4.
Catalogue.

New York, Fourcade, Droll. "De
Kooning: New Works – Paintings and
Sculpture." October 25-December 6.
Checklist.

Paris, Galerie des Arts. "De Kooning."
October 29-November 29. Catalogue by
Sam Hunter.

Hartford, Wadsworth Atheneum.
"Matrix: A Changing Exhibition of
Contemporary Art – Willem de Kooning/
Matrix 15." December-January 1976.
Catalogue by Andrea Miller-Keller.

West Palm Beach, Fla., Norton Gallery
and School of Art. "De Kooning:
Paintings, Drawings, Sculptures, 1967-
75." December 10-February 15, 1976.
Catalogue.

1976 Seattle, Seattle Art Museum. "De
Kooning: New Paintings and Sculpture."
February 4-March 14. Catalogue.

Amsterdam, Stedelijk Museum. "Willem
de Kooning: beelden en lithos." March 5 -
April 19. Traveled to: Duisburg, West
Germany, Wilhelm-Lehmbruck-Museum
der Stadt Duisburg; Geneva, Cabinet des
Estampes, Musée d'Art et d'Histoire;
Grenoble, France, Musée de Peinture et
de Sculpture. Catalogues (Amsterdam,
Duisburg, Geneva).

Amsterdam, Collection d'Art. "Willem de
Kooning." May 1-July 1. Catalogue by
Dolf Welling.

Los Angeles, James Corcoran Gallery.
"Willem de Kooning: Paintings,
Drawings, Sculptures." May 20-June 26.

London, Gimpel Fils. "Willem de
Kooning: Recent Paintings." June 29-
August 12. Traveled to: Zurich, Gimpel &
Hanover. Checklist.

New York, Xavier Fourcade. "De
Kooning: New Paintings, 1976."
October 12-November 20. Checklist.

1977 Paris, Galerie Templon. "Willem de
Kooning: peintures et sculptures
récentes." September 15-October 30.

London, Arts Council of Great Britain
(organizer). "The Sculptures of de
Kooning with Related Paintings, Drawings
and Lithographs." Traveling exhibition,
opened October; itinerary: Edinburgh,
Fruit Market Gallery; London,
Serpentine Gallery. Catalogue by David
Sylvester.

Washington, D.C., International
Communication Agency of the United
States Government and the Hirshhorn
Museum and Sculpture Garden,
Smithsonian Institution (organizers).
"Willem de Kooning: Paintings and
Sculpture." Traveling exhibition, opened
October; itinerary: Belgrade, Museum of
Contemporary Art; Ljubljana,
Yugoslavia, Museum of Modern Art;
Bucharest, Rumanian National Museum
of Art; Warsaw, National Museum;
Krakow, Branch Post; Helsinki, Helsinki
National Museum of Art; East Berlin,
Amerika House; Alicante, Spain, Caja de
Ahorros; Madrid, Fundación Juan
March; Oslo, Norwegian National Gallery
of Art; Dordrecht, Holland, Dordrechts
Museum. Catalogues (Washington,
Warsaw, Helsinki, East Berlin, Madrid).

Amsterdam, Collection d'Art. "Willem de
Kooning." October 8-December 11.

New York, Xavier Fourcade. "De
Kooning: New Paintings, 1977." October
11-November 19.

Los Angeles, James Corcoran Gallery.
"Willem de Kooning: Recent Works."
November 11-December 5.

New York, School of Visual Arts. "Willem
de Kooning: Drawings." November 15-
December 9.

1978 New York, The Solomon R. Guggenheim
Museum. "Willem de Kooning in East
Hampton." February 10-April 23.
Catalogue.

Helsinki, Helsingen Kaupungin
Taidekokoelmat. "Willem de Kooning."
March 6-April 22. Catalogue by Marja-
Liisa Bell.

Bridgeport Conn., Fairfield Arts
Festival, Museum of Art, Science and
Industry. "Artist of the Year."
June 3-11. Catalogue.

Berkeley, University Art Museum,
University of California. "Matrix: A
Changing Exhibition of Contemporary
Art – Willem de Kooning/Matrix 12."
August 30-October 29. Catalogue by
Andrea Miller-Keller.

Cedar Falls, Iowa, University of
Northern Iowa Gallery of Art. "De
Kooning, 1969-78." October 21-
November 26. Traveled to: St. Louis,
The St. Louis Art Museum; Cincinnati,
Contemporary Arts Center; Akron,

Akron Art Institute. Catalogue by Jack
Cowart and Sanford Sivitz Shaman.

1979 New York, Xavier Fourcade. "Willem de
Kooning: New Paintings, 1978-1979."
October 20-November 17.

Pittsburgh, Museum of Art, Carnegie
Institute. "Willem de Kooning:
Pittsburgh International Series."
October 26-January 6, 1980. Catalogue.

1980 Seattle, Richard Hines Gallery. "Willem
de Kooning: Paintings, Sculpture,
Drawings." January 23-March 8.

Chicago, Richard Gray Gallery. "De
Kooning: Late Paintings and Drawings."
February 16-March. Catalogue.

Düsseldorf, Hans Strelow Gallery.
"Willem de Kooning." November.

1981 Houston, Janie C. Lee Gallery. "Willem
de Kooning: Drawings of the 70's."
April 4-May 15. Checklist.

East Hampton, N.Y., Guild Hall.
"Willem de Kooning: Works from 1951-
1981." May 23-July 19. Catalogue by
Judith Wolfe.

1982 Baltimore, C. Grimaldis Gallery.
"Willem de Kooning: Paintings and
Drawings." February 3-28.

New York, Xavier Fourcade. "Willem de
Kooning: New Paintings, 1981-1982."
March 17-May 1.

1983 Amsterdam, Stedelijk Museum. "Willem
de Kooning: The North Atlantic Light,
1960-1983." May 10-July 3. Traveled to:
Humlebaek, Denmark, Louisiana
Museum; Stockholm, Moderna Museet.
Catalogue.

New York, Xavier Fourcade. "Willem de
Kooning: The Complete Sculpture,
1969-1983." May 14-June 30.

New York, Whitney Museum of
American Art. "The Drawings of Willem
de Kooning." December 7-February 26,
1984. Traveled to: West Berlin,
Akademie der Künste; Paris, Musée
d'Art Moderne, Centre National d'Art et
de Culture Georges Pompidou.
Catalogue.

New York, Whitney Museum of
American Art. "Willem de Kooning
Retrospective Exhibition." December
15-February 26, 1984. Traveled to: West
Berlin, Akademie der Künste
(organizer); Paris, Musée d'Art
Moderne, Centre National d'Art et de
Culture Georges Pompidou. Catalogue.

Group Exhibitions

1936 New York, The Museum of Modern Art. "New Horizons in American Art." September 14-October 12. Catalogue by Holger Cahill.

1939 New York, New York World's Fair. "Painting and Sculpture in the World of Tomorrow." Summer-Fall. Prospectus.

1942 New York, McMillen Gallery. "American and French Paintings." January 20-February 6.

1943 New York, Bignou Gallery. "Twentieth Century Paintings." February 8-March 20.

1944 Cincinnati, Cincinnati Art Museum. "Abstract and Surrealist Art in the United States." February 8-March 12. Traveled to: Denver, The Denver Art Museum; Seattle, Seattle Art Museum; Santa Barbara, Calif., The Santa Barbara Museum of Art; San Francisco, San Francisco Museum of Art. Catalogue (San Francisco) by Sidney Janis.

New York, Mortimer Brandt Gallery. "Abstract and Surrealist Art in America." November 29-December 20. Accompanying book by Sidney Janis.

1945 Chicago, The Art Institute of Chicago. "Modern Art in Advertising." April 27-June 23. Catalogue.

1947 New York, Betty Parsons Gallery. "The Ideographic Picture." January 20-February 8. Catalogue.

1948 New York, Whitney Museum of American Art. "1948 Annual Exhibition of Contemporary American Painting." November 13-January 2, 1949. Catalogue.

1949 New York, Samuel Kootz Gallery. "The Intrasubjectives." September 14-October 3. Catalogue by Samuel Kootz and Harold Rosenberg.

New York, Sidney Janis Gallery. "Artists: Man and Wife." September 19-October 8. Checklist.

New York, Whitney Museum of American Art. "1949 Annual Exhibition of Contemporary American Painting." December 16-February 5, 1950. Catalogue.

1950 New York, Samuel Kootz Gallery. "Black or White: Paintings by European and American Artists." February 28-March 20. Catalogue by Robert Motherwell.

Richmond, Virginia Museum of Fine Arts. "American Painting, 1950." April 22-June 4. Catalogue by James Johnson Sweeney.

Venice, 25th Venice Biennale. June 3-October 15. Catalogue.

New York, Sidney Janis Gallery. "Challenge and Defy: Extreme Examples by XX Century Artists, French and American." September 25-October 21. Checklist.

New York, Sidney Janis Gallery. "Young Painters in U.S. and France." October 22-November 11. Checklist.

New York, Whitney Museum of American Art. "1950 Annual Exhibition of Contemporary American Painting." November 10-December 31. Catalogue.

San Francisco, California Palace of the Legion of Honor. "American Painting Annual." November 25-January 1, 1951. Catalogue.

1951 New York, The Museum of Modern Art. "Abstract Painting and Sculpture in America." January 23-March 25. Catalogue by Andrew Carnduff Ritchie.

New York, 60 East Ninth Street. "9th Street Show." May 21-June 10.

São Paulo, Museu de Arte Moderna de São Paulo. "I Bienal do Museu de Arte Moderna de São Paulo." October-December. Catalogue.

Chicago, Arts Club of Chicago. "Exhibition: Ben Shahn, Willem de Kooning, Jackson Pollock." October 2-27. Catalogue.

Chicago, The Art Institute of Chicago. "Sixtieth Annual American Exhibition: Paintings and Sculpture." October 25-December 16. Catalogue.

New York, Sidney Janis Gallery. "American Vanguard Art for Paris." December 26-January 5, 1952. Traveled to: Paris, Galerie de France. Checklist.

1952 New York, Wildenstein Gallery. "Loan Exhibition of Seventy XX Century American Paintings . . . for a Special Purchase Fund of the Whitney Museum of American Art." February 21-March 22. Catalogue.

Buffalo, Albright Art Gallery. "Expressionism in American Painting." May 10-June 29. Catalogue.

Pittsburgh, Museum of Art, Carnegie Institute. "The 1952 Pittsburgh International Exhibition of Contemporary Painting." October 16-December 14. Catalogue.

1953 New York, Sidney Janis Gallery. "5th Anniversary Exhibition: 5 Years of Janis." September 29-October 31. Checklist.

São Paulo, Museu de Arte Moderna de São Paulo. "II Bienal do Museu de Arte Moderna de São Paulo." December 8-February 8, 1954. Catalogue.

1954 New York, Sidney Janis Gallery. "9 American Painters Today" [Davis, de Kooning, Gorky, Hofmann, Kline, Pollock, Rothko, Still, Tobey]. January 4-23. Checklist.

New York, The Solomon R. Guggenheim Museum. "Younger American Painters." May 12-July 25. Catalogue.

Venice, 27th Venice Biennale, American Pavilion. "2 Pittori: de Kooning, Shahn; 3 Scultori: Lachaise, Lassaw, Smith." June-September. Catalogue.

Chicago, The Art Institute of Chicago. "Sixty-first American Exhibition: Paintings and Sculpture." October 21-December 5. Catalogue.

1955 New York, Whitney Museum of American Art. "The New Decade: 35 American Painters and Sculptors." May 11-August 7. Traveled to: San Francisco, San Francisco Museum of Art; Los Angeles, Art Galleries, University of California; Colorado Springs, Colorado Springs Fine Arts Center; St. Louis, City Art Museum of St. Louis. Catalogue by John I. H. Baur and Rosalind Irvine.

Pittsburgh, Museum of Art, Carnegie Institute. "The 1955 Pittsburgh International Exhibition of Contemporary Painting." October 13-December 18. Catalogue.

1956 Venice, 28th Venice Biennale, American Pavilion. "American Artists Paint the City." June-September. Catalogue.

New York, Sidney Janis Gallery. "Recent Paintings by 7 Americans" [Albers, de Kooning, Gorky, Guston, Kline, Pollock, Rothko]. September 24-October 20. Checklist.

1957 New York, Leo Castelli Gallery. "First Exhibition." February.

New York, Sidney Janis Gallery. "8 Americans" [Albers, de Kooning, Gorky, Guston, Kline, Motherwell, Pollock, Rothko]. April 1-20. Checklist.

New York, Poindexter Gallery. "The 30's: Painting in New York." June 3-29. Catalogue by Patricia Passloff.

Minneapolis, The Minneapolis Institute of Arts. "American Paintings, 1945-1957." June 18-September 1. Catalogue.

1958 New York, Whitney Museum of American Art. "Nature in Abstraction: The Relation of Abstract Painting and Sculpture to Nature in Twentieth-Century American Art." January 14-March 16. Traveled to: Washington, D.C., The Phillips Gallery; Fort Worth, Tex., Fort Worth Art Center; Los Angeles, Los Angeles County Museum of Art; San Francisco, San Francisco Museum of Art; Minneapolis, Walker Art Center; St. Louis, City Art Museum of St. Louis. Catalogue by John I. H. Baur.

London, Institute of Contemporary Arts. "Some Paintings from the E. J. Power Collection." March 13-April 19. Catalogue.

New York, Whitney Museum of American Art. "The Museum and Its Friends: Twentieth-Century American Art from Collections of the Friends of the Whitney Museum." April 30-June 15. Catalogue.

Brussels, Brussels World's Fair, Palais Internationale des Beaux-Arts. "50 Ans d'art moderne." June-September. Catalogue by Emile Langui.

New York, Sidney Janis Gallery. "10th Anniversary Exhibition: X Years of Janis." September 29-November 1. Checklist.

Pittsburgh, Museum of Art, Carnegie Institute. "The 1958 Pittsburgh International Exhibition of Painting and Sculpture." December 5-February 8, 1959. Catalogue.

1959 New York, Sidney Janis Gallery. "8 American Painters" [Albers, de Kooning, Gorky, Guston, Kline, Motherwell, Pollock, Rothko]. January 5-31. Checklist.

Houston, Cullinan Hall, The Museum of Fine Arts. "New York and Paris: Painting in the Fifties." January 16-February 8. Catalogue.

New York, Whitney Museum of American Art. "The Museum and Its Friends: Eighteen Living American Artists Selected by the Friends of the Whitney Museum." March 5-April 12. Catalogue.

Houston, Contemporary Arts Museum. "The Romantic Agony: From Goya to de Kooning." April 23-May 31. Catalogue.

New York, International Program of the Museum of Modern Art under the auspices of the International Council at the Museum of Modern Art. "The New American Painting: As Shown in Eight European Countries, 1958-59." May 28-September 28. Traveled before New York showing to: Basel, Kunsthalle Basel; Milan, Galleria Civica d'Arte Moderna; Madrid, Museo Español de Arte Contemporaneo; West Berlin, Hochschule für Bildende Künste; Amsterdam, Stedelijk Museum; Brussels, Palais des Beaux-Arts; Paris, Musée National d'Art Moderne; London, Tate Gallery. Catalogues (New York, London).

Kassel, Museum Fridericianum. "Documenta II: Kunst nach 1945 – Internationale Ausstellung." July 11-October 11. Catalogue.

New York, The Museum of Modern Art. "New Images of Man." September 30-November 29. Traveled to: Baltimore, Baltimore Museum of Art. Catalogue by Peter Selz.

1960 Columbus, Ohio, Columbus Gallery of Fine Arts. "Contemporary American Painting." January 14-February 18. Catalogue.

Minneapolis, Walker Art Center. "60 American Painters, 1960." April 3-May 8. Catalogue.

New York, Sidney Janis Gallery. "9 American Painters" [Albers, Baziotes, de Kooning, Gorky, Guston, Kline, Motherwell, Pollock, Rothko]. April 4-23. Checklist.

Cleveland, The Cleveland Museum of Art. "Paths of Abstract Art." October 5-November 13. Catalogue by Edward B. Henning.

1961 Kansas City, Mo., William Rockhill Nelson Gallery and Atkins Museum of Fine Arts. "The Logic of Modern Art." January 19-February 26. Catalogue by Ralph T. Coe.

Sarasota, Fla., John and Mable Ringling Museum of Art. "The Sidney Janis Painters." April 8-May 7. Catalogue by Dore Ashton and Kenneth Donahue.

New York, Sidney Janis Gallery. "10 American Painters" [Albers, Baziotes, de Kooning, Gorky, Gottlieb, Guston, Kline, Motherwell, Pollock, Rothko]. May 8-June 3. Checklist.

Spoleto, Italy, IV Festival dei Due Mondi, Palazzo Ancaiani. "Mostra di Disegni Americani Moderni." June 16-July 16. Catalogue by Giovanni Carandente.

New York, The Museum of Modern Art. "The Art of Assemblage." October 2-November 12. Traveled to: Dallas, The Dallas Museum for Contemporary Art; San Francisco, San Francisco Museum of Art. Catalogue by William C. Seitz.

Dallas, Dallas Museum of Fine Arts. "Directions in Twentieth Century American Painting." October 7-November 12. Catalogue.

Brooklyn, The Brooklyn Museum. "The Nude in American Painting." October 10-December 10. Catalogue.

New York, The Solomon R. Guggenheim Museum. "American Abstract Expressionists and Imagists." October 13-December 31. Catalogue.

Pittsburgh, Museum of Art, Carnegie Institute. "The 1961 Pittsburgh International Exhibition of Contemporary Painting and Sculpture." October 27-January 7, 1962. Catalogue.

1962 New York, Martha Jackson Gallery. "Selections, 1934-1961: American Artists from the Collection of Martha Jackson." February 6-March 3. Checklist.

London, United States Embassy, U.S.I.S. Gallery. "Vanguard American Painting." February 28-March 30. Catalogue by H. H. Arnason.

Hartford, Wadsworth Atheneum. "Continuity and Change." April 12-May 27. Catalogue by Samuel Wagstaff, Jr.

Seattle, Seattle World's Fair. "Art Since 1950: American and International." April 21-October 21. American section, "American Art Since 1950," traveled to: Waltham, Mass., Rose Art Museum, Brandeis University; Boston, Institute of Contemporary Art. Catalogue.

New York, Sidney Janis Gallery. "10 American Painters" [Albers, Baziotes, de Kooning, Gorky, Gottlieb, Guston, Kline, Motherwell, Pollock, Rothko]. May 7-June 2. Checklist.

Amsterdam, Stedelijk Museum. "Nederlands bijdrage: tot de internationale ontwikkeling sedert 1945." June 29-September 17.

Milwaukee, Milwaukee Art Center. "Art USA: The Johnson Collection of Contemporary American Painting." September 20-October 21. Catalogue.

1963 Washington D.C., The Corcoran Gallery of Art. "The 28th Biennial Exhibition of Contemporary American Painting." January 18-March 3. Catalogue.

Northampton, Mass., Smith College Museum of Art. "Contemporary Painting." April 17-May 1. Catalogue.

New York, Sidney Janis Gallery. "11 Abstract Expressionist Painters" [de Kooning, Francis, Gorky, Gottlieb, Guston, Kline, Motherwell, Newman, Pollock, Rothko, Still]. October 7-November 2. Catalogue.

Waltham, Mass., The Poses Institute of Fine Arts, Brandeis University (organizer). "New Directions in American Painting." Traveling exhibition, opened December; itinerary: Utica N.Y., Munson-Williams-Proctor Institute; New Orleans, Isaac Delgado Museum of Art; Atlanta, Atlanta Art Association; Louisville, Ky., The J. B. Speed Art Museum; Bloomington, Ind., Art Museum, Indiana University; St. Louis, Washington University in St. Louis; Detroit, The Detroit Institute of Arts. Catalogue.

New York, Whitney Museum of American Art. "Annual Exhibition, 1963: Contemporary American Painting." December 11-February 2, 1964. Catalogue.

New York, The Jewish Museum. "Black and White." December 12-February 2, 1964. Catalogue.

1964 New York, The Solomon R. Guggenheim Museum. "The Guggenheim International Award, 1964." January 6-March 9. Traveled to: Honolulu, Honolulu Academy of Arts; West Berlin, Akademie der Künste; Ottawa, National Gallery of Canada; Sarasota, Fla., John and Mable Ringling Museum of Art;

Buenos Aires, Museo Nacional de Bellas Artes. Catalogue.

New York, Sidney Janis Gallery. "2 Generations: Picasso to Pollock." March 3-April 4. Checklist.

St. Louis, City Art Museum of St. Louis. "200 Years of American Painting." April 1-May 31. Catalogue by Merrill Clement Rueppel.

Cambridge, Mass., Fogg Art Museum, Harvard University. "20th Century Master Drawings." April 6-May 24. Traveled to: New York, The Solomon R. Guggenheim Museum; Minneapolis, University Gallery, University of Minnesota. Catalogue.

Bloomington, Ind., Fine Arts Gallery, Indiana University. "American Painting, 1910-1960." April 19-May 10. Catalogue.

London, Tate Gallery. "Painting and Sculpture of a Decade: 54-64." April 22-June 28. Catalogue.

Cambridge, Mass., Fogg Art Museum, Harvard University. "Within the Easel Convention: Sources of Abstract Expressionism." May 7-June 7. Catalogue by Rosalind Krauss.

New York, Whitney Museum of American Art. "Between the Fairs: 25 Years of American Art, 1939-1964." June 9-September 30. Catalogue by John I. H. Baur.

Kassel, Alte Galerie, Museum Fridericianum, and Orangerie. "Documenta III: Internationale Ausstellung." June 27-October 5. Catalogue.

New York, The Solomon R. Guggenheim Museum. "Van Gogh and Expressionism." July 1-September 13. Catalogue by Maurice Tuchman.

Darmstadt, Mathildenhoehe. "I. Internationale der Zeichnung." September 12-November 15. Catalogue.

New York, The Solomon R. Guggenheim Museum. "American Drawings." September 17-October 22. Traveled to: Ann Arbor, Mich., University of Michigan Museum of Art; Grand Rapids, Grand Rapids Art Museum; Minneapolis, University Gallery, University of Minnesota; Seattle, Seattle Art Museum; Denver, The Denver Art Museum; Dallas, Dallas Museum of Fine Arts; Columbus, Ohio, The Columbus Gallery of Fine Arts; Champaign, Ill., Krannert Art Museum, University of Illinois. Catalogue.

Pittsburgh, Museum of Art, Carnegie Institute. "The 1964 Pittsburgh International Exhibition of Contemporary Art." October 30-January 10, 1965. Catalogue.

New York, Sidney Janis Gallery. "A Selection of 20th Century Art of 3 Generations." November 24-December 21. Checklist.

1965 Philadelphia, Institute of Contemporary Art, University of Pennsylvania. "1943-1953: The Decisive Years." January 14-March 1. Catalogue.

Los Angeles, Los Angeles County Museum of Art. "New York School, The First Generation: Paintings of the 1940s and 1950s." July 16-August 1. Catalogue by Maurice Tuchman.

New York, Allan Stone Gallery. "De Kooning, Pollock, Newman, Gorky, Cornell." October 26-November 13.

New York, Whitney Museum of American Art. "1965 Annual Exhibition of Contemporary American Painting." December 8-January 30, 1966. Catalogue.

1966 Austin, Tex., University Art Museum, University of Texas. "Drawings &." February 6-March 15. Catalogue.

Chicago, Arts Club of Chicago. "Drawings, 1916/1966: An Exhibition on the Occasion of the Fiftieth Anniversary of the Arts Club of Chicago." February 28-March 11. Catalogue.

New York, Public Education Association. "Seven Decades, 1895-1965: Crosscurrents in Modern Art." April 26-May 21. Exhibition held at ten New York galleries: Cordier & Ekstrom; André Emmerich Gallery; Galleria Odyssia; Stephen Hahn Gallery; M. Knoedler & Co.; Pierre Matisse Gallery; Perls Galleries; Paul Rosenberg & Co.; Saidenberg Gallery; and E. V. Thaw & Co. De Kooning works shown at: Cordier & Ekstrom; André Emmerich Gallery; and Pierre Matisse Gallery. Catalogue.

Ridgefield, Conn., Larry Aldrich Museum. "Selections from the John G. Powers Collection." September 25-December 11. Catalogue.

New York, Whitney Museum of American Art. "Art of the United States, 1670-1966." September 27-November 28. Catalogue by Lloyd Goodrich.

New York, International Council of the Museum of Modern Art (organizer). "Two Decades of American Painting." Traveling exhibition, opened October; itinerary: Tokyo, The National Museum of Modern Art; Kyoto, The National Museum of Modern Art; New Delhi, Lalit Kala Academy; Melbourne, National Gallery of Victoria; Sydney, Art Gallery of New South Wales. Catalogue by Waldo Rasmussen et al.

1967 New York, Sidney Janis Gallery. "Selected Works from 2 Generations of European and American Artists: Picasso to Pollock." January 3-27. Checklist.

New York, Allan Frumkin Gallery. "The Nude - Now." January 10-February 4.

Champaign, Ill., Krannert Art Museum, University of Illinois. "Contemporary American Painting and Sculpture 1967." March 5-April 9. Catalogue by Allen S. Weller.

Irvine, Calif., University of California. "Selections of 19th and 20th Century Works from the Hunt Foods and Industries Museum of Art Collection." March 7-22. Traveled to: Riverside, Calif., University of California; San Diego, University of California. Catalogue by Marc C. Muller.

Paris, Musée d'Art Moderne de la Ville de Paris. "XXIIIᵉ Salon de mai." April 29-May 21. Catalogue by Gaston Diehl.

St. Paul-de-Vence, France, Fondation Maeght. "Dix Ans d'art vivant, 1955-1965." May 3-July 23. Catalogue.

Berkeley, University of California Art Museum. "Selection, 1967: Recent Acquisitions in Modern Art." June 20-September 19. Catalogue by Susan King.

Paris, M. Knoedler & Cie. "Six Peintres américains: Gorky, Kline, de Kooning, Newman, Pollock, Rothko." October 19-November 15. Brochure.

Eindhoven, Holland, Stedelijk van Abbemuseum. "Kompass 3: Schilderkunst na 1945 uit New York/Painting After 1945 in New York." November 9-December 17. Traveled, as "Kompass New York," to: Frankfurt, Frankfurter Kunstverein. Catalogues (Eindhoven, Frankfurt).

Dublin, Royal Dublin Society. "Rose '67: The Poetry of Vision." November 13-January 10, 1968. Catalogue.

New York, M. Knoedler & Co. "Space and Dream." December 5-29. Catalogue by Robert Goldwater.

New York, Sidney Janis Gallery. "Homage to Marilyn Monroe by Leading International Artists." December 6-30. Checklist.

New York, Whitney Museum of American Art. "1967 Annual Exhibition of Contemporary American Painting." December 13-February 4, 1968. Catalogue.

1968 New York, The Museum of Modern Art. "The Sidney and Harriet Janis Collection." January 17-March 4. Traveled to: Minneapolis, The Minneapolis Institute of Arts; Portland, Oreg., Portland Art Museum; Pasadena, Calif., The Pasadena Art Museum; San Francisco, San Francisco Museum of Art; Seattle, Seattle Art Museum; Dallas, Dallas Museum of Fine Arts; Buffalo, Albright-Knox Art Gallery; Cleveland, The Cleveland Museum of Art; Basel, Kunsthalle Basel; London, Institute of Contemporary Arts; West Berlin,

Akademie der Künste; Nuremberg, Kunsthalle Nürnberg; Stuttgart, Württembergischer Kunstverein; Brussels, Palais des Beaux-Arts; Cologne, Kunsthalle Köln. Catalogues (New York, Basel).

Irvine, Calif., Art Gallery, University of California. "Twentieth Century Works on Paper." January 30-February 25. Traveled to: Davis, Calif., Memorial Union Art Gallery, University of California. Catalogue.

Austin, Tex., University Art Museum, University of Texas. "Painting as Painting." February 18-April 1. Catalogue.

London, Nash House Gallery, Institute of Contemporary Arts. "The Obsessive Image, 1960-1968." April 10-May 29. Catalogue by Mario Amaya.

New York, Whitney Museum of American Art. "The 1930's: Paintings and Sculpture in America." October 15-December 1. Catalogue by William C. Agee.

San Francisco, San Francisco Museum of Art. "Untitled, 1968." November 9-December 29. Catalogue.

1969 New York, The Museum of Modern Art. "The New American Painting and Sculpture: The First Generation." June 18-October 15. Checklist.

New York, M. Knoedler & Co. "Gorky, De Kooning, Newman." June 26-September 20.

Pasadena, Calif., The Pasadena Art Museum. "Painting in New York, 1944-69." November 24-January 11, 1970. Catalogue by Alan Solomon.

New York, Whitney Museum of American Art. "1969 Annual Exhibition: Contemporary American Painting." December 16-February 1, 1970. Catalogue.

1970 Osaka, Expo Museum of Fine Arts. "Contemporary Trends." March 15-September 13. Catalogue.

Huntington, N.Y., Heckscher Museum. "Artists of Suffolk County, Part II: The Abstract Tradition." July 10-September 6. Catalogue.

St. Paul-de-Vence, France, Fondation Maeght. "L'Art vivant aux Etats-Unis." July 16-September 30. Catalogue.

New York, The Metropolitan Museum of Art. "New York Painting and Sculpture, 1940-1970." October 16-February 1, 1971. Catalogue by Henry Geldzahler.

Pittsburgh, Museum of Art, Carnegie Institute. "The 1970 Pittsburgh International Exhibition of Contemporary Art." October 30-January 10, 1971. Catalogue.

1971 New York, M. Knoedler & Co. "Lithographs by de Kooning, Fairfield

Porter, and Paul Waldman." May 4-June 5. Brochure.

Basel, Galerie Beyeler. "America." June 24-29. Catalogue.

New York, M. Knoedler & Co. "A Selection of Works by Louise Bourgeois, Salvador Dalí, Willem de Kooning, R. Duchamp-Villon, Arshile Gorky (and Others)." September 14-October 16.

Paris, M. Knoedler & Cie. "Willem de Kooning: New Lithographs." September 28-October 23.

St. Paul, Minnesota Museum of Art. "Drawings in St. Paul from the Permanent Collection of the Minnesota Museum of Art." December 2-January 23, 1972. Catalogue.

1972 New York, Whitney Museum of American Art. "1972 Annual Exhibition: Contemporary American Painting." January 25-March 19. Catalogue.

New York, Sidney Janis Gallery. "Abstract Expressionism and Pop Art." February 9-March 4. Checklist.

Huntington, N.Y., Heckscher Museum. "Artists of Suffolk County, Part IV: Contemporary Prints." July 16-September 3. Catalogue.

1973 Los Angeles, Irving Blum Gallery. "Some Recent Graphics: de Kooning, Stella, Warhol, Johns, Ruscha, Kelly, Lichtenstein." January 30-February.

Des Moines, Des Moines Art Center. "Twenty-five Years of American Painting, 1948-1973." March 6-April 22. Catalogue by Max Kozloff.

New York, International Council of the Museum of Modern Art (organizer). "Cuatro maestros contemporáneos: Giacometti, Dubuffet, de Kooning, Bacon." Traveling exhibition, opened April; itinerary: Caracas, Museo de Bellas Arte; Bogotá, Museo de Arte Moderno; Mexico City, Museo de Arte Moderno; São Paulo, Museu de Arte Moderna de São Paulo; Rio de Janeiro, Museu de Arte Moderna do Rio de Janeiro. Catalogues (Caracas, Bogotá, Mexico City, Rio de Janeiro).

Seattle, Seattle Art Museum, "American Art: Third Quarter Century." August 22-October 14. Catalogue.

1974 Santa Barbara, Calif., Art Galleries, University of California, Santa Barbara. "Five American Painters: Recent Works by de Kooning, Mitchell, Motherwell, Resnick, Tworkov." January 8-February 17. Catalogue by Phyllis Plous.

New York, Downtown Branch, Whitney Museum of American Art. "Frank O'Hara: A Poet Among Painters." February 12-March 17. Checklist.

New York, Sidney Janis Gallery. "25 Years of Janis, Part 2: From Pollock

to Pop, Op and Sharp-Focus Realism." March 13-April 13. Catalogue.

Los Angeles, Frederick S. Wight Art Gallery, University of California. "Twenty Years of Acquisition: Evolution of a University Study Collection – The Grunwald Center for the Graphic Arts." April 9-June 2. Catalogue.

Indianapolis, Contemporary Art Society of the Indianapolis Museum of Art. "Painting and Sculpture Today, 1974." May 22-July 14. Traveled to: Cincinnati, Contemporary Arts Center and the Taft Museum. Catalogue.

Stony Brook, N.Y., Green Gallery, Suffolk Museum. "Contemporary Long Island Sculptors." July 7-September 2.

Newport, R.I., Monumenta Newport. "Monumenta: A Biennial Exhibition of Outdoor Sculpture." August 17-October 13. Catalogue by Sam Hunter.

New York, William Zierler. "American Works on Paper, 1944 to 1974." November 2-30. Checklist.

New York, Noah Goldowsky Gallery. Group exhibition. December 3-31.

Düsseldorf, Städtische Kunsthalle Düsseldorf. "Surrealität, Bildrealität, 1924-74 – In den unzähligen Bildern des Lebens." December 8-February 2, 1975. Traveled to: Baden-Baden, Staatliche Kunsthalle Baden-Baden. Catalogue.

1975 Cambridge, Mass., Hayden Gallery, Massachusetts Institute of Technology. "Drawings by Five Abstract Expressionist Painters: Arshile Gorky, Philip Guston, Franz Kline, Willem de Kooning, Jackson Pollock." February 21-March 26. Reduced exhibition traveled to: Chicago, Museum of Contemporary Art. Catalogues (Cambridge, Chicago) by Eila Kokkinen.

Washington, D.C., The Corcoran Gallery of Art. "34th Biennial Exhibition of Contemporary American Painting." February 22-April 6. Catalogue.

Greensboro, N.C., Weatherspoon Art Gallery, University of North Carolina. "Selected Works from the Dillard Collection." April 15-May 18. Catalogue by James E. Tucker.

New York, Downtown Branch, Whitney Museum of American Art. "Subjects of the Artist: New York Painting, 1941-1947." April 22-May 28. Brochure.

New York, Whitney Museum of American Art. "American Abstract Painting." July 24-October 26.

1976 New York, The Solomon R. Guggenheim Museum. "Twentieth Century American Drawing: Three Avant-Garde Generations." January 23-March 28. Traveled to: Baden-Baden, Staatliche Kunsthalle Baden-Baden; Bremen,

Kunsthalle Bremen. Catalogues (New York, Baden-Baden, Bremen).

Miami, Miami-Dade Community College. "Abstract Expressionism: Works from the Collection of the Whitney Museum of American Art." March 8-April 1. Catalogue.

Chicago, The Art Institute of Chicago. "Seventy-second American Exhibition." March 13-May 9. Catalogue.

New York, Hirschl & Adler Galleries. "Second Williams College Alumni Loan Exhibition: In Celebration of the 50th Anniversary of the Williams College Museum of Art and in Honor of President John W. Chandler and Professor S. Lane Faison, Jr." April 1-24. Traveled to: Williamstown, Mass., Williams College Museum of Art. Catalogue.

Huntington, N.Y., Heckscher Museum. "Artists of Suffolk County, Part X: Recorders of History." May 9-June 20. Catalogue.

Washington D.C., Hirshhorn Museum and Sculpture Garden, Smithsonian Institution. "The Golden Door: Artist-Immigrants of America, 1876-1976." May 20-October 20. Catalogue by Daniel J. Boorstin and Cynthia Jaffee McCabe.

Katonah, N.Y., The Katonah Gallery. "Abstract Expressionism and Later Movements, 1955-1976: Part 1." May 29-July 17. Catalogue by John I. H. Baur.

Greenwich, Conn., Greenwich Arts Council. "Sculpture 76: An Outdoor Exhibition of Sculpture by Fifteen Living American Artists." June 1-October 31. Catalogue by Jacqueline Moss and Ida E. Rubin.

Indianapolis, Contemporary Art Society of the Indianapolis Museum of Art. "Painting and Sculpture Today, 1976." June 8-July 18. Catalogue.

Tokyo, Seibu Museum of Art. "Three Decades of American Art: Selected by the Whitney Museum." June 18-July 20. Catalogue.

Bonn, Rheinisches Landesmuseum. "200 Jahre Amerikanische Malerei, 1776-1976." June 30-August 1. Traveled to: Belgrade, Muzej Savremene Umetnosti; Baltimore, Maryland Science Center. Catalogue.

Huntington, N.Y., Heckscher Museum. "Heritage of Freedom: A Salute to America's Foreign-Born Artists." July 4-August 29. Traveled to: Montclair, N.J., Montclair Art Museum. Catalogue by Dorothy M. Kosinsky.

Geneva, Musée d'Art et d'Histoire. "Peinture américaine en Suisse." July 8-October 4. Catalogue.

East Hampton, N.Y., Guild Hall. "Artists and East Hampton: A 100-Year Perspective." August 14-October 3. Catalogue.

London, Thomas Gibson Fine Art. "Fourteen Paintings: de Kooning, Dubuffet, Ossorio, Pollock, Still." Fall. Checklist.

Basel, Galerie Beyeler. "America, America." October-November. Catalogue.

New York, Allan Stone Gallery. "Masterpieces in Abstract Expressionism." October-November.

Milwaukee, Milwaukee Art Center. "From Foreign Shores: Three Centuries of Art by Foreign-Born American Masters." October 15-November 28. Catalogue.

New York, The Solomon R. Guggenheim Museum. "Acquisition Priorities: Aspects of Postwar Painting in America." October 15-January 16, 1977. Catalogue.

New York, Wildenstein Gallery. "Modern Portraits: The Self and Others." October 20-November 28. Catalogue.

Washington, D.C., National Collection of Fine Arts, Smithsonian Institution. "The Art of Poetry." November 19-January 23, 1977. Catalogue by Peter Bermingham.

1977 New York, Xavier Fourcade. "Twentieth Century Paintings and Sculpture: Matisse to de Kooning." March 29-April 30. Checklist.

Cambridge, England, The Fitzwilliam Museum. "Jubilation: American Art During the Reign of Elizabeth II." May 10-June 18. Catalogue.

Paris, Musée National d'Art Moderne, Centre National d'Art et de Culture Georges Pompidou. "Paris-New York." June 1-September 19. Catalogue.

Kassel, Museum Fridericianum. "Documenta 6." June 24-October 2. Catalogue.

London, Arts Council of Great Britain (organizer). "The Modern Spirit: American Painting, 1908-1935." Traveling exhibition, opened August; itinerary: Edinburgh, Royal Scottish Academy; London, Hayward Gallery. Catalogue by Milton W. Brown.

St. Paul, Minnesota Museum of Art. "American Drawing, 1927-1977." September 6-October 29. Catalogue.

Indianapolis, Indianapolis Museum of Art. "Perceptions of the Spirit in Twentieth-Century American Art." September 20-November 27. Traveled to: Berkeley, University Art Museum, University of California; San Antonio, Marion Koogler McNay Art Institute; Columbus, Ohio, Columbus Gallery of

Fine Arts. Catalogue by Jane Dillenberger and John Dillenberger.

Southampton, N.Y., The Parrish Art Museum. "Twentieth Century American Paintings from the Metropolitan Museum of Art." September 25-December 31. Catalogue.

1978 South Bend, Ind., The Art Center. "Twentieth Century American Masters." January 14-February 26. Catalogue.

Worcester, Mass., Worcester Art Museum. "Two Decades of American Printmaking, 1957-1977." March 15-May 14. Catalogue.

Ithaca, N.Y., Herbert F. Johnson Museum of Art, Cornell University. "Abstract Expressionism: The Formative Years." March 30-May 14. Traveled to: Tokyo, Seibu Museum of Art; New York, Whitney Museum of American Art (co-organizer). Catalogue by Robert Carleton Hobbs and Gail Levin.

Philadelphia, Philadelphia College Art Gallery. "Seventies Painting." April 21-May 21. Catalogue.

Washington, D.C., National Gallery of Art. "American Art at Mid-Century: The Subjects of the Artists." June 1-January 14, 1979. Catalogue by E. A. Carmean, Jr., and Eliza E. Rathbone.

New York, Harold Reed Gallery. "Yale Faculty, 1950-78." October 18-November 19. Catalogue.

Buffalo, Albright-Knox Art Gallery. "American Painting of the 1970's." December 8-January 14, 1979. Traveled to: Newport Beach, Calif., Newport Harbor Art Museum; Oakland, The Oakland Museum; Cincinnati, Cincinnati Art Museum; Corpus Christi, Tex., Art Museum of South Texas; Champaign, Ill., Krannert Art Museum, University of Illinois. Catalogue by Linda L. Cathcart.

1979 Sydney, Australian Gallery Directors Council (organizer). "America and Europe: A Century of Modern Masters from the Thyssen-Bornemisza Collection." Traveling exhibition; itinerary: Perth, Art Gallery of Western Australia; Adelaide, Art Gallery of South Australia; Brisbane, Queensland Art Gallery; Melbourne, National Gallery of Victoria; Sydney, Art Gallery of New South Wales. Catalogue.

Claremont, Calif., Montgomery Art Gallery, Pomona College, and Lang Art Gallery, Scripps College. "Black and White Are Colors: Paintings of the 1950s-1970s." January 28-March 7. Catalogue.

Washington, D.C., The Corcoran Gallery of Art. "36th Biennial Exhibition of Contemporary American Painting: Willem de Kooning, Jasper Johns, Ellsworth Kelly, Roy Lichtenstein, Robert Rauschenberg." February 24-April 8. Catalogue.

Boston, Harcus Krakow Gallery. "American Abstract Painting in the 1950's." April 28-June 9. Checklist.

New York, American Academy and Institute of Arts and Letters. "Exhibition of Work by Newly Elected Members and Recipients of Honors and Awards." May 23-June 17. Checklist.

Williamstown, Mass., Williams College Museum of Art. "Documents, Drawings and Collages: 50 American Works on Paper from the Collection of Mr. and Mrs. Stephen D. Paine." June 8-July 5. Traveled to: Toledo, Ohio, The Toledo Museum of Art; Sarasota, Fla., John and Mable Ringling Museum of Art; Cambridge, Mass., Fogg Art Museum, Harvard University. Catalogue.

Düsseldorf, Städtische Kunsthalle Düsseldorf. "2 Jahrzehnte Amerikanische Malerei, 1920-1940." June 10-August 12. Traveled to: Zurich, Kunsthaus Zürich; Brussels, Palais des Beaux-Arts. Catalogue.

Philadelphia, Pennsylvania Academy of the Fine Arts. "Seven on the Figure: Jack Beal, William Beckman, Joan Brown, John DeAndrea, Willem de Kooning, Stephen DeStaebler, Ben Kamihira." September 20-December 16. Catalogue by Frank H. Goodyear.

New York, The Pace Gallery. "Five Action Painters of the Fifties" [de Kooning, Kline, Krasner, Motherwell, Pollock]. September 21-October 13. Brochure.

Miami, The Gallery, Miami-Dade Community College. "The Figure of 5." October 8-November 1. Catalogue by Jane Blum.

Chicago, David and Alfred Smart Gallery, University of Chicago. "Abstract Expressionism: A Tribute to Harold Rosenberg." October 11-November 25. Catalogue.

New York, Acquavella Galleries. "XIX and XX Century Master Paintings." November 1-30. Checklist.

Denver, The Denver Art Museum. "Poets and Painters." November 21-January 13, 1980. Catalogue by David Shapiro and Dianne Perry Vanderlip.

1980 Paris, Grand Palais. "L'Amérique aux indépendents." March 13-April 13. Catalogue.

Washington, D.C., Hirshhorn Museum and Sculpture Garden, Smithsonian Institution. "The Fifties: Aspects of Painting in New York." May 22-September 21. Catalogue by Phyllis Rosenzweig.

New York, Whitney Museum of American Art. "The Figurative Tradition and the Whitney Museum of American Art: Paintings and Sculpture from the Permanent Collection." June 25-

September 28. Catalogue by Patricia Hills and Roberta K. Tarbell.

Southampton, N.Y., The Parrish Art Museum. "17 Abstract Artists of East Hampton: The Pollock Years, 1946-56." July 20-September 14. Traveled to: Storrs, Conn., The William Benton Museum of Art, University of Connecticut; New York, Zabriskie Gallery. Catalogue.

St. Paul, Minnesota Museum of Art. "Drawings in St. Paul: Selections from the Miriam B. and Malcolm E. Lein Collection." October 16-December 23. Catalogue.

Norfolk, Va., The Chrysler Museum. "American Figure Painting, 1950-1980." October 17-November 30. Catalogue.

New York, Pratt Manhattan Center Gallery. "Sculpture in the 70s: The Figure." November 3-25. Traveled to: Brooklyn, Pratt Institute Gallery; Little Rock, Ark., Arkansas Arts Center; Tempe, Ariz., Arizona State University; Hanover, N.H., Dartmouth College Museum. Catalogue.

Brooklyn, The Brooklyn Museum. "American Drawing in Black and White, 1970-1980." November 22-January 18, 1981. Checklist.

1981 London, Royal Academy of Arts. "A New Spirit in Painting." January 13-March 18. Catalogue.

New York, Whitney Museum of American Art. "1981 Biennial Exhibition." February 4-April 19. Catalogue.

Roslyn, N.Y., Nassau County Museum of Fine Art. "The Abstract Expressionists and Their Precursors." January 20-March 22. Catalogue by Constance Schwartz.

Princeton, N.J., The Art Museum, Princeton University. "Princeton Alumni Collections: Work on Paper." April 26-June 21. Catalogue.

New York, Marisa del Re Gallery. "10 American Abstract Masters: de Kooning, Frankenthaler, Gottlieb, Hofmann, Kline, Louis, Motherwell, Pousette-Dart, Rothko, Stella." May 1-30. Checklist.

New York, The Metropolitan Museum of Art. "An American Choice: The Muriel Kallis Steinberg Newman Collection." May 21-September 27. Catalogue by William S. Lieberman.

New York, Xavier Fourcade. "Sculptures." July 24-September 11.

Houston, The Museum of Fine Arts. "Drawings into Sculpture, 1400-1980." July 30-September 20.

Akron, Akron Art Museum. "The Image in American Painting and Sculpture, 1950-1980." September 12-November 8. Catalogue.

Munich, Haus der Kunst. "Amerikanische Malerei, 1930-1980." November 14-January 31, 1982. Catalogue by Tom Armstrong.

1982 Washington, D.C., Hirshhorn Museum and Sculpture Garden, Smithsonian Institution. "Five Distinguished Alumni: The W.P.A. Federal Art Project" [Bolotowsky, Brooks, de Kooning, Lassaw, Neel]. January 21-February 22. Traveled to: East Hampton, N.Y., Guild Hall. Catalogue.

New York, Rosa Esman Gallery. "A Curator's Choice: A Tribute to Dorothy C. Miller." February 4-March 6.

New York, The Museum of Modern Art. "A Century of Modern Drawing." March 1-16. Traveled to: London, British Museum; Cleveland, The Cleveland Museum of Art; Boston, Museum of Fine Arts. Catalogue by Bernice Rose.

Amsterdam, Stedelijk Museum. "'60-'80: Attitudes/Concepts/Images – A Selection from Twenty Years of Visual Arts." April 9-July 11. Catalogue.

New York, Whitney Museum of American Art. "Focus on the Figure: Twenty Years." April 14-June 13.

Ridgefield, Conn., Aldrich Museum of Contemporary Art. "Homo Sapiens." April 15-September 19.

New York, Vanderwoude/Tananbaum Gallery. "Woman: Subject and Object." May 4-June 11.

Albany, N.Y., Senate Chamber and Lobby. "Twelve Americans from the Metropolitan Museum of Art." May 5-June 20.

New York, Whitney Museum of American Art. "Abstract Drawings, 1911-1981." May 5-July 11. Checklist by Paul Cummings.

Oklahoma City, Oklahoma Art Center. "American Masters of the Twentieth Century." May 7-June 20. Traveled to: Evanston, Ill., Terra Museum of American Art. Catalogue by John I. H. Baur and Ann Wiegert.

New York, Robert Miller Gallery. "Landscapes." June 9-July 3.

New York, The Solomon R. Guggenheim Museum. "The New York School, Four Decades: Guggenheim Museum Collection and Major Loans." July 1-August 29. Brochure.

Stamford, Conn., Stamford Museum and Nature Center. "Abstract Expressionism Lives!" September 19-November 7. Catalogue by Robert Metzger.

New York, Sidney Janis Gallery. "The Expressionist Image: American Art from Pollock to Today." October 9-30.

1983 New York, Monique Knowlton Gallery. "The Painterly Figure: Veteran Expressionist Figure Painters." March 2-26.

Lenders to the Exhibition

Abrams Family Collection
Albright-Knox Art Gallery, Buffalo
American Broadcasting Companies, Inc., New York
Mr. and Mrs. Harry W. Anderson
Art Gallery of Ontario, Toronto
The Art Institute of Chicago
The Art Museum, Princeton University, Princeton, New Jersey
Australian National Gallery, Canberra
Mr. and Mrs. Stanley O. Beren
Sarah Campbell Blaffer Foundation, Houston
Mr. and Mrs. Donald Blinken
Susan Brockman
Rudolph Burckhardt
Mr. and Mrs. Randolph P. Compton
Andrew Crispo Gallery, Inc., New York
Elaine de Kooning
Mr. and Mrs. John L. Eastman
Mr. and Mrs. Lee V. Eastman
Xavier Fourcade, Inc., New York
Mr. and Mrs. Ralph I. Goldenberg
James and Katherine Goodman
Richard and Mary L. Gray
Wilder Green
Mr. and Mrs. Irwin Green
Mrs. Tyler G. Gregory
The Solomon R. Guggenheim Museum, New York
Graham Gund
Ben Heller
Susan Morse Hilles
Estate of Joseph H. Hirshhorn
Hirshhorn Museum and Sculpture Garden, Smithsonian
 Institution, Washington, D. C.
Inland Steel Company, Chicago
Glenn Janss
Philip Johnson
Donald and Barbara Jonas
Mr. and Mrs. Paul Kantor
Gertrude and Leonard Kasle
Edgar Kaufmann, Jr.
Emilie S. Kilgore
Mr. and Mrs. Alain Kirili
Mr. and Mrs. Harry Klamer
Mrs. Berthe Kolin
Richard E. and Jane M. Lang
Estée Lauder Cosmetics Collection, New York
Mrs. H. Gates Lloyd
Los Angeles County Museum of Art
Linda Loving and Richard Aaronson
Marielle L. Mailhot

Martin Z. Margulies
Max Margulis
H. Mariën
Vincent Melzac
The Metropolitan Museum of Art, New York
The Brett Mitchell Collection, Inc., Cleveland
Mr. and Mrs. Robert Mnuchin
Mnuchin Foundation, New York
Moderna Museet, Stockholm
Musée National d'Art Moderne, Centre National d'Art et de
 Culture Georges Pompidou, Paris
Museum of Art, Carnegie Institute, Pittsburgh
Museum of Art, Rhode Island School of Design, Providence
The Museum of Modern Art, New York
National Gallery of Art, Washington, D. C.
National Gallery of Canada, Ottawa
Nelson-Atkins Museum of Art, Kansas City, Missouri
Mr. and Mrs. S. I. Newhouse, Jr.
The Muriel Kallis Steinberg Newman Collection
David T. Owsley
Estate of Betty Parsons
Mr. and Mrs. Donald A. Petrie
Philadelphia Museum of Art
The Phillips Collection, Washington, D. C.
Edmund Pillsbury
Kimiko and John Powers
Eve Propp
Judy and Ken Robins
Harold and May Rosenberg
Mr. and Mrs. Steven J. Ross
Mr. and Mrs. Fayez Sarofim
Mr. and Mrs. Richard Selle
Betty and Stanley Sheinbaum
Mr. and Mrs. Sherman H. Starr
Stedelijk Museum, Amsterdam
Allan Stone Gallery, New York
Paul and Ruth Tishman
Vanderwoude Tananbaum Gallery, New York
Wadsworth Atheneum, Hartford
Warner Communications, Inc., New York
Stella Waitzkin
Walker Art Center, Minneapolis
Weatherspoon Art Gallery, University of North Carolina
 at Greensboro
The Weisman Family
Whitney Museum of American Art, New York
Sue and David Workman

and other lenders who wish to remain anonymous

Photograph Credits